The
Hanging
Tree

The Hanging Tree

A NOVEL

David
Lambkin

COUNTERPOINT
WASHINGTON, D.C.

First American Edition 1996
Published by arrangement with Viking Penguin Ltd.

First American paperback edition 1998

LIBRARY OF CONGRESS CATALOGING-IN-PUBLICATION DATA
 Lambkin, David, 1947–
 The hanging tree: a novel / David Lambkin.—1st American ed.
 "A Cornelia and Michael Bessie book"—T.p. verso.
 I. Title
PR6062.A4814H36 1996
823'.914—dc20 96-18626
ISBN 1-887178-71-6 (alk. paper)

A CORNELIA AND MICHAEL BESSIE BOOK

COUNTERPOINT
P.O. Box 65793
Washington, D.C. 20035-5793

Counterpoint is a member of the Perseus Books Group.

10 9 8 7 6 5 4 3 2 1

This book is for

MY FATHER

1904 - 1952

for

POOR TOM

1990 - 1994

and for

HOMINID HUNTERS EVERYWHERE

ACKNOWLEDGEMENTS

The author would like to thank the following writers and publishers for permission to quote: Macmillan London for *In the Grip of the Nyika* by Lieutenant-Colonel John Henry Patterson, DSO; Statius Books for *Quantum Reality: The Masks of the Gods* by Dr Krystina Korcak-Dukowska; Leyden University Press for *Fragments of Witchcraft in Pre-Colonial Africa* by Dr Jakob Neukraft; Ourobouros Publishers for *Archetypes in the Primitive Psyche* by Dr Charles Young; Penguin and Mr Juan Mascaro for permission to quote from the Bhagavad Gita; Beolgorod University Press and Dr Gottlob Paiss for his translation of the Index Ludorum Proibitorum and Slim Volumes Press for permission to quote from *Keraunos: A Thunderbolt for Pan* by Paul Morgan.

Dr Andrew Sillen of the University of Cape Town was very tolerant and helpful fielding my uninformed questions about Strontium/Calcium ratios in fossil hominids and I would like to point out that the use to which I have put this information in the text does not necessarily reflect his views.

The professionalism and enthusiasm of Dr Lee Berger at the Palaeoanthropology Research Unit at the University of the Witwatersrand was a delight. He kindly and tolerantly gave me the benefit of his experience, as well as personal insights into his view of hominid evolution, some elements of which, in a modified form, I may have unwittingly incorporated into the text.

I'd also like to thank the inspiring Dr J Francis Thackeray, Head of the Department of Palaeontology at the Transvaal Museum, Pretoria. His generosity, unfailing courtesy and tolerance in the face of my intrusive and often dimwitted enquiries about fossil

ancestors was generous and unstinting. I owe much to his work and that of his associate, Professor Maciej Henneberg of the Wits Medical School.

Although there is an increasingly wide international canon of palaeontological works, I have drawn principally on those which deal with East- and Southern-African studies. This tradition is varied, complex and very combative. I would be nowhere without the wonderful writings of — amongst others — people as diverse as Mr Robert Ardrey, Dr C K Brain, Dr Robert Broom, Dr Raymond Dart, Dr Donald C Johanson, Mr Richard Leakey, Mr Roger Lewin, the legendary Dr Phillip Tobias, and Dr Elizabeth Vrba.

These are very few of the many active workers in this important field, many of them presently unsung, desiccated, hot, hungry and cold; all meticulously hunting our ancestors with passion and unceasing curiosity. They all deserve our thanks.

Finally, I would like readers to know that the presiding genius of this book is Eugène Marais, pioneer ethologist and poet.

Any remaining technical inaccuracies in the text are entirely those of the author.

AUTHOR'S NOTE

The historical facts are disarmingly simple.

In 1907 Lieutenant-Colonel John Henry Patterson, war hero and best-selling author of *The Maneaters of Tsavo*, was appointed first Game Warden of the British East African Protectorate, now called Kenya.

In January 1908 Patterson went on an extended safari of exploration to the deep north accompanied by his friend and fellow officer, Captain the Honourable Audley James Blyth, and Blyth's beautiful blonde wife Ethel Jane, known affectionately as 'Janey'.

Two months later, on the morning of 21st March, at a stony place amongst the thorns called Laisamis, Patterson found Audley James Blyth dead in his tent.

There was a bullet wound in his head and his .450 Webley service revolver was in his hand.

A verdict of suicide was given by the court of inquiry.

The concept of a search, quest or investigation implies the existence of an attainable objective. This assumption — that pre-ordained order exists, complete with answers waiting to be unearthed by diligent research — underpins all classical scientific enquiry.

Perhaps quantum theory's most bizarre violation of the untutored layperson's concept of common sense is the extraordinary way in which particles obediently seem to appear only when looked for and disappear when observation ends; as if the very act of looking compelled the creation of the object itself. This unsuspected collusion between the seeker and the sought, the observer and the observed, is as crass a betrayal of our innocence and trust as God's surrendering of Job to Satan.

Krystina Korcak-Dukowska: Introduction to Quantum Reality: The Masks of the Gods

In Musicke, a Fugue denotes the Flight of many Melodies; as it were, a Flight of many Birds in one flock, some Soaring, some Diving, yet all flying together to one Place, the End. For the Fugue is One in Many, a polyphonic Multiplicity of Songs or Voices intertwined like a Rope, the stronger for the binding; each Individual, yet all sounding Harmoniously together.

Sir Thomas Challis: Treatis on Fugueing (1698)

Albedo

The World of Silver

Our primitive nature demands a counterpoise to the world of light and crass rationality. There beats within us a second heart of primordial darkness, a shadowheart that nurtures the Luciferian side of our being.

Charles Young: Archetypes in the Primitive Psyche

In the same way that the very act of observation influences the behaviour of the observed object in the quantum universe, so witchcraft may be a refined form of 'observational interference' which has become codified in ritual over time.

In this model of the universe, a witch is merely one who can — by observational interference — 'switch the tracks' in another's life from one set of existential possibilities to another.

Krystina Korcak-Dukowska

Johannesburg, South Africa
The Present Day

In the summer of that year when the wind was right you could smell the blood from the slaughterhouse.

The museum where I worked was designed by Sir Edward Lutyens in high imperial style with tall imposing columns and classical friezes. It was sited on a low hill that raised it above the vulgar money-grubbing highrises of the commercial district and distanced it from the blood and viscera in the abattoir that was downtown near the railway yards. Aloof and Parnassian, it stood detached from the world. Unfortunately, it was also downwind from the slaughter-house when summer northerlies threatened rain.

My office faced the shunting yards with their distant silver veining of railway lines and on Thursdays, sick to my stomach, I would see frightened dehorned cattle being goaded down wooden ramps from open trucks and into the abattoir's bemerded holding pens where they milled apprehensively, scenting death. Now, three years later, I sit again in the same hot office, my windows pushed open to catch any hint of wind.

Pigeons warble fat-throated on the concrete sill in the late afternoon light. The air is thick and still. Summer heat masses dark thunderheads above the skyline, the windows of city buildings flame buttercup towards dusk and as I watch, the sky quickly closes over and the rain comes down sudden and grey. Steam rises from the hot streets. And borne on the rainwind, the abattoir smell is there

again: rich and sweet, conjuring memories of the desert and of the dead, of the blood scent that no effort of will, no drunken forgetfulness or drug can ever remove.

I stare at my photograph of the dead and still living, neatly framed and standing on my desk. A moment extracted unnaturally from time, seized to be examined at leisure: Chinta, Orde, me, Marion and Victor. So many dead, so many dead. It was taken as we were about to set out on our journey of discovery, our assault on the unknown, our enquiry into the unknowable. Our pilgrimage into the wilderness.

What I cannot accept is that there is no hint in the photograph of what was to come. No sign of the gunfire and bloodshed, love and ancient skulls and death that were waiting for us still folded in the involuted womb of the future. To those happy materialists who are secure in their certain knowledge of the here and now and reject the dominion of witchcraft, this will come as no surprise. I look amused and confident, leaning on my stick; Marion stares out with the arrogance of the professional beauty; Chinta looks self-effacing, and Victor is so distracted as to be almost invisible. Perhaps that was an omen.

Looking at the photograph, I think: surely I should be able to forget them all. Perhaps I should. But I cannot forget the blood. No one could ever forget all that blood. Who would have thought the scent of the slaughterhouse would follow me all the way to the desert? And I still have no answers. No answers at all. And although I have often thought failure more poignant than its opposite, I know now that my travails in the desert were worth nothing.

TWO

Despite all this, I am still a scientist.

True, on my bad days I now wonder whether science — clearly not as hard-edged and factual as I'd been taught — is worth pursuing at all. What happened in the desert broke my faith in the sovereignty of order. Now I often find myself trapped inside the empiricist's old nightmare: a blind seeker in a darkened room, deceived by my instincts, distrustful of the evidence of my trembling fingertips but deprived of any other way of knowing. I hear the chuckles of the good, sane eighteenth century Bishop Berkeley and remember his belief that only divine sanction can confer order on chaos and meaning on the universe and life. All else is smoke.

And I think: what if I am merely another lost quantum observer, adrift in a quantum universe, bemused because the object of my quest obediently seems to appear precisely when I seek it? What if I am the victim of a playful quantum god? A senile god, snaggle-toothed, dribbling and gormless? A combative parliament of gods, changing the rules at will, seeking not order but power over each other? Or a divine conjuror bored with creation, fit now only to toy with seekers like me... Am I deceived? What can I know?

These things will not let me be. I remember the innocent observer I was three years ago: still optimistic then, still convinced that somewhere beneath the apparent surface chaos of my everyday experience there lay a hidden pattern of great beauty and sense that would confer meaning both on my random life and on the serried collection of fossils that great palaeontologists living and dead had collected over more than a century. I remember so clearly sitting in my temporary office at the Museum of Man in Nairobi, holding the

5

skull Tregallion had found and waiting for the big annual Kenyan rains to rinse the edge of afternoon heat.

Let me explain.

My name is Kathryn Widd and in the beginning I went to Kenya to investigate a murder that may or may not have taken place over four million years ago. I am a palaeontologist by profession, a hunter of fossil people, seeking clues about our species by studying the bones of our ancestors. On my optimistic days I saw myself as a sort of detective, scrying the dry fossils of our past for clues that would explain the crimes of our present. A scientist by training rather than inclination, I was taught by an early perceptive lecturer to rely on careful observation, not on my favourite intuitive interpretative leaps. Analysis, technique and patience. The past, I had always been taught, will yield its secrets as it has before. The truth will be told. At the time, I still had faith, I still believed in truth. I see now how naive I was.

I am not really temperamentally suited to the detached pursuit of science. I suspect sometimes that only my love for my father persuaded me to persevere and take my degree. Or perhaps not; I often forget that as a child I was driven by a rage to know the past that was matched in intensity only by my intuitive knowledge of our cruelty.

I remember still the long dusks of the summer of my twelfth year, the year I first bled: our garden in Zululand thick with red hibiscus and scented jasmine, brilliant with magenta bougainvillaea; swollen with the perfume of Saint Joseph's lilies, the funeral flowers. Innocent still, I dug holes at the bottom of the garden and buried chicken bones, dug them up later highly disappointed to discover they'd not been transformed miraculously into fossils.

Dinosaurs fascinated me. The image I found in my encyclopaedia of an archaeopteryx etched in rock absorbed my mind. I have always had vivid dreams and visions of great toothed birds with leathery wings haunted my troubled sleep. I sensed even then that in the

byways of our past lay the truth both about my parents' combative present and our species' uncompromising passion for destruction. I nagged my patient father to take me to museums, stared in silence at the fossil hominid skulls placed so frustratingly out of reach behind glass.

Then, at university, I began to grasp that I was investigating not just the past but my own inherited animal nature and that of my species as well. I should add that at the time I studied, any hint that we were born with a genetic behavioural inheritance was the purest heresy. Behaviourism ruled. We are, I was taught, not animals. Despite all biological evidence to the contrary, my lecturers believed us to be beings specially created, not by God — who was regarded with amused tolerance as the infantile product of less gifted minds — but by culture, which was seen as a uniquely human attribute.

From textbook after textbook I learnt that we had no innate nature in the commonly accepted sense of that word. We were the spawn of some Promethean gene that had somehow liberated us and only us from reliance on our distant past; we were blank slates on which our environment — good or bad — could write what it wished. My lecturers saw this as liberation; I saw only rootlessness and dependence. If they were right there was no bedrock to our existence; we were illegitimate chimera, children of water and shadows, bastards cut off from an inheritance twenty million years old. Worse: saint or warlock, devil or witch could turn us into whatever they wished. We were defenceless. Born without innate evil, we were born also without virtue.

Knowing from my fieldwork and the fossil record the magnificent complexity of our ancestors' lives, their courage and fortitude, I could not believe that we'd inherited their physiology but not their minds. This seemed crassly stupid to me, and spendthrift in a way that nature never is. When I hesitantly pointed out the similarity of our DNA to that of chimps and gorillas I was labelled a reactionary heretic by my lecturers and friends and my professor sternly

7

downmarked my papers until I'd learnt to respect the correct dogma and repeat the correct answers without question.

But despite this, despite my predisposition to melancholy and my innate pessimistic view of the universe, I persisted. Some of the younger lecturers encouraged me; I regurgitated the correct behaviourist dogma in my papers but continued my personal search on the quiet. I knew that I wanted answers to simple childhood questions that my innocent professor and his melioristic doctrine could not give: What does it mean to be human? Why am I here? What must I do? Where do I belong in the cosmos? Why is there a cosmos? What must I do to be good? Why does evil seem to be so much more than the mere absence of goodness? Why do we kill each other? Why are there stars? And when I die? If I know where we come from, can I guess where I am going? A child's questions, to be sure. When I once tentatively mentioned my questions to my philosophy tutor he abruptly told me they were 'not worth asking' because they were 'unanswerable' and therefore 'pointless' and not the domain of 'proper philosophy'. Chastened, I dedicated myself to the formal analysis of sentences as dictated by his pet hero, Wittgenstein, but my primitive Zululand heart wanted more. I felt guilty that I was so unsophisticated; and yet, and yet —

My curiosity grew and at university and after I strove to understand what imperatives we carried still in our blood of our ancestors' long struggles against weather and predators, disease and death.

Often when I tramped the sunscoured windrent hills around the famous fossil hominid sites at Sterkfontein, Kromdraai, Makapan and Azazelsgat,[1] I would stare at the hot bleak landscape and know in some dark cloister of my ancestral soul the fear and the hard desire to endure that had brought us intact from our first savannah home to our comfortable suburban armchairs. Standing there once in the midday heat with a million-year-old stone axe in my hand, I realised with a shock that our ancestors were created by the hazards and delights of a distant age and that our blood was still pledged to

8

their antique ways. But this insight has brought me no good fortune. I am unknown, underpaid, entirely unloved.

In short, I am a failure; but I like to think this may be the result either of my corrosive sadness or of my specialised interest in human violence, a subject most people prefer not to think about at all. I remember: when I was a young girl trapped indoors by the tropical Zululand rain that came down sudden and hard in summer I would page through my father's books on war, fascinated by the photographs I found there of bodies draped on barbed wire; bodies piled one on another, refuse heaps of humanity. How is it possible, I wondered, for us to do this to each other? The stench of blood I knew, nobody told me: hot and sweet. And of corrupted flesh: ammoniac, running dark and wet, the slipperiness. Somehow, twelve, still innocent, I knew when I saw the first small petal of menstrual blood on my white school panties that I was mortal too.

How little we understand the moments of our undoing! When Ray Chinta's chance letter to my boss, John Morton, arrived at the museum in Johannesburg where we worked, I was restless and depressed. I had come to a dead end in my heart. It was not simply the inventions of spring and the early summer thunder that unsettled me at each season's turn. This desiccation of the spirit was colder and bleaker. It ran right to my marrow.

Even the sweet distractions of the flesh were denied me: there was no man I liked enough to allow into my life. After the long undelightful decay of my life with my lover the famous writer I'd sworn that I'd never again allow myself to be slowly killed inside. But the loneliness attendant on this harsh choice was hard to bear. I cooked for myself, practised my cello in the empty spare bedroom, played in a small but competent chamber group and listened to Bach. The other members of the group often urged me to dedicate myself solely to the cello. They insisted I was gifted. They were, they said, certain I'd find a place in the Transvaal Chamber Orchestra. But I was unsure, even afraid, deeply unhappy. True, there was my fat affable marmalade cat MacPuss, who lived with me in my house in Melville hard by the

edge of the stony hills where centuries ago people had smelted iron and hunted for survival. Now MacPuss stalked the same hills, ambushed fieldmice and olive thrushes and tormented the brown house snake that lived in our garden near the dead oak tree. Strange: there have always been snakes in my garden.

Sometimes when I woke in the night I'd think of my parents' pointless lives and lonely deaths and know there was nothing to say, nothing at all. All I could do was stare out at the darkness and feel the calm weight of MacPuss on the bed beside me and wait for sleep to come again. It was not what you'd call a perfect life. Even my career was stalled. Despite the fact that I had worked some of the richest hominid fossil sites in southern Africa, I'd not found a stunningly newsworthy ancestral skull that would offer the world a tantalising glimpse of our past.

But I thought there was hope. A new fossil find of a jaw and a partial cranium near the old Azazelsgat limeworks promised fame and success. I was by far the best qualified member of the museum staff to run a dig there, and passage gossip had it that I'd be asked to lead the team. I suppose I was waiting for the news.

Now, when the bloodshed is behind and the bodies of the people I loved so much are wrapped in their quiet desert graves, I think back and wonder. I remember the moment of my damnation quite clearly. I was sitting at my desk staring at the book I was reading, *Quantum Reality: The Masks of the Gods* by Dr Krystina Korcak-Dukowska. It lay open on my desk. I rarely trust scientists who write popular books about the cosmos but I'd reluctantly become interested in Dukowska's, principally because I was curious but had no understanding of the topsy-turvy Alice-in-Wonderland world of quantum physics. While I read I was half aware of the traffic noise from the busy streets, the remorseless thump of reggae from the basement where the motorbike messengers held court and smoked marijuana, the ancient black teacup circles engraved like Magdalenian cave paintings forever on my desktop.

Everything seemed so deceptively normal: my favourite books stood neatly inside their glassed bookcase; the cello case holding my Stradivarius was propped in one corner, last gift from my father and so intimately bound up with my understanding of myself that it travelled with me everywhere; my casts of famous fossil hominid skulls stood in a neat taxonomically-assured row, smallest to largest, afarensis to sapiens. A trapped fly butted softly at my closed office window. I was pondering a line in Dukowska's book: 'The scientific method is predicated on the assumption that nature is objective, that it exists "out there", independent of the observer. This assumption is no longer valid.'

The fly butted headlong against the window pane. I read on: 'The paradigm of man's plight is written in the Old Testament, in the Book of Job. Here, God bargains with Satan for Job's trust and delivers him up for torment. Job's world is suddenly without meaning. Truly he may have cried out — along with another of God's famous scapegoats — "Why have you forsaken me?"

'In the uncertainty and irrationality of the quantum universe, we find our equivalent and final abandonment of mankind by God. Hidden behind his masks, the creator is invisible, unknowable. Accidental, pointless, our cries echo across the vacant spaces between the stars, unheard in a universe that makes no sense...'

John Morton's radio in the next office was tuned as always to a news programme. Hopelessly addicted to facts, he had no use for music. Through the thin fibreboard wall I could hear reports about bloodletting in Yugoslavia, racial unrest in California. Rape in Los Angeles, murder in Soweto. A man in Maidenhead had kept his wife locked in a cupboard for a year, charging his friends ten pounds a go to sodomise her. When she was released her body was covered with cigarette burns. A commercial break for suntan lotion interrupted this catalogue for thirty seconds.

I read on: 'If the hypothetical tachyon exists, a particle which habitually travels faster than the speed of light, causality will fall away and we must understand that we live in a universe which is

deeply irrational. A universe where events may precede their apparent causes, where random conjunctions of events may conjugate their own meaning, where happenstance will rule in defiance of Einstein's famous and oft-quoted dictum: "God does not play at dice with the universe." '

Happenstance. It was at that moment that John Morton tapped softly on my office door. He appeared as always in a sweet mephistophelean cloud, his face wreathed about with aromatic pipe smoke. His speciality was climatic change in the Pleistocene age, more than a million years ago, when many of our ancestors took their first tentative steps in Africa. He thought in millennia, not decades. He was patient. He was also vengeful.

We were at university together. But he chose the path of museum politics rather than hominid violence and became my boss. He'd once tried to kiss me, late at night, clumsily, unexpectedly, in the cold basement vault where we keep the originals of the famous australopithecine skulls from Sterkfontein and Azazelsgat. His hands groped at my breasts. He was not a big man and I pushed him violently away. He stumbled and fell backwards onto an old warthog skull, hurting both coccyx and vanity. He never forgave me. Naively, I thought he'd come to tell me I'd be leading the new dig at Azazelsgat.

'I thought you should see this,' he said, handing me a letter. 'More your line than mine.'

'Sit down, John. Tea?'

'No, thanks.' His eyes were on me, expectantly.

I opened the letter, anticipating my new appointment. Instead, I found a letter from Ray Chinta, the research director of the small and obscure Museum of Man in Nairobi, inviting John to travel to Kenya and study a fossil skull reconstructed from dozens of fragments. There were photographs of the incomplete skull which had been tentatively assigned to the species Australopithecus

robustus. More interestingly, the skull was 'deformed by twin indentations in the calvarium immediately above the left supraorbital ridge'. Translated from fossil-hunter's jargon this means simply that there were two deep dents above the left eyebrow. 'These,' Chinta added prudently, 'may not be attributable to natural agencies.'

The letter concluded by offering John the opportunity to work on a low-budget dig in Kenya in an attempt to find more fragments of the skull. I considered this. It would not be a good career move for John. The photographs of the skull showed it to be largely incomplete and of a species not considered ancestral to humans. It was simply another robust hominid and would pass almost unremarked in palaeontological circles. No big grants, no fame and fortune.

'Are you going?' I said.

'No.' He watched me. 'I can't. Too many commitments here, I'm afraid.'

'Oh? What?'

He unfolded a small steel instrument and probed into the bowl of his pipe as if searching for a nerve. 'Well, I'm going to be running that new dig at Azazelsgat —' he paused, raised his eyes from his pipe bowl to see the effect of his words. 'Good chance for me.' He puffed at his pipe, exhaled a long plume of rum-scented smoke. I leant back in my chair.

'So I thought you should go,' he said quietly. 'You haven't got much on at the moment, have you?'

'No.'

'Good.' He rose. 'Oh, and I thought you might like to see this,' he said, and handed me a brochure. 'D'you think I've got a chance of winning at Azazelsgat?'

He waved a thin hand at me and left before I could reply. I looked at the brochure which said: 'Raymond Dart Memorial Prize'.[2] I opened the brochure, read quickly. The trustees, in conjunction with *International Nature* magazine, were offering a prize of half a million dollars for the most significant find in palaeoanthropology made over the next twelve months. Consideration would be given to scrupulosity (what a word!) and parsimony in the application of scientific principles. There was a list of the trustees' names. No one I knew personally. No chance of favouritism. Damn. The fly dinked softly at my window glass.

Happenstance. I needed to think. I took my cello from its case, sat near the window, closed my eyes and began to play — as badly as ever — Bach's Suite for solo cello number two, my favourite, the one in D Minor. This time I managed twenty-two bars from memory before musophobic John Morton banged on the thin partition.

I looked again at the brochure, read the copy. Half a million dollars. Fame for John Morton, more obscurity for me. I felt sadness fill me again. All those wasted hours spent poring over books in the musty recesses of university libraries, all the long hours spent staring at rocky fossils, all the integrity. Perhaps my colleagues in the chamber group were right. Perhaps it was time for a change. Perhaps I should dump this uncertain searching for bones and play my cello instead. Take a chance, audition for the Chamber Orchestra...

I put away my cello, drank the last of my cup of cold tea and opened the window to let the fly out. On the hot summer wind there was a faint patina of blood-scent from the downtown abattoir. In that instant I decided to accept Chinta's offer. My father had left me a small sum of money in trust, so I could afford the extra expense of a Kenyan holiday. I thought: Why not? You've never seen Kenya; perhaps you'll get down to the coast, Lamu, Malindi, Kilifi, swim in the warm Indian ocean, look at the coral reefs, play your cello on the beach. Get out of the city, get away from the dryness and the exhaust fumes. Think about your future.

Four days later at noon, my precious cello snug in its own aeroplane seat beside me (thank you, Daddy!), I was drinking a Bloody Mary forty thousand feet in the air, watching the sere African bush far below, winging my way to Nairobi. In my bags were eight books, the result of my hasty research into the history of East Africa: *Kenya Chronicles* and *Profit & Sport in East Africa* by the entirely potty Lord Cranworth; *In the Company of Adventurers* by John Boyes, self-appointed King of the Kikuyu; *Facing Mount Kenya* by Jomo Kenyatta; *My African Journey* by Winston Churchill, pompous as ever; *Not Yet Uhuru* by Oginga Odinga; a first edition of *The Maneaters of Tsavo* and — most prophetically — *In the Grip of the Nyika* by John Henry Patterson.

During the four hour flight to Nairobi I paged through the books. It was only later that I began to wonder . . . At the time I thought it was simply because the photographs of animals and landscape it contained reminded me of my childhood in Zululand that I settled to read *In the Grip of the Nyika* by John Patterson.

Engrossed, I refused the frozen toxic muck disguised as airline food and discovered that in 1908 Patterson had taken two friends on safari to the deep north of the East African Protectorate. Even his plodding, mule-like sentences could not conceal his love of the bush; and I knew immediately how safari life had delighted Patterson and his friends. It was all there in his book: the inexplicable stillness of the air at midday, the hot chai that came with the birdcalls before dawn, the small bright fires the camp servants built each day at dusk. It was not hard to picture their small forty-pound tents of pale Indian drill pitched under luminous yellow fever trees near a river, the stars close enough to touch, the night full of weird eldritch cries of suffering beasts or abandoned souls.

Over the intercom the flight attendant asked us in a deracinated accent to fasten our seatbelts. The aeroplane banked steeply. I looked up from my book and down at the dry bush below. In the distance I could see the pale flat-topped ice and snow of Kilimanjaro. Thorn trees were thick on the ground; the bush was

15

threaded with narrow game paths. I wondered idly if Patterson had walked there, little understanding that I was already damned to walk where he had walked, cursed to suffer where he had suffered. It was as if, I later thought, Patterson had gone before me: a tracker wonderingly following a faint trail of unknown spoor into the wilderness, a pathfinder unwittingly exploring the underworld that is disguised for the uninitiated as just another place on a map: the shadowheart of Africa.

THREE

When I arrived in Nairobi and had installed myself in room sixty-one in the quaint 1937 wing at the Norfolk, Ray Chinta, author of the aleatory letter, telephoned and very kindly invited me to dinner at his house in Langata, one of Nairobi's affluent suburbs. I knew Chinta slightly from various seminars on hominid evolution. I remembered him as a smiling self-effacing man with a good scientific mind and a gentle wit.

It was an unusually sultry evening for a city nearly six thousand feet in the sky and we dined outside by candlelight under a tumble of hibiscus and frangipani. Chinta's wife was a pretty Eurasian girl named Iris. She was tall for an oriental, with skin of a colour that troubled me all evening as I sought the best word to describe it. Ivory was too pale, cinnamon too dark. Chinta had also invited his boss, the museum's administrator Victor Macmillan: a tall thin man in his fifties with a stoop, small broken veins in his nose and a very beautiful young wife called Marion who wore too much makeup and too little skirt.

There were not enough men to make up the numbers and I was seated beside her at dinner. She wore a crisp black cocktail frock in matt taffeta with a bustier top and a layered flared skirt. She looked groomed and glossy and I surprised myself by feeling dowdy in the little black dress I'd had for ten years and had always considered stylish beyond the vagaries of fashion. She was quiet and smoked continuously, extracting stubby oval cigarettes from a silver cigarette case and lighting them herself with a gold Dupont. Her fingers were long, the nails filbert, manicured, lacquered patent-leather red. She wore a ring set with *pavé* diamonds on her third

17

finger, left hand, and on her little finger a signet ring with an indecipherable crest.

Her skin was honey, matt, unflawed. Skin looks like that only when cosseted with massage and the most expensive emollient creams from arcane laboratories staffed by French-Swiss gnomes. I envied her. It came to me that she was one of those pampered women, often blonde, who complain about the heat or cold simply to make men feel nervously guilty that they're unable to control the weather. She stared at anyone who spoke with a steady unblinking gaze, eyes slightly hooded, smoke curling softly from her mouth. At a loss for conversation, I asked about the notorious 'thirties inhabitants of Happy Valley.

She gave me a vulpine look from under mascara'd lashes and said quietly: 'Frankly, I don't know and I don't care.'

I looked at her carefully to see if she meant this as a rebuff but was surprised to see that she was simply being honest.

'Why?' I asked.

'All that sordid coupling,' she murmured. 'You know.'

'Yes.'

'And no idea they were damned. They all died of drugs or drink or something awful. But no idea they were damned. Insensitive people. Cursed.'

'There's a difference.'

'Between?'

'Being damned and the other. Which was it?'

'Cursed. No, damned.' She smiled at me: 'I don't know. What's the difference?'

'One's damned by gods, cursed by other people.'

'Ah. Damned, then. Do you know anyone damned?'

'No. Do you?'

'No. Perhaps Victor. I'm not sure. He might be damned because of me.'

'How long've you been married?'

'We're not,' she said with a little smile. 'We're "companions". We live together.'

'How long?'

'Two years.' She stared across the table at Victor who was pouring himself a glass of wine. 'I'm no good for him,' she said. 'I know that.' She drew on her cigarette and it glowed like a hyena's eye caught in torchlight.

'Why?' I asked, wondering if she was always so confiding to strangers.

'I sometimes think I'm some sort of instrument of divine retribution. Are you married?'

'No.'

'Ever?'

'Never.'

She waited for me to continue, nodded at my reticence and said: 'What do you do?'

'Didn't Victor tell you?'

'Does he know?'

'I think so. I hope so!'

'What?'

'I'm a detective,' I said, without knowing why. For an instant, before she could replace her ironical social mask, I saw real consternation in her eyes.

'Oh? What sort?' she said casually. 'Criminal? Divorce? Do you peek at people in their bedrooms?'

I relented. 'I'm not really,' I said. 'I just say that to make my life sound more interesting.' I explained about the skull. She nodded, looking at me, then said: 'But in your heart, you are a detective, aren't you? I think I can see that.'

'Yes,' I said simply. 'I think I am. I've always been taught that there's a logical explanation for everything. An answer waiting to be found.'

She smiled at this.

'You don't agree?' I said.

'No, but it doesn't matter. I'm not very logical. Or optimistic.'

'And what do you do? The same as Victor?'

She shook her head briefly and said, returning to her earlier subject: 'Do you know anyone who's cursed?'

'No.'

'I do.'

'You do?'

'Yes. No. In fact I don't know him myself; he's dead. They're all dead now.'

'All who?'

'A man called Patterson. He was game warden here, back in nineteen oh-eight.'

'How odd. I was reading his books on the plane today. He seemed a bit dull to me.'

'Not at all,' she said, stubbing out her cigarette. 'He's fascinating. He was cursed by a chap who was a high-up in the Colonial service. Jealousy. They're all dead now. Patterson, his lover, her husband. All dead.'

'Patterson had a lover in Africa?'

'Yes. Janey Blyth, his friend's wife. You said you'd got his books; haven't you got *In the Grip of the Nyika*? It's all in there, even photographs. They're all dead, because of the curse. Well, partly.'

'Yes,' I said slowly. 'I have got that book. What happened? What curse?'

'Nobody's quite sure. Patterson took Janey and Audley with him on safari to the north, to the desert country. She fell for him, head over heels. The husband shot himself. There was a court of inquiry afterwards; according to the safari boys her husband got sick almost the instant they left Nairobi and Patterson and Janey used to ride off together and go hunting and leave her husband alone in camp crazy with fever. All very romantic for her: camels and dawn rides and shooting lions, making love at midday out in the bush, all hot sun and acacia blossom.' I smiled at her eloquence and she laughed wryly, nodding her agreement. 'Not so romantic for the husband though; he killed himself up in the desert at a place called Laisamis. In the nyika.'

'Nyika?'

'Wilderness. Desert? Wasteland. All because of the curse. At least, we think he shot himself. The uncharitable say Patterson shot him; naturally all those terrified emotionally crippled males in the Muthaiga Club bar say she shot him. It's one of the unsolved mysteries of Kenya. Everyone's got a different theory, of course, but no one really knows what happened. It caused a terrible scandal.'

'Why?'

I watched her light another cigarette, inhale, pause, lick her lips and exhale with her chin tilted to the sky. 'Well: Patterson was quite the hero; DSO, famous author, all that. And Janey and her husband were both children of peers. You know: more scandalous behaviour by the dreadful white settlers in Kenya. But it wasn't their fault. They fell in love because they were cursed. Star-crossed lovers...'

'Do you believe that?' I asked slowly.

'Oh, yes. I believe in curses. Don't you? I thought you would. And I've seen photographs and everything. Poor old Patterson.' She smiled at me and made an airy gesture with the hand holding her cigarette, dismissing the subject. Then: 'What're you going to be doing in Kenya?'

I explained in more detail about the skull and its dents.

'Murder? That long ago?'

'Perhaps. I'm interested in violence.'

'Are we violent?'

'We seem to be, don't we?'

'Men certainly. Is that why you look for fossils?'

'Partly. I think I thought if I knew where we came from I might know where we're going and what I'm doing here. Silly, I suppose.'

'Do you believe we're born evil?'

'No, not evil; evil had no meaning for us when we were evolving.'

'How do you mean?'

I hesitated, then decided she deserved to be treated honestly. I'm normally very reticent but to my surprise I told her how we'd learnt to take pleasure in sunrise and rainstorm, wind and thunder and

22

how we gloried in our attachment to all living things. I told her how the relentless Pliocene drought — four million years long — had slowly eaten away at the lush Miocene forest that was our first home. Eventually, I said, we abandoned the safety of the tall trees and stood erect and hairy, tough but vulnerable at the edge of the great yellow savannahs that hissed in the wind.

'But you don't believe in evil?' she said suddenly when I'd finished.

'As much as I believe in good.'

'And witchcraft? Curses?'

'As a way of releasing evil?'

'Yes.'

'Why not? The opposite of prayer?'

'No; prayer to a different part of the same god.'

'Go on.'

'About witchcraft?' She paused, glanced at the table. Victor Macmillan was watching us carefully with slightly unfocused eyes. I'd seen him down four whiskies before dinner and he'd drunk a bottle of red wine with the roast lamb.

'Is she talkinbout Patterson?' he asked.

'Not any more.'

'We're talking about witchcraft, if you must know,' said Marion.

'Slongsit's not Patterson,' said Victor. 'She's always talkinbout Patterson. I'm so bloody tired of Patterson. Ghost, bloody ghost. I've seen him, walkin' round the house looking for her at night. Fancies her, y'see. Ghost, though, can't do a thing, too soft, y'see. Impossible.'

'He's being rude,' Marion said, watching him without interest, 'because he thinks I'm in love with Patterson.'

'Are you?'

'Head over heels,' called Victor. 'Keeps's books by the bed, reads them again and again. Bloody ghost. Always mooning round the house. But too soft, y'see. No problem there.' He sipped his wine, nodded and added plaintively: 'And all this witchcraft rubbish: since we've been in Kenya all I've heard about is witchcraft. I've got a house full of nasty smelly fetishes that I'm told I'm not allowed to call fetishes because it's not what? Oh, yes — politically correct; and a pile of damn knucklebones and bits of skin that look like the remnants of a hyena kill. Horrible stuff.' He poured himself a fresh glass of Chinta's sulphurous burgundy and sipped. His eyes were heavy. He frowned. 'Awful wine,' he said softly and shrugged. He smiled unsteadily at us, murmured: 'Bloody Patterson...' and fell down face forward onto his plate. His forehead came to rest on a piece of cheese.

Silence fell. We all looked at him. A quick wind fluttered the candle flames horizontal. Iris giggled suddenly. Marion smiled at her wryly, looked at Macmillan and sighed. 'I'd better take him home.'

'I'll help you,' said Chinta and got hold of Victor under the armpits and pulled him upright. A fragment of cheese clung to his forehead. His jaw was slack. Marion looked at him for a second through narrowed eyes, then stepped forward and slapped him once, hard, in the face. His head snapped back and fell forward and he began to snore. Chinta hoisted him into a fireman's lift and carried him into the darkness.

'I'm sorry about this,' said Marion.

'Don't be silly,' I said.

'Everyone gets drunk once in a while,' said Iris.

They kissed each other goodbye and I watched the way Marion's heavy blonde hair swung forward in a swathe.

'Don't come out,' she said. 'I'll be fine.' She turned to me. 'I'm glad we met. Thank you for listening.'

'I enjoyed it. Perhaps we'll meet again; you can tell me more about colonial curses and your ghost who walks in the night.'

She smiled. 'Perhaps. Goodnight.'

'Goodnight,' I said. I watched her walk away. She had undeniably lovely legs, I noted again with envy.

Iris let out a deep sigh. 'Oh dear,' she said. 'Every dinner party we have, someone gets drunk. It's this awful country.'

'Is it?' I said. 'Isn't it just people?'

Iris shook her head. 'I honestly don't know. Perhaps he's just another stupid old man who shouldn't have got involved with a pretty young girl. How old would you say?'

'Fifties?'

She shrugged. 'Too old. For her, anyhow.'

Chinta appeared out of the darkness.

'Would you like a brandy?' asked Iris, and put her arm round him and kissed his cheek.

'No. But coffee would be nice. Kathryn?'

'Coffee would be lovely. Do you mind if I have a cigar?'

'Not at all.'

'That's very unusual for a woman, though, isn't it?' said Iris.

'Yes,' I said shortly. I've no patience with this reaction from women and I fear I'm sometimes too abrupt. I opened my father's old

crocodile case and took out a panetella and cut off the end. Relenting, I said: 'I got the habit from my father. I like the taste.' I offered the case to Chinta but he shook his head and looked at me with a smile, head on one side.

'I think it kind of suits you.'

'Thanks, Chinta.' I lit the cigar.

'They do smell wonderful,' said Iris brightly. 'So masculine!'

I looked at her; to cover her embarrassment she called her servant and asked for coffee. Chinta turned to me and said: 'I guess you're keen to see the skull.'

'Of course.'

'Why not come to the museum tomorrow morning? I'll show you the skull then and the map of the site.'

'Where was it found?'

'Near a place called Maleleji, in the north. Volcanic country. Very wild.'

'Pretty name.'

'Maleleji? Yes. It means "Place of Uncertain Winds". Kind of appropriate, really.'

'Why?'

'Well,' he shrugged. 'You know. Our past. Uncertain which way the wind would blow us.'

'Maleleji?' I turned the word on my tongue.

'We'll have you speaking Swahili in no time.'

We talked for a little longer. I finished my cigar, we drank more coffee and then I pleaded tiredness. As I drove off in my hired car I

remembered two things: Marion's reference to Patterson and witchcraft, and the look of fury in her eyes when she slapped Victor Macmillan in the face.

FOUR

Three years later, I dream about them still; but that night I had the first of my many dreams about Patterson and Janey and remember it as vividly as when I woke in my room in the Norfolk. This had none of the discontinuity of my ordinary dreams but came to me coherent, structured almost like a film with close-ups and wide shots, dialogue and sound effects. Unlike my other dreams, I could not intercede like a celestial director and control the story; I am powerless to act; this is not active dreaming. Patterson's story always unfolds and I watch passively. I dream only of them in this way.

★

... Her husband lay wrapped deep in dreams. Seated beside him in her camp chair, Janey watched, half asleep. The oil lamp flickered yellow in the nightwind that shifted the tent flaps. Outside, the night was alive with sounds: insects scratched and ratcheted, a nightbird interrogated the darkness. A hyena there, two; no, more: there, towards the hills where the sun went down in a smouldering pit of darkness. There, where the bleached grassland started beyond the riverine trees. Thorns and dust, the silence. Far upstream, at the very edge of hearing, a young fishing owl called; a soul falling into a bottomless pit, crying forever, Patterson said.

Janey stared down at her husband's still profile, gravid with sleep, and thought: He sleeps like a child, as if he does not yet truly inhabit his body. His soul is only just attached to his body. Or the dying: he sleeps like one dying. She felt his forehead. The fever was gone.

She listened again to the hyenas calling, closer now. The distant thud of fleeing hooves rising up under the earth, fear. The hyenas

28

had stopped calling. Had they killed? Blood, dust in the moonlight. How long now till night ended? How long till dawn when Munyakai would come and watch over Jamie in her place? How long until she would see Patterson again?

His hands: when she'd first met him that Christmas at her father's house in Berkshire — snow thick on the ground and an old cock pheasant rising long-tailed against the wild air and curling away windblown out of shotgun range — (along with his wife: dark hair, unkempt eyes) she'd noticed his hands only. Not his face, nor his eyes nor his voice. His hands: as if his soul rested in the shape of his hands.

His hands. That was it: it was all in his hands.

<div align="center">★</div>

I woke and lay for a moment in the darkness, my heart beating in my ears. The dream had been so vivid: I had seen Patterson and Audley, had watched Janey watch him asleep in the tent. Then I remembered where I was. I got out of bed and threw back the curtains. It was just before dawn. I switched on the television and turned down the sound. A CNN report showed bodies sprawled face down in muddy streets lined with palm trees. Grubby children grinned at the camera, AK-47s cradled like teddy bears; weeping women, dead babies wrapped in rags, the CNN stringer neat in her designer khaki. Somalia? Ethiopia? Rwanda? I switched off the television, put on my black Speedo swimming costume and stood outside on my porch, walking stick in hand, the dawn air cool on my face. A sulphur-barked fever tree towered above the gardens. Like the other hunters of the time, Patterson had sat often on the porch of the old Norfolk hotel; had he seen the same fever tree? Was it just a sapling then?

I thought about my dream: thought of Marion's stories. Patterson caught in the toils of the wilderness. Patterson: doubtless bewildered by his fate, blaming witchcraft, the nyika, the woman, himself, God, the gods and their masks. But God, I have come to think, is neither

compassionate nor cruel; merely indifferent, as befits a deity. This makes our little hardships no easier to bear, I know. I used to think God was actively retributive and railed against events I believed had been set cunningly in train to strike against my flesh, but over time I have surrendered my illusion of centrality and become more resigned. Perhaps I should explain.

I was a boarder at a famous girls' school in Pietermaritzburg where I excelled at athletics and swimming, natural history and English. I even played the cello quite well; or so I was told by Ernst Stoller, my smitten cello teacher. I won academic prizes, captained the swimming team, grew my hair long, styled it ceaselessly. I was vain: I practised alluring glances in shop windows and stared in wonder at my naked maturing body in the long mirror in our dorm when no one else was about. I took my beauty for granted, thought myself singled out for a special future. Not for me babies and a sweet suburban house with a double garage and a dull but worthy husband. I was right and wrong. Just after my seventeenth birthday the good Lord finally reminded me of my essential ordinariness. It happened like this.

My family lived in Santa Cruz, named by devout Portuguese seamen when they dropped anchor in its sweltering estuary in the late fourteenth century. My father was a vet, employed by the quaintly named Native Affairs Department in Zululand. In those days, northern Zululand was still very wild. Under cloud the sea was dull and sluggish but on clear summer days shone hot tropical aquamarine and hid sharks, sailfish and rapacious blue marlin beneath its surface. Inland, beyond the empty caramel beaches, there grew riparian forests in every shade of green, from peppermint to lustrous olive. Palms and matted lianas, wide-branching albizias, flame creepers and wild figs all tangled together to create mysterious green shadows at the base of the trees. Small secretive suni antelope lived here, and long black mambas with coffin-shaped heads, gaboon vipers and little bushbabies whose lost despairing cries echoed through the still forests at night when I lay awake, listening, beneath my pale mosquito net.

My father had wanted a son; but it was not to be. My baby brother, their second child, died of an unknown tropical fever at three weeks and my mother's grief was unbounded. She often lay for days unspeaking, wrapped in a favourite blue silk shawl, staring at the ceiling, eating chocolates, sometimes reading trashy novels. Often I would hear her crying all alone in the night but when I went to her room and climbed up onto the bed to comfort her I would see her lip-wrung face unconsolable in the moonlight, her eyes unfocused with grief, and I would return to my own bed and press my pillow to my ears to shut out the sound of her crying. I don't think my parents ever slept together again.

So from the time I was very young I was a surrogate son and my father took me on 'little adventures' to the secret land beyond the Ubombo. He took me deep into the Zululand bush and to the remote coast north of Kosi Bay on the wild borders of Mozambique; pointing out birds and trees and flowers with an innocent delight that was nearly childlike. He taught me to shoot his twelve-bore shotgun and to catch fish for the pot, to swim and to skin dive. At night we'd proudly pitch his treasured and much stitched Kenyan Manyara tent, build a small fire and talk about the stars. He'd smoke an after-dinner cigar, drink a brandy and slowly and luxuriously eat the two squares of chocolate he allowed himself after dinner. Then we'd lean back in our chairs and listen to the night. I learnt my enduring love of all wild places from him. And there in the hot sweaty bush or on the wild untrampled Zululand beaches where the hermit crabs scuttled and hid, I first learnt to wonder about the devious workings of God's mind.

Our property at Santa Cruz did not seem in the least bit sinister. We lived in a big white-painted wooden house with a green corrugated iron roof and a wide encircling veranda. It was set back from the road in five acres of untameable subtropical bush. The house was overarched by a tall cocopalm and a dark-leafed mango tree that bore sweet red fruit in summer. I thought of it as my garden of Eden and, confirming this fantasy, God obediently provided me with a serpent. Two weeks after my seventeenth birthday I came home

from school on holiday and was bitten by a puff-adder that had strayed into our garden from the open veld. Puff-adder venom destroys tissue as effectively as strong acid. The bite was uncharacteristically high behind the knee and my leg swelled, turned black and, despite the attentions of eager surgeons in Durban, much of the flesh of my right calf sloughed off in rank pus.

Then the fever was done and I found that I could not stand without help and would always walk with a limp. I passed through the conventional parabola of emotions: disbelief, anger, bargaining — perhaps if I pray, this will go away — depression and final acceptance. Swimming became an ordeal, athletics impossible. The deep runnel of scar tissue and the stitch marks were hardly attractive and my hungry young men with their hard thighs and eager tongues dropped me instantly, as did my immortal beloved Ernst Stoller, my cello teacher, who'd once sworn undying love. My first lesson in the fickleness of men and God.

I can look on my misfortune now with a certain detachment but at the time I took it badly. I was very young and painfully immature; and for many years I resented the fact that I'd been singled out by providence, Joblike, for punishment. I saw my adult life stretch melodramatically before me, a wasteland of deprivation. My father despaired; my mother's consumption of chocolates soared. Not surprisingly, in time I found solitude congenial. I have also come to understand that my handicap is not serious. I have seen bilateral amputees, my mother bereft of reason by Alzheimer's, my father tormented by a relentless carcinoma, small quiet children dying in African drought, their eyes growing larger by the day in emaciated faces dominated by cheekbones. Compared with these, I am scarcely afflicted at all.

Not that it matters, but from the knees up I still look good. I have inherited my mother's high cheekbones, my father's black hair and pale green eyes. When I wake alone at night I sometimes put on the light and look at myself naked in the mirror. MacPuss purrs politely and watches me, blinking, kneading the duvet, impatient to sleep

again. My breasts seem as firm as ever, my stomach flat. My waist is narrow, my hips full. Men often find my intellect too challenging but there are those who are attracted to the toughness, the lack of sentimentality, in my cast of mind and these men — few, very few — I have taken as lovers; but I have tried to keep my soul inviolate. God being an ironist, there were two with whom I fell deeply in love. The first was a conquest I made to flatter my vanity and had no place in the real pattern of my life. He was a beautiful young man, very young, who had the vibrant courage still of youth; the innocence and ambition, the energy and compassion of the untested soul. He left me for a dancer, the bastard.

The other was a writer. You have in all likelihood read one of his novels. They are not popular — their vision is too dark for that — but he has a small enchanted following and I was one of them. I met him at the launch of one of his novels which took place in the old Elephant House at the Johannesburg Zoo.

When we were introduced I made some trite remark about creative writing and he said to me, amiably drunk, 'What if God is just like me? Neither good nor evil, but simply in love with the power of creation?' This intrigued me. Later he pointed at the parquet flooring which Victorian architects had inexplicably considered ideal for an elephant's boudoir, and said: 'See that groove in the floor?'

I looked at the deeply worn circle in the wood. 'Yes?'

'That was made by the bull elephant they kept in here. They cut down his tusks and chained him to a post by one leg so he couldn't get out.'

'That's awful.'

'Yes,' he said and smiled at me. 'But we do the same to our own animal inside, don't we? Don't we? Don't you?'

I decided, stupidly, to take him home with me. The over-groomed and glossy society women who'd made the same decision for

different reasons looked at me, looked at my leg, looked at him, and no doubt decided I was merely a research project for him. Sadly, despite our passion, despite all our ferocious intimacies, they were right. Gods are enigmatic. At the time I had no way of knowing that I'd been given this glimpse of transcendence so that I would recognise it again when I needed to, there in the vacant desert far from Maleleji where great fata Morgana stalked the burnt skies and the winds blew round at midday in hot tight swirls of dust. Who would have predicted it? I had no way of knowing then that I was simply being held in wait for Tregallion to be incarnated in my future. It took me a long time to understand but now I know that my life is like a fugue: all its themes are interlinked. This, I suppose, is meaning of a sort.

I looked up at the pale morning sky. The gods were resolutely hidden behind their quantum masks so I walked in the dawn coolness through the quiet gardens to the hotel's still blue pool. I wanted to swim my laps before the rest of the hotel was awake.

Alone, all alone. I still have my pride.

FIVE

Later that day I held in my hands an incomplete hominid skull that had been painstakingly reconstructed from hundreds of tiny fragments of fossilised bone. We were sitting in Chinta's sunny office at the museum. Dust and sunlight, tea and old books. The windows were closed against the noise. The sound of Nairobi's homicidal traffic was soft.

The skull was tantalisingly imperfect; perhaps eighty per cent of the calvarium was missing. One canine emerged dagger-like from the maxilla.

'Who did the reconstruction?' I asked.

'I did,' said Chinta shyly.

'It's very good.'

'See? The depressions are there, above the left supraorbital bone,' said Chinta, pointing with a delicately manicured little finger.

'If only there were more fragments.'

'Yes.'

I stared into rocky eyesockets. If only divine fire would animate it: if only it could speak to me, godlike, from the past. Was I looking into the face of an ancient murder victim? Or had the damage to the skull been caused by natural agencies . . . rockfalls, pressure of above-lying breccia. I looked more closely. No: they were too precise.

'The depressions imply a left-handed assailant,' I said.

'If there was an assailant,' he said. Any reference to primordial murder is treated with great scepticism.

'You don't like the idea of our ancestors being born with a capacity for violence?' I asked carefully.

'No.'

'You'd believe we were happy scavengers munching mongongo nuts and following a pacific matriarchal female?'

He smiled at my vehemence. 'Not necessarily. I simply don't think we can say anything meaningful about our species by looking at the bones of an animal that's not even ancestral to us.' I watched him struggle with his desire to be gallant. Honesty won. He really was a good man.

'Kathryn,' he said slowly, 'I'm not from Kenya. Where I come from I saw a lot of evil. I don't want to contribute to any dictator anywhere tightening his grip on a nation by implying that our kind is somehow bad in its genes and that we need a firm controlling hand. I've seen too much exploitation.'

I watched him. I wanted to say: Chinta, we're not fallen angels, we're risen apes. Even chimps go to war. But I decided not to. He smiled at me, laughed.

'There's more than one depression,' I said, turning the skull to the light.

'Yes, I see that.'

'And they're superimposed one on another. Strange.'

'So what do we know?'

'Male, from the size of the single canine; a robust australopithecus? Difficult to tell for sure because the rest of the calvarium is missing so we can only guess at cranial capacity; I don't know what you

think, but I don't think the robust australopithecines could be ancestral to Homo.'

He frowned. 'There's no sagittal crest.[3] And that canine —'

'What?'

'It's very primitive.'

I stared at it. 'Is it?'

'I reckon so.'

'Why?'

'Look how long this is, how deep that root goes. That's primitive.'

'More primitive than the South African australopithecines?'

'We can compare, but I think so,' he said slowly.

'And the dents?'

'If we were writing a paper, I'd say something like, "The left parietal region of the calvarium has been indented and displays fracture lines radiating from the points of impact." '

'Where was it found?'

Chinta opened a file, read briefly and said: 'The nearest town is Maleleji, in the far north. The skull was in a bed of volcanic tuff. I've got map coordinates.'

'Who found it?'

'Some guy called Tregallion.'

'Tregallion who or who Tregallion?'

'Who Tregallion. Daniel, I think. I've read stories about him. He's a madman who wanders around the desert up there.'

'Doing what?'

'He crops up in the newspapers from time to time. Finds the odd fossil, discovers the odd lost tribe. Kind of explorer.' He adjusted his spectacles, paged through the file again. 'Here's a press cutting,' he said, handing it to me. 'Daniel Tregallion.'

There was a blurred photograph of a dark man wearing a bush hat. He was staring intently at the camera, a faint smile on his face, holding a large irritable looking lizard towards the camera lens. Thirty-six, -seven? Nice teeth. Interesting hands. I read the cutting which reported Tregallion's discovery of a new species of desert lizard, handed it back to Chinta.

'We don't have a huge budget, so no one's been back to check out the site any further,' he said, closing his file.

'Dating?'

'Not yet. We're waiting for results from Cambridge. That volcanic tuff should give us an accurate date. But quite honestly, you're the only person who's shown any interest in the skull at all.'

'Where's Maleleji? I know you told me, but I don't know Kenya.'

'Way to the north of Kenya. Desert, a couple of lakes, some big elephants, lots of shifta — bandits — from Somaliland. Samburu, Gabbra, Rendille. All nomads. Waterholes, camels. I've never been there, but I believe it's awful.'

'Can we fly there?'

'I'll check it out.'

'There's something else,' I said. I opened my briefcase, found the brochure from the Raymond Dart Foundation, handed it to him. 'If we truly think this is an important find, we could make a lot of money.'

He read quickly, looked at me, frowning. 'Half a million dollars? That *is* a lot of money.'

'Yes.'

'Freedom?'

'Freedom.'

'If it's an important find.'

'Yes.'

'Violence would make it important,' he said slowly. 'Murder.'

'We'd need more than we've got, more than a partial cranium and one tooth.'

'We'd need it to be ancestral to us, too, not just another robust.'

'And then?'

'And then you'd be rich and famous. And free.'

He stared at me.

The door opened and Victor Macmillan peered round, looking pale and drawn.

'There you are,' he said.

'Are you feeling better?' asked Chinta.

'Much. Sorry about last night, Kathryn,' he said, still peering round the door. 'Damn malaria tablets. Can't drink on top of malaria tablets.'

'I'd heard that,' I said. 'Bad for the liver.'

Reassured, he opened the door wider and came in, glanced at the reconstructed skull on Chinta's desk. 'Ah, the famous skull. Interesting?'

'Yes,' I said. 'We're thinking of going to Maleleji.'

'What for?'

'To look at the site.'

'Maybe find some postcranial remains,' added Chinta.

He nodded. 'Good idea. No one else's interested in that skull. Don't know why not, it's a fine enough specimen. What about the dents?'

'Don't know. I say murder, Chinta says not. Who knows? Perhaps we'll find out at Maleleji.'

'In the meantime, I think Kathryn and I'd better collaborate on a description for publication,' said Chinta.

Macmillan shrugged, glanced at his watch. 'Just as you say. Are you two free for lunch? It's just twelve.'

'I'm sorry, I've got to get back to the hotel,' I said and patted my leg. He nodded his head and looked grave. What people think I do to my leg in the privacy of my room I cannot imagine.

'What about you, Chinta?' said Macmillan.

'Sure, why not,' said Chinta, glaring at me.

'Wish I could find Marion,' said Macmillan. 'She could've joined us. Don't know where she is; shopping probably. Always shopping. Loves shopping.'

'Probably,' I said. But we were both wrong.

<p align="center">★</p>

As I was descending the museum's long stone staircase and listening to the triple echo of my passage — footfall, stick, footfall — I saw a narrow door open in the shadow to the left of the bottom of the stairway. There was a slight movement in the darkness behind and I strained to see but the door swung shut and closed with a double click. Thinking I might have surprised a thief, I tried the door when I reached the ground floor but it was locked tight from the inside.

<p align="center">40</p>

SIX

Marion was not out shopping. She was waiting for me in my room at the Norfolk, looking cool in a crisp white cotton summer frock, smelling of Guerlain's Vol de Nuit and smiling at me when I opened my hotel room door.

'Hello,' she said. 'I hope you don't mind; I climbed over your veranda and found your door was open. I had to take refuge.'

'From?'

'From a pink German tourist wearing socks and sandals.' She shuddered. 'On the terrace. I was having a quiet pink gin and he kept winking at me. He looked like a boiled eisbein. He obviously thought I was some kind of impoverished colonial tart, can you believe it. Bloody men.'

'Bloody men. What about a salad?'

'What about a drink?'

'Better!' I phoned room service.

She looked at herself in my mirror, ran her fingers through her hair, turned and glanced at her body in profile with her hands on her hips. 'I mean, really; do I look anything like a tart?'

'Hardly.'

She smiled at me and said, 'You're probably wondering why I'm here.'

'Let's sit on the veranda.' I held the door open.

'Are you?'

'No. I expect you'll tell me.'

'I did think you might misunderstand.'

'Why should I misunderstand?'

'You seem so in control,' she said drily.

I smiled.

'I thought you'd think I'd come for a bit of sisterly commiseration about Victor's drinking,' she said and picked up an ashtray and her handbag.

'Did you?'

'No. The fact is, you seemed vaguely interested in Patterson and witchcraft and the curses last night so I've brought you something to read,' she said, ignoring my question.

'That's very kind of you.' I looked at her carefully.

Uninvited at the Norfolk. Was she one of those essentially heterosexual women who assume that I must be gay because of my leg, that I must be driven to love women because men are too embarrassed to be seen with me? Ageing lover, drunken binges. Lonely? Perhaps she thought we'd make love. Pity for me, hatred for the impotent Victor; infidelity and revenge without guilt because I was a woman. She seemed on edge.

'Shall we sit outside?' I said again. 'The veranda's quite private.'

'Yes.'

We went out onto the balcony. I watched her settle herself comfortably in her chair. A thick red-gold chain bracelet hung from one wrist and she wore a Cartier ring in three colours of gold on her right hand ring finger. There was an air of wealth about her,

the kind of wealth you rarely see these days. A thought struck me. 'How did you and Victor meet?'

She stared at me. 'What a strange question.'

'Not really.'

'We met in London,' she said. 'I wasn't born in Kenya, nor was he. He's out here as a favour to the trustees of the museum. Do you mind if I smoke?'

'Not at all.'

She rummaged through her bag as if she'd never seen the contents before, found her silver cigarette case and her lighter. 'I was working at a PR company in London, doing front desk work. They like modelly women on the front desk, and they thought I moved well because I'd been a dancer and a mannequin.'

'Yes?' I watched her eyes.

'And I used to work as a croupier in a gambling club in Mayfair at night,' she said, lighting her cigarette. 'I met Victor there. God, he was a useless gambler. I can't imagine why he enjoyed it so.'

'Yes?'

'I'd just come out of a very bad relationship with a Greek, a millionaire. He was very possessive, had me followed, all that. Damn, I seem to've gone out.' She lit her cigarette again.

'Why did you end it?' I asked. It occurred to me that she'd never before told anyone about herself. She aimed a long plume of smoke at the motionless veranda fan before answering.

'Oh, he was a bit kinky. Wanted me to make love to all his friends while he watched.'

'Did you?'

She looked at me, her eyes veiled. 'Does this appal you? The idea's usually shocking to women.'

'Nothing shocks me any more,' I said.

She stared at me, nodded.

'Did you?' I asked.

'Once or twice. I quite enjoyed it at first. I mean, it wasn't very different from making love to Ari if I closed my eyes — men really are very much like each other, aren't they — and we weren't in love or anything.'

I watched and said nothing.

'But I think it was because he didn't care what I thought. I wasn't a person, just three holes and a sort of attractive personality. You know. And I know it was a sort of — what? — a denial of me?'

'Yes, I see.'

'Do you?'

'What makes you think I don't?'

She stubbed out her cigarette. 'I thought about the things you said at dinner about our ancestors: how precarious their lives were, how they had to learn how to suffer, their stoicism?'

I waited. She went on: 'Is that what makes you dig for fossils?'

'Partly.'

'Why else?'

I looked away. I think I've lived alone too long; I feel uncomfortable talking about myself. 'Some other time.'

She watched me, then said: 'There's a woman I want you to meet. She lives up at Maleleji; she wrote the book I've brought you. We're quite close.'

'Our skull's from near there.'

'I know. Victor told me.'

'Who is she?'

'Oriana Talmadge.' She stared at a clump of yellow chrysanthemums that blossomed stolidly in a box. 'What awful flowers,' she said and turned back to look at me with her hooded bird-of-prey eyes, but said nothing.

'Why do you want me to meet her?' I waited for her to reply. She took out another cigarette and lit it. 'Marion: you really do smoke too much. It's so bad for you. You ought to stop.'

'I know,' she said dismissively. 'But you see, I read all of Patterson's books when Victor and I decided to come out here. Background stuff. And it felt as though I knew him. As though... I don't know.' I watched her. I knew she was lying but I couldn't say why.

'Heroes?'

She smiled her wolf's smile. 'Do you think I'm that simple?'

'Is that simple?'

'Girlish hero worship? Isn't that simple?'

'Not to me.'

'Anyway, I think I'm more interested in the woman in Patterson's story.'

'What woman?'

'Blyth's wife Ethel Jane. I told you at dinner, do try to keep up! She was Swiss. Well, Swissish. Blonde, long hair, tiny, very beautiful.

45

And truly a femme fatale. I fear I find her very intriguing. Not at all Swiss, really. A Valkyrie. Do you know what a Valkyrie is?'

'I always imagine a huge soprano wearing a helmet with cow horns.'

'No. A Valkyrie is an ancient creature from Scandinavian myth: a "chooser of the dead". Apparently there were twelve war maidens, all incredibly beautiful, the Valkyries. And they'd sort of hover over the battlefield and choose the dead warriors they particularly fancied and carry them off to Valhalla and sleep with them. Ethel Jane was a chooser of the dead. I wonder if her husband went to Valhalla.'

There was a tap at the door: the steward with our pink gins.

'Let's order some more,' said Marion, adding wryly: 'Lunchtime soddenness. You'll get used to it, it's a venerable tradition in the tropics.' She looked at me critically as I walked back to my chair. 'You know,' she said, 'you're a very beautiful woman.'

'Marion!'

'No, you are. Your leg doesn't matter at all, not that it's very scarred anyway. What was it?'

'A snake.'

'Awful for you,' she said. Then: 'Can we talk about Patterson and witchcraft or are you terribly bored?'

Curious, remembering that I'd once read something interesting Dukowska had written about witchcraft, I sat back and said: 'No. Tell me more about Patterson.'

'I'll have to go back a bit, because you do need to understand his background.'

'Are you in love with him? Victor says you are.'

46

'Patterson?' She laughed. 'In love with Patterson? Darling, he's a ghost!' She stared at me. I stared back, waiting. She grinned at me and said: 'How can anyone love a ghost?'

'Too soft?'

'Too soft!'

Very well, I thought. If she wants to hide, she can. I sipped my drink and watched, wondering if what I suspected about her past was true.

<div align="center">★</div>

Two hours later Marion exhaled with her face tilted towards the ceiling, drew in more smoke womb-deep with hollowed cheeks, exhaled a second pale tumbling cloud of aromatic smoke.

'Turkish?' I said.

She nodded, stared vaguely at her cigarette. 'Yes. Victor has them made up for me in London.' She smiled slightly. 'Perhaps he's hoping to kill me.'

I'd listened in silence while she'd told me about Patterson's childhood in India, his cadetship at Sandhurst, his building of the Uganda railroad from Mombasa to Lake Victoria and his hunting of the Tsavo maneating lions who'd brought to a halt for three weeks the construction of the Uganda railway.

Her imagination was alert and the things that impressed her most vividly about Patterson revealed more about her than they did about Patterson: the pure white Viceroy's train that snuffled in the station at Calcutta on the sweltering coast, waiting to transport the whole of the Raj to the cool uplands at Simla in the foothills of the Himalayas; the sexual intrigue in Simla where subalterns on leave flirted shamelessly with married women under the fragrant deodars; the heat and scents and unfathomable mystery of India seen through romantic western eyes. And Africa: Patterson's infatuation with the unending lion-coloured grasslands, the umbrella acacias giving

grateful shade, the grunting rush of a charging lion and the elegance and dignity of the lonely bull elephant who walked the savannahs under a limitless dry-season sky.

She'd come now to what she called the key: Patterson's friendship with a fellow officer called Blyth. She stared at me gravely.

'Patterson had known Audley James Blyth for long years.'

'Bligh? Like Admiral?'

'No. Spelt bee ell why tee aitch but not pronounced like Blithe Spirit; pronounced...'

'Go on.'

'It was very odd. Patterson's wife Frances and Blyth's wife Ethel Jane were good friends, had been for ages. Patterson and Audley joined the Imperial Yeomanry together — you know, those county cavalry regiments, all jingly harnesses and sabres — and fought together in the Boer War. Patterson was Blyth's hero: warrior, famous author, all that. And yet despite all that Patterson seduced Blyth's wife.' She stopped, stubbed out her cigarette, stabbed at stray sparks with her forefinger. 'Blyth was the victim.' She looked up at me. 'Do you think victims choose, or are they chosen?'

'Marion; how on earth do I know? What do you think? Was Blyth a victim? What is a victim? What happened?'

Marion was silent. The sun was sunk; the gardens were turning blue. The turaco in the hotel's large aviary called, a high pitched melancholy screech. Stewards walked quickly across the courtyard to the rooms, carrying sundowners on trays. Ice buckets shone in the yellow light.

'Not now,' she said. 'And thank you for listening.'

I could see her face pale in the dusk. 'Shall I put a light on?'

'No.'

'Would you like a drink?'

'No, thank you. I must go.' But she did not move.

'Won't Victor be wondering where you are?'

She sighed, was still. Then: 'I expect so. But he'll have had a scotch or two by now and he's not violent.'

Strangely, I believed her. I listened to a tree frog tinkling in the shrubbery as the day's heat drained out of the earth and cooled the air. I said: 'Where did the shooting happen?'

'How do you know it was a shooting?'

'Wasn't it?'

'Yes, it was. At Maleleji in the north. Well — quite near Maleleji; actually at a place called Laisamis.'

'Maleleji. Your friend?'

'Yes.'

'And our skull.'

'Yes.'

'And Patterson.'

'Yes.' I heard her chuckle. 'Isn't that interesting.' Before I could question her I saw her move in the shadows, felt a quick warm pressure of her hand on mine, Vol de Nuit; then she said, 'Don't get up ...' and was gone.

SEVEN

I phoned room service, showered, and looked through the book Marion had brought me. It was called *The Imperial Wizards: Witchcraft and the Fall of Patterson of Tsavo*, by her friend Oriana Talmadge. I glanced at it. The pages were covered with notes, scrawled comments and queries in a tiny, illegible but exuberant hand. Passages were underlined. Unpromising. I paged through, found her account of Blyth's death and read:

> ...The morning when Audley died dawned like any other. There was no hint in the way the light hung or the winds blew that he was about to die. The desert was cold and quiet before dawn. The askaris' hard mimosa wood fires still smouldered white-ashed. Behind the protective thorn zeriba the baggage camels protested with guttural roars as their drivers goaded them to their feet and drove them down to the Laisamis wells to drink. The desert hills were dark and silent.
>
> Janey woke when she heard the camels and was up well before dawn. Ibrahim had not yet brought tea or hot bath water and she washed reluctantly, using chill water poured from a chagoul, in the canvas camp bath at the rear of Patterson's tent, and rubbed herself dry with Patterson's coarse army towel. In the yellow light of a paraffin lantern hung on the tentpole she dressed for the coming hunt: jodhpurs, a khaki silk blouse and her soft cotton twill safari jacket. Patterson's camp bed was empty.
>
> She tugged on her riding boots, took her crop, pulled open the tent flap and went outside into the cold air with her long blonde hair still down. Two months ago at the start of

the safari she would not have allowed the camp servants to see her like this. Against her will, the code of her Swiss grandfather sometimes still asserted itself. But Africa was not England; her grandfather was dead; and Patterson liked to see her hair hang loose down her back. She would pin it up later before they mounted their camels and rode out ahead of the safari in the cool of the morning.

The sky was still dark. She walked towards her husband's tent, pitched thirty yards away under a struggling whistling thorn that gave a little shade in the heat of the day. She found she was rapping her riding crop against her boots as she walked. Silly. Her gunbearer Abdi Hassan walked past with her .450 and .303 double rifles broken open in the crooks of his arms. He looked at her curiously, then softly called, 'Jambo, m'sabu.'

She nodded and said, 'Please take my shotgun too, Abdi Hassan, the small Lancaster; we'll shoot sandgrouse later when they flight in to the lugga to drink. And the cartridge bag for the twenty bore.'

'Ndio, m'sabu.'

As she walked she thought, Why did Abdi Hassan look at me like that? Surely he can't suspect? The red dawn sky began to show. Janey stopped to watch. Was it wrong to enjoy the savagery of it all? The sunsets that looked like butchered meat, the cold nights and rainstorms that brought the dry luggas down in sudden flood, the killing? Why did one delight so in the killing? How extraordinary to be so far from civilisation and not care.

Patterson's old camp headman appeared out of the darkness swathed in a white burnous. In his arms he held the empty goatskin chagouls that the servants would fill with brack water from the deep Laisamis wells that had served the desert people for more than a thousand years. He was discreet and had beautiful manners. Janey liked him.

'Jambo, m'sabu,' he called softly.

'Jambo, Munyakai bin Dewani,' said Janey. 'Where is Bwana Patterson?'

'With the camel porters, msabu, by the waterhole.'

'Thank you, Munyakai,' she said. 'And where is Ibrahim? He didn't bring chai this morning, or hot water for my bath.'

'I am sorry, m'sabu. I will find him. He will bring chai now.'

'Thank you, Munyakai, but don't bother.' Janey turned to go.

'M'sabu —'

Janey stopped. 'Yes, Munyakai?'

'M'sabu, last night your husband did not sleep well. He walked in the night.' Munyakai watched her eyes carefully to see if she understood.

'When?'

Munyakai ignored this and simply said, 'I thought I should tell you.' He bowed and walked away into the dark.

Janey walked on. The sun had just crested the hills and she felt the temperature drop as it did every morning at sunrise. She stopped outside her husband's tent and took a deep breath. There was no point in delaying. She pulled open the tent flap, held it back and peered inside and called, 'Jamie . . . ?'

It was dark inside the tent. A paraffin lantern, turned low, burnt at the bedhead. The man lying in the camp bed did not answer. She could just see his shape under the pale mosquito net. 'Jamie?' she said again.

'You bitch,' he said in a quiet voice.

'Jamie?'

'You bitch,' he said again, very quietly.

'Don't be silly,' said Janey. She turned up the wick of the paraffin lamp and pulled back the mosquito net and looked down at her husband. 'You're sick and you're tired. How's the fever?' She reached out to feel his forehead but he turned quickly in the bed and gripped her wrist and stared up at

her. 'I am not sick,' he said. 'I do not have a fever. But I did hear you last night.'

'Hear what?' she said, and watched the sick man. The sheets were wet with his fever sweat.

'I heard you,' he said. 'And if I heard you, so did the whole camp.'

She looked at him and said nothing.

'I thought you'd be discreet,' said Jamie. 'But no. And with Patterson.' He shook his head and stared at her, still holding onto her wrist.

She said nothing, watched him.

'You bitch!' he said again. He sat up in bed and she could see the fever in his eyes. 'God, how I hate you,' he said quietly.

'Stop it, Jamie, you're hurting me,' she said and pulled her wrist away. 'It's your fever, you're delirious. You've been having bad dreams, that's all. Don't be tiresome. It's a beautiful morning. Lie down and I'll take your temperature —'

'Tiresome?' he said in sudden fury. His hand appeared from under the covers and she saw the black revolver. She turned to run from the tent and when the gunshot came she felt the explosion inside her head...

I put down Oriana Talmadge's book, switched off the lights in my room and went out and stood on my veranda and listened to the night. Tree frogs and crickets, cicadas and mosquitoes. The roar of traffic from Harry Thuku road. A distant black voice raised in song: thin keening notes, words I could not hear, a lament. Had it been sung by slaves on their long journeys down to the coast from deserted villages inland? Sung while the Arab slavers and their Swahel bullyboys marched the long shackled columns of near-dead to the slave markets of Dar-es-Salaam and Mombasa? With a small shock I realised a curious inner presence: as if a stranger, long dead, had been roused in me. I had not felt this since my teenagehood, when I fell in love. But this was not love; this was a calm, silent alter

ego; a watchful dark inner self — neither man nor woman — a doppelgänger I had never suspected. Then, as I stood there listening, the feeling passed and I was just a crotchety palaeontologist with a sore leg and an empty stomach. There was a knock at the door. I showed the steward where to put my supper, waited till he'd uncorked the wine, tipped him, then settled down in bed to read Patterson's books.

The Maneaters of Tsavo was a typical Victorian adventure story, full of tales of savage beasts and rebellious indigenes, in which plucky old Patterson Saved the Empire and imposed The British Way on recalcitrant coolies. He also shot large numbers of innocent animals — 'beasts' in his terminology — and displayed an upper lip so stiff it appeared starched. Dull stuff.

In the light of Marion's stories, I decided to start Patterson's *In the Grip of the Nyika* again. I learnt on page one that in 1907 his old friend Lord Elgin had wangled Patterson's appointment to the post of Game Warden of the East African Protectorate. Early in October 1907 Patterson said goodbye to his wife and son in England, crossed to France on the Channel packet, caught the boat train to Marseilles and embarked on the 10th of October for Mombasa on an unnamed ship of the Messagerie-Maritimes line. Three weeks later, he wrote, the steamer dropped anchor in the sticky heat of Kilindini harbour and he climbed down the swaying rope ladder to the waiting bumboat. Chanting oarsmen rowed him ashore. Across the still clear water he caught the scent of rotting fruit and the putrid odour of the mangrove swamps.

I stopped reading, intrigued. The whole tenor of his prose had suddenly changed and I wondered why. I re-read the last passage and realised slowly that when Patterson saw the piles of reddish mangrove poles lying on the shore at Mombasa, saw the ocean-going dhows turning in their greasy reflections, saw the turbaned Sikhs waiting at the traders' godowns and smelt the filth and stench of Kilindini, he knew finally and with complete certainty that he had come home at last.

I went to sleep well after midnight. But by then I knew what I wanted to do. Every living thing is also a fossil. Every fossil is still living. History is here and now. Here, there and everywhere.

<p style="text-align: center;">★</p>

Percy Shelley, alert to the promptings of the numinous, wrote: 'Some say that gleams of a remoter world visit the soul in sleep.' Perhaps he was right; that night I had my second dream.

They came for him at midnight: Kivondo the wiseman and the tall unspeaking Nandi warrior who carried three spears. It was dark amongst the ironwood and ebony trees that stood tall and black. The white man followed the moonshining spearpoints of the warrior who walked a little ahead. When they came at last to a small clearing deep in the trees, Kivondo led him to a reed-and-thatch hut that squatted in the darkness. The spearman stood silently beside a narrow doorway that was set low in the wall. Kivondo touched him briefly on the shoulder and said: 'Kimeu and the others wait for you inside. Do you have the likeness of him?'

He nodded and felt for the photograph in his breast pocket.

'Then go,' said Kivondo, and pushed the man towards the ground. He knelt and crawled forward into the darkness. There was a smell of burning wood and something sweeter; cassia or vanilla.

He crawled forward down the long dark passage towards flickering light and emerged into a small low-ceilinged hut. The air was thick and foetid. Before him on the pounded earthen floor stood two carved wooden idols. Kimeu the laibon knelt to the right, dressed in a colobus skin cloak. A small fire spat softly in an earthenware dish. The sweet smell was stronger. The larger of the idols was perhaps twenty-four inches high, carved from black heartwood, bound about with beads and fragments of fur. The other, just twelve inches tall, was held together with wire and skin and was scabbed with dried blood. Vulture feathers stood out from the head. Hyena teeth

studded the base. Two bowls stood before the idols on the floor. One contained meal; the other, fresh blood.[4]

'Give me the likeness,' said the laibon. The man handed him the photograph of Patterson. The laibon looked at it briefly without expression, then tore it across and placed the two halves in the bowl of blood.

'Close your eyes,' he said quietly. The man obeyed. The laibon began to chant in a soft, sweet voice, the cadences as lilting and tender as a nursery rhyme.[5] The sweet smoke filled the man's nose and throat. He felt his head spin. Sweat started. He felt nausea churn in his stomach. Silence fell. The man could hear crickets chirping.

'It is done,' said the laibon. 'Go now. It will be finished soon.'

There was no space in the small hut to turn. The man bowed his head to the idols — it seemed right — and crawled slowly backwards out of the hut, down the passage and out into the night. He stood erect and looked up at the stars. The Southern Cross, the Pleiades. Vega, burning iris-flower blue, Aldebaran. Al-Debaran in Arabic: the one who follows. The warrior ignored him.

'So?' said Kivondo. 'So?'

'It's done,' said the man, and inhaled deeply. The night air was cool and clean. The nausea had passed. He felt purged. 'Take me back,' he said, and felt himself smile.

★

I did not wake from my dream. I slept through till dawn when the muezzin in the old Al Jamia mosque in central Nairobi woke me with his sweetly chanted words, summoning reluctant churchgoers to their devotions, his lone voice rising pure and clear above the sleeping city in praise of a god invisible and unknown: '...God is great... God is great... Prayer is better than sleep... Prayer is better than sleep...'

EIGHT

After a quick bath and a trip to the hotel cashier to exchange traveller's cheques I went through to the Lord Delamere room and found the Norfolk's famous breakfast buffet laid out on a long table spread with starched white cloths. I sat outside near the large aviary and thought about my dreams. Perhaps my instincts should have alerted me; perhaps my reading of Dukowska's book should have warned me; perhaps I should have packed my bags and left. I didn't. I still believed in the sovereignty of the here and now. Sitting outside beside the giant fever tree I indulged in an excess of pineapple, papaya and small sweet finger bananas and even ordered bacon and eggs. Drinking my second coffee while I planned my day, I watched a scarlet and mauve Ross's turaco stare disconsolately through wire mesh at the mousebirds who fossicked energetically in the shrubbery.

After breakfast I called Chinta to tell him I'd be late and caught one of Nairobi's constantly lurking grey London taxis to Esquire Limited, the famous safari outfitters on Kaunda street. Feeling uncomfortably like Ernest Hemingway, I bought two very authentic bushjackets, four pairs of khaki trousers and four khaki shirts. In the noise and ferment of Biashara street I bought four bright cotton kikois to use as wraparounds and from the gracious Mr Pitamber Khoda's dark narrow shop on Tom Mboya street, a pair of handmade Gurkha sandals called chopplis.

I've been on digs in remote places before and know of old that even the most mundane things can suddenly become unobtainable. Floods and washed away bridges, foreign exchange deficits, tribal warfare and sudden coups all affect your comfort. So I bought ten sticks of insect repellent, Stingeze to soothe itchy-bites, suntan

cream, several boxes of tampons and four large tubes of Lancôme factor ten blockout for my nose. Most important of all, I bought a six month supply of assorted Lindt chocolate. There's a limit to how austere a girl can be.

Chinta was waiting for me in his office, dressed in a soft tweed jacket, chinos, a polo shirt and a pair of Cole-Haan penny loafers so well polished they looked as if they'd been carved from ancient burnished copper. The skull with its disputed indentations stood on the desk in front of him. He was staring at it perplexedly. A long fax lay on the desk beside him.

'Yo, sister,' he called.

'Hello, Chinta. What's wrong?'

He smiled and did a big pantomime sigh of despair. 'It's this fax. Tea?'

'Please. Who's it from?'

He picked up his phone and ordered tea. 'Dr Garth Tucher, the guy from Cambridge who's doing the dating on the tuff from Maleleji where we found the skull. Oh, and this arrived for you.' He handed me a letter. South African stamps neatly aligned, a precise, inhibited, puritanical handwriting. I opened it, read the repressed anal-retentive syntax. I didn't bother to look at the signature; it could only be John Morton. I read:

Dear Kathryn,
 Salutations from the far south. Here things proceed satisfactorily. We have recently made several startling discoveries of hominid teeth, firmly datable by biostrati-graphic evidence to between 2.5 and 2 million years before present. They appear at this stage to be either africanus or habilis, and therefore significant. We hope to find crania and perhaps a complete skeleton soon.

We have in fact such a plethora of teeth that we have elected to section a canine that seems to correspond in size to that of the Taung infant. As you are aware, this has never before been attempted. A first for me and for the Museum. We intend to settle finally the disputed age of that famous hominid in this way, and perhaps contribute to Life History Theory as well.

The team have no doubt that we are well on the way to securing the Raymond Dart Prize and we have hardly begun excavations here. Future promise is limitless.

How is your dig? Is the robustus skull interesting? I must add en passant that we have found so many intact crania and mandibles of the Southern African robustus that future work on this species will undoubtedly be defined here at the Museum. It's rather a pity in a way that you're not able to be part of all this.

Do keep in touch and let me know how you're doing there. If you turn up anything even remotely intriguing — however insignificant — do let me know.

Yours,

J. Morton.

PS Have you found a Great White Hunter in Nairobi to sweep you off your feet?

Bastard.

'Something wrong?' asked Chinta, staring at me.

'No. Nothing.' I folded the letter and slid it back into its envelope. 'Maleleji?'

'Yes. Two routes. We fly or drive.'

After a brief discussion we decided to fly because the risk of being shot by Somali bandits was, as Chinta put it, 'rather high'.

'When do we leave?'

'Tomorrow early. Our safari man, Orde Nash, will fly us. Our luggage will go by road. There's one small problem though,' added Chinta.

'What?'

'Victor wants to come.'

'Why?'

'Says it's his job. At least, that's what he said at lunch yesterday after four scotches and an Irish coffee.'

'His job?'

'Yes, and he says he wants Marion to come too.'

'Why?'

'Hasn't seen the country yet. Bored, up to naughtiness in the long slow afternoons.'

'He said that?'

'Not really — implied.' He smiled at me.

'And the fax?'

'Tucher's.' Chinta handed it to me.

'What's he say?'

'He says he's getting two dates: some of the tuff may be too weathered. He's getting one date of half a million years before present, and another of four and a half million.'

'Four and a half? That's bad. I haven't worked with him. Is he good?'

'Victor says so.'

'Does Victor know?'

'He knew Tucher at Cambridge. His doctorate's on dating.'

'What does he say?'

'He hasn't seen the fax yet. But maybe that won't help anyway. You see, OK, he did his doctorate on dating, but he's a pig man; he did a study on rates of evolutionary change in Miocene and Pleistocene pigs and cross-checked that change against pig fossils found in strata of known age at Omo river. So his pigs are a sort of geological time clock. The problem is, so far we've got no other faunal remains from our site in association with the skull, so we've only got the tuff dating to go on.'

'Look,' I said. 'We know it's probably a robust australopithecine skull; it can't be much older than two million, or it'd have to be a hominid ancestral to ours.'

'Like afarensis.'

'Like afarensis. And it's just not that primitive, is it? Is it?'

'Yeees,' Chinta said dubiously. 'I just wonder... the cranial capacity's much too small for it to be Homo habilis. That canine's very primitive. And there's no sagittal crest. No crest, no robustus.'

'Agreed.'

'So the younger date's wrong.'

'It must be, surely.'

'So we assume what?'

'Four and a half's just not possible,' I said. 'It's too old. No one's found anything that old, not even Tim White's new hominid is that old. Surely the tuff's not consistent? We need to send another sample to Tucher to run his tests on again.'

He folded the fax carefully, nodded, looked up at me, smiled and said: 'All true. But.'

'But what?'

'But what if we've got something odd?'

'Odd? Odd how?'

'Tucher's no bimbo. What if the four million date's right?'

'Chinta: no one's ever found a hominid that old.'

'I know that. So what? Don't look so sceptical. What if we've got a four and a half million year old ancestral hominid? A Pliocene ape so old it's almost on the edge of the Miocene. Not a young robustus, but something never, ever found before? The great-great-grandaddy hominid that's ancestral to every other hominid ever found.'

I thought immediately of the half million dollars offered by the Raymond Dart Foundation and smiled at him. I couldn't help it.

'You see?' insisted Chinta. 'We've assumed too much. What have you said in your *Nature* paper?'

I shrugged. 'I placed it in the genus Australopithecus; said it's probably a robust like the South African ones from Sterkfontein and Kromdraai.'

'It may not be.'

'What's next then?'

'We need more of the skull; we need some postcranial remains: vertebrae, scapulas, ribs; we need a hip joint, for God's sake! We know the bastard walked upright from the placement of the occipital condyle just about right underneath the skull; but did it walk well, like afarensis? We need a braincase so we can estimate brain size.'

'OK. That's the first job at Maleleji: postcranial bits. Number two?'

'Excavate the site properly and catalogue any other faunal remains, especially suids,[6] along with samples of the tuff they were found in, so we can cross-tab Victor's established and accepted pig dating with the potassium/argon. He should run argon/argon too.'[7]

'Agreed. Which means that Victor must come to Maleleji.'

There was a pause. I realised Chinta was embarrassed. I waited. Finally he said: 'Have you seen Marion at all?'

'Once. She came round to the hotel to talk about Patterson. Why?'

'I'm sure it's quite innocent,' he said quickly, 'but Kathryn —' he hesitated — 'perhaps I'm talking out of turn; but I sometimes feel you're not a very happy person.'

'Chinta!'

'Let me finish,' he said, smiling. 'As if what happened to your leg has made you angry inside. Don't be cross with me for speaking plainly. Maybe you prefer ladies to men, I don't know, and frankly I don't care. But I saw you looking at Marion's legs all night at my dinner party, and so did Victor.'

'Envy, I assure you.'

'Maybe.'

'Chinta: you don't have to be Aristotle to know why I might look at Marion's legs.'

'Yes, maybe it means nothing to you, but there's this — well, your anger —'

'We haven't established the existence of any anger yet,' I said.

He grinned and went on: ' — as I said, there's this anger of yours, and to Victor, your sexual preferences must look ambiguous.'

'That's not fair. You just say that because I'm so tall. And anyway, so what?' I said. 'And anyway again, I'm not angry. How dare you?'

He ignored me and went on. 'Victor was going through a bad divorce when he met Marion. His drinking ruined his first marriage and when he met Marion at a gambling club in London he vowed to stop drinking if she'd marry him.'

'Oh dear. Go on.'

'As you say, oh dear. She didn't marry him; but she did go and live with him. He was attracted to her prettiness; but there was another thing: you know that Victor's very rich?'

'I didn't, no.'

'Well, he is. Very. His father invented some switch that goes on diesel trains and controls I don't know what, and he became a millionaire. He was eccentric — kind of a militant agnostic — and he founded the Museum of Man to counter creationist propaganda. Now he's dead, Victor owns the museum.'

'And his father's fortune?'

'And the father's fortune.'

I thought about this. 'Marion's passport out of the gambling clubs?'

'Exactly. He's under no illusions about that. But he's devoted to her. There's some kind of sexual dependence too. I think it's because she's so pretty; and I gather she's very sexually adept.'

'What does that mean?' I asked, fascinated.

'He wouldn't say. But I think she's quite experienced, and Victor's not. She obviously does something he thinks no one else will.'

'Like what?' I asked, wondering about her Greek boyfriend.

'Don't be a bitch, Kathryn, how the hell do I know? He's desperate not to lose her, but he can't control his drinking. He's convinced Marion'll stay with him despite the drinking as long as some other attractive option doesn't come along.'

'And you think I'm an attractive option?'

'Yes.'

'Chinta!'

'There's one other thing.' Chinta was even more embarrassed now. 'He said — mentioned — when he was drunk that Marion had had some kind of affair with a woman in London. Ages ago, before they moved in together.'

'Chinta, a woman like Marion won't fall for me. Even if I were into women, which I'm not. Be realistic.'

'That may be true. All I'm saying to you is that Victor's very vulnerable; he's very powerful, too. He can screw up our dig instantly if he suspects there's anything going on between you and Marion. You see? The research is at stake. Think about the money from the Raymond Dart Foundation. Remember? Fame and fortune? Be careful... you keep that anger in check. Don't get involved with her just because you can. Say "I promise".'

'I promise.'

The door opened and the stern tea lady, a woman of perhaps sixty with a very upright carriage and a shaved head, brought us a pot of fragrant Kenyan tea. She and Chinta spoke together in KiSwahili and she left laughing as Victor came in.

'There you are. Hello, Kathryn. How are you?'

'Well, thank you, Victor. And you?'

'Well, well, well, very well. Look here, Chinta, I think I definitely ought to come with you. I've been thinking, and it seems to me you might need me up there in Maleleji.'

'Sure,' said Chinta.

'Of course,' I said.

'I mean, we may find some faunal remains and if they're piggies, I'm your man.'

'Isn't that damn strange,' I said. 'Chinta and I were just saying exactly that.'

Chinta kicked my leg hard beneath the desk, realised what he'd done and closed his eyes in remorse.

'You were?'

'Yes.'

'So that's settled,' he said, and poured himself a cup of tea. 'We leave tomorrow?'

'Yes.'

'If you two would excuse me,' I said, 'I need to get back to the hotel to pack.'

'Of course,' said Victor.

'Sure,' said Chinta. 'I'll walk with you. I need some stuff from the chemist.'

As we were descending the stairs — Chinta politely holding my elbow in case I fell — I remembered the door at the bottom of the stairs and said: 'When I came down here yesterday, that door at the bottom was open. I heard someone close it. But when I tried it, it was locked.'

Chinta frowned. 'That's odd. It leads down to the basement of the old museum that stood here before this one was built. It's where we store a lot of old skulls. Junk and stuff. No one goes down there. It's a bit spooky, to tell you the truth. I think everyone's scared.'

★

As retribution for his lecture about Marion and my anger I took Chinta to lunch at the Thorntree Café at the New Stanley, fed him

wine and Nile perch and half a bottle of Amaretto di Saronno and sent him reeling home at dusk to his dear sweet obedient little wife entirely drunk and reeking of garlic. Revenge can indeed be sweet.

NINE

Back at the Norfolk I went to my room and switched on the television and turned down the sound. There was a news programme that showed civilians with vacant faces walking down a dusty central European road lined with scrappy poplars. Dust rose from the wheels of handcarts. Burnt-out tanks smoked beside the road. There was a close-up of a woman holding a shrivelled nipple to the mouth of a thin baby. She screamed at the camera. I switched off the television. I needed to think about coincidence. I suspect that somewhere just beneath the leaf-litter of consciousness I had already begun to question the coincidences: Maleleji and Patterson and Oriana Talmadge and our skull; but my intellect was too crass to hear.

I uncased my cello, wound the bow taut, placed the rubber mute against the strings below the bridge and quietly began to play the sad, reflective cello part of Bach's first fugue from his great Art of the Fugue. What if Dukowska was right? What if there is a contrapuntal connecting principle at work in the universe that is beyond causality, beyond chance, beyond aleatory happening? Beyond my understanding...

The fingering of bar thirty-three is complex and I concentrated, forgetting my undergraduate astrophysics, listening to the timbre of the cello, wishing for the other strings — viola, violins — to sing with me and complete the fugue. Was it true? Why did I feel I was woven into a fabric of time and space where here and now and then and there had ceased to have meaning? Unenlightened, I paused at bar seventy something, unwound my bow and put away my cello. My mind was no clearer.

I opened Oriana Talmadge's manuscript at random: 'Patterson's friend and fellow officer from the Boer War, Audley James Blyth, and his lovely wife Ethel Jane, arrived in Nairobi three months after Patterson. Patterson met them at Nairobi station, packed them into rickshaws and took them off to their rooms at the Norfolk Hotel . . .' The Norfolk. Had Patterson looked at her, watched her body move, wondered how her mouth would taste? Had they walked where I now walked, held each other in the quiet of the tropical forenoon, made love here? And in which room?

I wondered suddenly if there was any record of Patterson's stay at the Norfolk. I brushed my hair, freshened my lipstick and walked across the Norfolk's grassed courtyard between a parked buckboard and an antique rickshaw. The air was thick and warm. I wondered why I felt so at home; perhaps because the dark mossy-bricked 'Old Wing' looked just like the dormie-house of my boarding school. I almost expected to see Ernst Stoller striding across the quad, cello case tucked under his arm, a quartet of adoring schoolgirls trailing behind him.

The duty manager shook his head when I asked if the hotel had an archive but added that the manager under the previous owner had kept 'a lot of old stuff' in a large safe in the basement but had inconsiderately died 'without leaving instructions as to its destiny'. A quickly summoned page took me into the old wing and down a short flight of stairs to a small cellar. There he switched on a bare globe dangling from plaited flex and unlocked the safe that stood against one wall. A brass plate told me it was a Chubb Thiefproof made in London in 1899. The page handed me the safe keys and left me alone with a scent of dust, foxed leatherbound hotel registers and a pile of mouldering scrapbooks.

I paged through the hotel registers which started on the 25th of December 1904, the day Aylmer Winearls and Major Ringer first opened the doors of the Norfolk. The registers read like extracts from Burke's Peerage or Debrett's: the Earls of Carlisle, Warwick and Cowley had stayed; so had Lords Delamere, Lawley, Hindlip,

Cole, Cardross, Montgomerie, Fitzgerald and — a moment of personal delight — Lord Cranworth, whose books I'd bought before leaving Johannesburg.[8]

The scrapbooks were hardbound in crocodile and contained photographs, cuttings, faded print advertisements laid out using idiosyncratic wording and typography: 'The Globe Trotter. Vol.1 No.13. Nairobi (BEA) April 4th 1906. Norfolk Hotel Nairobi. ENTIRELY NEW and Up-To-Date in all respects. The Rendezvous for Big Game shooters and Distinguished Visitors. Under direct supervision of the proprietor...' Interesting; but still nothing about Patterson. I looked at the photographs, sepia with age, of 'distinguished visitors' now all long dead, and wondered if they had ever been troubled by intimations of their own mortality. Standing there smiling under the parasols and wide-brimmed hats that shaded them from the 'fierce actinic rays' of the equatorial sun, had they ever wondered about their deaths? They smiled still, even in death. All of them titled, all too toothy. No wonder they'd nicknamed the Norfolk 'The House of Lords'.

I opened a scrapbook dated 1907-8 in longhand chocolate ink and immediately found what I'd hoped for: a photograph of Patterson, Audley and Janey standing beside a grass-roofed open shelter in the Norfolk's courtyard. Major Ringer, the owner, stood beside them, wearing khaki jodhpurs, riding boots and a double terai hat. He held his pipe in one hand. Patterson stares intently at the camera, face hidden in the shade of his pith helmet. Janey is dressed as Diana the Huntress in a bushjacket and riding breeches, her hat tilted back to show her candid pale eyes and perfect nose. Her mouth is slightly open to reveal her small white teeth, as even and feral as a jackal's. Her hair is twisted into a plait. Beside her, tentative, almost invisible, faded by time, is Audley. One hand is blurred: the slow shutter speed could not freeze it in time as he raised it towards Janey, perhaps to touch her, perhaps to take her hand. Now he will never touch her again: in this incarnation his gesture is forever incomplete, his desire forever unsatisfied. A handwritten note beneath the photograph said simply: Major Ringer (Prop.), Col.

Patterson and Party. (Capt. The Hon. A.J. Blyth and Wife.) January 20th, 1908.

I replaced the books, closed the safe, locked it and climbed the narrow stairs to the hotel lobby and went out onto the terrace and ordered a gin and tonic. I sipped my drink and watched the bustle of Harry Thuku road. Somali whores with long hair extensions and angular cheekbones; Land Cruisers disgorging corpse-white Swedish tourists; Americans dressed like Teddy Roosevelt about to go forth and slaughter game; package tours of minute Japanese moving obediently in unison like shoals of tropical fish in a tank. The busy Norfolk lobby was filled with luggage, polyglot deracinated tourist trash, gleaming spectacles and video cameras.

Across the road grew tall fever trees that would have fringed a noxious swamp when Patterson and Janey had stayed at the Norfolk back in 1908. The hotel had been built originally from stone and tile and idling guests on the cobbled veranda were separated by a sturdy white fence from the hoi-polloi who walked the dusty streets. I sipped my drink and thought of Nairobi as it had been, the frontier town at the edge of the great plains. The scrappy eucalyptus trees and the red lateritic dust that the wind blew about in the midday heat. The rusted corrugated iron shanties and the reeking market that Patterson had ordered burnt down in 1899 because he'd suspected an outbreak of bubonic plague. The black-haired Indians, their women soft and dark eyed, Muslim-pliant; the smell of tamarind and chilli, ginger and joss, open cesspools and sun-dried meat. The cool of morning, the vast sky blue and cavernous. Rats and lice. In the Dhobi Quarter, the smell of steam, wet cloth and sour yellow soap.

And the Kikuyu, patiently enduring the idiocies of the settlers; the arrogant Maasai[9] leaning on their long-bladed spears and watching everything through long downcast lashes. The Somali, unrepentant slavers still, riding their groaning desert-weary camels into town. The rattleclap of Hindustani, the singsong lilt of Swahili. Spears, double rifles and double terai hats, khaki drill and horses,

remittance men, ivory hunters and rickshaws. In the dry season, dust always; in the rains the black cotton soil turned overnight into a bog. The Maasai called it Uaso Ny Robe: The Place of Cold Waters.

★

...In the bedroom of their cottage at the Norfolk Ethel Jane powdered her neck and shoulders, carefully rouged her lips and stared at her reflection in the looking glass and thought about her first sight of East Africa. When their steamer had rounded the mlango — the opening — in Mombasa's protective coral reef, she'd first seen the squat black and white lighthouse on Ras Serani point, then Fort Jesus, standing white and stolid on its headland with the Sultan of Zanzibar's flag flying scarlet from the topmost bastion. Their steamer's anchor chain had rattled down into the placid fathoms of Kilindini harbour amongst the beautifully carved ocean-going Arab dhows. It was then that she'd turned and watched Audley for any sign of delight; but he'd smiled his same absentminded smile at her, had stared at the mauve baobabs on the shore, at the dense stands of paw-paw and mango with the same bemused expression he wore when he first saw their baby son squalling in her arms.

Ethel had brought no lady's maid with her to Africa and now, seated in front of the looking glass, she began to construct her coiffure. She carefully pinned the grey mouse-shaped stuffed felt pads in place to form the foundation of the upswept chignon that would balance the long column of her throat as it rose from the décolleté evening dress designed by Charles Frederick Worth. A discreet hint of cleavage; the pale bare shoulders rising from the whaleboned bustier. The long blonde hair tamed into swathes and little curls. The pendant diamond ear-rings, and her long black gloves. She inserted a pin, pressed her hair at the back with the flat of her hand, held up a small looking glass, stared critically at herself.

What had Audley really thought? He'd said nothing, even when they were rowed ashore by half-naked black boatmen whose skins glistened with sweat in the heat. Said nothing when they'd mounted

hand-drawn tramcars in the narrow streets of the Old City, seen Arab women swathed in black buibui, smelt the rotting fish and spices and the delicious smell of octopus grilling on open charcoal braziers. Yet he'd said nothing. And then there was the train journey to Nairobi. At first the lush coastal plain, all bananas and palms, then the stunted flat-topped African thorn trees which gave way finally just outside Nairobi to the unending grassland of the Athi plains that stretched from horizon to horizon. When they passed Tsavo Bridge, she'd asked Jamie about Patterson's adventures there with the maneating lions. But he'd remained silent.

He'd even ignored the animals. The great herds that wheeled and galloped, playing in the sun, at home on their earth. Strange: the land here was not domesticated. It was leopard, not ox. Even the red dust that penetrated everything and found its way into the shuttered train compartment and into eyes and nose and mouth was typical of the country. This land insinuated and intruded. It was not England.

Crossing the Taru desert, all barren and small-bushed and baking hot, she'd felt stifled inside her clothes. Her corset too tight, her skin too long out of touch with the air. Her silk stockings clinging too hotly to her thighs, her garters too taut. Her very blood felt thick and congested. Confined, she felt confined, constricted, bound like a Chinese woman's feet. She wanted air, she wanted sun.

She warmed her curling tongs in the flame of the small spirit lamp as her mind turned to Patterson. A lion roared nearby. Startled, Janey dropped the tongs. The sound filled her room. So close... The soughing grunts tumbled guttural into silence. She waited, holding her breath. The deep phlegmy roars started again. She could feel the vibrations in her breasts, her thighs. She counted the grunts: fifteen. What had Patterson said? If there are twelve grunts it's a female; more, it's a big male. Silence. She picked up her curling tongs again, held them in the mauve flame. She'd seen lions before, in London Zoo, asleep and extremely boring to look at. But this: lions in the streets; it was strange to think of wild things in the streets...

★

The only wild things in the street now were tourists deranged by constantly pestering beggars. The air was full of foreign curses. I signed the chit for my drink and walked through the dark gardens to my room. There I took up Oriana Talmadge's book and paged through it, looking for a photograph of Janey and Patterson. Instead I found a photograph of Mrs Blyth perched on a dead black rhino, her double-barrel rifle poised, her legs crossed. Her pert, pretty face was turned to the camera. A wide delta of blood issued from a bullet wound in the rhino's shoulder and pooled on the ground. The rhino looked asleep rather than dead. Its prehensile snout rested wearily on its forelegs. Beneath the brim of her pith helmet Mrs Blyth's face was slightly foxlike, the nose delicate and pointed, well formed. Her chin was sharp, her eyes attentive and pale. She was clearly a very beautiful woman. I read on and found that Oriana Talmadge had researched her subject carefully or perhaps had a fructive imagination:

... Mrs Blyth rode her pony dressed in khaki jodhpurs made for her by Hawke's, her husband's military tailors. She was a little over five feet tall, and wore her thick blonde hair in a long plait that hung down her back and moved slowly with the rhythm of her horse as she rode.

Her riding boots were made by Lobbs, and had a slight heel, like a cowboy boot, that gave her more height and made her gait when she dismounted and walked coquettish and almost flirtatious. In her tight jodhpurs her bottom was full and rounded and the pale silk blouse she wore beneath her bushjacket buttoned right to the neck but could not conceal the rich soft swell of her breasts in their Guipure lace bodice.

Her husband adored her; worshipped her pluck and beauty. If contemporary gossip is to be trusted, he was wholly sexually enslaved by her. In a later age, one thinks of Edward, Prince of Wales, entranced by Wallis Simpson. Ethel Jane was indeed a fascinating creature. Just thirty years old at the time of our story, she had borne Audley

James a son, and was at the peak of her womanhood. She was only one generation English: her father was descended from the Swiss, a Brunner from Zurich who was given a baronetcy as a sop for his tireless political work and remorseless philanthropy. Theirs was not old money; she could trace no lineage to armigerous Normans. They were parvenu upstarts, as were Audley James Blyth's family who had received their baronetcy for peddling liquor to the Royal Family. So these two newly ennobled families were joined by marriage: the Valkyrie to the soft English mummy's boy. Tragedy must follow.

Interesting. Why should she think that? I paged on:

And Patterson Sahib? In the few photographs we have of him, he stares out at the camera lens with a tentative self-effacing smile, his eyes hidden by his pith helmet as he crouches beside the carcass of some dead beast, his hand resting caressively on the inert flank of lion or rhino or elephant... What a weird man! An Irishman obsessed by Zionism, he was in favour of a fatherland for the Jews but against Home Rule for Ireland. However much one learns about Patterson, he remains an enigma: a man who betrayed his friend, his wife and the complex unspoken ethic of his caste...

I showered and went to bed but could not sleep. Recurrent memories of my lover the writer returned: my head pressed back against his pillows, eyes tight closed, hair spread like bats' wings, the tendons on the inside of my thighs taut as I fought to encompass him, hold him inside me forever. But he was no longer there for me. I slid my hand beneath the thin sheet, felt petals wet; closed my eyes and let my mind dance back in rhythm with the music of lost time to an age when I had been loved and ecstasy, I had foolishly thought, would be mine forever.

TEN

That night I did not dream. I woke in the darkness well before the muezzin at Al Jamia began to call and read Patterson's book. Audley was still ill and Patterson 'had a serious talk' with him after they'd crossed a thornscrub desert where the young man was carried in a litter. Patterson urged him to return to Nairobi and find proper medical care but Audley was stubborn and reckless; he would, he said, shake off his fever shortly. All would be well. Three days' march brought them to water.

...They pitched camp at four o' clock on the banks of the slow Guaso Nyiro river under a clump of tall doum palms that reared up high and calm towards the vacant cloudless blue; now, past midnight, they were angular against a night sky bleached by moonlight. Janey could see firelight flicker against her tent roof through the big gauzed windows. She lay and listened to her husband's feverish breathing, waited for it to steady, deepen and relax into a soft snore. Her heart was beating hard. Surely it was not betrayal simply to sit with Patterson in the dark and talk?

Undecided, she lay and listened to the night. A lion coughed, a long diminuendo of guttural rasping that made her hair stand up on her arms. Softly she drew back her bedcovers, took a gown and her soft leather mosquito boots and slipped out into the moonlight. The night was still, as if the whole bush were alert but waiting, quietly, for some cataclysmic event to take place. The askari guard was nowhere to be seen. No lion. Where was Patterson? He'd said he'd wait for her by the fire.

She half ran towards Patterson's tent, pitched a short way away beneath a doum palm. The tree creaked, its bole flexed by the

nightwind that hissed in its crest. Outside the dark tent stood a yellow-glowing oil lamp. Patterson's small campfire burnt steadily, quick little flames gnawing at the dry wood, but Patterson was not there. His camp chair was empty; but the tent flap was drawn back. She hesitated politely, bent and peered into the darkness, called softly: 'Patterson? Are you there?'

Two arms gripped her from behind. She turned in panic and saw Patterson's face in the firelight. He was dressed in a flowing white khansu like the Arab slavers in Mombasa.

'You frightened me!' she said.

'I'm sorry. Come, I want you to see something. Put this on, it's cold.'

'What is it?'

'My burberry. Come.'

'But what about Jamie — ?'

Ignoring her question Patterson said: 'Take my hand; it's quite dark.' He led her into the night beyond the firelight. A waiting askari appeared from the darkness, handed Patterson a double rifle and walked ahead down a narrow sandy path.

'Who's that?'

'Asmari bin Kombo, the askari headman. Good man.'

'Where are we going?'

'To the waterhole.'

'Why?'

'Rhinos playing.'

She followed quietly, watching Asmari's pale turban up ahead. There was a sudden hiss of grass and a male lion bounded yellow and rapid-pawed across their path. Asmari levelled his Martini-

Henry but the lion was gone. He turned to Patterson and said: 'Rudi, bwana. Rudi... Hapa mbaya sana!' and shook his head. Janey took Patterson's arm, her heart beating fast.

'What does he say?'

'He says we should go back to camp because this is a very bad place.'

'Shan't we do that, then?' She felt her throat tight with fear.

'No. I want you to see this. It's remarkable.' He gestured impatiently to the askari. Asmari shrugged and walked on.

They stalked carefully over the rocky ridge that formed the backdrop to their camp and on the far side came to a small rise covered with scrub grass. Patterson and Asmari knelt. Patterson raised his head carefully and said softly: 'There. Look.'

She peered carefully over the berm and was astounded to see, just ten yards away, sixteen rhinos drinking quietly side by side at the waterhole. Beside her, Asmari drew in his breath and murmured to Patterson in Swahili.

'What's he say?'

'He says he's never seen so many rhinos in one place in his life. He says we should shoot those two, there, because he's never ever seen horns that long.'

'Are you going to?'

'No. Too interesting to shoot. Let's watch.'

Janey watched the rhinos. They drank quietly, without aggression, without fighting; lowering their strange prehensile lips into the water, sipping daintily and raising their heads to look around. It was a scene of such complete tranquillity that Janey felt as she once had in a little church in Pisa when she'd come upon a choir singing an a

cappella Mass, Palestrina, the Latin voices rising silver and pure in praise of a God invisible and unknown.

The moon went behind a cloud and the night was suddenly very dark. 'We should go,' said Patterson quietly. Then the moon slid out from behind the scrappy patch of cloud and to her surprise the waterhole was silent, the pool one calm unfractured plane of moonlight. And the rhinos were gone.

★

I called a taxi and was outside the museum at five-thirty. Our safari guide was already there, standing quietly beside his Land Rover in the morning cool, smoking a pipe.

He was perhaps sixty-five. He had two Land Rovers, two black assistants and a tall Unimog supply truck with a thorn tree logo on the side that said 'Nyika Safaris'. He was dressed in a dark blue polo shirt, a natural-coloured cashmere pullover and a pair of soft khaki trousers that had seen many washings. He shook hands and said his name was Orde Nash. He'd been a professional hunter, he said, when there was still dangerous game to hunt, and before the damn silly government had slapped a ban on all hunting.

We chatted about the route our supply convoy would take and he told me how the land to the north had gradually been eaten up by ranches and the quick spread of people. 'But there's still wild land way up there,' he said. 'That's what's so good. The NFD is wild still; really wild.'

'NFD?'

'Northern Frontier District. It's the old name.'

'What's it like there?'

'Tough. We'll be in the old hunting block seventy. Wonderful country, but tough. Dry as hell, and as hot. Desert. Sand rivers, vultures. Some lion, still. Big elephant, despite the poachers. Very

79

primitive. You can understand why we're like we are when you see the NFD.'

This intrigued me; I decided to watch him more closely.

Marion and Victor arrived shortly before six. Marion had eight pieces of matching black leather luggage that looked like Swaine Adeney and a black leather rucksack from Moschino to take on the aeroplane that I presumed contained essential emergency supplies: cigarettes, lipstick, perfume, nail polish.

'Morning, Kathryn,' said Victor, rubbing his hands together and hunching his shoulders. 'Chilly.'

'Hello, Kathryn,' said Marion. She was wearing a beautifully tailored bushjacket over a silk shirt in chrome yellow and a pair of verdigris coloured bush trousers in the softest cotton twill. She lit a cigarette and stared at Orde who was supervising the packing of our luggage. 'Great White Hunter?'

'No. I think he's an interesting man. Reminds me a bit of my father.'

She watched me with her violet eyes, exhaling smoke in a long plume that curled like dragon's breath.

'Is the cello case yours?'

'Yes.'

'Will you play for me?'

'Perhaps, but I'm so bad. I get shy.'

'Still.'

'Of course. Up in the desert.'

'I used to play the viola,' she said. 'At school.'

'That's wonderful! Why did you give up?'

She smiled wryly. 'I wanted long nails. Bach doesn't respond well to long nails.'

'Time to go,' said Orde, looking at his watch. 'Who's missing?'

'Chinta,' said Victor.

At that moment Chinta's dented Peugeot drove up and he was out almost before the car had stopped. He kissed his wife hurriedly through the driver's window, and then she was gone in the thickening Nairobi morning traffic.

'Sorry I'm late,' he said and smiled.

There exists a photograph of us all standing in front of this little convoy, the pompous stone cornice of the museum's enclosing façade just visible behind us: Orde, me, Chinta, Marion and Victor. Victor's smile is a little distrait because he's just sprinted to take his place beside Marion after tripping the self timer on his tripod-mounted camera.

I often look at that photograph. I've framed it in old walnut, creased though it is, bloodstained. I cannot accept that there is no hint there of what was to come. Nothing. No hint of the blood and ancient skulls that were waiting for us in the empty desert where the great mirages stalked the skies and the big bull elephant walked their lonely mountain footpaths in the deadening mist.

Our cases were packed into the Land Rovers. Orde stared hard at my heavily padded cello case but said nothing. Then the convoy started off and we waved goodbye to the drivers in the cool morning and Orde smiled at me and we were off to the airfield. I can't help thinking that we were all very blind.

ELEVEN

At Wilson airport we walked in the cool air to Orde's white twin-engined Beechcraft parked on the apron in front of its hangar at the Aero Club of Nairobi. Orde told me a little of the Club's history. It seemed Orde's father had been a founder member; Denys Finch Hatton had taught him to fly one Saturday afternoon in 1930 in the very same buttercup yellow de Havilland Gypsy Moth in which he later crashed at Voi. Orde had been flying since he was twenty-one.

'Beautiful weather for flying,' he said. 'I like the mornings. It can get a bit bumpy in the afternoon.' We stowed our luggage in the nose compartment. I watched Orde carefully. Fossil skulls are usually found in remote places and I've often thought I should get my pilot's licence and fly myself to the sites to avoid being flown by macho bush pilots who evidently think that frightening women passengers is irrefutable proof of their masculinity. I loathe these airborne cowboys and I was relieved that Orde's pre-flight checks seemed entirely thorough. He asked me to sit beside him in the co-pilot's seat and I watched intrigued as he ran through his cockpit checks.

In front of me on the control panel between the artificial horizon and the altimeter there was a knob bearing the curious injunction 'Pull For Quick Erect'. I pondered this and decided not to ask Orde what it was for; and thought how much my friends at university with boyfriends in the rugby team would have given for the use of such an instrument on Saturday nights after their lovers' long beerswilling celebrations. We taxied to the holding point. The windsock hung limp in the quiet morning.

When he'd checked the pitch and mixture and magnetos Orde asked the control tower for permission to take off and the aircraft

shuddered as he held her against the brakes on full throttle. Then we were away, the runway racing past. At one hundred and ten knots on the indicator he pulled back on the yoke, the nose obediently rose and there was a sudden smoothness and weightlessness as the aeroplane settled gently onto its net of air and the ground fell away below. Orde turned to me, smiled, touched his toe brakes to stop the wheels revolving and retracted the undercarriage. Three red lights appeared on the control panel.

'You seem interested?' said Orde.

'Yes.'

'Track oh-two-oh degrees,' said Orde, pointing to his compass. 'Flight level one-one-oh: eleven thousand feet. About an hour and a half to Maleleji.' I watched him adjust his NavCom dial to frequency 264. He saw me watching and said: 'Maleleji's Automatic Direction Finder beacon is Mike Romeo two-six-four. Do you like flying?'

'Very much.'

'You should do your licence. Slip the surly bonds of earth.'

I smiled at him and sat back in my seat and opened Oriana Talmadge's book at a new chapter which began with a very intriguing reference to Major Ringer, the owner of the Norfolk hotel when Patterson had stayed there with the Blyths before his safari into the nyika.

'Major Ringer,' wrote Oriana, 'was a professional soldier who had served under Sir Garnet Wolseley in the West African Ashanti campaign of 1873 and bore a fearsome scar on his cheek, earned in hand-to-hand combat with a fierce Ashanti warrior. He had many tales to tell of cannibalism and gruesome acts of witchcraft which he would happily relate over a pink gin on the wide terrace of his hotel. But his facial scar was not his only memoir of that war; he had also brought back with him from the sack of Benin — the City of Blood — two fetishes belonging to an executed witchdoctor, which he kept

in his rooms at the Norfolk... One was small, carved out of soft forest ivory and depicted the head of a native with tribal scars showing lividly on its cheeks; it represented a ju-ju or god worshipped by the West Africans. The other stood all of eight feet high and was more of a totem pole than a fetish. Photographs exist of Major Ringer standing beside this totem, the central pole strung about with a human skull, a male lion skull, vultures' wings and a crosspiece of buffalo horn... Major Ringer was so deeply impressed by the power of his fetishes that he called his farm at N'derogo "Ju-Ju" in honour of this omnipotent Ashanti god...

'These ju-jus were famous for their power in blessing hunters' rifles as well; and in an age where the majority of hunters sought elephant for their ivory or lion for sport, a rifle that functioned reliably in the face of a charge by an irate tusker or a wounded lion was highly prized. Almost certainly, Patterson visited Ringer's rooms at the Norfolk and asked him to bless his rifles under the portraits of the two old hunters that Ringer revered: Selous and Neumann...'

I looked up unseeing at the sky that showed through the windscreen.

'Good book?' asked Orde.

'Not bad. It's about a hunter called Patterson —'

'— the Tsavo lion Patterson?'

'That very one.'

'Awful hunter. Couldn't shoot for toffee. Kept missing the maneating lions.'

'Really?'

'Yes. Natives and coolies thought the lions were magic, were-lions, witchcraft.'

'Were they?'

He glanced at me. 'Who knows?'

'Orde, you were a hunter. Did you ever have your rifles blessed by a witchdoctor?'

He watched me for a moment. 'Why do you ask?'

'Just curious. Did you?'

'Yes,' he said, talking to the sky ahead. 'Often. Every season, actually, sometimes more.'

'Why?'

He moved the trimmer wheel slightly. I felt the aeroplane respond, balancing itself again on the river of air that swept past. 'Because of the way I hunted,' he said. He glanced at me. 'There are two kinds of hunter, I've always thought; born hunters and hunters who come to it for reasons to do with vanity or doubtful masculinity or status or some other such macho rot.' He waved a hand impatiently at these people. 'They only hunt in the here and now. They only believe in the here and now. Weak people, no imagination. They think hunting's like looking for something in a supermarket: they think they own the thing already, somehow; it's been bought and paid for. They don't understand that you can't own an animal, ever, even if you kill it. It's gone, it eludes you even in death. So they hunt with their heads, not their hearts.'

'How can you hunt with your heart?' I asked, although I think I already knew the answer. I felt certain my father had hunted with his heart.

'Well, I don't know.' He glanced at me again, smiled slightly and said: 'Even when I was taking out the most awful clients — you know, clients wearing rattlesnake-skin waistcoats and fancy leopardskin hatbands — I always thought that I'd only find a really big elephant or lion or whatever if my —' he hesitated, laughed softly and went on '— if my heart was pure.'

I watched him.

'I didn't hunt as if it was an act of conscious will. I think we've all got a whole menagerie of totem animals. It's as if every animal is already a totem animal of some part of your personality; and I had to concentrate on that totem animal and find the real one that corresponded to it in the bush. Does this make any sense at all?'

'Yes.'

'It was almost as if the animal appeared because I wanted it to; as if I created it from inside me; as if it was our destiny to meet.' He glanced at me. 'It sounds a lot of poppycock now I say it.'

'Not at all.'

'I always thought I could tell when I saw the trophies of a hunter who hunted only with his head. I'd look at the heads and horns hanging on the wall and while I watched they'd sort of disappear. I had to concentrate really hard to make them come back so I could see them. They kept disappearing into nothingness. As if the animals were gone and only an act of will could make them come back. I don't see how that can bring any satisfaction at all. Probably that's why these silly bastards have to gloat out loud all the time. They covet animals, but they don't love them. Nauseating. But I must say, some horns and tusks seem quite at home; as if they belong there.' He laughed, jeering at himself. 'Hunted by the pure of heart.'

'And that's why you had your rifles blessed?'

'Yes.'

Strange to think that Patterson probably took Janey and their rifles to Major Ringer's rooms at the Major's invitation. That they'd laid the rifles down in front of the small ivory fetish and knelt together as if in prayer and seen the framed portraits of all the old pure-of-heart hunters hanging on Ringer's wall. 'Do you know of a hunter called Selous?' I said to Orde.

'Certainly. Frederick Courtney Selous. He hunted with a huge four-bore muzzle loader, guided Roosevelt on his safari and was killed by

a German askari sniper in the First World War. He's buried at Beho-Beho in Tanganyika. I went to see the grave once. Why do you ask?'

'Just curious. And Arthur Neumann?'

'Of course. He's famous.'

'Not to me.'

'Well, no, he wouldn't be, would he? They say he was a courtly and reclusive chap. He shot himself for love when the woman he'd proposed to turned him down... Neumann: he was such a good shot his gunbearers called him "Bwana Nyama Yango" — "Lord My Meat" because he said those words softly every time he took aim, and never missed. "He caused the animals no suffering," as his gunbearer once said.'

'And Frederick Jackson?'

'No. Know of him, not about him.'

And Audley? I thought suddenly. I wonder if anyone blessed Audley's guns...

Rubedo

The
World
of
Fire

The alchemical concept of rubedo implies the existence in the alembick vessel of the fiery red matter which immediately precedes the 'nigredo' or 'blackening' and is linked to the church's concept of willing purgation.

If science — despite the integrity of its practitioners — is the creation of credible curtains that conceal the abyssal darkness from the credulous, then Mercurius, The Eternal Seeker, is a noble figure indeed; the incorruptible detective of popular fiction who pursues investigations with dedication and passion in the full knowledge that no solution to the mystery exists.

Charles Young: Archetypes in the Primitive Psyche

TWELVE

'Look,' said Orde. 'There's Mount Kenya.'

I looked ahead. A snowcovered cluster of peaks loomed up toward the clouds that floated above us. Black volcanic rock bulked through the snow.

'Seventeen thousand and eighty-five feet,' said Orde. 'Or seventeen thousand and twenty-two, depending on whom you believe. We're at eleven thousand. High.'

'Yes.'

'That's Batian, the tallest peak; thirty-six feet higher than Nelion, that one there. We'll pass it to our left. Too much cloud on the other side between here and the Aberdares; plenty of plane wrecks down there. Intrepid aviators.'

I looked down. Below us the earth showed red between smallholdings and the larger cultivated areas of big ranches. 'The bright green's tea,' said Orde. 'And those funny round patches up ahead are disused Maasai manyattas.'

'Manyatta?'

'Farm or village. Only about an hour to go.'

'Tell me about Maleleji.'

'Maleleji? Well, it's rather incongruous. It sits in the middle of the desert like a great big oasis. It's a bit like Marsabit — do you know Marsabit?'

'Big elephants? Ahmed and Mohammed?'

'That's the one. Maleleji's very similar but less well known and much nicer, really. Oasis in the middle of nowhere. Great big mountain, green as slime on a duck pond. Beautiful. You'll love it.'

I nodded and took up Patterson's book. Patterson had spent long weeks before his friends' arrival in Nairobi preparing carefully for his three month safari into the unknown. Under his direction, his headman Munyakai bin Dewani accumulated fifty five-gallon water tins and hand-stitched canvas waterbags of Patterson's own design to be carried slung on poles; rope, bales of cheap amerikani cloth, jangling coils of brass, copper and iron wire, and bags of multicoloured beads to tempt the savage heart to barter. Patterson was almost dully methodical in his passion for order. Along with rice, mposho meal, beans, tentage, tools and rifles, his meticulously acquired equipment was divided into sixty-five pound loads, each numbered and assigned to a pagazi or porter who bore a corresponding number on a tin disc worn around his neck. Patterson records that many of these pagazis were strangely nicknamed: 'Punda', 'Fow', 'Nyumbu', 'Kazi Moto': 'Donkey', 'Rhino', 'Mule' and 'Hot Worker'.

Before first light on the twenty-first, the safari assembled outside the Norfolk hotel. Patterson was mounted on his white Arab, Aladdin. His little Jack Russell terrier Lurcher danced excitedly under the stallion's hooves. The Blyths rode salted horses Patterson had bought from his friend Jack Riddel who traded thoroughbreds with the Arabs in Somaliland way to the north.

As Patterson describes it, the red dust and scrappy gum trees of Government Avenue ran with shadows cast by the blazing paraffin-dipped brushwood torches held by Patterson's askaris. Major Ringer, the proprietor of the Norfolk, stood on the steps of the hotel and watched, absentmindedly lighting his pipe. Munyakai bin Dewani, dressed in long white robes and a tightly wound turban, strode up and down the long line of pagazis, shouting instructions in Swahili as the bearers bickered over possession of the lightest loads. The untrained baggage mules at the rear of the safari brayed and

kicked out as the muleteers strapped on their hessian panniers of mposho meal and clanging empty water tins. No one from Government House had appeared. Too early, Patterson recorded, even for Freddy Jackson.

Abuddi, Patterson's Maasai guide, stood quietly holding the bridle of Aladdin, watching the uproar with a slight smile, his long moran's spear with its heavy blade shiny in the torchlight. Munyakai bin Dewani walked up to Patterson, saluted and said: 'All is ready, Patterson sahib. We can go.'

Patterson turned to his companions and said: 'Well, this is it. Kismet. Shall we go?'

'Yes,' said Audley. Janey smiled and nodded. Patterson leaned down from his saddle and shook Major Ringer's hand. 'Thanks for all your hospitality and help, Major,' he said. 'We'll see you in three months.'

'Best luck,' said Major Ringer, and stepped back out of the road. 'Best luck! Wish I were going with you!'

Patterson turned to Munyakai. 'Give the order.'

Munyakai saluted and called out: 'Haya bandika! Bandika!'

The call was passed down the waiting line of pagazis and Patterson watched as they shouldered their sleeping mats, small tents and cooking pots and finally placed their loads on their heads. Patterson pulled on his reins and with his friends at his side, rode into the nyika. From the steps of the Norfolk, Patterson wrote, Major Ringer waved and called out to them; Patterson just managed to catch his words: 'Remember the ju-ju! Remember the ju-ju!'

There were strange omens that Patterson foolishly ignored. Just how Patterson could have misunderstood the portents is hard to understand. Two days out from Nairobi they came across a caravan of Arabs, Somali and Boran: bleating goats, sheep, haughty looking camels and hopeless plodding mules. In itself this was

neither strange nor portentous. But scarcely two miles further on they came across the body of a Kikuyu with a wide-bladed spear wound beneath his fifth rib. The blood was still wet and bright in the dirt, blue flies whined in the heat. A goat thief, Patterson says, killed out of hand by the recently met Somalis. Shaken but undaunted, Patterson and his safari pressed on. Pausing all unsuspecting to rest under a shady tree, they promptly found a second body: the sun-dried and mummified corpse of another Kikuyu, curled up small in death as if he had died in great pain. 'I hoped,' said Patterson, 'that these depressing sights foreboded no evil to our fortunes throughout the expedition.' Poor Patterson.

How early in the safari did Patterson and Mrs Blyth begin their romance? When did Mrs Blyth begin to despise her husband? After the second day's march, Blyth was already complaining of pain in his foot; was there malice in the way Patterson treated the inflammation with a 'poultice of hot cow dung'? 'Unfortunately,' says a deadpan Patterson, 'the remedy did not have much effect.'

'Don't you want to watch the countryside?' said Orde.

I looked down, saw a long line of Rendille riding their camels on the far horizon, the bowed ribs of their tents outlined against the skyline like dhows with furled sails. Then the heat haze claimed them and they shivered into nothingness and were gone. The country softened slightly and the ground was riven by deep dry watercourses — called luggas, Orde told me — and covered more thickly with thorn trees that were stunted and thin.

'Zebra,' he said and pointed. 'See? There?'

'Fascinating,' said Marion from behind me. I turned to look at her and she rolled her eyes heavenward. We flew on across the dusty plain with the sun now a hot daffodil haze and the zebra galloping in a slow unhurried rhythm away from the sound of the aeroplane and its racing shadow. Marion leaned towards me and said, 'I've got a surprise for you at Maleleji.'

'Yes? What?'

'You'll see.'

Victor leaned forward from behind and called over the roar of the engines, 'You know that room you're in at the Norfolk?' His breath smelt of stale scotch. 'Room sixty-one?'

'Yes?'

'Chap shot himself in it. Jilted.'

'Really?'

He nodded. 'Damn bad show, actually, made a helluva mess all over the place: ceiling, bed. Ruined the mattress of course. Back in the fifties, Mau-Mau time. Shouldn't've done that, left the revolver lying around, room boy could've picked it up, anyone. Damn bad luck.'

I turned and looked at him. 'For whom?'

He shrugged and smiled.

I turned away and watched the animals below us and wondered what Marion's surprise was. Nothing occurred to me so I returned to my reading and found an extraordinary chapter in which Patterson described how he and his two companions sat up all night in a hastily built hide beside the carcass of an eland killed by lions.

... It was cold in the hide. The smell of the dead eland was strong. There was no moon. The three of them sat quietly in the darkness and listened. All she could hear was the whip-wheep call of a nightjar that Patterson said sounded like an impatient duellist whipping his sabre through the air: whip-wheep. Patterson had set a heavy steel trap near the carcass and through the plaited saplings of the hide wall she thought she could just see the steel in the moonlight. The .450 Rigby was heavy across her thighs.

When they were planning their safari with Patterson one cold August weekend at their country house in Berkshire, Audley had

tried to dissuade her from ordering the heavy large calibre double rifle from Rigby's because he thought the recoil would be too much for her. But Patterson had gently insisted that it was unsafe to use a smaller calibre on dangerous game and took her out on the Blyth estate very early one morning when the hoar-frost was still white on the grass, bringing his own worn and trusted Jeffery in the same calibre.

She could still remember the travel-battered leather case with its brass corners, the rancid smell of Rangoon oil when Patterson raised the lid and swung the barrels in place on the action and snapped on the forend and handed her the rifle. It was heavy, but the weight fell between her hands. Then he taught her how to mount the weapon and tuck the butt firmly into her shoulder so the recoil would not be too fierce.

She could remember clearly the pressure of his hands on her own, the firm touch of the flat of his hand on her back as he pressed her shoulder into the butt of the rifle, the momentary contact of his chest against her back as he leant towards her from behind and positioned her hands on the rifle and said, 'Just squeeze the trigger; don't pull it, squeeze it...' And Audley fussily saying, 'Be careful Ethel, please be careful, darling...'

And then the boom of the rifle and the sudden shock of the recoil and she was falling backwards towards Patterson, the muzzles of the rifle still rising, and Patterson simply caught her against his body and she felt the hard unyielding strength of him. He held her momentarily. As she turned, confused by the noise and the blast and the recoil, he took the rifle from her, pushed over the top lever and the ejected cartridge spun ringing from the breech and landed in the grass. Cordite smoke curled from the barrel. Patterson smiled down into her eyes and said, 'There, that wasn't so bad, was it?' and she felt a sudden fierce elation that was encapsulated for her in the sharp smell of burnt cordite and the sweet corrupted scent of the gun oil.

That night, lying alone in her bed waiting for Audley to come to her as he always did on a Saturday night when all the house guests were

asleep, thinking about the feeling of release she'd had as the heavy rifle rose unstoppable in recoil in her hands, for the first time she understood that she was no longer a girl. She recalled the way Patterson had smiled right into her eyes — right into her eyes — watching her carefully for any sign of fright or fear, and she wanted Audley there in bed beside her now, now.

Now, sitting in the blind waiting for the lions, she felt alone in the darkness, isolated from Audley, from Patterson and certainly from the two black askaris guarding the frail entrance to their hide. Crickets. She could hear crickets and was that an owl and what about snakes and the sky above was so dark and awash with stars!

'Quietly,' whispered Patterson. 'Don't make a sound. The lions are coming.'

She felt the soft hair at the nape of her neck rise. She opened her mouth wide to listen as she'd done as a child playing hide and seek in the nursery of the big old house, her rocking horse outlined in the moonlight as she crouched amongst the toy soldiers and teddies and dolls. Her heart thudded loudly now in her chest, in her ears. Surely the lion would hear. She was breathless, terrified and excited all at once. With a mixed feeling of horror and elation she heard the cautious fall of a paw in the dry grass right beside her on the other side of the flimsy wall of sticks — and reached out a hand to touch Patterson to tell him. But he'd heard. His hand met hers in the darkness, gripped it and held it. She did not withdraw her hand.

As the lion's careful padding moved closer she closed her eyes and felt as if her heart would stop, the sensation of longing was so intense. Then there came the clang of the steel trap, a sudden snarling and roaring and thrashing and Patterson's hand was gone and he called out 'Shoot! Shoot!' and she heard the boom of his rifle. She aimed for the sound of the snarling and spitting, squeezed the trigger and felt the rifle recoil violently away from its dead rest. Audley's rifle roared too, then the snarling was gone and the echoes of the shots tumbled across the bush in the moonlight and silence fell. She was filled with exultation.

In the darkness she reached out her hand towards Patterson and felt his own waiting for her.

<div align="center">★</div>

I looked up from my book. Desert. The Rift Valley was behind us. I saw Orde reach out a hand and ease back on the throttles. The nose dipped.

'Maleleji up ahead,' he said. 'See?'

There was a green smudge in the middle of the black desert, a bump on the horizon. Orde spoke into his chin mike and the VHF radio in my earphones murmured metallically, incomprehensibly, in reply. As we flew closer I saw unexpected lushness and a flush of misted green mountain slopes, eroded craters, a silver flash of lake water. Then we banked right. Orde reached over towards me and pushed down a small white lever and I saw the flaps extend from the trailing edge of our wings. The aircraft slowed perceptibly, as if it had flown into a soft pillow of feathers. Orde lowered the undercarriage which locked with a slight thump. Three lights showed green on the control panel. He throttled back. Then we were low over rushing thornbush and plodding tail-swishing cattle, goats, a waving herdboy leaning on his long stick, face raised up towards us. The perimeter fence flashed beneath, the orange gravel runway rose towards us and there was a momentary weightlessness as Orde cut the power, pulled back on the controls and we floated gently down on a trampoline of air. Then the wheels touched with a rubbery jounce and a burst of red dust and we were taxi-ing to the Nissen huts in the heat.

When we climbed down the heat was unthinkable: dry heat that sucked moisture from your eyes, skin, nose and mouth until your tongue was bedded stickily against your teeth and when you blinked the grit beneath your eyelids scratched your eyeballs. Heat, sweat, the blinding light, the runway a darker red scour mark against the red of the desert sand. Thornbush and lizards; dust devils that whirled across the flat arid plain and spent themselves. The silence.

We unpacked our luggage, repacked it into Orde's Land Rover that had been sent up the previous day and drove through a grove of stunted paper-barked commiphora trees, passed a rundown village and their manyattas. Maleleji town was unimpressive: a waterhole beside the lugga, an old flawed bell dully tolling at the Catholic mission, a deserted school, a row of corrugated iron dukas, gaudy bars, a grubby-walled dispensary, a police station neatly demarcated with white-painted volcanic rocks.

'Patterson came past here after Blyth died,' said Marion. I turned and looked at her. She nodded. 'Probably walked right past here.'

I sat disconcerted in the Land Rover in the afternoon sun. This was the first time the death had been real to me. Yes, I had heard the story from Marion, read about it in Oriana's manuscript, speculated. But somewhere near here the bullet had bored through skullbone and brain, exiting into the hot desert air. Dead.

'What do you think?' said Marion.

I looked at her. 'Eerie.'

'Yes. Isn't it strange to think that Patterson and Ethel and Audley were right here?'

'I often have that same feeling when I find a skull, or some other bit of hominid. I always look about. It's as if they're all still there, watching.' I thought of Dukowska's quantum masks. Perhaps, I thought, they are still here, everywhere. Undiminished star-stuff made over into spirit in the crucibles of their different deaths.

★

We passed quickly through Maleleji town. The football field a red dustbowl, the sports stadium deserted, the post office's shiny satellite dish reaching towards Venus in the desert sky. Then we raised the incongruous green oasis of the Park and Maleleji mountain from the desert and clustering dark and rolled wearily into the parking lot of the safari lodge.

There I found waiting for me at reception a plain white envelope that smelt faintly of rosewater. I slit open the envelope while Marion watched. Inside I found a stiff white card covered in a sprawling arthritic script that said in black ink: 'Marion has told me about you. My husband and I should be delighted if you could join us for drinks this evening around seven. Don't bother to dress.' It was signed 'Oriana Talmadge'. Her address was engraved in an elegant serif type.

I turned to Marion. 'You knew all along?'

'Yes.'

'What's she like?'

She smiled, her eyes unfathomable. 'You'll see...'

THIRTEEN

My room was perfectly adequate and looked out over the hotel gardens. I threw open the windows to the last of the sun. After a quick bath I lay down and read a little more of Patterson's book and found that he had, despite his almost tedious matter-of-factness, an unexpected faith in the supernatural.

... The skinner had made a bed of soft grass under a whistling thorn and the four gunbearers carried in the black-maned lion and laid the carcass down in the shade. The lion's big head hung loose on a slack dead neck. The long stained canines showed white in a rictus.

Janey and Patterson stood in the shade and watched Kariuki the skinner carefully cut down the inside of each of the lion's forearms and slice centrally into the skin of the chest, kneading the skin back with his left hand. The massive chest muscles of the lion stood out starkly blue-white beneath their thin muscle sheath. The big paws hung limp and broken-wristed, moving slightly as the skinner worked. The long unretracted dewclaws showed in pale horned arcs. The central entry hole made by Janey's four-fifty bullet was blue and contused. There was no blood. It was hot in the shade. Janey saw ticks scurry multilegged in the coarse fur of the lion's dark mane. She shivered. Patterson glanced at her questioningly but she shook her head. 'Not nerves, Patterson. Nor fever. Someone just walked over my grave.'

He smiled at her, turned to watch Kariuki attentively.

She thought back to the killing. The big shaggy head profiled like a heraldic lion's in deep shade beneath a paperbark acacia, the pale grassland burning white in the sun behind. Patterson saying, We'll walk towards him, slowly, the wind's good; and the quiet stalk to

under fifty yards. Patterson finally said, Take a rest on the anthill there and shoot him in the shoulder: and as he spoke the lion turned lazily, looked at them yellow-eyed and incurious. The wind lifted his mane lightly. She raised the heavy rifle, saw the silver bead of the front sight lodge neatly into the vee of the rear, remembered to squeeze the trigger, not pull, and the rifle went off and the lion was down, roaring, legs striking at the air and Patterson yelled: Careful, he's coming! And the lion bounded broken shouldered towards them, mouth open in a silent roar and the trackers scattered for the trees and Abuddi the Maasai stood firm beside Patterson, long spear poised silver and she knelt and aimed at the big savannah coloured chest and shot the lion down like a rabid dog.

'He's so lean,' she said in wonder. 'All muscle.'

'What fat there is the natives consider very powerful magic,' said Patterson. 'Lion fat's supposed to cure almost everything, from syphilis to impotence.'

'Oh, yes?' said Janey, and smiled up at Patterson. He smiled back.

'And his whiskers too. They cut them up and eat them.'

The skinner was peeling back the skin on the shoulder now and she saw where her first shot had taken the lion a little too far forward. Pale lung blood oozed from the wound. She thought in awe of the way the lion had come for them even with his shoulder smashed and blood and pain hot and deep inside his lungs. She shivered again and hugged herself. The pain.

'There's another bit of magic with lions,' said Patterson and knelt beside the skinner. He probed with the point of his sheath knife, cut deep into the resilient shoulder muscle and removed a small bone, curved like a boomerang, white and glistening in the midday light.

'Dawa kwa m'sabu,' said Patterson. The skinner nodded and grinned and said: 'Thahu.'

'Here you are,' he said and handed her the small bone. 'Floating collarbone. A rather rudimentary clavicle. Big magic. Not many people know about them.' To the skinner he said: 'Nataka ile ngine kwa bwana Blyth.'

Janey took the thin bone and felt its resilience. Her fingers were wet with the lion's blood.

'Very big magic, that,' said Patterson gruffly, wiping his knife blade clean with a handful of dry grass. 'Don't ever lose it. Keep it forever. The skinner'll cut out the other for Audley.'

Janey looked down at the bone in her hand. 'No,' she said. 'If you don't mind, I'd rather not. If you don't mind, I'd rather keep them both for myself.'

★

At seven that evening I was driven in the Land Rover by one of Orde's assistants to the address given on Oriana Talmadge's invitation. When we drew up at a dark copse of trees I thought at first there was some mistake; there was no house in sight; I could see only a dense clump of trees and a small flickering yellow light. I could hear, faintly, violin music. A cuckoo called monotonously.

'I wait here,' said Orde's driver Sayyid. 'You follow the path...'

'Path?' I said irritably. 'What path?'

'You cannot see the path?' queried Sayyid.

'No.'

'There, m'sabu...' he pointed. 'That path.'

I now discerned a slight track that wound towards the dark trees through knee-high grass. Listening to the violin music, I followed the path, stumbled in the dusk light on the uneven ground, came finally to a clearing in the trees. In the clearing was erected a very large, very old safari tent, heavily patched and darned and

surrounded by cane and thatch additions and shaky lean-tos that spread higgledy-piggledy into the surrounding bush and trees. Paraffin lanterns were set at intervals in a semicircle about the clearing, their flames flickering a little in the wind.

The violin music was louder now and at first I could not place it; it was tantalisingly familiar yet also unknown. Then I realised I was listening to the first violin part from the slow movement of Bach's lovely Violin Concerto for Two Violins. This is one of my favourite pieces of music and, intrigued, I stopped to listen. A very fat, extremely angry bull mastiff bounded from the tent, barking hoarsely and showing a set of uneven, discoloured but very large teeth.

I backed away as the violin music stopped and a tall white-haired woman wearing a low-cut black evening dress and carrying a violin and bow emerged from the tent into the yellow light of the storm lanterns and called: 'Don't be afraid. Simba's never bitten anyone in the twenty years I've had him.'

'I'm delighted to hear that,' I said as Simba prowled stiff legged towards me, hackles erect. He sniffed suspiciously at my slacks, seeking the faintest scent of infidelity with other dogs, still growling in a phlegmy bass register.

'You must be Kathryn,' she said.

'Yes.'

Simba pressed his nose into my groin, sniffed deeply, sneezed, took my stick in his teeth and shook it experimentally.

'I'm Oriana,' she said, and we shook hands. 'Come indoors and meet my husband.' I retrieved my stick from Simba's mouth and followed her into the tent and looked around.

The interior was much larger than I'd expected, the rear of the tent extending into a spacious bamboo-walled, grass-thatched room lined with bookshelves. The tent floor was covered with silk

Persians, soft woollen Shiraz rugs and kelims. Old and worn, still their colours were magnificent. Large battered overstuffed chintz sofas were placed together to form a comfortable group near a large brazier, now unlit, made from a hammered forty-four gallon petrol drum. At the rear of the tent a solid Jacobean table was laid for dinner: silver candlesticks, white napery, crystal.

A tall silver-haired man wearing a black kikoi and leather sandals with his dress shirt, black tie and dinner jacket walked towards me, a whisky glass in his left hand, his right outstretched in greeting. 'You must be Kathryn,' he boomed. 'Kathryn Widd? Marion wrote to us.' We shook hands.

'For God's sake turn up your hearing aid,' said Oriana Talmadge.

'What?'

'Turn up your hearing aid, Toad.' She fiddled behind his ear. 'There. Now perhaps you'll talk normally, instead of shouting at us. He's deaf from shooting,' she explained.

'Sorry,' said her husband. 'You must call me Grenville,' he added. 'I'm sure you'd like a drink. Scotch? Gin? Or one of those ghastly cocktails?'

'Scotch, thank you.'

'Come and sit here,' said Oriana, leading the way to the sofas. She laid her violin and bow in their case. 'You like music?'

'Yes, very much. You play beautifully.'

'We used to play the Bach together until Toad's arthritis got the better of him; now I have to do it alone. Do you play?'

'Yes, the cello.'

'Well, my dear! We must play together then.' She picked up her glass from a Benares table with barley-twist legs and an engraved brass

top. 'There are cashews beside you,' she said. 'I eat thousands of them and get fat, but Toad doesn't mind, do you, Toad?'

'No,' said Toad, handing me a glass. 'Widd, Widd, Widd. Unusual name. I knew some Widds once. Are you related to the Surrey Widds? Findhanger Hall?'

'I've no idea.'

'Collateral branch, no doubt,' he said. 'Interesting name.'

'It's Celtic. A Widd was a priest. The word "Druid" was originally "Drus-Widd" which means, I think, "chief priest". My father loved all that.'

'How very interesting. So you're a descendant of a chief priest? A sort of, um, Druid witchdoctor. Good. Good.'

'Very handy in Africa,' murmured Oriana.

Simba settled on my feet to prevent escape, farted softly and began to snore.

'Poor Simba,' said Oriana. 'He's getting so old. Toad used to hunt lions with his great-grandfather, didn't you, Toad?'

'Athi Plains. Even the Maasai were still wild then.'

Oriana softly said: 'You can't think how dashing Toad looked. He was a Lancer, you see; wonderful seat on a horse.'

I looked at her. The fine skin of her face was upheld by her strong Saxon bone structure and was pretty still, though lined and folded by age. High sharp cheekbones, a clean jaw; her eyes were pale blue, and, when she looked at me, filled with uncanny knowingness.

Toad was tall and stooped, his silver hair brilliantined flat, his dark blue eyes kind and interested. They were both in their nineties, but had apparently not noticed. 'Where is that bloody Somali with the gadgets?' said Toad.

'Here,' said a voice from behind and I turned to see a thin hook-nosed man dressed in a red fez, a soft white robe and an embroidered waistcoat coming towards us with a silver tray in his hands.

'Good evening, madam,' he said to me, and smiled graciously.

'Good evening.'

'You're bloody late,' said Toad. 'Again. Can't you get anything right?'

'Don't be insolent,' said the Somali. 'Or I won't wear this silly costume every time you've got guests. You are nothing but exploitative colonial relics; and I warn you, you are tolerated here merely because your eccentricities are no threat to the people. But you must not push me too far.'

'Getting above himself again,' said Toad to Oriana softly.

'Don't whisper, it's rude,' said the Somali and placed the tray carefully on the low table in front of us. He pointed. 'Angels on horseback,' he said. 'And other foul heathen savouries; smoked oysters, mussels, nasty ham with which I am forced to sully my hands by these unbelievers, olives, anchovies.' He stepped back, bowed, exited.

'I understand you're interested in Patterson,' said Toad, handing me a little plate of snacks.

'Yes. But I know very little about him, although I've nearly finished your manuscript, Oriana. And I've started reading *In the Grip of the Nyika*. Marion's told me a bit, too.'

'Why are you interested?' asked Oriana.

'I'm not certain,' I said. 'Why did you write about him?'

'We knew him, you know,' said Toad.

'You did?'

'Yes. Not well, of course. He was our parents' friend.'

'His house at Iver was near our family houses in Buckinghamshire,' said Oriana.

'Our parents' houses,' explained Toad, 'were on adjacent estates, and Patterson's place was down the road. Grove House.'

'Our parents often had him and his wife to dinner,' said Oriana. 'I remember that quite clearly. I thought him very handsome, when I was small. We children used to sit in the gallery above the dining hall and look down at the grown ups eating and I was entirely in love with him.'

'Me too,' said Toad. 'Or rather,' he added quickly, 'with his exploits. Rather an adventurer.'

'Yes, in so many ways,' said Oriana and her pale blue eyes looked briefly into mine then away.

'Patterson was,' said Toad, 'a Pouncer. Pounced on women.'

'Did he, darling?' said Oriana.

'Of course. He pounced on your mother, for one, before she was your mother. You know that. Your brother Sebastian was fifteen or sixteen, I remember it clearly.'

'Poor Sebastian,' said Oriana softly. 'Such a beautiful straight nose. He was killed at Ypres.' She sipped her whisky. 'Or was it Cambrai?'

'Cambrai,' said Toad briskly. 'Damn it, Oriana, you ought to remember that. Twentieth of November, nineteen seventeen. Patterson was fighting in Palestine then, he commanded a cavalry unit called Patterson's Column. I received a letter from him when they took the city.'

'Palestine?' I said.

'Yes, ended up with Allenby at Megiddo. The biblical Armageddon.'

'Father never did like Patterson,' said Oriana. 'I never understood why until later. Yet they were still asked, Patterson and his wife Frances, a bluestocking, very dark, long hair. She smoked cigarettes, which was very daring then, and sat talking for hours in the Café Royal, which was considered extraordinarily indecent for some reason I never quite understood. Hooked nose, father an architect. Very pale woman. Dark rings under her eyes. Beautiful in a driven sort of way. Lovely son called Bryan.'

'Patterson the Pouncer pounced on Oriana's mother,' said Toad. 'Sebastian saw it.'

'He shouldn't have told you, Toad,' said Oriana reproachfully.

Toad turned to me. 'Sebastian used to escape from his family to read in the bedrooms in the unused wing of the house. They were kept furnished, fires lit every day in winter or the wallpaper foxes and the carpets rot. Sebastian was very fond of Swinburne; his age, you see. He was rather influenced by the girls of The Corrupt Coterie: do you know about them, Kathryn?'

I shook my head.

'Diana Manners and her friends? Not? Well, they all loved Swinburne in those days. One day Sebastian went off to read his Swinburne in the Red Bedroom and he opened the door and found his mother astride Patterson on the carpet in front of the fire —'

'— Dammit, Toad, you make it sound so sordid —'

'Was sordid; skirts up around her waist, knickers pulled to one side, posting away while Patterson hung on for dear life.'

'Toad!'

'It's true. Sebastian told me himself. Of course, he was old enough, he knew, and he said, "Mamma, what on earth are you doing?" And Patterson said, quick as a flash, "Mending the carpet, Sebastian. Now go away!" '

'Oh God!' said Oriana. 'Really, Toad.'

'Yes.' Toad nodded. 'Sebastian always called it that, it was our secret when he thought I was old enough: "Mending the Carpet". "I'm going Mending the Carpet in Paris tomorrow," he used to write to me from France during the War.'

'He was in the Guards,' explained Oriana. 'Such a lovely uniform with that red collar.'

We all thought about Sebastian and his red collar in silence and Toad ate a heathen savoury and I said to Oriana, 'What did your father do?'

'About Patterson? Oh, not a lot. I don't think he knew. He wasn't fond of Patterson but we had to ask him because my father was a friend of Theodore Roosevelt's and when Roosevelt came to stay, he asked to meet Patterson and the three of them sat up for hours over the port talking about double rifles and whatnot and smoking cigars and the poor women had to play piquet until they could hardly keep their eyes open.'

'I remember That Woman, too,' said Toad. 'That Awful German Woman whose husband got shot by Patterson.'

'For goodness sake, Toad,' said Oriana. 'She wasn't German, she was Swiss, and Patterson did NOT shoot Blyth.'

'I thought he shot himself,' I said. 'If he didn't, who did?'

'No one knows,' she said, and looked directly into my eyes. 'Do you?'

'Not yet.'

'Awful German Woman,' said Toad, taking my empty glass and walking to the drinks tray. 'Long blonde hair down to her waist. Red mouth like Clara Bow. Good figure. Short, very short. Rode well. Shot well, too. Father was an industrialist, chemist, dull stick, just like her brothers. Mournful. Germans, you see, no sense of humour. Made a fortune.'

'They were NOT German,' said Oriana firmly. To me: 'All her evening gowns were made by Worth in Grosvenor Street, Empress Eugenie's couturier. She always said only Charles Frederick Worth knew how to cut a bodice properly. This was important to her, you see, because her breasts were very large for her height.'

'Didn't like her,' said Toad. 'Common.'

Oriana raised her eyebrows at me and said: 'She once took me with her to London to buy underwear. Hers, not mine. I was entirely shocked, because she took me to Lady Duff Gordon's, a shop called "Lucile's". Lady Gordon was the sister of Elinor Glyn, who wrote dreadful romantic novels. Do you remember?' She smiled and quoted: ' "Would you like to sin with Elinor Glyn on a tiger skin? Or would you prefer to err with her on some other fur?"[10] Lucile's was shocking, you see, because Lady Gordon was the first to introduce underclothing made entirely from silk crêpe de Chine. My mother considered this far too decadent, but Ethel coveted such things. And Lucile's mannequins didn't even wear the usual black cotton bathing suits. They were very nearly naked. Quite shocking at the time, I can tell you.'

I thought about Ethel Jane in her décolleté evening dresses, her too large breasts perfectly supported by Monsieur Worth's structural genius, her body cosseted by Lady Gordon's silk underwear. Toad handed me a second whisky and I ate a smoked oyster.

'Why are you so interested in Patterson?' asked Oriana again.

'I wasn't,' I said and explained how Marion's stories had intrigued me.

'Yet you don't know why?'

'No.'

She stared at me with her pale blue eyes. 'Perhaps you're the one to put matters right,' she murmured. 'Miss Widd, Miss Widd, Miss Widd.'

'Put what matters right?'

'Well, you do realise Patterson was a victim of witchcraft,' she said, and watched to see my reaction.

'Oh, dear God! Not that again,' said Grenville softly. 'Please.'

'You said that in your manuscript,' I said. 'I didn't realise you were serious.'

'Oh, completely! It was, I think, Frederick Jackson who arranged the curse, his rival. He wanted Patterson's job, you see. Awful man.'

'Tell me about him.'

'Time to go,' said the major-dòmo's voice from behind me. 'Unless you're staying for dinner?'

'Damn cheeky,' said Grenville. 'Take no notice.'

'The soufflé can't wait,' said the Somali. 'Make up your minds.'

'Do stay,' said Oriana.

'I'd love to,' I said and stood. Surprised, Simba snapped sleepily at my ankle but missed, sat back abashed and stared longingly at my throat. 'I'd love to, but I've got a meeting back at the hotel.'

'To do with your skull?' asked Grenville.

'Yes.'

'Did you travel up with Orde?' he asked casually. 'Nyika Safaris?'

'Yes.'

'He's very good. Old-timer.'

'Do you know a man called Tregallion?' I asked. They exchanged quick glances.

'Yes. Why?' said Oriana.

'He found our fossil skull, and we need to meet him to discuss where he found it.'

She nodded, glanced at Toad. 'He should be here shortly. He's off on safari in the desert at present...' She rose, held out her hand. 'Thank you for coming,' she said. 'I had hoped to show you some of the old photograph albums. Perhaps soon?'

'I hope so.' We shook hands and escorted by the snorting Simba I found my way back down the unlit path to the road where Sayyid dozed patiently at the wheel of the Land Rover.

FOURTEEN

That night I was visted by my third Patterson dream, my first in the desert. Like the others it came to me edited and comprehensible, with none of the discontinuity of my ordinary dreams. It was as if the material was already structured and coherent; as if it had been ordered by an intelligence alien to my own. Despite this I did not question its origin; I simply assumed it was another upwelling from my unconscious. I hadn't yet realised that another mechanism was at work.

...He waited for the dizziness and nausea to pass. Earlier, humiliatingly, he had vomited weakly into the dust while Patterson held him: long thin strings of viscous bile and sputum. Patterson had made him drink a vile decoction poured from a brown medicine bottle. An old hunter's cure, he'd said, called mdundugo: laudanum and bark and roots and God knows what else. He closed his eyes against the sunlight that came and went with the tread of the four Africans who carried him in the swaying machilla.

The fever sweat had soaked his bushjacket. He felt as if he were burning up, his skin aflame, his chest. He fumbled clumsily with his buttons and Asmari the askari headman, who walked always beside him, slung his Martini-Henry and undid the damp khaki jacket and folded it back.

'Asmari —'

'Bwana?'

'What does mdundugo mean?'

'Mdundugo. It is Swahili name for a medsin for making you safe against bullets.'

'Bullets?'

'Yes, bwana.'

How odd, thought Blyth. Bullets. How odd of Patterson. 'Where is bwana Patterson?'

'He and m'sabu ride off to hunt,' said Asmari.

'Where?'

Asmari waved his arm vaguely towards the horizon. 'There... In the nyika...'

'And how long till we camp?'

'Bwana Patt'son he say maybe five hour. We can pitch tents soon enough at dusk.'

Five hours. The nausea stalked him again, contracted his stomach. He half rose on one elbow but the spasm passed and he lay back. There was no breeze, no air in the shade beneath the dusty palm-frond roof. Patterson had improvised the machilla from a hammock earlier in the day when the fever finally took hold and the long racking shivers started that shook his body and grated his teeth one against another.

Patterson. Who watched him with amused eyes in which he could see no compassion. Patterson, who watched him shiver with the cold and heat of fever. The indifferent eyes. And then there was Ethel Jane. Patterson shamelessly called her Janey as if she were some dreadful penny horrible heroine. Ethel, who slipped from the tent at night when she thought he was fevered with dreams; who came back just before dawn to sleep. Who went off riding alone with Patterson before sunup and returned with an impala or a Thomson's gazelle slung carelessly across her pony's withers at sundown.

Inchoate with fever, he'd once heard her call out to the camp headman at dusk. He'd crawled from the tent and seen her mounted still on Patterson's white Arab, a dead gerenuk slung in front of her

saddle. Blood from the animal's newly cut throat glistened thick and wet on the pony's shoulder and ran in coagulating rivulets down the horse's cannon bone and into the sand. There'd been a look about her then that he'd never seen in London. The pale hair clubbed in a long tail like a Maasai moran's; her eyes laughing, her back straight like a subaltern's, legs splayed. There were splashes of blood on her boots. And something else in her face: triumph? Victory? Exultation. He felt consciousness tremble and fade: the laudanum at work. Yes: exultation. It was the exultation that was so worrying.

<p style="text-align:center">★</p>

The bearers sang a slow Swahili marching song as the safari forded the Guaso Nyiro river through the sandy shallows at Elongatta Embolyoi and wound its way slowly along the north bank, the horses calmer now the water they had scented was in sight. Patterson led, mounted on his white Arab stallion Aladdin, his terrier Lurcher trotting on ahead, nose happily to the ground. Janey followed on her bay charger, eyes bright and excited beneath the brim of her pith helmet. Her husband's gelding followed obediently. The rest of the safari was strung out through the tangled riverine bush, the machilla in which the feverish Jamie slept carried on the shoulders of four sweating porters. Patterson reined in Aladdin and waited for Janey to ride up beside him.

'We're coming up to Neumann's old camp,' he said. 'Do you remember? I mentioned him in Nairobi: Bwana Nyama Yangu. The hunter who shot himself because of a woman?'

'Yes.'

'We'll camp at his old boma tonight.'

'Isn't that bad luck, Patterson?'

'Bad luck?'

'Yes. Temptation.'

<p style="text-align:center">116</p>

'You're superstitious!'

'No; careful.'

Patterson rode close beside her so that her leg, splayed by her saddle, touched his own from time to time. The heat was intense and Janey felt a droplet of sweat roll down her forehead to the tip of her nose.

'Here, let me ...' said Patterson and leant over and caught the drop on his silk neckerchief. Janey looked at him. He smiled at her.

She watched him carefully now and thought of the wild mango he'd once given her. Four days out from Nairobi and they'd ridden ahead of the safari — Jamie was sick with fever again — winding in and out of thick bush. Patterson had reined in Aladdin unexpectedly, dismounted, picked a pinkish-red fruit from a tree dark with blade-shaped leaves and held it up to her where she sat mounted on her bay. She looked at him now and remembered the way he'd stroked the swollen fruit and said to her: 'Look, Janey: don't you love mangoes? See how it fills my hand, so heavy; see the weight? That indentation? The raised rib here, the split in the roundness, the softness? Isn't it beautiful? Have you ever eaten a mango?'

'No.' Fearful, almost. Panic.

'Let's eat it together, then.'

And the way he'd cut into the thick pink skin with his belt knife, the slice he'd handed her, dripping with juice. And when she ate it the sweet iodine-and-sugar taste was unexpected and wild, unlike any other fruit. The juice ran down her chin. She'd turned to Patterson, found him watching her. And she'd bent down from her horse and kissed him tentatively, thoughtfully: tasting his mouth through the taste of the mango.

'Shall I come to you tonight, Patterson?' Janey now said, softly and gravely. Then, smiling at the look on his face: 'In Neumann's old boma? Which isn't bad luck? Not bad luck at all?'

117

'Janey —'

'Shall I?' The panic again, the feeling of dissolution.

He stared hard at her. 'Yes. Come to me,' he said. 'Please come to me. Come to me when the moon's up.' She looked at him. 'And Janey —' he said, hesitated.

'What?'

'Will you do me a great honour?'

'Of course.'

'Will you wear your ballgown?'

★

She lay naked beside Patterson on the tarpaulined floor and looked at the moonlight coming into the tent through the opened flap.

Well, now they had done it at last. The first betrayal. Patterson was asleep, arms outflung as if inviting crucifixion; as abandoned in sleep as he'd been when they'd made love. The first time. How strange that such an ordinary act can change entirely the relationship between three people. She fumbled amongst their tumbled clothing for Patterson's gold half-hunter, found it. She'd come to him at eight, it was now past midnight. Four hours. Janey pressed her thighs tight together. She was sore, the lips of her sex everted still, her vulva swollen like a ripe fruit. A mango, she thought. The mango... It had been unlike anything she and Audley had ever done together. There had, it seemed to her, been a third presence, a daemon, a god or a devil in the tent with them, urging them to perform acts of barbaric intimacy. His tongue probing her darkest places, her lips enfolding him. She could still feel the blunt dull power of him inside her.

A hyena howled far away, another joined in, whooping, voice pitched high and then another and then the bush was silent. She listened. Crickets. A nightjar. Earlier, baboons had barked, then

118

they'd heard the rasping grunt of a big leopard in the dark. Male, Patterson had whispered, still for a moment thick inside her, braced on his arms. When she had dressed for him in her tent — fastening the satin and taffeta dress behind, clipping on her silk stockings — even then, she'd felt herself soften and swell. And then she'd walked the twenty fatal yards to his tent — Jamie was sleeping fitfully again, drugged by fever — and pulled aside his tent flap. Patterson was standing there in his long white slaver's khansu. His tent inside was cathedral-like: candle flames in the dark.

He'd led her silently to a chair, seated her, knelt in front of her as if to pray. Then he'd slid the full sculpted folds of her ballgown skirt upwards to the tops of her legs and bent forward and kissed her pale thighs. And when she knelt on the floor of the tent and lowered her head submissively and raised her buttocks and turned to look at him: she knew Patterson could not save himself.

A hyena whooped again, closer. She curled her body small and turned her back to him and wriggled her wet buttocks into the incurve of his waist and laid her head on his outflung arm and slept.

FIFTEEN

Next morning we breakfasted early in the spacious hotel restaurant and I discovered an unsuspected side of Victor. He was a born administrator. Our meeting the previous evening had proved fruitless: everyone was tired, no one wanted to talk about skulls, everyone wanted to sleep. Victor sensibly suggested we reconvene at breakfast.

Armed with a clipboard, rimless spectacles, a dictaphone and copious pages of notes, he called our breakfast meeting to order. He'd drawn up an agenda, assigned tasks, recruited labour in consultation with the hotel manager and arranged a picnic lunch. Marion elected to stay behind at the hotel and go on a game drive later in the day. The rest of us — Chinta, Victor, me — were to set up camp on site, peg out the area with transect lines and begin the excavation as soon as possible. Within the hour we were heading for our fossil site, the Land Rovers purring happily, air fresh, our labourers clinging precariously to the back and sides of Orde's Unimog truck and singing loudly. Work is scarce at Maleleji.

The site was about three hundred miles outside the park boundary, deep in the shattered red landscape of the Chalbi desert. The whole country was the colour of curry powder and terracotta: as if it had been burnt with a blowtorch, scoured by fire and left to rust. Doubtless God had set trials for this land as he had for Job. Having come through, the country was not cynical but it was without illusions. It waited without hope for subsequent trials: ice, drought, floods, scrubbed clean of all sentiment.

Directed by our local Gabbra guide dressed in bermuda shorts and an old khaki shirt, we stopped in the thin shade of two thorn trees

and looked around. A small wind shifted the dust. The sky was already white with heat. It was midday. The desert stretched empty from horizon to horizon.

'Well,' said Victor, 'I suppose we'd better get started.'

Tents were erected, shade nets strung, a water bowser arrived from Maleleji and our little camp was soon set up. Using a Magellan Global Positioning System[11] we established the location of the site where the skull had been found by the mysterious Daniel Tregallion, alleged mystic and Intrepid Explorer. Under Victor's guidance, the workers marked out transect lines for the aerial survey.[12] There was an atmosphere of happy industry: the slow tunk-tunk of wooden maul on tent peg, the guttural Gabbra and Rendille of the local labourers, the soft murmuring of Orde's team, as melodic and hypnotic as an old Swahili tune played on an Arab flute.

I climbed a small rise and looked down at the site. The bare stony hills stretched glittering around us in the heat. Despite my sunglasses the glare was intense. Looking at the exposed uplifts I realised regular volcanic eruptions had deposited thick layers of ash, now solidified into rock-hard tuffs of differing thickness. I was looking at the shores and bottom of an ancient lake; there'd been an uplift that exposed a layer-cake of volcanic tuffs. Dating would be no problem; and perhaps pollen analysis? I felt certain the lake had once been fringed by Miocene gallery forest. I looked into the distance, wondering where the volcano had been. Rock, sand, hills, dust, sun, heat.

Staring at the stony hills that lay still under the sun, I had a sudden wholly unscientific premonition and shivered: I knew without doubt that something momentous would overtake me here in this camp amongst the rocks. At the time I thought it meant a new exciting palaeontological find. Right and wrong. God help me: I knew then and did nothing.

★

Back at the hotel we reconvened for a sundown drink and Marion joined us. She sat beside me on a cane sofa and told me about her game drive. She'd seen elephant, multitudes of birds and shy bushbuck, gerenuk and zebra, strange plants, giant lobelia above the cloudline, in the bitter cold air. I listened and watched.

'And how's the site?' she asked.

'Oh, pretty good. Lots of fossils. We'll move in the day after tomorrow. Let Orde get the camp running smoothly. And we'll have the aerial pictures and a preliminary idea of the geology by then. You're coming too?'

'Perhaps for a while.'

'It's a very rich site,' added Chinta.

'Piggies,' said Victor, smiling at Marion. Slyly, he produced a small dark brown metatarsal from his pocket. 'Miocene porker,' he said. 'Found it this morning. Now you'll be able to watch me swing into action at last. Whoosh! Superman!'

Marion stared at him, inscrutable.

Orde walked up. 'I'm driving into Maleleji town to send a cable to Nairobi. Anybody want anything?'

'Toothpaste,' said Chinta. 'I always forget toothpaste. Let me give you some money —'

'Don't be ornamental. What kind? I hope there is toothpaste...'

Victor watched all this with a strange little smile. Turning to me, he said softly: 'You know he's a ginger beer?'

'Ginger beer?' I said, nonplussed.

'Ginger beer: queer. He's a poof.'

'That's the most appalling phrase, Victor. So what?'

122

'Yes! Odd, isn't it? Great white hunter, tough as boots, likes men. He's off to Maleleji to find himself a Somali boy.' He laughed and drained his whisky. 'Time for another.' He ordered a round and while he was busy at the bar Marion said: 'What was that about?'

'Victor says Orde's gay.'

Marion looked at Orde. 'Really? How odd. How interesting.'

'Why?'

She shrugged. 'You know why. By the way: I had a message from Oriana. She says you're welcome to drive out and see them tomorrow afternoon for tea if it suits you. She's got some family albums and things to show you.'

'What things?'

She smiled at me. 'You'll just have to wait and see, won't you?'

'Why don't you come too? She's your friend.'

She shook her head. 'Not this time. This time it's for you alone. Perhaps next time.'

★

'How good to see you,' said Oriana and took my hands. 'Come in. Grenville has a visitor, and so won't join us.' Simba was asleep by the unlit brazier, snoring. 'Come through to the study,' she said, leading the way to the back of the tent and out along a bamboo-lined walkway. 'We rather grandly call it "the study",' she said, 'but it's no more than a thatched boma where we can keep our books away from the ants.'

As we walked down the track — overarched by shiny-leafed buffalo-thorn, the sandy path covered with short sticks bound together with soft wire to make the way underfoot sure during the rains — I saw a dark figure, tall, muscular, exit the structure up ahead and disappear into the trees.

123

'That's Tregallion,' she said. 'Take no notice.'

'Tregallion? But I need to talk to him.'

She shrugged, made a small gesture with her left hand that was no more than a query, as if she herself echoed my question. 'He lives here sometimes... Shy, very shy until he gets to know you.' She led me into a tall open-sided thatched structure lined with bookcases whose feet stood in small dishes of paraffin.

'The ants seem to like philosophy best,' she said. 'And of the philosophers, the newer English. They've attempted Russell and abandoned *Principia Mathematica*, no doubt for reasons of taste. They've eaten Gilbert Ryle and that awful man Moore and even Wittgenstein: they ate halfway through the *Tractatus* and stopped quite suddenly but their particular favourite is A J Ayer. They've eaten *Language, Truth and Logic* twice and *The Problem of Knowledge* three times, perhaps assuming as cannibals do that consuming the heart and brains of their dead will bring wisdom and courage. Yet their behaviour has undergone no perceptible change. Perhaps an argument against the consolations of philosophy? You see they haven't eaten Boethius at all. Or perhaps there's simply too little nourishment in these little men. I'm sure Hatchards think we're mad, ordering the same books over and over. Would you like some tea?'

'Very much.'

She rang a small brass bell and gestured me to a chair, sat herself on a deep sofa with loose pale apricot linen covers. An abandoned cigar burned still in the copper ashtray beside my chair. The air was thick and sweet with its smoke. A small piece of paper lay on the table beside the ashtray. Squinting, I read, written in pencil, the word 'Lioness'. Tregallion?

She said: 'I myself find the trivial English obsession with the wholly impenetrable relationship between words and the phenomenal

world very trying. Why do we have no courage for metaphysical speculation?'

'I wonder.'

I looked again at the piece of paper, angled it slyly towards my eyes under the pretext of moving the ashtray. The word was not 'Lioness' at all. It was 'Lionness'.

Amman the Somali appeared, dressed today in a khansu and embroidered golden slippers with upturned toes. His eyes were thickly lined with kajol. 'Good afternoon, madam,' he said to me. 'Are you well?'

'Yes, thank you.'

To Oriana: 'You rang?'

'Yes. Please bring some tea, Amman. Do we have any biscuits?'

'Yes, my lady. There is still some shortbread from the last hamper.'

'Some of those, then, and lots of hot water.'

We talked briefly about the dig. Amman appeared with the tea tray which he placed on a small table. Oriana busied herself with the tea things.

'Kathryn, I've looked out some books for you,' she said.

'Yes?'

'About Patterson. I have here —' she picked up a large buff envelope from the floor beside the sofa and handed it to me '— copies of correspondence between the office of the Governor of the East African Protectorate and the Colonial Secretary in London. They deal with Blyth's death and the Colonial Office's attitude to Patterson.'

I made to open the envelope but she stopped me. 'No, wait. I want to talk to you about Patterson and Sir Frederick Jackson first. It was

not possible on the last evening because Grenville does not credit peculiarities like witchcraft. He is a rigorously practical person.'

'Tell me about Frederick Jackson.'

'Let me show him to you first.'

She walked to a bookshelf, took down a book titled *The Elephant Hunters of Africa*, opened it and handed it to me. 'It's written by a silly American hunter who idolises these wildlife butchers but the photographs are good,' she said. I took the opened book and looked at a photograph of a dark bearded man whose eyes burnt black from under a wide felt hat. His face was big boned, gaunt, his eyes aflame. He was crouched beside the body of a dead buffalo, one hand resting caressively on the animal's rump. The other held a large bore double rifle. He looked resentfully at the camera, eyes intense with a passion I could not place, wholly out of context with the photograph.

'Frederick Jackson,' she said. 'He came to Africa in 1884 from Yorkshire. He was a friend of Rider Haggard's, the novelist? *King Solomon's Mines*? *She*? Haggard based his character Good on Jackson, the chap in *King Solomon's Mines* with beautiful white legs. Dreadful character. Jackson was a gentleman adventurer, you see. He shot elephant for a living. They all did, then. Later, he was recruited by Sir William Mackinnon who started the Imperial British East Africa Company to explore — and, of course, ruthlessly exploit — East Africa.'

'How did he know Patterson?'

'Wait! Eventually the British government woke up to the fact that Bismarck was stealing Africa from under their noses and decided to colonise the place, and Jackson was on the spot: an experienced African. He ended up in the colonial administration as Deputy Commissioner of the East African Protectorate. He was an immensely powerful man.'

She handed me a cup of tea and offered biscuits.

'In what way?' I sipped tea, ate a piece of shortbread.

'There were no anthropologists then. When the British government wanted "native experts" they had to use the people who'd been with William Mackinnon's company. So no Governor — or Commissioner as he was known then — could claim deeper insight than a man like Jackson who'd lived here for years. He once forced Sir Charles Eliot, the Commissioner, to resign over a land dispute concerning Maasai grazing rights. He went to the Foreign Office in London, discredited Sir Charles's point of view, got the policy revised and Eliot resigned. Jackson was very much in love with himself.'

I looked again at the photograph of Jackson. His eyes burnt negatively, a dark flame. I turned the page and found another photograph: Jackson sitting in a chair beside a group of Kikuyu. The caption said: 'Sir Frederick Jackson and the signing of the Kikuyu Treaty with Chief Kinanjui.' The same furious eyes, the same intensity and restlessness.

'Tell me more,' I said.

'He was wounded by the Sudanese in the 1899 Rebellion; shot through the lungs. He should have died but didn't. A witchdoctor saved him. He'd spent much time with the Kikuyu, got to know their ways, met the witchdoctor — laibon — called Kimeu, who saved his life. He owed Kimeu a favour. They made a pact.'

'What pact?'

'Wait. You need to understand him. He hunted bongo in the Congo —' she smiled tolerantly at the rhyme '— and had a special camouflage suit made to hide himself in the dark glades where the bongo live; went back three years running and didn't get a single shot. Patient hunter... Patient man. Essentially a hunter. In his heart, a hunter.'

She watched me.

'And you say he made a pact with this Kimeu. Why?'

'To damn Patterson. Patterson was too strong. He'd tried to stop Patterson coming to East Africa and failed. Look at this —' she searched through the manila envelope, handed me a photostat of a telegram dated April 1907. It was addressed to the Secretary of State for the Colonies and had been sent by Sir Frederick Jackson, acting Commissioner of the East African Protectorate. It read: 'Dear Sir, It is rumoured locally Colonel Patterson is to be appointed Chief of the Game Department. If true, earnestly request that the decision be reconsidered as person named considered unsuitable...'

I looked up into Oriana's smiling eyes.

'You see?' she said. 'He was jealous. He'd written a book that was a dismal flop whereas Patterson's was a best-seller. And Kimeu the Kikuyu wanted revenge on Patterson for building "The Iron Snake", as they called the Uganda Railway, that brought the white man to annex their land.'

'But why the curse?'

'Does it matter why, Kathryn? You've studied fossil man. You can't think our heritage entirely good.'

'No.'

'Well, then.'

I smiled. 'I'll have to think about this.' I gathered my buff envelope and Robert W Parker's book and stood.

Amman entered and said: 'My lady, I need to discuss tomorrow's dinner menu with you.'

'Can't it wait, Amman?' said Oriana. 'I'm busy now.'

He smiled apologetically, spread his hands. 'My lady, the trader from the market is waiting in the kitchen. If we do not talk now, I may not have the ingredients...'

'Oh, all right, Amman.' She turned to me: 'Kathryn, do you mind? Go ahead, I'll catch up with you.'

'Of course.'

I walked slowly along the shaded path, enjoying the fading sunlight. Cicadas screeched shrilly and an unidentifiable bird called three descending notes in a minor key: Tchaikovsky lamenting a lost romance. A chinspot batis? I stopped to listen, followed the call of the unknown bird to a buffalo-thorn tree that stood near a grey-weathered reed-and-thatch hut with mosquito gauze windows. Engrossed, walking softly, I approached the tree. I'd assumed the hut was empty. Now I heard a soft intake of breath, a rustle of fabric. Through the gauzed window I caught sight of two bodies lying interlinked. As I turned away, embarrassed, I saw Orde's Land Rover parked behind a straggly thornbush. I walked quickly back to the main tent. When Oriana came to me, I said casually, 'Where's Grenville?'

She glanced at me, smiled slightly and said: 'With a friend. Why?'

'No reason.'

SIXTEEN

Afternoon tea and our talk had taken longer than I'd thought. Oriana walked with me out into the rising dusk. I turned and looked out to the east beyond her tent to see the sun set but it was already down behind the nearby hill. I was about to turn away when I noticed two silhouetted figures on the hilltop beneath a thorn tree a quarter mile away.

'Who's that?' I said, pointing.

She glanced quickly up. 'Daniel Tregallion and his tracker, I fancy,' she said. 'His so-called blood brother, Seremai Smith.'

'What're they doing?'

'Looking. They always sit there looking,' she replied. 'When they stay with us.'

'What at?'

She shrugged. 'I've never asked.'

'What does he do here?'

'Walks across the desert,' she said. 'Wanders in the bush.'

'Why?'

'I've always supposed him to be some sort of desert mystic; you know, like Lawrence. An anchorite,' she added, relishing the word, and went on, a fine irony in her voice: 'Seeking communion with the Absolute. He's popularly believed to be entirely mad. I know you want to meet him. Seremai Smith, too, his tracker. He's equally interesting.'

'Yes,' I said. 'As I said, I need to talk to him about our skull. Perhaps he can help us. And Seremai? Is that Somali?'

'No, Maasai. It means "Place of Slaughter". He's interesting, Seremai. He used to be an astrophysicist; I believe he did good theoretical work at Cambridge. He's the very opposite of Tregallion.' She glanced slyly at me. 'Perhaps if you don't have to haste away so soon, we might ask them to have a sundowner with us?'

'I'd like that.'

She sent a servant to invite the two watchers and we went back inside the tent where her manservant Amman — dressed now for evening in a long black gold-embroidered robe, his hair in little oiled ringlets — was setting out the cashews and peanuts in small bowls. We sat in her comfortable overstuffed armchairs about the unlit brazier and talked casually about the late rains, the gerenuk's long-necked adaptation to desert browsing, the loveliness of the doum palm. In the silence, I said: 'Your book about Patterson. Why did you stop writing?'

She took a handful of cashews, pushed the bowl towards me.

'Ah, that. Well, history seems so impenetrable to me. The past seems impenetrable. Anything we say with certainty about the past is partly fabrication. How can we know? We can't really know. At least, not in a way that was satisfying to me. And the more I researched Patterson, the more records I consulted, archives I plundered and books I read, the more the past seemed to recede until I found all my insights replaced with perhapses.'

'But still.'

'No. It would've been a form of lying. Patterson eluded me. The past is entirely elusive. And I found I was writing mythology, or bad romance. It was all too simple to write a straight historical narrative, glossing over the bits I didn't know about, inventing from the facts, seeing everything as though through sepia. Not real.

Fabrication. Like those novels where people say gadzooks or methinks. The past is gone, as if into a black hole. Unredeemable.'

Night fell. We waited. At my feet, Simba snored and farted. A small desert wind shuffled the tent. A jackal called distant and shrill; a nightjar too.

'Do you know Marion well?' I asked, on an impulse.

There was a momentary pause before she replied: 'Not very. We've corresponded about Patterson. She read my book and wrote to me.'

I was sure she was lying. I tried to see her eyes but the tent was too dark.

'Have you ever been married?' she asked suddenly.

'No. Never.'

'No children?'

'No, never. I can't have children, I'm afraid. Or so the doctors say.'

'I'm sorry. Why is that?'

'Oh, I had an operation, once. Infection.'

'I think that's sad. I think the world would be a better place with more of your genes.'

'Oriana, that's very flattering.'

'I mean it.'

'And you? Do you and Grenville have children?'

'One, yes, a son. He was in the army. Rather a family tradition, the army.'

'Grandchildren?'

'One, a granddaughter. Very pretty girl, bit of a disappointment to us, in a way. Blonde, you see; so easy for blondes to get lost.'

Amman lit the oil lamps and I heard a soft footfall outside. The tent flap moved and two tall men dressed in dark verdigris cotton twill — one white, one black — ducked slightly as they entered.

'Ah, Tregallion!' said Oriana. 'Daniel Tregallion and Seremai Smith. Come and meet Kathryn Widd.'

Tregallion was not at all what I'd expected. Despite the press photograph I'd seen, I'd imagined a Wilfred Thesiger-like character: spare, sinewy, pared down by privation, with peregrine eyes and a restless spirit; fastidious, hawk-nosed, with tobacco-coloured skin and a distant ascetic manner. Instead, Tregallion was a tall muscular man somewhere in his thirties with a dark mane of Byronic curls and extraordinary tawny-green eyes. His nose was hooked but he looked more like a gypsy than a patrician TE Lawrence. His eyes were penetrating. He looked at me with great attention and seemed to listen very intently when I said how-do-you-do. I saw a spider's web of white lines at the corners of his eyes that disappeared when he smiled. His face was very brown and he moved with an almost comical combination of muscular grace and awkwardness; as if he was an old athlete with a deep respect for the pain ancient injuries can bring. He didn't seem the least bit shy.

'Why are you staring at me like that?' he said, and the white laugh lines disappeared as he smiled.

'I wasn't. You were,' I said.

'Nonsense. I never stare. Well?'

I shrugged. 'You're just not what I expected.'

'Ah,' he said. 'I know. You expected a scrawny weatherbeaten desert madman hellbent on deliverance. Yes?'

'Yes.'

'Well, I drink far too much to be thin, and Seremai feeds me too well. We never eat locusts,' he added.

He turned to his companion. 'This is Seremai Smith, my tracker and blood brother. He's thin because he never drinks or eats.' Seremai Smith smiled slightly and shook his head.

'Sit down and have a whisky,' said Oriana.

Amman brought drinks on a brass tray. 'Mr Tregallion,' he said. 'How kind of you to grace us with your presence. You too, Mr Smith.'

'Go away, you whoreson cutpurse pimp,' said Tregallion. 'You Somali are all the same; all pederasts and syphilitics.'

'Mr Tregallion is another quaint colonial relic the government tolerates only from generosity of spirit,' said Amman to me. 'Were it not for the fact that my father, the chieftain of all lands north of Wajir, has an unaccountable affection for this exploitative capitalist pig, I would have inserted my dagger decades ago between his worthless ribs.' He bowed charmingly and left.

'I see he's still suffering from that crippling shyness,' said Tregallion. 'Poor boy.'

'What were you doing up the mountain?' I asked.

'Looking,' said Tregallion. 'Why?'

'You looked so funny up there. So still.'

'Seremai's the observer, I'm the mystic,' said Tregallion, eating a cashew. 'What do you do for a living?'

'I'm a palaeontologist,' I said. 'And I've wanted to talk to you about the skull you found.'

'Yes?'

'Yes. We're up here from Nairobi to excavate the site. It might be very important.'

'Why?' said Seremai.

'Long story.'

'Come to our camp,' said Seremai. 'I'll cook you dinner and you can tell us.'

'Well,' I said. 'I don't know . . .'

'Don't be such a ninny. Of course you must go,' said Oriana.

'Well, if you think so . . .'

'We do,' said Tregallion firmly.

'There's eland fillet, and even some vulturine guineafowl for starter,' said Seremai. 'You won't regret it.'

★

We sat under the stars a little distance from Tregallion's tent and drank a whisky called Ardbeg from Islay that Tregallion swore was better than any malt scotch he'd ever tasted. I explained the problems of the taxonomy of the skull and Tregallion and Seremai listened carefully but made no comment. A desert hyena hooted and muttered, its voice brittle in the night. We listened in silence.

'Why do you walk about all the time?' I asked.

'He's an unrepentant mystic,' said Seremai Smith. He smiled quietly and shook his head. 'Tregallion can't face the fact that death is the cessation of all knowing,' he said. 'He has to tell himself fairytales all the time or he gets scared.' He lifted the lid from his three-legged pot and inhaled the aromatic cloud that rose. He stirred, added dried herbs and rock salt and replaced the lid. The hyena's voice dipped and lifted, teasing the moon.

'How?'

'Don't get him started,' said Seremai. 'He'll get drunk, talk all night and then he'll dance and keep me awake.'

Tregallion ignored him. He said: 'I'm already drunk. But what if the whole cosmos is a fugue; six, a dozen, two dozen, a million intertwined melodies all dancing together in unison? Individually, each may be entirely thin and without charm. But together! Imagine: a joyful mass of vertical harmony, a tumble of horizontal melody that flies headlong towards resolution. The massive chords celestial, the songlines heartbreakingly lyrical. What a beautiful universe. A fugue cosmos-wide.'

Seremai clapped slowly, ironically. Tregallion laughed, the hyena joined in and for a moment their voices sang together. I watched sparks from the thornfire whirl upwards in the hot column of air and lose themselves in the stars.

'And evil?' I said. 'What about evil?'

'Ah, evil. The devil, Old Nick, Beelzebub, Mephistopheles. Well: my heavenly music praises god, the unmoved mover; naturally it's as evil as it is good. The cosmic fugue renders death and forever with each beat of an unseen baton. Bloodletting and childbirth are hymned equally with hallelujahs. So much for evil.'

We ate under the stars. The guineafowl was potroasted, the eland fillet grilled on the open fire. Seremai found some red wine in his tent and they toasted the cosmos. Later, when the fire had burned down to turkish delight embers dusted softly with icing-sugar ash, Tregallion said: 'You can't drive home at this hour. Sleep here. You can leave early, before dawn. There's a spare tent and I promise I won't steal in and ravage you while you sleep, much though I'd like to. What happened to your leg?'

'Snakebite.'

'Oh? Desert horned viper?'

136

'Cerastes cerastes,' murmured Seremai. 'Or perhaps even the common sand viper? Cerastes vipera?'

'No. It's an old bite, when I was a child. In my father's garden. A big puff-adder.'

'Bitis arietans,' murmured Seremai Smith. 'Cytotoxic. Nasty. Very nasty.'

'Does it hurt?' from Tregallion.

'No. Sometimes.'

'Muscular damage,' said Seremai.

'Please don't go,' said Tregallion. 'There's so much to talk about. Seremai's got a new toothbrush you can use. Soap, towels, the shower bag's hung in that tree there. We won't watch, will we, Seremai?'

★

Hours later I woke suddenly and listened. No desert lion roared, no jackal called. The hyena were silent. I wondered what had woken me. Faintly in the night I heard the sound of a cello; no, a violin, other strings. I unzipped my borrowed sleeping bag, found my stick and slipped out of the tent to listen. The stars were bright and cold, the air cool. Wind.

The music was coming from Tregallion's tent, pitched a little distance from the others. There was flickering lamplight, a small campfire burned. I walked closer in the dark, saw a dim figure leaping and flying in the firelight, twisting and bounding, arms outstretched. Tregallion. The music I knew: Bach's Art of the Fugue recorded by a large string orchestra. I watched Tregallion's shadow fly across the sand, watched his strange muscled arabesques and jetés, saw him crouch and leap starwards — arms upstretched, following the sparks of the fire as they whirled towards the Milky Way, encompassing the sky, touching the roof of heaven — a fugue

137

made flesh. He danced for an hour and I watched him all the time, saw his rhythm falter and his leaps lose their snap, watched until he fell to his hands and knees, waited for him to roll onto his side and be still.

When I was certain he was asleep I walked to his tent, switched off his tape deck, fetched a blanket and covered him where he lay, head at rest on his outflung arm, snoring with exhaustion. I looked up at the sky. Constellations overarched the heavens: red giants, white dwarfs and quasars, neutron stars. Light millions of years old reached me, light emitted before Magellan set sail, before my hairy ancestors stood awed and silent and raised their eyes to a different sky. Light reached me that was born before the first ambitious amphibian crawled from the protozoal slime.

Tregallion snored on. I walked back to my tent and slept.

SEVENTEEN

That night I dreamt again about Patterson and Janey and neither the context nor the content of the dream were lost on me.

. . . The untethered horses ground noisily at the coarse yellow grass. Patterson had wedged his heavy .450 Jeffery double rifle safely into the split trunk of a tall umbrella thorn and spread soft Shiraz rugs on the ground.

They lay together interlinked on the rugs. Eyes half closed, Janey looked at the patterns: small birds and trees, little animals. A whole universe woven there. And the colour? They're the colour of dried blood, she thought. It was cool in the lace shade of the thorn tree. The treetops were alive with wind; seed pods rattled softly. Janey felt Patterson's sweat dry slowly on her naked breasts. She kissed his forehead, tasted the sweat that beaded there. His eyes were closed and she could feel his heart thud hard and deep inside her still, as intimate as a foetus.

'Patterson,' she said.

'Yes?'

She leant up from his chest on braced arms and stared down into his eyes. 'I don't love you. Do you mind?'

He watched her. She felt him slide and contract inside her.

'No. Should I?'

'No. Perhaps. Do you love me?'

He smiled up at her.

'I don't know if you do,' she went on. 'I don't even know if I care. I'd care if you died; but this is different from what people call love, isn't it?'

He contracted, slid from within her, softly, slippery. She felt a momentary loss. Patterson said nothing.

'Do you think lust is a sin? Is it evil? Pure lust?'

Patterson stared up at her face: the beautiful high-pitched death's head cheekbones, the skin tanned a little now, the English pallor banished. Eyes blue, pale, gravely watching his own and he thought: the eyes are not the windows of the soul. When I look into her eyes I see the pupil, the iris, flecked darker blue there and there, the impenetrability. I do not see her soul.

'Do you?' she insisted. 'Do you think it's evil?'

Patterson, transfixed by her impenetrability, said nothing. He watched her uneasily. Little that he experienced could be expressed in words. He either knew something to be true or not. He knew now that in Africa, now, here and now, their acts were neither evil nor good but were suspended devoid of meaning like penitent souls in some pallid antechamber of the underworld. He did not say this. Instead, he said: 'I don't know,' and watched her eyes. The pupils dilated slowly, depthless, black as a dead lion's. What was she thinking?

Janey thought about the way it felt when they made love: for the first time she knew how ancient and primitive was the urge to be one with another human being. This was as acute as hunger, as urgent as the need to escape death. Nothing in her past had prepared her for this. This was no meek obedience to male will; this rose from her own insistent inner nature: ancient, unbiddable, unrepentant. She felt the longing start again that ached deeper than loss or grief: it was womb-deep. There was no logic and no morality to it.

She smiled at Patterson, rolled from his body and lay on her back. The sunlight was bright through the moving branches. She closed

her eyes. Patterson knelt beside her, bent to kiss her. His tongue licked tentatively across her lips. She moved her feet until her legs were flexed wide apart, the tendons high on the inside of her thighs drawn taut.

'Patterson,' she said. 'Again. Do what you did again. Please do it again.'

★

Next morning before sunup I left a thank you note propped against the screwtop sugar jar on their folding dining table, started my Land Rover and left quietly before they woke. Or so I thought. As I followed the winding gravel track back to the main road, I caught sight of a distant figure standing on the top of a very high dune. Tregallion. Standing dark and tall, staring out at the wasteland. He raised one arm in silent farewell then turned away to stare once more at the desert and the rising light of dawn.

★

I became quickly immersed in the dig and Oriana's book lay unread on the night table in my tent beside my bed. I forgot Patterson and the beautiful Janey, forgot Jamie the wimpish husband, forgot curses and adultery and lust and began my search for clues to a death in the more distant past. I tried to forget the vividness of my dream about Patterson and told myself that it was purely coincidence that I'd dreamt it just after meeting Tregallion.

He paid us a short visit, showed us where he'd found the skull fragments — thereby confirming the accuracy of Victor's Global Positioning System — and in reply to my complaint that we'd found no more skull fragments, said: 'If I were you, I'd look a little further north.' He left in a cloud of volcanic dust and loud backfires from his untuned Land Rover. He and I had hardly spoken and when he left I felt curiously disappointed. But I shrugged this away and concentrated instead on palaeontology.

Each week our Unimog made the three hundred mile run to Maleleji, the nearest town, for fresh greens and pale tomatoes, sugar, mposho meal, vegetables and beer. Beer was essential. Working in the naked sun day after day we drank cases of pale dry petillant Tusker lager but were never drunk. An occasional safari to a nameless river that fed a distant stony well produced bags of green pigeon, fat from their meals of sweet wild figs. These birds, braised slowly by our cook in copper pans over open coals and served with wild rice thick with onion and garlic, were a welcome change from our staple diet of stringy goat and cassava.

To the perverse delight of the team I was adopted by a particularly vile young goat. The ugliest of the kids we'd bartered from local goatherding entrepreneurs, it had quite understandably been abandoned by its mother, a flighty ewe who immediately bolted at the sight of her horrible newborn infant. I took pity and fed it with a baby's bottle bought at the duka at Maleleji, the 'Place of Uncertain Winds'. We became inseparable. Orde christened it Quasimodo.

Quasimodo was blotched unfetchingly white and black, had a downcast snout and affected an air of pained surprise, as if bemused by inexplicable early maternal neglect. At inopportune moments it would let out an especially piercing bleat. Orde took an immediate and intemperate dislike to it. I fought a partly humorous war with him and defended the goat when he constantly suggested that 'that fucking awful animal of yours' should be slaughtered for aesthetic reasons and consigned to the cookpot. Quasimodo returned Orde's hatred. Some bestial sixth sense alerted it to Orde's fastidiousness and it would trot up on silent hooves to his chair at lunch, reverse surreptitiously towards him under the table and void a stinking stream of raisin-like turds straight onto his freshly polished boots.

Orde never anticipated these attacks on his dignity and the goat would drop its load and gallop away unscathed before Orde could respond. The camp staff would watch bemused as a smelly and infuriated Orde chased the scampering goat into the dunes, roaring with fury, fork in one hand, napkin in the other, his stained boots

shedding goat turds like hail. In time, God knows why, I grew fond of Quasimodo and allowed it to sleep outside my tent where it curled up like a watchdog and slept until dawn when it would wake me with bleats of earpiercing shrillness. It followed me everywhere, even waiting patiently for me outside the shower tent. At night, while I sat in my camp chair watching the firelight, it would sit beside me like a faithful hound and urge me with butts of its repulsive snout to tickle it behind the ears.

Work proceeded. My guess that we were excavating uplifts that represented the shores of a Miocene lake with later Pliocene and Pleistocene tuffs superimposed was proved correct by the geologists' report. There were fossils of ancestral baboons, elephant and forest antelope in the earlier tuffs, gradually supplanted by dry-country antelope like ancestral kudu, tsessebe and eland as the lakeshore receded during the Pliocene. There were pigs aplenty, too, ranging from the little two million year old Mesochoerus to younger ancestral warthogs. Victor was entranced, laying out his pig fossils on the long tables in our tall work tent, muttering to himself and marking the locations of his finds on large-scale stratigraphic maps. His work was crucial for corroborating the dating of any hominid fossils we might find, so we all tolerated his nightly whisky-sodden lectures on basalt flows and sediments, warthogs and piggies. And although primates in the form of monkeys and baboons abounded there were no hominids.

We fell easily into a routine: up before dawn to work in the cool morning air, a break for tea or beer around eleven, a rest in the noon hours, a light lunch, siesta, and a further stint from three till six. At night we worked on our fossils by the light of hissing gas lamps, removing accretia with dental picks, strengthening fragile fossil bones with Bedacryl, separating fossils from tufa with airscribes driven by our rackety petrol generator. In all, it was exhausting, unrewarding, backbreaking work. We all developed coughs from working in the constant volcanic dust.

But there were compensations. The night sky was thick with stars, the Milky Way a white swathe, the dusk air fragrant with thornwood smoke from the cook fires. And life had meaning: we had a goal, a quest; however pointless each probe of the dental pick, we expected always a major find. And Chinta reminded me constantly of the Raymond Dart Foundation prize: half a million dollars of freedom.

Where Orde was an impish provocation, Ray Chinta was a solid reassuring presence. Never ill-tempered, always cheerful, always professional, he ran the dig with an efficiency I envied. I was dismayed by my lack of agility in the stony desert: often my stick skittered away and I fell in a tangle of arms and legs, careering down slopes and coming to rest at the bottom of rocky gullies. This amused the labourers terribly and they often mimicked me cruelly until Chinta flew into a rage one hot midday and fired the lot, only to rehire them an hour later from remorse. I was not bitter. My tumbles were the only entertainment they had.

And I fell less and less. Chinta encouraged me to walk the soft desert sand without my stick and gradually I grew confident, carried my stick more as a tool to poke away at a likely looking patch of tuff, less as a prop for my scarred leg. There were ambiguities, too. Our work was so tiring, the heat so sapping, I thought all sensuality had been sucked from me by the dry desert air and relentless sun.

And yet, and yet... One evening I walked to my tent from an indigestible supper of vulcanised goat and saw light flicker through the gauze windows of my tent. When I cautiously entered, stick raised expecting a thief, I found Marion bathing in the rear section in my canvas camp bath. The tent was filled with the light of an oil lamp and the scent of her soap. Sandalwood, roses, lilies? Expensive. Reclining, she looked like a pinup of a Hollywood screen goddess.

'I hope you don't mind,' she said, washing suds from a long leg that rose elegant and wet with highlights from the small canvas bath. 'But there's a Rendille workman who spies on me every night and I

got pissed off by that and thought if I was going to be spied on I'd like to be spied on by someone I like. So here I am. Do you mind?'

'Of course not. Can I offer you a drink?'

'How about some chocolate? I know you've got a stash of Lindt or Côte d'Or.'

'You've been spying.'

'Not at all. Nothing but expensive chocolate can give that look of smug satisfaction.'

'And a scotch?' I took a slab of Lindt from my coolbox.

'A scotch too? Why not? I haven't touched a drop since we've been here and I think I need cosseting. God, the state of my nails...'

I found my bottle of Lagavulin in my blue metal trunk, poured a stiff tot, added chill water from the goatskin chagoul that hung from the tent post and took the glass through to her. The water in my shallow canvas bath covered her pubis but her belly and torso and breasts were lapped by warm soapy water. She looked up at me, eyes impenetrable under upslicked brows, took the glass with a wet hand and sipped. I handed her four squares of chocolate which she took and slowly ate. 'God!' she said. 'Is that better than sex, or what?'

She closed her eyes and chewed slowly, making small murmurs of delight. I looked curiously at her body. Her breasts were large, the aureoles faintly pink, her nipples very long. She opened her eyes and watched me look at her body in silence, smiled and said: 'What do you think?'

'Your body's lovely,' I said. 'You know that.' I felt a surge of melancholy, with a start felt a longing to be wanted by a man. I turned away and sat on the bed with my back to her and poured myself a Lagavulin and lay back on my camp bed and sipped it and stared up at the roof of the tent and ate my two squares of Lindt. The two rectangles of mosquito-gauzed window showed pale

against the dark canvas. A small breeze came in through the open tent flap, hustled around the tarpaulined floor, exited through the rear of the tent.

'God, that's chilly,' said Marion. I heard the gurgle and hush of water as she stood, the sound of her towel rough against her body. I did not look round. She came to me, glass in hand, wrapped in her white towel, her hair long and wet and slicked behind her ears. She sat on the bed at my side and crossed her legs and looked at me.

'Cheers?'

'Cheers,' I said. We drank in silence.

'Have you got more choccy?'

'Here.'

She took the chocolate, broke off four squares and ate them, watching me carefully. I looked away and she said, 'Don't you want me here? Shall I go?'

I turned back and looked at her. I did not know what to say. She drank and I watched the long smooth tendons in her neck draw taut and relax as she swallowed. A pulse throbbed in the hollow formed by the angle of her collarbone, skin stretched taut across, thudding softly like a tiny drum.

'Do you?'

'I don't know,' I said. 'Why are you here?'

'I told you. The Rendille voyeur.'

'The Rendille voyeur.'

'Yes.'

'Really?'

'Really. And your chocolate. More because of your chocolate. Do you want me?'

'What an absurd question!'

'Shall I go?'

'Perhaps that'd be best,' I said gently.

She stared at me, emptied her glass and kissed me on my forehead. 'You're probably right,' she said, but did not move. I watched her. A drop of water ran down her face from her damp hair and beaded on her upper lip in the small hollow beneath her nose. She sniffed. I wiped the drop away and she caught my hand.

'Did you ever sleep with the girls at school?' she said.

'What an extraordinary question. Of course not!'

She did not reply. Instead she took my face in her hands and kissed me on the mouth. I drew back. She stood and looked down at me. 'You're a very beautiful woman,' she said softly. 'Thank you for the chocolate.'

I closed my eyes and listened to her gather her things and leave. The smell of hot water and soap slowly drained away as I lay there in the dark until I could smell only the desert air and the Lagavulin and the Lindt chocolate. Then I turned on my side but sleep would not come.

EIGHTEEN

Perhaps now is the time for confession. I was thin and gawky and gangly until puberty, bookish, shy, intelligent and withdrawn. Then a sudden storm of hormones made me precociously tall and well developed. My breasts were suddenly high and well shaped, my legs long but muscled beneath my teenage softness. I was athletic, even beautiful, a kind of daunting Amazon. I played all sports, excelled at swimming and athletics but was never less than adequate at any. As I mentioned before, I was clever too, won academic prizes, was even a good cellist. This nauseating competence angered the more emulous, but many other girls liked me. I became the object of several crushes, teenage erotic speculation.

Flattered, I allowed myself to be initiated into the awesome ecstasies of sex by several of the older girls. I remember still the milieux: the changeroom after swimming, the first shy kiss, the taste of pool chlorine mingled with lipsalve as the earth turned dark and my eyes closed; or splayed on rubbery gym mats beside our discarded leotards: sweet high summer, the sweat of exercise and the soft probing fingers. All gone now.

Immature and unaware of the real nature of love, I fear I broke many hearts, but remained myself almost unmoved until I fell in love with Ernst Stoller, my cello teacher. He was tall, saturnine, wild-haired, given to inexplicable rages and helpless lust. I suspect it was not my dreadful playing but rather my splayed thighs and the glowing cello nested between them that so entirely entranced him. One hot summer afternoon we were bewitched by goblins. Ernst was one of the first music teachers to use recordings of the major cello concertos by great orchestras, mixed without the solo instrument, to inspire his pupils. Bewitched by the swell of the

music, its melancholy and drama, I'd played the solo cello part from the slow movement of Dvorak's great concerto uncharacteristically well and in an outburst of passion surrendered my virginity to Ernst backstage in the school hall: pressed up against the wall in the secret darkness, my uniform skirt rucked up around my waist, my panties pulled down about one ankle, his lips wet on my neck. I was drunk still on Dvorak's cantabile cello writing, afloat on the lingering Slavic cadences and I felt a terrible power watching Ernst's eyes flutter as he came inside me.

I had no fear: I was ancient, I knew I could encompass his warlocksbane. There was no risk of evil, no fear of pregnancy or contamination. I was a sorceress. I knew that my power — inward, female, involuted — could hold him inside me, devour his seed and mute his fury. I was all women: Salome, Cleopatra, Helen of Troy and Mary Magdalene, Lilith and Eve, the Divine Whore and the High Priestess, all at once. Afterwards I sobbed in an ecstasy of conquest, filling poor bewildered Ernst with terrible guilt.

Later, after I'd left school and temporarily abandoned my cello, I sought him out again. Driven by an optimistic compulsion to verify the lyricism of my first love and lust — and to convince myself that my scarred leg was no barrier to passion — I seduced him and rode to lonely orgasm, his acquiescent body prostrate on the dusty kelims of his little flat with its rows of neatly filed orchestral scores. If I'd guessed the sordid results of this unlovely coupling, I would never have surrendered to my romantic need for affirmation. The suction curettage: purulent mucus, the tiny cowering foetus, the blood clotting in a bucket. And then the humiliating infection, the discharges and pain; my doctor's quiet confirmation that I'd never have children. All gone now. All gone forever.

And then there was my writer, the first great fragmentation of my maturity. We loved each other but it was not enough. Nor could he heal the wounds I'd made somewhere in the deepest pit of my femaleness. He left me after a year's titanic struggle of wills which I could never hope to win. But biology is wise. We fell in love against

all dictates of logic and good sense and perhaps in a simpler age we would have married, even had children, reared our family together. But that was not to be. We had both begun to understand that chance or destiny had other plans for us that did not include domestic bliss.

Yet I was powerless to reason away my loss, no matter how I tried. For long years I could not watch love scenes in films without crying. Not from an excess of sentimentality, nor in mourning for lost love; but because the intimacy depicted so vividly onscreen reminded me that my moments of transcendence, when I'd held the whole universe close and tight in my arms, were no longer a part of my life. Or perhaps they were. Still unseeing, I think I made up my mind then, in the cooling desert night. It was not easy.

Sleep came later.

★

When it happened, it felt as natural as sleep or breathing, as essential as sun on my skin.

Orde had decided to make one of his periodic safaris to a small nearby lake fed by a cold spring that bubbled up bright and clear from a fissure deep in the desert's ancient volcanic heart. His fastidious palate, indulged on a hundred millionaire safaris and accustomed to Mombasa oysters and chicken Kiev, had finally reacted in disgust to our camp's monotonous diet of cassava and 'fossilised goat' as he called it. He was after sandgrouse: those plump-breasted, succulent, fast-winging birds who sweep in dense chittering droves to waterholes to drink each dusk and dawn.

I decided to declare a day off when Orde announced this plan one morning at breakfast. Marion said she'd come too. Chinta very kindly said he'd carry on chipping away at fossil accretia with his airscribe and look after the camp. Victor was still in bed, nursing an aching head. I left Quasimodo in the care of a newly hired goat-tender, and we set out immediately after breakfast. Marion and I sat

beside Orde in the front of the Land Rover, the early hot air cooled by our speed, the wind taut in our hair. Orde's gunbearer Haroun sat in the back with the leather guncases and cartridge bags. It was only an hour's drive and we parked in the shade of a stand of tall doum palms whose heads reached up forty feet into the sky. A sulking vulture crouched disconsolately in the crown of the tallest and eyed us thoughtfully.

The spring fed a chain of small reed-fringed oases that lay still and unmarked, pale blue reflections of the empty sky. The banks shelved gently and over centuries the beach had been washed clean and white by gushing water. Small antelope spoor showed in the soft sand.

'But Orde: it's an absolute paradise,' said Marion, staring. 'You're a swine to have kept this place a secret.'

'Didn't want the whole camp here,' he said. 'Frighten the birds and muddy the water. Why don't you swim?'

'Crocs?'

'Here? Never.'

'What about your shooting? Won't we scare the birds off?'

'No. They only come at sunset, and I'm going to walk a bit further on with Haroun and the shottie-guns and bag a few green pigeon as well. You'll be quite private and you should swim, really; it's cool but not icy.' He and Haroun waved goodbye and shouldered their shotguns and disappeared into the encircling scrub palm.

'Well,' said Marion. 'Shall we?'

The sun was hot, even in the shade. 'Definitely.'

Marion stripped off her khakis, undid her bra, slipped off her panties and dived into the water, arms outstretched, head tucked neatly between. I followed more slowly, shy, conscious of my

scarred leg. Marion surfaced, swam closer. 'It's heaven,' she said. 'Stop thinking about your leg and come in!'

I dived in, felt the caressing iciness close over me, slide through my hair. I stayed under for as long as I could then arced slowly upwards, bursting through the mirrored surface into air and sudden sunlight. Marion was treading water nearby. I looked at her. She laughed and I laughed with her, the laughter bubbling up out of me. 'Why are you laughing?' she called.

'I don't know,' I said. 'I really don't know!'

She laughed all the harder.

★

And later. Drying our hair in the sun, the sky flaming endlessly cornflower blue, the distant shotguns making soft puffball puckers in the air as Orde and Haroun downed soaring pigeon... Stretched naked beside each other on Orde's big tarpaulin; my eyes closed, the sun's heat burning blood-red through my eyelids: I felt Marion lean close, her body cool, her lips wet with ancient subterranean water. Felt her mouth on my nipple and reached for her in turn and it all felt as natural as sunlight, as ordained as spring rain. The vulture called once, spread its wings and heaved itself into the hot air to rise on widening thermal circuits high up against the blue, sailing the wind.

★

That was the start. I was not in love, but I loved her. We were together every day: me digging in the hard volcanic tufa for fossils while Marion smoked under the shade of an umbrella, sardonically reading me extracts from her collection of dreadful bodice-ripper novels; eating Hamid's disgusting stews, making love together nightly in my tent. But discreetly, discreetly. Marion did not, she said, want to hurt Victor, nor jeopardise the dig.

152

I was perfectly content. For the first time in my adult life I felt simply happy; and this should have alerted me: to covet happiness is to miss the point entirely of our being here in this harsh dreamladen twilight between foetal blood and mucus and our final rattling inhalation that lasts forever. But at the time, entranced by Marion's grave, ironic beauty, addicted to her calm acceptance of homoerotic lust, I felt no instant's qualm, no tremor of fear at our presumption. As if in reward, I soon made the first of what was to be a series of shocking fossil finds.

I remember the moment of revelation quite distinctly. I'd woken early and walked with Quasimodo to the fossil site. I stood alone in the growing desert heat, staring at the site peg where the dark fossiliferous tuff was sandwiched between the two pale chalky ones and wondered why we had found only freshwater mussels and chips of fossil fishbone there. I recalled what Tregallion had said: If I were you, I'd look a little to the north. Obediently, I looked northwards to an uplift that showed a similar sandwich of tuffs and thought: What if we're looking in the wrong place? What if a channel of floodwater carried the fragments of the skull here to the shallows of the ancient lake but left the rest of the skeleton untouched upstream? Perhaps the balance of the skeleton still lay on the lost banks of the ancient river, quiet and unsullied after millions of years. What if we were digging in the wrong place entirely?

Walking slowly northwards, I tried to sense from the upraised tuffs the ancient topography of the site, tried to feel beneath my feet the old course of a stream which was, I then thought, simply my imaginative creation. I should have remembered Dukowska's dictum: we create the universes we seek. I came to a sandwich of tuffs which corresponded to the stratigraphy of the skull site and stood for a moment undecided. The heat was mounting. The horizon shuddered and the thin desert thorn trees, grey and emaciated by privation, vibrated in the hot air. Quasimodo bleated at me, watched with beady eyes.

I stared at the earth. Impulsively knelt and tapped softly with my pick. A fragment of pale tuff came away neatly and there, white, silent and accusing, snugged into the dark ash deposit below, I saw the distal end of a fossilised antelope femur. My breath caught in my throat. I stared. I knew. This was no ordinary fossil. I knew — a certainty beyond logic, beyond rationality — that the twin raised knobs would fit exactly the indentations in the skull Tregallion had found. I was looking at a weapon. The weapon.

Sweat soaked my body. I began, very carefully, to excavate the rest of the femur, noting that it was very likely ancestral kudu and that it was largely undamaged. By lunchtime I had exhumed the whole bone. There were slight marks of gnawing (probably porcupine) which pre-dated its fossilisation. I freed it gently from the residual clinging tuff and held it in my hand. Thoughtfully, I hefted it. Despite the accumulated weight of fossilised stone, it balanced handily: a potent and deadly club. I felt elation fill me. I danced a little jig and let out a brief pagan shout of victory. Quasimodo bleated and cantered away.

'What're you doing?' said Marion coolly from behind me. I almost dropped the fossil in fright. Quasimodo bleated at us. 'What're you doing?' she said again. 'What's that?' She put her arms around me and kissed me on the mouth. Over her shoulder I saw Victor's head appear warily from behind a dusty mound. He stopped and stared. Quasimodo bleated at him.

'There's Victor,' I whispered.

'Oh God, no.' She stood away from me. 'Did he see?'

'Definitely.'

'Oh, hell,' she said, then shrugged. 'Why shouldn't I hug you? You've found a bloody fossil, haven't you? Is it important?'

'Yes. Yes yes yes!'

Victor struggled up the shallow rise, paused, breathing heavily, beside us. 'Hello, Marion, Kathryn; I was worried. You've been gone all day and no one'd seen you. What's that?'

Unable to contain myself I danced another little jig of triumph. 'That,' I said, 'is our half million dollars of prize! That's the murder weapon!'

★

That evening we ceremoniously tagged the femur with its site number and laid it on the worktable in pride of place. Victor made a short incomprehensible speech. We toasted the find and each other with Victor's warm Asti Spumante and laughed at silly jokes. Everyone was smiling. Chinta kept aligning the twin orbs of the distal end of the femur with the grooves in the cast of our fossil skull, shaking his head in disbelief. 'I don't believe it,' he murmured. 'I just don't believe it!'

Victor carefully marked the find on his large-scale stratigraphic map and persuaded the labourers at dusk to help him peg out the new site with transect lines and hang plumblines by the light of storm lanterns. He was touchingly proud and kept hugging me and saying, 'My dear! My dear!' in a disbelieving undertone. Marion stared at this with sardonic eyes and smiled at me from behind his back.

Dinner was accompanied by more of the highly acidic Asti Spumante. At ten I yawned and stretched and said: 'Well, it's been a long day. I'm for bed.'

Marion looked at me sharply and drank her wine. Victor said: 'My dear girl! Well done! Well done!' Chinta raised his glass in a toast. Quasimodo bleated. Orde smiled and winked. They all looked so happy, I remember. So very, very happy.

★

I tossed the blanket from my bed. I lay on my back and waited. I knew Marion would come to me. When I thought of her lips, her

155

body holding me close, her mouth touching my ear as she whispered of unspeakable intimacies, I felt my stomach grow hollow. The longing, the anticipation of repeated ecstasy, the hunger. Then the tent flap moved and she stood there in the dark and I heard myself say: 'Come to me.' And she was kneeling there beside me on the canvas floor of the tent, dark wraith, her mouth in my hair, wet on my neck, her hands sure and knowing but more tender and gently searching than a girl-child's. Her eyes were closed with her wanting: I could feel her eyelashes tremble on my thighs: my Lilith, my succuba, my love.

★

'He knows,' she said later. 'Victor knows.'

I leant up on one elbow in the dark. 'How?'

'Where are my cigarettes?'

'Here. How does he know?'

She lit a cigarette, said, exhaling smoke: 'He wanted to sleep with me tonight. I said no. And he looked at me; such a funny look. He's like a child, he knows things.'

'Oh, God.'

I felt her shrug. 'So what? So what if he suspects? He won't do anything.'

'No,' I said, dubious. 'Perhaps he won't.'

'And he's so delighted with your find,' she said slowly. 'He won't do anything to jeopardise that. Not now. It's too important to him.'

'Why?'

'He's never achieved anything,' she said. 'Rich boy, indulgent father. He's always had it easy.'

'And you? Did you?'

156

'Me? What about me?'

'Did you?'

'Impoverished gentility?' she said scathingly. 'No, I didn't have it easy.'

'What do you mean?'

'Oh, Kathryn! I know you know. I wanted all the pretty things but I was too lazy to work for them. You know what I did. I know you know. No wonder that awful German at the Norfolk kept winking at me. They say you never lose the look.'

'Yes.'

'Does it worry you?'

'No.'

She drew on her cigarette. I smelt the tobacco sourly overlay the woodsmoke of our thorn fire.

'He wants to announce the find immediately,' she said.

'I thought he might. But it's too early. We need to find more skull fragments, some other bits of skeleton in association with the club for it to have any real meaning. He mustn't do it yet,' I said.

'I'll tell him,' she said. 'He listens to me.'

'I hope so.' I lay back, thinking about the site. 'I must get up early tomorrow,' I said. 'Before the heat. There are incredible things to find, Marion; I can feel it.'

'Then you must sleep,' she said. 'Sleep.' She pressed my head softly down onto her shoulder. 'Sleep, my love...'

I did not hear her leave. I often wonder: if I'd known that was the last time we'd sleep together, would I have done anything differently?

Nigredo

The
World
of
Darkness

When early explorers called Africa 'The Dark Continent', they were not only referring to their paucity of knowledge. Africa was primal darkness; a projection of the unknown, uncharted and terrifying contents of the unconscious onto a geographic area. Africa truly was 'Terra Incognita'.

The long Western tradition of punishing women — damning them as witches — for perceived contraventions of social norms is bound up with male fears of women's supposed emotional and psychic closeness to the dark side of Nature and of mankind...

Charles Young: Archetypes in the Primitive Psyche

NINETEEN

Chinta woke me out of sleep at three into darkness profound and complete.

'Kathryn! For God's sake wake up. Something terrible's happened!'

I sat up in bed, still asleep. 'What?'

He was standing beside my bed holding a dull paraffin lantern. His eyes were wide with fright. His hand shook. The lantern flame flickered uncontrolled. Quasimodo bleated at him from the open tent flap.

'What is it, Chinta?' I said irritably, pulling hair away from my eyes.

'It's Marion,' he said. 'She's — Victor — Victor hit her. She's unconscious and I don't like the look of her at all.'

'He hit her?' I repeated, awake now, still uncomprehending.

'Yes,' he said, his eyes wide. 'With your fossil bone —'

Within twenty minutes we were in the Land Rover, Orde driving, me sitting beside Marion where she lay stretched out on the rear seat. Orde had bound her head and blood showed through the folds of the white gauze bandage. Her eyes were half open and her breathing came shallow and fast. Her forehead was cold. I held her hand and wiped her forehead and watched the rock-strewn road ahead. It was nearly eight and the sun was well up when we turned into the sandy drive that led to the whitewashed Catholic Mission at Maleleji and Marion was still unconscious. Orde found a nun and spoke to her in Gabbra. He filled in forms and she called Emergency.

161

A trolley appeared wheeled by a grinning male nurse who wore a Superman T-shirt.

We laid Marion gently on the trolley and followed Superman down an echoing white corridor. He parked the trolley in an arched passageway at the end of a long ward filled with beds. Somewhere out of sight a woman screamed once, a long wail of pain. I stared about. Bedpans, catheters, bustling nuns. A sister carrying a clipboard hung a bottle of saline on the trolley's stand and found a vein in Marion's wrist. I watched her eyelids flutter and held her hand, standing sweating with fear under the cool whitewashed arches. I stared at a wooden crucifix hung on the wall. The nun clipped on a stethoscope and listened to Marion's heart and looked at a watch and avoided my eyes. Blood had drenched the bandages around her head. Her breathing had become laboured.

'Can't you do something?' I said. 'She's going to die.' The nun stared at me with calm eyes. 'Please,' I said. 'Please do something.'

Orde patted my back and spoke to the nun in Gabbra and she replied at length.

'She says the doctor's coming.'

He lit a cigarette and smoked until a passing sister told him brusquely not to and he slipped out through a tall wooden door into a courtyard where frail patients in worn dressing gowns coughed drily and spat into the dust and a tall palm held out wild orange clusters of young dates roof-high to the sun. I held Marion's hand: her palm was as dry as paper. Her fingers were cold. The blood that seeped through her bandages had coalesced into seas of haemorrhaging. As I watched, the pupil of her right eye slowly grew in size until her blue iris was erased and appeared totally black. I called Orde in a panic. 'Look,' I said. 'Look at her eyes. Oh, sweet Jesus. Orde — please do something!'

A young doctor with fresh blood on his green operating smock walked briskly towards us, glanced once at Marion, gave quick

orders in German. Five rustling nuns wheeled Marion away and he waved aside my questions, saying, 'Later! Later!' They disappeared through two worn wooden bump doors at the end of the passage and I looked at the pale knotted mosquito nets hung like disembowelled cadavers above each bed in the long white ward and felt entirely alone and without hope.

Orde took me gently by the arm and led me through to the entrance hall. There we sat on hard wooden benches and stared out at the day that had become suddenly very bright. A sharp rim of light edged everything I saw: the lurid painting of Jesus in pinks and acid greens that hung on the wall; the nuns who hurried silently past, heads bent; the bench, the floor, even the dusty palm that stood outside wilting in the heat. Orde found a tea urn and brought me a cup but I couldn't drink it. Each time a nun or doctor walked past I looked up but no one stopped.

Finally Orde said, 'Look, I probably shouldn't be saying this, but I understand about you and Marion. Better than you think.'

I looked at him, kissed him on the cheek. 'I know you do,' I said. 'What are we going to do about Victor?'

He sighed, lit a cigarette. 'I don't know. Honestly, I don't know.'

When Chinta had woken me, we'd run to Victor's tent, the lantern light swaying ahead of us. Victor was standing rigid inside the tent, hands pressed tight against his mouth, making a thin keening sound, staring with wide eyes at Marion. Marion lay on the tarpaulin floor, blood in a wide dark pool at her head. The fossil femur, matted with blonde hair and skin, lay beside her.

I shook Victor, but his eyes were fixed and staring.

'Wash that,' I said to Chinta, pointing at the femur. 'And put it away in the tent. And look after Victor.' Then we carried Marion to the Land Rover. As we drove away I could still hear Victor's crying. What to do?

'Look,' said Orde. 'I'm going into town to get some supplies. Why don't you come? We can't do anything here.'

'No; thanks, Orde. I'd rather stay.'

While he was gone Chinta drove up in the other Land Rover and ran into the entrance hall and stopped when he saw me.

'Is she OK?'

I told him what I knew and we sat side by side on the bench and he drank my cold tea to get the dust out of his throat.

'I brought you some clothes and things,' he said.

'Thanks. What's Victor doing?' I asked.

'Sitting in his tent and crying. What d'you think we should do?'

'Nothing.'

He looked at me.

'Nothing. We don't want a lot of policemen and newshounds all over the dig. If Marion pulls through, we'll say nothing. If she dies; well, that's a different thing. Give me a cigarette.'

'You don't smoke.'

'I know.'

★

At three Orde returned and shortly after the young German doctor appeared. The blood on his smock had dried to a rusty black. He looked tired.

'What relation are you to the patient?' he asked.

'Friends.'

'Did any of you see what happened?'

'She fell,' I said.

The doctor hung his head thoughtfully on one side and said: 'If I were to write a report I would say that the lines of fracture leading from the points of impact suggest that she was struck at least twice with a double headed bludgeon.'

'Struck?' I said.

'Yes. Struck.' He watched us. When we stared back in silence he said: 'Well, she is lucky. There are depressed fractures but there is minimal subdural haemorrhage.'

'In English?'

'There's very little bleeding between the brain and her skull to exert pressure. She is badly concussed. Who knows? I have stabilised her, and given her a transfusion to counteract the blood loss and she is on a respirator now.'

'Will she live?' I asked.

He shrugged. 'There is no reason why not.'

'AIDS from the blood?' asked Chinta.

He shook his head. 'All screened.'

'Where is she? Can we see her?'

'Of course. But she is unconscious.'

We followed him to the ward and stood and looked down at Marion and were silent. The long blonde hair that escaped her bandage was matted with dried blood. After discussion, Chinta and Orde left me a Land Rover and drove back to the site. It made sense. Chinta was much more experienced than me at fieldwork and the dig needed a leader. I was a visitor; although I'd found the kudu femur I was dispensable. They promised to look after Quasimodo and to send me books and more clothes and my toiletries.

Marion lay in a bed in a small room that contained three other patients. The beds were screened by curtains. To save electricity the room was lit at night by oil lamps that tinted the walls the pale caramel of desert sand. The thick blue plastic respirator tube filled her mouth. The hiss of air was faintly audible as it oxygenated her lungs. She was quiet, deathly still. Her soul was attached lightly to her body.

The cardiac monitor traced the pattern of her heartbeat. The red digital lights settled steadily on seventy-two and I held her hand and gazed at the saline drip and plastic bags of the catheter bottles and willed her to live. Every hour a nun came past and noted details on a clipboard, smiled indifferently at me and left. Through the open door of the nurses' room I could see a television set. The sound was turned down and the sisters were watching a news programme. I saw blurred images of what looked like a street war in Bosnia. Shellfire exploded soundlessly amongst tall seventeenth century buildings. Walls tumbled. Then I saw the aftermath of an execution in central America: sagging blindfolded bodies tied to bullet-splintered poles somewhere on a beach amongst nodding palms. A dog sniffed at the bodies. I looked away.

I stayed at Marion's bedside until midnight, then went to the safari lodge, checked in and slept.

TWENTY

I settled into a routine: breakfast early, a stroll round the gardens of the lodge, short drive to the Mission, a lone vigil by Marion's bed holding her hand. The flashing lights of the monitor, the gaseous hiss of the respirator were my world now. Often I stared out through the long windows at the sun. One day an old man in a threadbare dressing gown and pink pyjamas struggled past using a walking frame, his face contorted with effort.

That same day I saw a child of three or four running with typically wobbly gait after a small kitten. The gardens of the Mission were full of wary stray cats but this kitten was tame and scampered playfully just ahead of the child's outstretched hands. Finally the kitten tired and rolled onto its back in the sunlight. The child caught it and hugged it tight to its chest and ran back towards me. The kitten writhed slightly to get away and to my horror I saw a strange vengeful look come into the child's eyes. It took the kitten by the neck with both hands, held it outstretched at shoulder height and squeezed. The kitten bucked and tried to kick free with taloned hind feet but the child smiled and squeezed harder, a mindless look of delight on its face.

I banged on the window. Startled, the child turned to me. 'Put the cat down!' I shouted. 'Now!' My meaning was clear, despite the language barrier. The child bent and laid the kitten down on the ground and ran away. The kitten wobbled to its feet and walked unsteadily into the shrubbery. I turned away. I shall never forget the look of perverted power on that child's face.

Chinta drove in for a night bringing more clothes, my books and news of the dig. He took one look at Marion and rousted the young

doctor — whose name was Ludovic — out of his bare office and shouted at him but got no new answers. We spent a hilarious evening together at the lodge: dinner with good wine, lots of nervous laughter and camaraderie. After dinner we walked round the gardens of the lodge before turning in. The sky was clear, stars multitudinous and crisp.

'How's Quasimodo?' I asked. 'I miss her.'

'That goat. It's fine. It keeps chasing Orde. It's started crapping on Victor's boots, too.'

'And how is Victor,' I said, 'other than his boots?'

'He's such a stupid bastard,' said Chinta mildly. 'He doesn't understand anything. He wanted to see Marion until I explained she was still unconscious and we'd wait until she decided whether or not she wanted to see him. Then he lost interest. It's almost as if he didn't really care for her at all. I think he smacked her on the head from vanity, not jealousy. And I think he wanted to visit her for show, not because he cares. He's a fuckwit. Maybe we should just turn him over to the police and let him hang.'

'They don't hang people any more,' I said. 'And anyway, I'd rather have something on him and protect the dig than have a lot of police tramping all over the site, crushing fossils with their great big boots. Has he been drinking?'

'No more than usual. But he's such a stupid bastard. How could he do such a thing? And yet — can you believe it? — I feel guilty just leaving him in camp like that. He's moved out of their tent and pitched one of his own on the far side of camp. And he's talking to himself now, more and more. And what if Marion dies?'

'I'm sure she'll be fine,' I said and Chinta looked sharply at me.

'You can't know.'

'True. How's the dig?'

He shrugged. 'Lots of pigs, lots of baboons, elephants by the ton but no hominids.'

He left early next morning. As he kissed me goodbye he smiled wryly and said, 'Come back soon, we have need of thee!'

★

At first I sat in silence by Marion's bed and watched the nurses' daily regimen of temperature taking and catheter checking. One day Ludovic appeared abruptly in the doorway and said: 'I can't afford to have an able bodied young woman sitting here and not working. Come with me . . . come with me!'

Against my will he set me to work under the guidance of a German sister called Gudrun who had two pert dimples and a pair of bright naughty eyes. She taught me to give injections, to take blood samples without causing pain, even to suppress the queasy feeling of incipient nausea and insert a butterfly drip into the thin veins of nervous patients. The hospital was overcrowded. Patients slept on the hard floor, wrapped in their own blankets. Beds carried two patients, toe-to-nose. There were not enough drugs; bandages were washed and re-used. The suffering was awful. At night when I walked the long wards lit dully by oil lamp light, the encumbered moaned in their sleep, tormented by pain even through the barrier of painkillers.

I emptied bedpans, bandaged spear wounds, disinfected weeping body ulcers and cried unconsolably when a small boy I'd been nursing died while I held his hand. He'd been brought to the Mission by his withdrawn uncomprehending mother who irritated me because she was so cravenly grateful. I wanted to say: It is your right to fight for your child's life, to rail against his going; but, of course, I said nothing. The boy, Karenge, was perhaps seven years old and was suffering from a high fever. He had a dry mouth and bright staring black eyes. Despite endless tests we could not discover the cause of his fever and he slipped quietly away into death while I watched. When I told his mother through a translator that her son

was dead, she stared at me without expression then simply turned on her heel and walked back into the desert.

That night Doc Ludovic was on duty and asked me into his cluttered little cell of an office for a drink. An oil lamp burned, its brimstone light flickering over white plastered walls. Ludovic handed me a toothglass of Teacher's whisky, poured himself a small tot and raised his own glass ironically to me.

'Florence Nightingale,' he said softly and drank. 'You are upset about the boy?'

'Yes.'

He nodded. 'The holy sister Gudrun told me.'

'You don't like the nuns?'

He shook his head. 'It's not that, not the religion in itself. It's that the religion makes them unable to suffer. The nuns have God; the dying have nothing. Do you follow?'

'He was too young to be so hopeless,' I said. 'I think that's what hurts most. He didn't expect to live. He didn't think he was important enough to live. He couldn't imagine it was part of his future to live.'

Ludovic nodded. 'The first war killed twenty-five million people in five years. A tragedy. But the influenza epidemic that followed killed twenty-five million in five months. A disaster?' He smiled at me. 'Perhaps. But I wonder, sometimes. The urban population of Africa in the next thirteen years will be about three hundred and sixty-one million people. A growth of three hundred and forty-seven per cent. How can any government plan for that? In Europe? Never! In Africa? Please!' He enumerated on his fingers: 'Sewage, health care, food, water, housing. There's no hope. So death is welcome, in the abstract. And each time a patient here dies, I think: another removed from the breeding cycle; six children, thirty-six grandchildren, one-hundred-and-fifty great-grandchildren... and so on. But I am a

healer, am I not? I didn't become a doctor to make money, idealist that I am. I came here to serve my fellow people, suffering humanity.' He paused, poured another small drink, held up the bottle of Teacher's questioningly towards me. I shook my head. 'So I continue to save lives — individual lives — for selfish reasons. To fulfil my destiny,' he said self-mockingly. 'To continue my love affair with myself which is based on the assumption that I am a healer.' He laughed, shook his head.

'What made you choose medicine?'

'I am a German. My grandfather was a doctor and died on the Eastern front, fighting Russians. My mother was raped by Russian soldiers in Berlin when she was fifteen and a virgin. She never talked of it; she worked in a brothel for Allied soldiers till she was eighteen. She became a proctologist specialising in prostate problems.' He smiled bleakly: 'Revenge, perhaps? My father's mother was Jewish; she survived Treblinka but could not talk of it. My father was a doctor in Dresden; he lost all his family when the Allies bombed it into rubble.' He smiled at me. 'Violence and decreation, yes?' I nodded.

'So, I am a doctor.' He poured me another drink, handed the glass to me. 'Death passes through here daily, Kathryn. I welcome it when I feel pessimistic, decry it when I think of Germany and the war. All wars. And, naturally, selfishly, when I think how long it took me to become a doctor.' He smiled at me. 'None of which helps you about the little boy who died.'

'No,' I said. 'But nothing will, anyway.'

<p style="text-align:center">★</p>

When I was not on duty I passed the time sitting by Marion's bed and read Oriana Talmadge's manuscript and Patterson's book and watched the procession of nightmare images of death on the silent television newscasts. One night I saw smuggled footage of a political execution somewhere in Africa. The newly ousted government

ministers stood in a downcast row, their expensive suits torn and matted with blood and mud. In a clearing ringed by banana palms stood grinning members of the new People's Revolutionary Army for Liberation, all holding AK-47s. The ministers were executed very simply: a burlap sack was placed over the head of each, tied tight with string. The condemned man was persuaded to kneel with deft prods of a bayonet and a burly soldier with sergeant's stripes then beat in his head with a pickaxe handle. As I stared at this, one of the waiting ministers fainted. The soldier beside him laughed. A subtitle said in English: 'The People's Revolutionary Army say this is Humane Execution for Respected Enemies of the State.'

★

As the bright sunlight crept up the walls of Marion's room and the mustard and daffodil shadows followed each late afternoon, I left the here and now and inhabited Patterson's universe.

I saw through his eyes how 'Mrs B', as he called Janey, 'bowled over' an impala with one shot; how the two of them rode out together ahead of the safari and had tea under an ancient acacia; how Patterson nursed his lover through an acute attack of fever and treated her by feeding her 'copious draughts of very hot tea on top of phenascetin'; and from his poignant account learnt how his dog Lurcher 'brought on an attack of pneumonia by getting overheated while galloping about...' and then 'lying down in the cold water of the river...' Patterson did everything he could to save his little dog but the poor creature died and Patterson buried him 'under a palm tree not far from my tent... and missed him for many a day afterward...'

I read on and found the moment when Patterson sensed he was embarked on more than a simple safari through the here and now; the instant he realised that chthonic forces were at work. Dimly he had come to see that he lived in two parallel universes, one filled with people, places and things; the other a bloodless, impalpable nowhere driven by a dance of electromagnetic fields where good and evil, up and down, here and now ceased to have meaning. He was

adrift. This was the land of magic, where only the witchdoctor held hegemony; the land where initiates could tamper with past and future, life and death. Frederick Jackson's meddling was taking control.

It happened like this: Patterson had been told that north of the Guaso Nyiro, between Kampi ya Nyama Yangu and Marsabit, there was no water. The territory was uncharted. Patterson was entering the unknown. True, the adventurers of the newly formed Boma Trading Company travelled to the very north of Kenya to buy horses in Abyssinia and it was Jack Riddell, one of their partners, who had told Patterson that water was scarce. No rivers, no tributaries, swamps or seasonal pools; no waterholes dirtied with mud and droppings where game warily drank, no water at all.

Conversely, Sir Frederick Jackson had told him that here 'was a veritable land of promise...': verdant, lush, a land running with streams and waterfalls. Patterson had based his plans for the trip on Jackson's advice; he had no reason to doubt its validity. But now his intuition and experience told him that ahead lay a piece of country very different from that described by the smiling Jackson over tea at Government House. Determined to discover the truth, Patterson resolved to climb a nearby mountain called Quaithego and gaze north from its vantage point that rose dark and craggy three thousand seven hundred feet into the empty sky.

... The winds blow cool here at this height, thought Patterson. He stood at the summit of Mount Quaithego, his men silent about him, and gazed northwards to Marsabit.

There before him stretched the most godforsaken land he had ever seen. To his right the Guaso Nyiro river wound slow and khaki behind his back and lost itself in the reedy mess of the Lorian swamp. Ahead of him lay a wasteland: stone, rocks, thornscrub, dust. Peak after peak of rugged mountains stretched away to the horizon and shivered in the heat haze that rose already from the barren rock. Desolation and lizards; dry stone and thorn. Red land.

A land of fire. Snakes, and birds of prey flying high in the sun. But no water. Patterson felt his spirit fail.

'Papai,' he said to his Samburu guide, 'is there water?'

The man shook his head. 'Not here, bwana.' He pointed with his spear. 'There, bwana, beyond the mountains, is water. It is hard from here from Guaso Nyiro to Serah, a long walk, no water. We must use camels here. Also, there further in Kaisoot, the desert, no water. Bad land, bwana. Bad land.' He shook his head and spat for luck. The men behind him murmured softly.

'Yes,' said Patterson slowly. 'Bad land.' He turned to his headman. 'Munyakai, have the men build a stone beacon here at the summit. Stone on stone till it is so high...' Patterson left the men, walked a little way and sat on a rock that was already hot from the relentless sun and looked northwards.

Truly, wrote Patterson in his book, this was no promised land, no country flowing with milk and honey. Why had Jackson told him there was water aplenty? Revenge? Patterson took stock. Five gallon water tins he had, fifty of them, and canvas water bags, but no camels. That could be arranged... But would they get through? So many people relying on him, so many. Audley sick and Janey weak still from fever: Janey.

Janey: was this love? Now, middle-aged and cynical, had he fallen in love with Janey or was this mere lust? He thought not. There was in this union a very ancient imperative, thought Patterson. Not love, more than love. Janey. What they had done, the wickedness of it: her soft cries, her tears. And Audley? What did he think? Had Blyth guessed that while he slept and sweated out his fever in a mist of dreams Patterson was couching his wife? Her legs taut over his shoulders, her mouth wet against his neck. Had he? Patterson gazed northwards and thought, No; we've been too careful.

But that night Janey slipped into his tent late and lay beside him in his camp bed and said softly, 'Patterson. He knows.'

Patterson rose on one elbow in the dark and looked at the paleness of her face and hair. 'How?'

He felt her shrug, sigh. 'He wanted me to sleep with him tonight and I made the usual excuse women make. And he looked at me very strangely, Patterson. He's like a child: he understands things like a child does, quickly, with insight, without knowing why. He just knows. And he said, Ah! Just Ah! And he looked at me and laughed. He knows.'

'We've not been careless,' said Patterson slowly.

'No; but that gunbearer of yours? I don't trust him. I've seen him looking at me in a very strange way. One night I swear he was watching me as I bathed. He may have guessed.'

Patterson lay back. Damn. Damn! He hadn't wanted this. He felt fury rise. Damn these people. He, Patterson, was a loner, not a damned safari guide and wet nurse. Damn them! Janey so reckless, and her stupid husband: always sick, always whining, always losing things and cutting his bloody foot and going down with fever. Damn him.

'What is it?' said Janey.

'Nothing,' said Patterson. 'Nothing.'

'Shall I stay?'

He thought about this, then: 'No, Janey. Not tonight. We mustn't hurt him . . .'

'He's already hurt,' she said. 'He knows. We can't hurt him any more now.'

'Then stay,' said Patterson and felt her small fingers search for him and he closed his eyes and thought, Dear God, I wonder if we shall ever get out of this desert.

Next morning Patterson rose early, put on his colonel's dress uniform and rode out mounted on Aladdin, his white Arab charger. Munyakai bin Dewani and Papai rode with him. They headed in the cool of the morning for the manyatta of Legurchalan, the local Samburu chief, to arrange the hire of camels for the crossing of the Kaisoot desert. Papai rode badly, unaccustomed to the small English saddle; he rode camels, not horses, and camels do not gallop. Munyakai, dressed in flowing Arab robes, his turban wound round with a colourful paggri, bore the safari's Union Jack proudly aloft. These negotiations, thought Patterson, must be accomplished with panache. Damn it, he thought, I've forgotten my bloody sabre.

But the sabre proved unnecessary. Negotiations with Legurchalan proceeded slowly, with much exchange of pleasantries and flowery language and finally it was agreed that Patterson should have four camels in return for six bales of amerikani cloth and seven rolls of soft wire. Back at camp, Patterson supervised the preparations for the coming trek across the waterless emptiness of the desert: water tins filled, spare rope woven from fresh sansevieria, panniers mounted on baggage mules, bearers' loads fairly distributed, tents packed, Jamie's fever treated.

Then, as the sun dropped, they struck northwards into the dry rock wasteland. Patterson's heart felt like a stone.

TWENTY-ONE

As I read on over the following days, I witnessed in his writing Patterson's slow realisation that Jackson had outwitted him.

Two days' hard march across the thornscrub desert had brought the safari to the foothills of a mountain called Laishamunye. Sheer cliffs reared up two thousand feet from a plain of sun-cracked boulders. A dry sand river shone white in the sun where it ran through a narrow gorge. Two dusty doum palms stood tall against the sky. Vultures turned on thermals high up, sailing the desert wind. Here Patterson made camp. They were now, he wrote, 'absolutely in the grip of the nyika...' There was no way out. They could only go through.

Chaotic inside, outwardly calm, Patterson gave orders. The servants pitched tents, lit cook fires. A hyena whooped far away across the desert, fell silent. A jackal called. The sun set and night came down. The air was still and hot. Patterson sat in his old wood and canvas chair outside his tent and watched the flames of his small campfire and drank a whisky and water. Janey was in her tent, bathing. Blyth was sick again, restless in his camp bed, sweating out his recurrent fever. The askaris stood guard.

Patterson tried to clear his mind and take stock. He was, he wrote, in a very 'awkward and unpleasant predicament'. The country was hard, muscled, unyielding. He wanted to go on alone, taking only the fit: Janey, Munyakai and a few bearers. Yet Blyth was too ill to be left alone in a strange country with merely camp servants for company, no doctor and no knowledge of the Africans nor their language. It seemed wisest to carry on slowly to Marsabit where Blyth's health might improve in the cool moist highlands. At

Marsabit there was plenty of water. The country was soft, rounded, gentle.

... There came the cracking thump of a big calibre rifle, a boubou shrike whistle and a chuff of air as the bullet passed close to Patterson's head. He threw himself to the ground. For an instant he was back in the war in South Africa. But this was East Africa. He knelt warily.

'Who's there?' he called. 'Damn you, who's there?' He walked quickly beyond the circle of firelight and found his gunbearer Embu holding a .450 double rifle in his shaking hands. Patterson's own rifle.

Patterson took the rifle, opened the breech. One fired cartridge ejected into the darkness. The other barrel was empty.

'What is the meaning of this?' Patterson said very quietly. 'What are you doing with my rifle?'

'Bwana —'

'Speak to me, Embu, or I'll have you flogged.'

'Accident, bwana; accident!'

'Accident? I have been shot at before. I can tell from the sound of the bullet: you shot at me. Why?'

The gunbearer shook his head, eyes wide with fear, shaking all over.

'No, bwana —'

'Tell me the truth, Embu, or I swear I'll beat you myself.'

'Accident, bwana. Accident! The bullet she slip in, I not know how, I look at fiveohclock, it empty, bwana. No, I don't shoot bwana. Never.'

'No? Then why did you point the rifle at me and pull the trigger? Speak to me!' But the gunbearer simply shook his head and shivered and opened his mouth but no sound came. 'Why?'

'Witchcrafti, bwana! It is witchcrafti!'

Patterson stared at him for a moment then turned away and called, 'Munyakai!'

The headman ran up. 'Bwana?'

'Take Embu and flog him.'

'Yes, bwana.' He took Embu unquestioningly by the arm.

'And Munyakai: flog him hard. He tried to shoot me.'

Munyakai's eyes opened wide and he spat on the ground at Embu's feet, cuffed him hard on the back of the head and led him away.

'And search his tent,' called Patterson on an impulse.

He walked slowly back to the fire and propped his rifle carefully against the arm of the camp chair and searched the ground for the ejected cartridge, found it in the sand, stared at it. Then he went to his tent and poured another whisky and water. Taking two rounds from the flat yellow pack of Jeffery Express cartridges he went back outside, loaded the rifle and sat with it across his thighs. He gazed thoughtfully at the fire. There was only one explanation, there could be only one explanation, and it was not witchcraft. When Munyakai walked up and said softly, 'Bwana, I find this in the tent of Embu...' and handed Patterson fifty pounds sterling in crumpled notes, Patterson felt his heart contract. He stared at the money.

'Patterson sahib,' said Munyakai.

'Yes, my friend?'

'Embu swore to me that he did not know the rifle was loaded. I believe him.'

Patterson turned and stared at his headman. 'You believe him?'

'Yes. He swore to me that it was witchcraft. He says all the porters know you have been cursed, all the askaris, too.'

'Cursed? By whom?'

Munyakai shrugged. 'Embu would not say.'

'Would not or could not?'

Munyakai shook his head. 'No. I believe he knows. I believe they all know.'

Patterson pondered this. Then: 'What do you think, my friend?'

Munyakai was still, then said: 'I do not think Embu was lying. I think he believes in his heart that you — and therefore the whole safari — have been cursed. He says that is why we wander lost in the desert.'

Patterson stared at him, said: 'Thank you, Munyakai,' very softly and turned back to his fire.

<p style="text-align:center">★</p>

Later, when the night had turned cold and the fire had burnt down to white ash, he heard Embu's first screams as the headman wielded the rhino-hide kiboko and the whip bit into the gunbearer's back. He drank another whisky then went to his tent and climbed into his bed and lay on his back and listened for Janey's footsteps but she did not come. The hyenas called closer and closer and a wind came up in the night and rustled the tent flaps. Patterson listened for a long time to the night then turned over and thought about the desert waiting for him up ahead. Tomorrow, he thought, we march to Serah across the desert. God help us if we are cursed.

Then he slept.

TWENTY-TWO

Marion woke from her coma at dusk thirteen days after she'd been struck. I was standing looking out through the tall doors that gave onto a well tended garden thick with subtropical shrubs. Bats were starting to flicker and dart amongst the palms.

I turned back to Marion, thinking how much I wanted to eat a hamburger. I noticed that the cardiac monitor registered a higher pulse rate than before — eighty-four — and looked at Marion as her eyes opened. She turned to me and said very softly, 'What are you doing in my tent?'

I stared at her.

'Kathryn,' she said. 'What are you doing in my tent?'

'Looking after you, idiot. How do you feel?'

'Sort of fuzzy. And thirsty.' She looked around, said indignantly: 'This isn't my tent. Where am I?'

'In the hospital at Maleleji.'

She stared up at me, said softly: 'Oh, yes. I remember now.' She closed her eyes and felt for my hand. 'Please stay by me . . .'

'Yes.'

I rang the bell. The sun had gone down. Marion snored softly. I freed my hand from hers and walked over to the window and stared at the palm trees and breathed in deeply. There was a scent on the air; but whether blossom or perfume or fleshly decay I could not say.

★

181

The following day we first met Sister Mary.

It was morning and Marion was cheerful but weak. Despite the protestations of the French and German sisters, she insisted on smoking her Turkish cigarettes in bed and with much tut-tutting over the indulgence and irregularity she was given an electric fan to dissipate the smoke. Her scars were healing well, though still pink and shiny. Doc Ludovic assured her that his stitches were the 'most delicate conceivable' and would heal invisibly. At times she would stare with unfocused eyes out to the garden with its date palm; unsmiling, silent, withdrawn. I feared these silences and sat by her bed and regaled her with camp gossip and stories about the hotel, Chinta's obvious affection for her, the list of the fossil finds made since her coma. I did not mention Victor, nor did she. Perhaps in retrospect I should have seen that these silences presaged a change in her affections; perhaps I should have sensed that our love was at an end, that being so close to death had changed her forever. But I didn't. I expected us simply to continue loving each other as we had before. I think I even hoped she might now leave Victor so that our love could be open and honest. So silly.

On the morning of our first meeting Sister Mary, the sisters had brought tea and were bustling about: emptying bedpans, taking temperatures, checking monitors, cajoling reluctant patients to take their pills. The tall windows were thrown open, the morning sun blinding on the white curtains.

I was looking out through the windows and saw Mary before the others did. I watched her: a small hunched figure walking through the garden: hair cropped short like a convict's, a forgotten cigarette, an absentminded walk, head bowed, a posture of total and utter exhaustion. She was wearing an ill-fitting black calico shift like a long nightdress. I thought for one moment she must have escaped from some well concealed ward reserved for the criminally insane. She stared up at the sky, her face blank, watched swifts swoop and dive.

There was about her an air of hopelessness, of failure, that was very compelling. Marion fell silent, watching her. The bustling sisters had stopped to watch her too.

'What a very strange looking woman,' said Marion. 'Go and see, I think she's lost.' She touched my arm. 'Go, Kathryn.'

If I could have known, would I have gone? Still, I went, reluctantly, their eyes on me. I felt I was intruding on some private ritual of absolution or self-reproach. As I walked up to her, she turned to look at me but watched me without interest. I saw her eyes flicker to my leg, register my walking stick, return to my face.

'Yes?'

'I'm sorry to intrude, but my friend and I thought you might be lost.'

'Lost?' She looked at me.

'Lost.'

'No, I'm not lost,' she said at last. 'I'm walking in the garden.'

'Then I'll leave you,' I said. 'I'm sorry if I disturbed you.'

'What friend?' she said as I turned away.

'I'm sorry?'

'You said you had a friend.'

'In that ward there.' I pointed.

'In the ward? Sick?'

'She fell and banged her head. She's better now. Nearly.'

'Can I see her?'

'Of course. My name is Kathryn,' I said.

'I'm Sister Mary,' she said and shrugged. 'At least, that's what they call me.' We shook hands. I felt her palm rough in mine, looked down and saw her nails were broken, fingers scratched.

I led her back to the ward, introduced her to Marion who watched her carefully. She sat beside Marion, leant forward smiling very gently and said: 'I believe you've had a bang on the head. Were you in great pain?'

'Only at first,' said Marion, surprisingly meek. 'Then I don't remember anything at all.'

Mary leant forward. 'When the pain was at its worst, did you want to die?'

Marion stared at her. 'What a funny question. I don't know. Perhaps.'

'Were you glad to pass out? To be gone? For the pain to be gone?'

'Yes. But I don't remember anything, really, except terrible dreams.'

'Dreams?' Mary said sharply. 'What dreams?'

'I don't want to talk about them,' said Marion firmly.

'Of course not,' said Mary, and smiled. 'Thank you for chatting to me. May I come and see you again?'

'Of course.'

She smiled vaguely at us and walked back outdoors and resumed her slow patrol of the garden, head bent, newly lit cigarette forgotten between her fingers.

'What a funny woman,' said Marion, lighting a cigarette.

'Complètement fou,' said a passing sister. She had formidable feet and wore black leather sandals from which protruded pale competent-looking toes. Her calves were muscled and hairy. 'Marie? Fou ... Mais complètement!'

'What did she say?' I asked.

'Mary's completely crazy,' replied Marion. She called the sister back and they spoke together in French. The sister gestured extravagantly with a full bedpan.

'Well?' I said.

'Apparently she's been working in Ethiopia. They don't know much more than that. She appeared one day at the Mission in a clapped out Land Rover, wrapped in a blanket, shivering with fever. She won't speak to anyone, spends her time wandering around in the garden talking to herself about Job.'

'Job? Old Testament Job?'

'Yes. They swear she's crazy. She's been here for weeks. They thought she'd been raped by shifta at first, but Doc Ludovic says not.'

I looked out of the window. Mary was standing in the garden staring intently up at a flock of darting palm swifts. They spun and dived around a tall palm that held out dense clusters of vibrant yellow dates as if they were burnt offerings to the sun.

★

That day marked the end of the integrity of our love.

I'd decided to wait until I thought Marion was strong enough before I questioned her about Victor's attack. I felt guilty, personally responsible. I suspect I wanted Marion to absolve me.

When I said to her one day, tentatively, 'Do you remember what happened?' she simply shook her head abruptly and said, 'I don't want to talk about it.'

'But what are you going to do about Victor? You can't just carry on as before.'

She lit a cigarette, glanced at me quickly. 'No, I suppose not.'

'What are you going to do?'

'I don't know,' she replied. 'And I don't want to talk about it.'

'Will you leave him?' I said.

She glanced shrewdly at me and said: 'What? And marry you?'

That night another act of separation took place and still I didn't understand. Even now I go hot with embarrassment when I remember. Marion's room was quiet. I held her hand as she lay staring up at the ceiling. She was naked under the thin sheet and I leant over and kissed her on the mouth and rested my hand on her breast. But she did not respond as before: she twisted her mouth away from mine and pushed my hand away.

'Marion —' I said, surprised.

She stared at me with wide eyes. 'Please,' she said. 'Don't ever touch me unless I ask you to. Please.'

'Of course,' I said. 'I'm sorry.'

'You must go now,' she said.

'Of course.'

★

I know. I should have recognised the signs but I didn't. My only defence is that used by jilted lovers through all time: I loved her so much I thought I could make her love me still. I had no idea that she'd changed, that Sister Mary had already begun to magic her away.

Marion had begun to take long walks with Sister Mary. At first I'd walked with them, enjoying the sun and the gardens of the Mission, but in time it became clear that Marion did not want me there. This hurt: I felt excluded and unloved but decided that Marion needed a

stranger to talk to, someone who would listen without prejudice to her story.

It shames me to admit this; but one evening I followed them in a controlled jealous fury as they walked to an enclave in the vast Mission gardens where they were hidden from prying eyes by the dense shrubbery. Sister Mary was carrying a kikapu, a large shopping basket made from woven palm fronds.

They sat together on the grass and I watched from my hiding place as Sister Mary produced a black lace mantilla and a grass mat from her bag. She draped the mantilla over Marion's face and reached into her bag and produced a carved ivory fetish about twelve inches high. This she placed on the grass mat. As I watched, she began to chant in a strange high-pitched voice. It was an eerie little hymn; the sort of mad keening you'd expect from a deranged child as it disembowelled a kicking frog: abrupt changes of rhythm and pitch, a tuneless nasal pagan humming. To my astonishment Mary bowed down towards the idol as if in supplication. Marion knelt beside her and they bowed in unison like Muslims paying homage to Mecca. I turned and walked away and did not sleep that night with worry.

I knew I had to do something to save Marion; but I knew also that it would not be easy. It took great discipline but for a week I sat alone in a small arbour of palms each morning and watched the swifts and waited for Marion to be done with her lengthy confessions and mad little masses. At that time I still believed her dependence on Sister Mary would be temporary.

One morning I woke with that feeling of tearfulness, of unplaceable tension, of meaninglessness that I never recognise as heralding the onset of my period and committed a foolishness that hurt me for months to come. Impatient, angry, resentful, all too human, I decided to question Marion early, before Sister Mary appeared as she did every day at ten. We were drinking coffee together in the sunlit arbour. Yellow weavers with black heads busily stripped palm fronds to build their nests and I watched them as I said to Marion: 'I'm sorry about what happened in your room that night.'

'Don't be silly. It's over.'

'What's over?'

'That. It happened; leave it, for God's sake.'

'I wanted you to know that I still love you and if there's anything I can do —'

'Thank you.'

After a long silence I said: 'Marion, I've got to go back to the dig soon. I'd like you to come with me. But first I need to know what happened between you and Victor.'

She was silent for so long I looked at her to see if she'd heard. 'I said —'

'I heard what you said,' she murmured, watching the weaverbirds. 'And I don't want to talk about it.'

'But Marion —'

'I said I don't want to talk about it.'

'Marion; I can help you.'

She turned to me. 'Why won't you listen to me? I told you I don't want to talk about it. I most certainly don't want to talk about it to you. It's not your business.'

'But I'm worried about you. I'm worried about Sister Mary —'

'What about Sister Mary?' she said and in her eyes I saw a look of such fury I felt inexplicably afraid.

'I'm just worried. All that silly chanting —'

'It's not silly and you've been spying on me. How dare you. Leave me alone. You're always hanging around, spying on me. Leave me alone, just go away and leave me alone!'

I stared at her. She looked away, lit a cigarette, blew smoke towards the homemaking weavers. Again — wrongly — I decided that she deserved honesty.

'Marion,' I said, 'I still love you.'

She turned to me, a half-smile on her face and said: 'Well, that's bad luck for you, isn't it?'

I watched her.

'Isn't it?' she said again.

'Why?'

She looked at me with the cunning triumph of a child and said: 'Because Sister Mary loves me, not you. And I love her, not you. So there.'

I looked at her, saw a combination of conscious cruelty and infantile triumph in her eyes before they slid away from mine and focused on something behind my back with a look of pure delight. I turned and saw Sister Mary walking briskly towards us through the Mission gardens, her eyes fixed on us as if she could detect even at that distance the chaos that surrounded us. I stood.

'Are you going?' said Marion. I nodded. 'Good. Good. Go. Go soon. And don't come back. You're not wanted here, can't you see? Can't you see? We don't want you here.'

I turned and walked away. The pain was so intense I felt I could not see where I was walking.

★

I fought to be calm. I packed my bags, sought out Doc Ludovic and thanked him. He refused any payment, so I gave him a cheque as a donation, took the X-rays I'd asked for, thanked the sisters and went out into the mid-morning heat to check the Land Rover's oil and water. As I raised the bonnet I saw a movement in the shrubbery

189

and was disconcerted to see Marion crouched on all fours watching me from behind a straggling bush covered with bilious yellow blossoms. She was clearly more deranged than I'd thought. I felt hollow inside. Sister Mary stood beside her, arms behind her back, staring. There was a minute Lamian smile on her face. It looked almost as if Sister Mary had collared Marion on a dog's leash. I closed the bonnet and started the Land Rover and drove away without looking back, feeling as if I'd been told that a child I'd known and loved had just been killed.

<p style="text-align:center">★</p>

I drove blindly into Maleleji, shopped for vegetables, salad and fruit in the rowdy, noisome market, automatically packed the Land Rover, drove southwards into the wasteland. The road unfolded in front of the Land Rover's speeding bonnet and I refused to cry. The pain was intense; and I knew it would never lessen, ever, but merely retreat a little beneath the rim of memory.

I had learnt how to deal with pain before. The deeper I penetrated into the stony wasteland, the harder it was for me not to cry and I realised with a sudden jolt that the desert stillness reminded me of that time in my childhood just after my parents had separated for the first time. Theirs was not a happy marriage; I was just fourteen and this trial was the first of many attempts they made to live apart. I remembered the darkened rooms, my mother lying weeping histrionically in her bedroom, immobile and beyond all comfort. I had learnt to be alone then. I had learnt to find a quiet inviolable centre inside myself that no one could reach, where no one could touch me or hurt me. I needed that now.

I recalled my mother's wild attempts to tame me into an imitation of herself: wasted, driven, frustrated, bitter. On days when her guilt and self-hatred were at their worst and neither chocolates nor novels nor her blue silk shawl could stop her shrieking abuse at me, I would flee the dark clock-infested confines of our house in Santa Cruz and take my cello with me. My father had made me a small trailer for my cello that held it firm and safe and I would ride my bicycle and

trailer in concentrated fury to the tall planting of casuarinas that broke the back of the trade winds that came in off the sea from India.

Here in the desert I felt again the sudden calmness I'd first known when I played my Bach suites in amongst the casuarinas that swayed kelp-like in the wind, the notes fleeing between the trees. Later, my centre inviolate again, I would lie back on the spiced pine-needle carpet under the trees and stare up through the dark branches to the summer sky that showed hot baked indigo between the treetops. I had learnt then how to be alone; because of my leg I had been alone much of my adult life; I could surely, I thought, learn to be alone again. Surely I could learn not to love Marion...

I drove into the campsite just after lunch. Chinta, Orde and Victor were still sitting at the long table in the shade of the thatched dining area. Quasimodo was lying in wait for Orde outside. Chinta threw his hat in the air, Orde smiled his absentminded smile and hugged me and Victor looked as if he'd just eaten a dubious oyster. Quasimodo danced a dainty black-hoofed jig and bleated softly and butted me. I sat down. Chinta and Orde both started talking at once: How's Marion, how was the drive, why didn't you let us know you were coming, you should see the primate fossils we've found...

'No hominids?'

'None,' said Chinta and sat down at the table and began to peel a banana. 'Everything but. The site where you found the femur —' a small glance at Victor — 'there's nothing else there at all. Nothing.'

I could feel Victor staring at me. Orde glanced at him, glanced at Chinta and said: 'Ray, won't you give me a hand with my Land Rover? I need a pair of young eyes to help me change a fuse.'

'What? Oh, sure,' said Chinta. To me: 'Maybe we can take a walk round the site when it's cooler?'

'Of course.'

Victor waited for them to leave, turned to me and said: 'I'd like to thank you for what you did.'

'What, Victor? What did I do?'

'You covered for me.'

I looked at him. All the suppressed anger I'd felt over the weeks, all my unspent tears over Marion, all the controlled fury welled up suddenly in my throat. I felt the first rush of tears pass, controlled myself and said: 'I didn't do it for you, Victor. I don't care enough about you. I did it for the dig.'

He stared at me, mouth working like a child's, chin shivering with his need to cry, eyes hot with imminent tears. He'd expected forgiveness; he'd hoped for compassion. I watched him and could feel no gentleness, no compassion at all. I simply watched him. 'God,' he said, and stared at me disbelievingly. 'God, you're cruel! How could you do with Marion what she and I did? How could you do it with her so the whole camp could hear? How could you do that and expect me to do nothing in return? You've got no shame, no shame at all! How could you?'

I watched him and said nothing. Perhaps I should have told him I knew exactly how he felt; that Marion had just done the same thing to me.

'Oh, God!' he said again, and hung his head. He made a muted snuffling noise, like a bulldog inhaling. I turned and walked away to my tent and decided that I didn't like myself at all. Not at all.

★

Later, when the dunes were long-shadowed and blue, I walked to the femur site with Chinta. We stood and stared at the debris of excavation: the tall heaps of sifted dirt, the sieves lying still and

192

abandoned, the trowels and brooms and shovels, the footprints of the workers. Chinta shook his head.

'I can't understand it,' he said. 'The femur was lying there — ' he pointed — 'and yet there's nothing else here. Nothing.' He sighed, sifted a fistful of sand through his fingers. I tried to imagine what had happened. An arcing descent, a cry of pain: did the little hominid just drop the club? An idea — no, less than an idea: a faint hint, a lost memory — tantalised just beyond consciousness.

'How's Marion?' said Chinta suddenly. 'I thought she'd come back with you.'

'So did I,' I said, trying to sound casual. 'But she's found a new friend at the Mission.'

He looked at me. 'A new friend?'

'Yes.'

'Who?'

'A woman called Sister Mary. Some kind of a lay preacher or nun, I'm not sure. We met her at the Mission.'

He was silent. 'Is she OK?'

'Chinta, quite frankly I don't think she's well at all. But there's nothing I can do now.'

'What's wrong with her?'

'I think she needs serious psychiatric help. And I don't trust this woman Mary.'

'Why not?'

'I saw her performing some ghastly pagan mass of some sort. She's obviously a complete crank.'

'Couldn't you have done something? Talked to her?'

'I tried but Marion wasn't interested. She asked me to leave.' I stared out at the desert and willed my tears to stay unshed.

He looked straight at me. 'I'm sorry, Kathryn,' he said. 'I know —'

'I know you know, Chinta,' I said. 'It's fine. I'm fine.'

'Are you?' he said dubiously.

'No,' I said, and laughed. 'No, actually I'm not fine at all. But we'll give it time.'

'Sure,' he said and put his arm round me. I rested my head on his shoulder. Dear Chinta.

'Perhaps we should come back here tomorrow,' I said. 'I think I've got an idea. Tomorrow. Humour me?'

'Sure. Why not. And in the meantime, if you want to talk about Marion or anything, I'm there. OK?'

'OK,' I said and turned away so he would not see me cry.

★

It came to me in the night as I lay awake with menstrual cramps that felt like crab claws nipping at my womb. So obvious, so human. I lay awake and thought about the creature who'd wielded the club, thought about Marion and Victor. Perhaps, I thought, it was no dispute about meat; perhaps it was a dispute about love. Perhaps the skull with its dents was the skull of a punished lover, not that of a rival for food. I lay there awake for a long while, missing Marion's softness and warmth, the intimate tactility of a loved body close and comforting in the night. Where was she now? Alone with her demons. Like all of us. The crabs nipped deep in my uterus. I got up, took two aspirin, lay awake waiting for the pain to be gone. Then I slept.

TWENTY-THREE

Before dawn I was standing at the site with Chinta and the workmen, shivering in the pre-dawn cold, in my hand a smallish kudu femur that I'd found on our fossil table. I held it out to Chinta.

'Throw it,' I said. 'Stand on the spot where we found the big femur and throw it.'

'Why?'

'Humour me. You promised.'

He stared at me. The workmen stared at him. He shrugged and threw. We watched the femur tumble end over end across the dawn sky and fall with a small spurt of dust thirty feet away. Chinta turned to me. 'Well?'

'What if our little friend didn't drop it? What if he threw it away?'

He nodded slowly. 'I like it. So we dig in a circle?'

'Yes.'

'Think of the overburden.'

'Think of the half million dollars.'

'You're a hard woman.'

That night I went to bed early, unable to face either dinner or Victor. Trying to forget Marion I sat up late reading Patterson's book by gas lamp, slapping at relentless light-seeking insects and drinking whisky. As I read I remembered the dream I'd had in Nairobi: the laibon and the idols in the low hut, the curse; thought

of Sister Mary and her pagan chanting; and a strange thought came to me: what if Patterson's desert trials and my own quest in the volcanic wasteland were one and the same? What if we'd been bewitched too? Impatient, intolerant of any naive belief in supernatural solicitings, I paid too little attention to this insight. If I'd believed, if I'd had faith in my instincts, perhaps they would still be here, all of them.

I dismissed my premonition and read on. On page one hundred and sixty-two of *In the Grip of the Nyika*, I found Patterson's description of his chance encounter with an aggressive black rhino and began to understand a little of his growing affection for Janey. 'I could get no information as to what the country was like between the Pes swamp and the Guaso Nyiro which flowed to the east of us,' he wrote; 'so taking my rifle and some ammunition, I went off by myself to explore in this direction.'

About fifteen miles from camp he 'fell in with a vicious old rhino' who was standing under the shade of a thorn tree. The rhino charged and only the speed and agility of Aladdin saved Patterson. He was badly hurt by long grey-white acacia thorns while 'plunging wildly through the jungle' in his efforts to escape the irate rhino. It was easy to imagine Patterson riding wearily back into camp, erect and straight-backed in the saddle to maintain appearances, blood soaking through the rents in his khaki bushjacket.

. . . 'It's nothing,' said Patterson, handing the reins to Abuddi. 'Just thorns. Munyakai will pull them out. It's happened before.'

'Oh, God, Patterson,' said Janey. 'You are a mess. What on earth happened?'

'Rhino. Didn't see him till it was too late. Just got away.'

'Here, come and sit in the shade. Munyakai, fetch a chair.'

'Don't fuss so, they're only thorns. Where's Jamie?'

'Asleep.' Munyakai ran up with a camp chair and Patterson sat. 'The fever got worse again but now he's sleeping. Take off your bushjacket.'

'Can't,' said Patterson. 'Munyakai, fetch the tongs. We'll pull the thorns out first.'

'N'dio, sahib.'

'Don't be a fool,' said Janey firmly. 'I'll cut the jacket off. Give me your knife.'

'It'll ruin the jacket,' said Patterson mildly, handing her his sheath knife.

'I know that, stupid. I'll sew it for you. Hold still.'

She cut away the jacket, drawing in her breath sharply when she saw how deeply the long grey thorns were embedded in his flesh. Finally the folds of the jacket fell away and she looked at Patterson's torso naked for the first time. His skin was very white except for the newly red vee at his throat where the fierce sun had burnt him. His arms were long and muscled differently from Jamie's: Patterson was almost thin, his forearms sinewed and lean, the veins standing out blue and proud from pale Irish skin. The sparse mat of hair showed dark against his chest. She was struck by the idea that he looked very mortal, almost fragile: his flesh was ringed pale where thorns were broken off almost flush with his skin. She wiped away the blood. The thorns were three inches long, curved thickly like the horns of Maasai cattle.

'Give me the pincers, Munyakai,' she said.

'M'sabu —'

'I know what you're going to say, but I'm perfectly strong enough. Go and boil some water, please, Munyakai, and bring the medicine case.' He went reluctantly.

She took hold of the first thorn with the pincers and said, 'Be strong, Patterson, this will hurt.'

'I know,' he said. 'Don't worry about that.'

The first sharp thrust of pain was less intense than he expected and he tried to absent his mind while she worked. Distantly, he heard her make little motherly ticking noises with her tongue as she wiped away the blood. She stood close by him and he could smell her: rosewater and a hint of some powder, another perfume compounded from skin and faint sweat and sunlight. She smelt unlike the women in London, he thought: those women with their perfumed cleavages, always married, always with a son and heir already delivered obediently to the anxious husband. The women who watched him by candlelight at dinner across a walnut table in some echoing country house and came to his room shamelessly after midnight, their hands eager and seeking, mouths alive with a desire that their sweet plodding husbands could never sate and would never credit. Yet the women were to blame as well: they wanted warriors but turned their men into stuffed dummies, unimaginative, obedient, dull. And together they wallowed in their stewed-prunes-and-kedgeree kind of marital intimacy, the fury and hatred always just concealed, the contempt and derision barely hidden. And the men in evening dress visited The Portland Rooms in London or Kate Hamilton's off Leicester Square where the only drinks were champagne and Moselle and the girls' breasts tumbled out unashamed and pink-nippled from their chemises and their soft thighs parted obediently and mechanically for the smiling men with their handfuls of money who demanded no intimacy.

And in revenge the wives dressed in softly flowing teagowns and entertained their lovers in the dreamy slow London townhouse afternoons while their complaisant husbands toiled away in the House or in the City or snored away the day tucked cosily into a winged chair at White's or Boodle's in St James's; or they met their lovers in the opulent rooms above 'Beautiful for Ever', Madame

Rachael's discreet but exorbitantly expensive beauty parlour in the West End.

What of your own marriage, thought Patterson. Is that so different? What of Frances Helena? He thought back to the long summer days that waned slowly through bat-quickened twilight to quiet night. Frances Helena asleep upstairs, he downstairs writing *The Maneaters of Tsavo* alone in his study, a torment of midges whirling around the lampglass.

Guiltily he remembered: through the empty rooms of Grove House stalked the silent reproachful figure of his neglected wife. Since the war and the birth of their son she'd withdrawn from him and he'd grown away from her, grown older without her. He had tried to tell her about the war and about Africa: the corpses tumbled slack-bodied like sleeping children into shallow graves dug into the stony highveld earth, the slaughters and rhetoric and the humiliation of barbed wire entanglements and concentration camps where Boer women and children died unheroic deaths from cholera and filthy water and starvation. He'd even tried to explain the feeling of limitlessness and freedom he'd felt in East Africa where he was not hemmed about by hedgerows and smut-covered eighteenth century brick; but he saw in her hardening face only incomprehension and resentment. The clocks ticked on in the quiet vacant rooms, the shadows lengthened earlier across the lawn and Patterson wanted to feel the sun on his face again. This sun, this sun.

Patterson looked at Janey. Her hair was tied back in a plait like a Maasai's and her silk blouse was open a little at the neck. His eyes strayed to the first mother-of-pearl button that shone with rainbow colours in the vee of her cleavage.

He looked up to her eyes and saw that she had been watching him.

'What is it, Patterson?'

'Nothing.'

'There is. I can see. Is it sore?'

'Yes,' he said truthfully. 'Very sore.'

'I'll try not to hurt you,' she said and took hold of the last of the thorns with the pincers. 'Be brave.'

'Yes. But Janey —'

'Yes?'

'Please will you undo your hair and let it hang down?'

'Now? Right now?'

'Yes. Please?'

'What about Munyakai?'

'Bother Munyakai. Please.'

She watched him for a moment then reached up a hand and unpinned her hair and shook it out and it fell about her shoulders and down her back savannah-pale in the sunlight.

★

Next morning we found our first really important hominid fossil. It seemed insignificant at first: a vertebra, found within ten feet of the spot where the kudu femur had landed, bedded into the dark grey tuff that was sandwiched between our two pale marker tuffs. We carefully pegged the area, marked the find and began to search as a team. Chinta shortly uncovered another vertebra and then we began to find fossil after fossil: more vertebrae, some fragments of pelvic girdle, a piece of jaw, tiny fragments of crania, the distal end of a hominid femur, another small cervical vertebra — and then the best find of all that day: a brow ridge and part of the facial bone of a hominid.

When I uncovered this fossil I knew two things immediately: the fragment would not fit our existing skull, it was simply too small; and it was clearly a more gracile form: another species? a female? a

200

juvenile? I held it in my hands and wondered. The femur fragment was male; the pelvic girdle was probably female; perhaps the facial bone was female. Why were we finding two sexes tumbled together in death? It was then that I began to grasp that we had found something utterly extraordinary. I called out to Chinta.

'Chinta: look at this.'

He took the fossil, studied it carefully.

'Well?'

'Well. Small molars, big incisors. It's old, very old. Gracile australopithecine? It's very gorillarish, isn't it? Not a robustus, something ancestral.' He looked at me and I could see his excitement. He smiled. 'Fame and fortune?'

'Fame and fortune!'

'Don't just stand there, woman. Dig!'

By sundown we'd found additional vertebrae, more of the gracile pelvis and, most importantly, dozens of cranial fragments, some no bigger than a fingernail. Reconstructing the two skulls would take hours of frustrating work but I was convinced the labour would be worth it. We'd found something unknown, undiscovered. I knew it.

That evening we began cleaning the fossils and laying them out in two groups, one robust, one gracile. Two new species? It was difficult to believe. Next day we dug on. The fossils were there in profusion: edging dark brown and lustrous like chocolate-carapaced beetles from the matt grey volcanic dust; or hidden shyly in the tight embrace of crusty tufa, to be freed in time and show themselves like polished chestnuts in the white glare of our worklamps late at night.

Over the next week the skeletons grew more complete as we discovered new fragments. There were numerous small missing pieces: ribs, some vertebrae, some metacarpals, the knee joints, two sacra. But already we had the proximal end of both robust and

gracile femurs which meant we could start making judgements about how well the animals had walked. Frustratingly, the cranium or braincase of the gracile form was missing, as was that of the robust. But we'd found the jawbones of both, including a selection of teeth, so we could begin to form ideas about facial shapes and diet.

But despite the wealth of fossils I was unhappy. They made no sense. One night late after everyone else had gone to bed I sat alone in the deserted tent and stared at the skeletons that lay silent and enigmatic on the table in front of me. It was cold in the tent and I could hear a lone male jackal call, disconsolate canine baying in the empty reaches of the night. The flickering oil lamp cast small quick-moving shadows that made the skeletons dance. The jackal called again, bleakly, and I thought of Marion, tried to hold down the pain in me that I'd exorcised till now with brainwork and manual labour. But it was there still, resolute and demanding. I thought of Sister Mary and Marion in bed together, the soft probing fingers, the muffled cries; the tenderness and love I'd known and lost. Sexual jealousy must be the most absurd evolutionary burden of all, more stupid even than the vain peacock's counter-productive tail or our backbone that could do with a few more benevolent mutations to make it into a perfect support for an erect-walking hominid. I wondered, looking at the fossils, where in our past there could have been need for an emotion that still causes such pain and brings no solace at all.

I remembered Oriana Talmadge saying that the past is lost and gone, unredeemable. I knew she was right, that it was all gone, that I'd have to learn how to let Marion go; but it was not easy. Work was the only balm. And falling in love with Marion I'd forgotten the precious insight I'd had when I'd been betrayed by Ernst Stoller: no other human being can validate your existence. That's an illusion. The only way to find meaning is to discover who you are and be that person. And I was a detective, was I not? Mercurius. I was meant to solve the riddle of the bones that lay on the table in front of me. And I needed to know the truth. Despite everything, I still believed then that truth was accessible. I sat there in the dark and refused to think

of Marion and pondered the fossils' contradictions. The gracile form looked more modern than the robust, yet we'd found them in the same tuff: they were of the same antiquity. I stared at the crania: one robust and heavy browed, with a raised sagittal crest and huge molars; the other delicate, slight. I sat there until the lamp burnt down low, watching, wondering, imagining. Then, in a moment of magical insight, I remembered two research papers I'd read and quickly removed a few milligrams from both crania with my dental pick, bottled them in four separate sample tubes, marked them carefully, addressed the tubes and packed them for mailing to the universities of Cape Town and Harvard. Past midnight I turned down the wick and walked to my tent but could not sleep. Instead I lay and listened to the dark.

Tregallion once told me he was 'good at love'; I am not good at grief. I had learnt too well when young how to deny myself the pain attendant upon loss; I knew that my malaise of spirit was the result of my refusal to buckle, to allow the central struts of my sense of self to be gnawed away by my longing for Marion and my grief at her leaving me. But internalised pain like this will not be denied forever. Evolution is wise: my unshed tears and fury were real, could not be willed away, were the time-dimmed remnant of emotions evolved over millions of slow years: they are with us still because they were benevolent mutations that helped us cope when we were a young species. Sooner or later they would have their way and seek outlet like pus from a tooth abscess.

I knew all this: knew that I'd never heal until the necrotic was excised; but I was fearful of the pain, fearful of the capacity for derangement I'd seen in my mother and suspected in myself. I did not want to go so close to the edge. Perhaps, less nobly, I suspected that my grief was condign punishment for a life lived wilfully and consciously at one remove from the mundane. Over years, my studies had taught me that there is a miraculous regulatory mechanism inside us, a kind of Law of Homeostasis that demands balance, demands payment of emotional debt. Any longing for

detachment, for emotional autonomy, exacts a price: we pay for our serenity. In nature, nothing's for free. I knew all this but denied it.

Quasimodo nuzzled my hand as I lay there in the dark and it was this gesture of disinterested affection that lanced my fistula inside. I began to cry and once started could not stop. I curled up tight around my fisted hand and howled away in silence. But it was not enough. I wanted comfort, I wanted the touch of a hand that cared. Selfish, knowing I was betraying myself, I gathered my sleeping bag and blanket and walked like a nightmare-riven child through the dark to Chinta's tent and knocked hesitantly on his tent pole.

'Yes?' came his startled voice.

'It's me,' I said, trying to keep my voice level. 'Can I come in?'

'Of course.' I pulled open the tent flap and stood there shamefaced in the light from Chinta's torch.

'What's wrong?' he said, sitting up in his camp bed.

'Bad dreams,' I said. 'Will you hold me?'

'Of course.' He threw back his bedcovers and made room. 'Come and lie down.'

It was too late to change my mind. Embarrassed, I fussily arranged my blankets, lay down stiffly beside him with my head tucked into the angle of his jaw and shoulder. His arm was tight around me.

'What's wrong?' he said quietly.

'It's Marion,' I said.

'Ah,' he murmured and held me tightly. This tenderness was too much and I felt myself begin to shake with suppressed crying. Then all my control went and I turned towards him and began to sob in a way that it shames me now to remember. Chinta simply stroked my shoulder and lay there beside me: stolid, warm, strong. Finally I fell

asleep, still crying, but too exhausted to care, too empty to feel remorse.

Early next morning I slid from Chinta's bed, hoping to escape before he woke but he caught my hand and said quietly: 'Are you OK?'

'Yes,' I said. 'I'm fine now. Thank you.'

'If you ever —'

'I know.' I bent and kissed his forehead, feeling like a complete bitch. He knew I'd used him.

'I mean —'

'I know.' I searched for a way to elude his request for more intimacy. This was cruel: he was a lonely, gentle man and I'd used him unfairly. I said: 'Chinta, I'm sorry I was such a ninny. You know it's not like me. I'll never be able to thank you properly for what you did last night. For being so stuffy and nice and for not —'

' — terrifying self-control,' he said. 'Nothing left for me now but a life of onanism. You owe me one.'

'OK. But, Chinta,' I said, and punched him lightly on the arm. 'You'd better behave yourself and do everything I ask without question from now on.'

'How so?'

'If you don't,' I said, 'I'll tell your wife I slept with you.'

Later that morning, puffy eyed but back in control, the healing started at last, I was at work again, sifting volcanic lava, probing the tuffs, searching for the essential fragments of the gracile cranium that we needed. At midday I found the first, and within the hour Chinta found two more. The pieces fitted perfectly. We aligned the fragments and stared disbelievingly at twin indentations that I could see would match exactly those in the robust male's skull.

I stared at Chinta. Sweat had started on his forehead. He knew. The workers were watching us, leaning crossarmed on their shovels. He smiled at me. 'I know what you're thinking.'

'What?'

'Murder.'

'If the dents match the protrusions on the kudu femur?'

He nodded. 'Maybe you'll be right. But, Kathryn. Do you know what we've got here?'

'Yes. The most complete remains of the oldest hominid ever found. A hominid that's probably ancestral to all others.'

'Not only that. If we'd found the femur alongside, we'd have reasonable proof of tool use. And possibly of violence.'

'We need electron microscope scans of the femur and both skulls.'

'Yes.'

'If violence is that old —'

'Yes.'

'I don't like it.'

'Nor do I. But let's just carry on.'

'We'd better make an announcement.'

'Not yet. We can't yet.'

'It's going to be hard to stop Victor.'

'Chinta,' I said, 'I need some time. You can stop him announcing, he listens to you. Help me. I need time.'

'Time for what?'

'I can't tell you yet. Just do it, my friend, please just do it.'

As the weeks passed we began to see that we'd found a continuous vertical series of tuffs deposited over millions of years and ranging from perhaps four million to two hundred thousand years before present. We'd found an Olduvai Gorge in miniature. We could easily trace the progressive evolution of suids, kudu, ancestral horses and, of course, our hominids' behaviour. In the Bed Four horizon, for example, we found crude Oldowan stone tools and I remember standing one day in the fierce midday heat holding a chipped pebble-tool and thinking awestruck that mine was the first hand to heft it in over two million years. It fell comfortably into my palm, balanced and functional.

We also made troubling discoveries. At perhaps one hundred and fifty thousand years we found a serried collection of antelope bones in a kitchen midden. It took little effort to imagine the flayed carcasses lying in rows in the heat by the lake shore, the meat seared black by the sun, blood clotting in thick red rivulets in the chocolate volcanic ash while the men and women butchered the animals. The smell of blood and slaughter and dust, the grunts of the hippo, the black kites swooping and waiting.

Just above this horizon we found another butchering floor complete with beautifully worked Acheulean flint tools. The unpleasant surprise was this: amongst the omnipresent antelope bones we found six crushed hominid crania and thirty-two femurs. The cut marks where stone tools had sliced through muscle and into bone were clear, even after all that time. The crania had clearly been expertly trepanned. And the conclusions were inescapable. Our ancestors had hunted their own kind, had killed and eaten them. They'd even cracked open the big thigh bones to get at the rich toffee-coloured marrow, and sliced open skulls to reach the soft brain tissue. I stopped work early that day and drove to Orde's lake and swam and watched the baboons and wondered about myself.

As we uncovered more and more of our fossil skeletons in the lowest and oldest bed I found myself vexed by two practical questions: Why were the two types intermingled, and how did the creatures

die? Were the dents in their skulls the cause? Or did they die of disease; predators? The longer we excavated and talked the more I found my thoughts turning to Tregallion. For reasons I could not grasp, I sensed he would be able to help me.

One cool morning I drove over to his camp on the shores of the black volcanic desert and was surprised to find no trace of him there. He and Seremai had simply struck camp, packed their tents and left. There was no hint of habitation. Perhaps a faint darkening of the sand where a campfire had burnt, no more. The desert winds had erased all footprints, moulded new dunes where tent pegs had once held guyropes taut, smoothed with a spirit's breath the deep tyre tracks of their vehicles. Nothing. A cold desert wind blew black sand in fast-running scurries that eddied and died in the lee of small dunes, hurried in thin wisps into the distance, disappeared. Jagged volcanic stones vibrated in the coming heat, dark as obsidian, as reflective as polished haematite. I stared, felt the darkness engulf me, the emptiness and absence, the silence. I shivered and started the Land Rover and drove back to camp.

Victor was waiting for me in the fossil tent where our finds were laid out on the long trestle tables.

'Ah, Kathryn. Good, good, you're back. I've got a new fossil to show you.'

'Hominid?' I poured water from the condensation bag.

'No. Nononono. A piggy. A fine metridiochoerus. Ancestral warthog. Here, look: pretty? Metridiochoerus andrewsi, actually.'

'Yes?'

'Yes. Look here. Notice anything strange?' His eyes gleamed with enthusiasm. He held out a fragment of lower jaw with molars and premolars still firmly socketed. I took it and looked carefully.

'No.'

'Sure?'

'Sure.'

'Very well. Look at the length of the third molar. See? Now compare it with this —' He handed me a similar fossil from the table. 'Same genus, but oh, two and a half, three million years younger. This species is a kind of time-clock. The third molar grew higher as metridiochoerus evolved over time. Their absolute dating is accurate, too. See? Here? Longer.'

'Yes.'

'Also: look at the size of the chewing surface on this older one. See? Smaller. The younger is broader.'

'So?'

'So. I found the older one in the tuff above your hominids. It's over three million years old. Possibly nearer four.'

I stared at him. 'What?'

'Exactly, exactly. I knew you'd be impressed. It could mean that your hominids are older than anything ever found before. Probably four to four and a half million. Bingo.' He smiled at me. 'See? See?'

'Yes,' I said. 'I see. Where's Chinta?'

'At the site.'

I ran down to the site and found Chinta sifting volcanic ash. The workers leant on their tools and stared at me. The heat was palpable.

'Chinta,' I said, 'we need to send more samples of the three marker tuffs to that guy at Cambridge. And quickly.'

'Tucher?' He wiped sweat from his forehead with a dusty forearm. 'Sure. I've already sent some.'

'Send more.'

'Why? Are you OK? What's the hurry?'

'Insurance. Time.' I explained Victor's find.

Chinta nodded, eyes wide. 'Maybe the first date Tucher got was right. That was about four million.'

'Do it, Chinta. Do it now.'

He stared critically down at the tuffs. 'There's no difficulty with the stratigraphy. We should get three good dates. One before, one smack on, one younger.'

'Please do it now. Please?'

'You're so brattish, sometimes, you know that?'

<p style="text-align: center;">★</p>

Dear John, (I wrote that evening)

I hope your dig is going as well as ours.

Good news for us: it seems the early identification of this Kenyan skull as a robust hominid was entirely wrong.

We've made a big breakthrough here, finding two hominid skeletons that promise to be very nearly complete. Fortunately, they lie in a clearly defined tuff bracketed by two marker tuffs and our early Potassium/Argon tests show a date of at least four million years before present, probably older. Biostratigraphic evidence confirms the older dating, but we intend running fission track as well, plus two more K/Ar tests by Tucher at Cambridge. We'll also investigate the magnetic polarity of the site. Ideally, it should sit in the Gilbert Normal well prior to both the Cochiti and even the Nunivak Events which both lie, as you know, in the Gilbert Reversed; the Nunivak earlier than 4,2 million years BP.

We've also found a continuous vertical series of volcanic strata that run from five million to one hundred thousand years before present; a sort of mini-Olduvai. Isn't that lucky!

To sum up: we seem to have found the oldest known hominid; ancestral to Australopithecus afarensis and ramidus; to everything, in fact. We're going to have to redraw all our family trees!

Best wishes,

Kathryn.

PS Any new news at your end? How's your sectioned molar?

I went to sleep feeling good for the first time since I'd left Marion at the Mission. Stupid. I should have known my peace would be short-lived.

★

Next morning Marion arrived from the hospital driven by Sister Mary. I was walking to the dining tent quite early, Quasimodo trotting beside me, when I heard the Land Rover's worn diff grind in low gear up the steep road from Maleleji. I shaded my eyes against the low sun and made out two upright figures sitting side by side, stiffly, in the front. As the car drew closer I could see that the Land Rover was so old the paintwork had been abraded to bare aluminium by wind and volcanic sand. Marion was wearing her sunglasses and had tied her hair up in a black silk scarf against the dust and wind.

Sister Mary wore a pair of tank commander's goggles under a dirty canvas bush hat. Her black hair had grown a little and was pulled back tight in a small pony tail. The bones of her face and forehead looked drawn and taut in the low morning light. Mary stopped the car beside me. Marion stared at me without expression and said nothing. She was as beautiful as ever and I felt my heart contract. I was a fool to have believed against all the evidence of experience

that her love would endure; equally stupid to think that I'd heal quickly and feel nothing when I saw her again.

'Hello,' said Sister Mary. 'How are you, Kathryn?' She pushed up the goggles and I saw in her eyes a curious and distasteful look of triumph. At the time I wrongly thought that her new poise was purely the result of her hold over Marion. Sadly, I paid too little attention to her strange seance in the garden.

I said: 'Well, thanks. Hello, Marion. How are you?'

'Perfectly well,' she said. 'Why? Don't I look well?'

'You look lovely,' I said. 'Welcome back.'

There was little scarring to mar her beauty. Doc Ludovic's meticulous stitches had healed seamlessly. Quasimodo bleated at her. She stared down and said : 'Such an awful looking goat. Sister Mary's coming to stay with us,' she added, turning her face to me and hanging her head on one side as if listening to a soft inner voice.

'I see.'

'Do you mind?'

'I mind? Why ever should I mind?' I said.

She ignored this. 'Where's Victor?'

'In his tent, I suppose.' It was suddenly clear to me that she was no longer the woman I'd loved. Watching her, I realised that Marion had always possessed the same enchanting combination of profundity of insight and fickleness of passion that you find in young children. It was her great charm as well as her principal failing. But now the fickleness had taken charge, and the profundity was reduced to mere stubbornness. And I wondered about her sanity.

She turned to Mary, put a hand briefly on her arm. 'I'd better talk to Victor first,' she said softly. 'But don't worry. It'll be fine.'

Sister Mary smiled at her, turned to me and said with blatant insincerity: 'Are you really well, Kathryn? You seem tense.'

'No,' I said. 'I'm fine. I'll see you later.' Quasimodo bleated stridently at her. I turned away to the dining tent, feeling empty in my stomach, hollowed out and lost.

'Oh, Kathryn,' called Marion. 'We met a friend of yours on the road. Two friends. One of their cars had broken down; they were both covered in grease. We stopped to see if they needed help. They asked me to give you this.' She held out an envelope to me. I took it and thanked her and walked to the tent and opened my letter and read:

Hello Kathryn:
 We're temporarily stranded here, just up the road from you, and your rather strange but beautiful friend kindly agreed to pass on this note to you. We should have the car repaired soon (Thursday PM? Friday AM? depending on spares available in Maleleji) and when it is we thought you might care to return our hospitality? Friday? Dinner? If you can't do it, send a reply by forked stick.

Yours,

Daniel & Seremai.

PS Who's that awful woman with her? A Stymphalean bird? A mad aunt?

I sat down at the dining table with its gay red and white checked tablecloth and stared at the bottles of sauce: HP, Heinz tomato, piccalilli.

'Goodi morning, Kathryn,' said Hamid, our cook. 'Eggezi andi baycon?'

'No, thanks, Hamid. Tea?'

'Coming up.'

I read Tregallion's letter again. Dinner Friday. I thought about this. It was now Wednesday and the supply truck would only make the long journey to Maleleji on Saturday; we were down to cassava and tomato relish and mposho meal. We'd even run out of goat: Hamid was deep in convoluted financial negotiations with our two local goat suppliers who'd realised our dependence and grasped the financial potential of controlled supply and regular demand.

Guineafowl stew? Sandgrouse casserole? Orde pulled out a chair and sat beside me and poured tea.

'Morning, Kathryn. Good sleep?'

'Yes. Orde?'

'Yes?'

Hamid placed a plate of pale eggs and blackened bacon in front of Orde who stared at it disconsolately. 'My God! The food, the food,' he murmured.

'That's what I wanted to talk to you about,' I said. 'I've got two friends coming to dinner on Friday and I've got nothing to give them, so I thought —'

'You'd cook that ghastly goat of yours?'

'No.'

'Why not? Do us all a favour, especially the goat. Put it out of its misery. Imagine going through life that ugly.' He poked at an egg with his fork.

'Orde! Stop it.'

'Who're your friends? Anyone nice? Any lissom young people? Anyone I know? Give me a reason to care.'

'Perhaps. Daniel Tregallion? Seremai Smith?'

'Of course. Tregallion was a very good hunter. Ethical, which is rare. One of those who hunts from the heart,' he added and smiled at me. 'Don't know Seremai that well.'

'Will you help me? I can't give them mposho and tea.'

'Ah. I see. You want a little safari. Turn to the dreaded professional in times of need. Yes?'

'Well, yes. Could you —'

'No. But you're welcome to borrow a twenty bore and go out with Haroun and bag some guineas or sandgrouse yourself. Very tasty.'

'I don't know if I can shoot anything living.'

'Oh yes? You were perfectly happy to eat the guineafowl, I noticed.'

'Yes, I know, but —'

'Hypocrite?'

'Yes, I know, but —'

'Well then.' He dipped a piece of toast in pale egg yolk and stared at it without enthusiasm.

'Are there any fish in the lakes we went to?'

'Yes. Bream. Quite nice bream, too. God only knows how they got there.' He placed the toast in his mouth, chewed thoughtfully. 'Don't fish count as living things?' He swallowed reluctantly. 'I wonder: are these crocodile eggs? Nothing else could possibly taste quite so foul.'

'Fish don't count quite as much as birds,' I said uneasily.

'Hmmm. I see. Nothing cuddly about a bream. You're a speciesist. The closer an animal is to us, the more value it has. Yes?' He glanced at me, smiled, relented. 'I'll lend you a rod if you like.'

Victor, Marion and Sister Mary came into the tent before I could reply. Marion still wore her dark glasses. Victor looked as if he'd grown suddenly very old. Mary looked serene, wearing the kind of fixed vampire's smile you see painted on bad plasterwork statues of the Madonna looking down at a swaddled infant Jesus as if wondering which vein to plunge her teeth into.

Orde kissed Marion, shook hands with Sister Mary and offered tea. Emboldened by this unexpected influx of custom, Hamid produced three plates of cold eggs and bacon. Marion shuddered slightly and pushed hers away.

'I think I'll go back to hospital,' she murmured. 'All that glorious boiled cabbage.'

I finished my tea and stood. 'I'll come and borrow that rod from you later if I may,' I said. Orde nodded. Marion stared at me without expression. In Victor's look I thought I saw the same mute pleading I'd once seen in the eyes of an abused donkey that had collapsed at the side of an African road, its body held erect only by the harness and the shafts of the trap it had drawn. Its owner lashed at it with a long whip; but beyond goading, the animal had stared at me silently with unsurprised eyes. When I berated the owner and freed the donkey it lay down spreadeagled in the hot dusty road and I could see in the dark long-lashed eyes that it was beyond caring; it wanted only to die. Sister Mary watched me still with her irritating amused smile. I left for the site.

★

That night, snug in my camp bed while a hard desert wind harassed the tentfly and rattled the guyropes, I thought about Marion, so close in her tent, sleeping with Mary. I remembered our acts of passion, so tender and intimate I'd thought I'd never be able to recapitulate them with another human being. So naive, so silly. I took up Dukowska's book again; perhaps, I thought, quantum physics will heal where time can't.

216

I read: 'There is a tantalising modern parallel to medieval belief in the Music of the Spheres to be found in the new cosmological theory of superstrings which holds that ultimate reality is composed of minute bundles of multidimensional strings of energy vibrating in harmony...'

Startled, I thought of Tregallion's hands moving in the firelight as he described his vision of the universe: 'A fugue cosmos-wide...' I put down my book, turned down my lamp and knew suddenly that I wanted very badly to see him again.

TWENTY-FOUR

Early in the false dawn of Friday morning I left Quasimodo in the care of her babysitter, packed Orde's rod and tackle box into the Land Rover and left camp even before Hamid was up to blow the bruised mauve coals of his cook fire into life. The air warmed as I drove and when I reached Orde's oasis the sky was already pallid in the east and swifts and weaverbirds were busy in the feathered heads of the wild date palms that reclined over the still pool of the lake.

I jointed the rod, screwed on Orde's old but well-kept Orvis spinning reel, threaded line and chose a small silver Mepps spinner. As I tied it on — remembering the summer of my seventh year on a butterscotch Zululand beach when my father first taught me the seven-twist clinch knot — I saw the flat untroubled surface of the oasis ripple in a widening circle as a bream surfaced.

I cast beyond the circles and retrieved smoothly. Immediately there was a tug. I struck and suddenly the rod was vibrant with the muscled tension of a fish that ran and darted, trying to throw the hook. The rod tip bent and trembled but I reeled him in and soon he was beside me on the soft beach: silver and black and shiny as dawn, his gills working, his tail beating the sand. I felt sick but delighted and in compassion knocked him behind the head with the hilt of Orde's bait knife. He lay still and beautiful even in death. I touched him. His body was cool and smooth. The weavers were busily building houses, tying knots, chittering. The sun rose above the far dunes and lit up the palm trees. The air was suddenly warm. It was going to be a beautiful day.

I caught three plump bream for our dinner, took pity on Orde and Chinta and cast until I'd landed two more; debated catching another

three for Victor, Marion and Sister Mary, pettily decided not to; relented, fished until I'd caught them, packed carefully and walked back to the truck.

As I climbed into the Land Rover I saw a group of three male baboon, dog-snouted, big-bodied and dark, sitting still and watchful in the shade of a nearby clump of palms. They stared at me quietly, their eyes direct and challenging. The biggest male scratched thoughtfully at his side, hung back his head and silently bared two long white canines. I started the Land Rover. They stared harder. The biggest stood, his tail raised, alert. As I drove off I waved but they did not wave back and I heard the roar of their call echo around me: 'Tha-Hu! Tha-Hu! Tha-Hu!'

★

Hamid was fascinated by the idea of me 'entertaining strange gentlemen', as he put it. That night he built me a russet-coaled cook fire by my tent, laid a collapsible table with much obscene leering and winking and donated a grey tin of jealously guarded butter marked: 'Gift of the Government of Sweden. Not for Sale'. Adjacent was a price sticker: nine hundred Kenyan shillings; about twenty pounds sterling. Robbery.

Tregallion and Seremai Smith arrived in the brief twilight, bearing fresh fruit and vegetables, tomatoes and lettuce. I introduced them to Victor and Chinta and Quasimodo and we had a sundowner in the dining tent. Orde, Marion and Sister Mary did not appear. Chinta questioned Tregallion about the fossil site and persuaded us to go to the tent where our fossils were laid out.

There, in the clear white light of our pressure lamps, Tregallion picked up the two restored crania, one robust, one gracile, and stared at them. 'So gorillarish, aren't they? Or do I mean chimpish?'

'Both,' I said. 'Probably more chimpish. If the DNA analysis guys are right the split between us and the chimp only happened around six million years ago. So if my dating's correct, this is probably the

219

first hominid — hominoid? — after the split. The oldest human ancestor; I reckon it's even older than Tim White's hominid from Omo, the one he's just found —'

'Australopithecus ramidus?'

'That's the one. And our dentition's different. His looks like a fruit eater; ours is an omnivore.'

'Handsome fossils,' said Tregallion.

'Yes. Very handsome fossils,' murmured Victor.

'Very handsome,' said Tregallion. 'Pity you don't have an endocranial cast. It'd be interesting to see if they died from the blows or something else. Two species?'

'We think so,' said Chinta. 'Strange they died together.'

'Yes.' Tregallion glanced curiously at me but I said nothing.

'Not old age,' said Seremai, and laughed. 'They definitely didn't die from old age.' He picked up the robust femur, studied it. 'Long neck, isn't it? They probably ran better than they walked?'

'Yes, that's right,' said Chinta. 'Better mechanical advantage.'

'Have you spoken to Todd Wister at Kent State? The locomotion man?'

'Yes. He's coming out to work on the fossils here.'

'Why haven't you made an announcement yet?' said Tregallion. 'These are wonderful fossils.'

'Exactly! Ex-actly!' said Victor. 'My pet quibble. Funding, we need funding. We must announce, and soon, too.'

'Not yet. We haven't got the dating right yet,' I said. 'I want the dating exactly right. Without that, we can't really decide what we've got.'

Tregallion stared at me, smiling slightly.

'Who's doing the dating? Tucher?' asked Seremai.

'Yes.'

'Good guy. Is he still at Cambridge?'

'Yes. And we've sent zircon crystals to Cathy Cohen at Cleveland for a fission-track date, too,' said Chinta.[13]

'What's your guess about the date?' Tregallion asked me.

Reluctantly I said: 'Older than four million. We've got the metridiochoerus date, and we've got hipparion teeth with a clear ectostylid that we found in Bed Three, the one above our hominid fossil bed; and equus well above the hipparion.[14] I'd say four and a half, minimum.'

'What do you think?' said Chinta.

'I think,' said Tregallion, 'that you've found the oldest known hominids ever. It's just odd you've got two species so close together. Do you think the gracile one was the predator, and the other the prey? Do you think maybe the robust one's a gorilla/chimp ancestor, and the gracile one's ours?' He looked at me, waiting. I stared at him, expressionless. Carefully he replaced the crania and we walked outside. Tregallion looked up at the stars, turned to Victor and said: 'Seremai and I aren't doing much at the moment. Would you like some help with the dig? Muscle?'

'Delighted to have you,' said Victor. 'Absolutely delighted.'

'Chinta?' Tregallion turned to him.

'Of course,' said Chinta.

'Miss Widd?'

'I'd love to have you.'

'Well then, Seremai,' said Tregallion. 'We'd better pitch our tents.'

★

The bream tasted wonderful cooked in butter with a little chopped onion and garlic. Hamid had made mashed potato and a fresh tomato and basil salad and found me some coarsely ground black pepper and Seremai had brought two bottles of dry white wine that he'd cooled in his condensation bag. Tregallion admitted he was a 'confirmed chocolate fiend' and we sat under the night sky and ate the plain, dark, bitter Bendick's chocolate he'd given me as a present and sipped our coffee in silence. It was past midnight. The fire had burnt down low, coals coral and purple, the ash bone-white. I wondered whether to put on another piece of our dry wood to brighten it.

Tregallion stretched and stood and said: 'I'm off to bed. What time do we start in the morning?'

'Early, before sunup, before it's hot. Shall I call you?'

'No, thanks. Where's your tent?'

'The old one. That pale one there.' I pointed.

'I'll make coffee early,' he said. 'I'll call you and you can come over for a cup and one of Seremai's homemade biccies.'

'Thank you.'

'And thank you, too. For dinner, for your hospitality, for your beauty.'

'Tregallion!'

'Smooth bastard,' said Seremai softly.

'I mean it!' protested Tregallion. He stopped, turned abruptly to the east, stared across the dunes. Seremai stood, walked softly towards

222

Tregallion and they stood together immobile, staring in silence like two watchdogs.

'What is it?' I said.

'Nothing,' said Tregallion.

'Probably nothing...' from Seremai.

'Probably nothing,' said Tregallion.

We said goodnight and I walked to my tent, bathed sleepily and was dreaming the instant I climbed into bed.

★

I was woken in the long hours before dawn by the sound of fireworks. No, more: screams, ululations, the muffled rumble of horses' hooves. And nearby, gunshots: the crack-boom of a hunting rifle. Trilling voices and galloping hooves came closer. Quasimodo bleated. I ran to my tent flap, unzipped it and stared out.

Mounted figures in white flowing robes galloped through the darkness. I heard gunshots and ululating voices, saw horses' arched necks straining taut against short reins. From Tregallion's tent came the cracking roar of a big hunting rifle. I saw Orde run naked from his tent, raise a rifle and fire at the horsemen's retreating backs. A scattering of automatic fire, a slow rainbow of tracer across the darkness, then silence. Quasimodo stared up at me. I patted her flank and found she was shivering. I realised I was naked, tied on a kikoi, found my stick and ran clumsily to the dining tent where lanterns were beginning to flicker.

When I reached the tent, I found chaos. Everyone was talking at once. My knees were shaking from fear and excitement and I pulled out a chair and sat before my legs collapsed. Chinta took charge. Victor had slept through the attack. A quick headcount showed that no one had been hurt. Marion looked irritable but still lovely, Mary was alert, her dark simian little eyes bright and watchful. She'd

searched, she said, for wounded, but found none. She seemed faintly disappointed. Orde stood to one side holding his magazine rifle. Tregallion and Seremai stood together, each holding a double rifle. The labourers were there, too, silent and watchful.

Chinta turned to Tregallion. 'Who were they? Why did they do it?'

'Shifta!' called the labourers' headman. 'They kill and kill.'

'Somali shifta from across the border,' agreed Tregallion quietly. 'A raiding party. They probably thought we'd be a soft target.'

'Yes,' said Orde. 'I think you're right. If we'd not fired back, they might've pressed home their attack. I think we surprised them.'

'They certainly surprised me,' said Marion. 'I hate being woken up with a fright. Bastards.' She lit a cigarette and watched us sleepily.

'I doubt they'll come back today,' said Orde. 'I'd go back to sleep.'

Hamid brewed coffee and after brief discussion, we agreed that someone should drive to Maleleji and telephone Marsabit lodge and ask them to alert the army base at Marsabit town. Seremai and Orde volunteered and left. I heard their Land Rover churn in low gear out of camp and grind away to the north.

It was now dawn. The workers went back to their tents, Victor appeared looking bemused and Chinta explained what had happened. Victor looked grave. He turned to me. 'Kathryn, I'm sorry, but I think we ought to pack up and leave.'

'Leave the dig?' I said, astounded.

'Yes. Think: there's more at stake than a few fossils. There are people's lives.'

'And you think we should simply scuttle off? Because a few bandits came across us by chance?'

'Yes, I do.' He watched me.

'I won't do it,' I said. 'I know there's more to be found here. Don't you understand? This is what I do. This is what I am. I look for fossils. This is what I am.'

'For God's sake! What more do you want? We've already found the oldest fossils ever —'

'— we don't know that,' I said.

'Granted. But the finds are superb. Do you agree?'

'Yes.'

'And we can always come back.'

I stared at him, turned to Chinta. 'What do you think?'

He frowned. 'Hard to say. Tregallion?'

'They may come back, they may not. If we post sentries, we might be safe. Tough one to call.'

'What d'you think we should do?'

'No comment.' He watched me, smiling.

'I'm not going,' I said.

'We could announce the finds,' Chinta murmured.

'No dates yet,' I said.

Victor took me by the arm and I pulled away. 'Don't touch me,' I said. 'How can you just give up and run away?'

'Kathryn,' he said calmly, 'I think Chinta's right. Let's compromise and announce the finds. I know you have reservations, and they're valid, but we need protection. This may happen again. We should announce immediately. If the world's interested, we'll get protection. We can carry on the dig in safety. Chinta?'

'I think he's right, Kathryn,' said Chinta reluctantly. 'Kathryn?'

I could feel Tregallion watching me.

'I suppose you're both right,' I said. 'Shall I drive to Maleleji and send telegrams to Reuters and *Time* and *Newsweek* and *International Nature* in Nairobi?'

'Good thinking, yes! And tell Margaret Hwange at the museum. She'll handle the enquiries.'

'I'll drive you,' said Tregallion. 'Shall we go?'

'No,' I said firmly. 'You won't drive me, I'll drive myself; you can come along and guard me. And I want my toast and tea first.'

★

Tregallion tucked his rifle, protected by a cracked but well-dubbined leather gunslip, into the gap between the dashboard and downfolded windscreen of my Land Rover, put two long red and yellow packs of cartridges beside the butt and climbed up beside me. I drove off along the red murram track that led to the main road and Maleleji. Seremai's tyre tracks were clear and fresh. The road wound between the dunes and up ahead I could see hoof-churned sand where the shifta had galloped away.

'Please stop,' said Tregallion. I drew up short of the hoofprints and he got down and paced alongside the prints, climbed the far dune where the gallopers had crested the rise, stopped and picked something up, came back to the Land Rover. He was wearing khaki shorts and an old bushjacket and his legs were muscled and brown. Tendons and sinews drew taut as he walked. I looked away as he caught my eye.

'Hard to tell,' he said as he climbed back into the passenger seat, 'but I think there were about ten or twelve of them. Scouts, probably. The main body of them should be about a hundred strong. They won't be far off.' He handed me a small cartridge case, dark-metalled, not brass.

'AK-47,' he said. 'Shall we go?'

I put the car in gear. 'Did you save our lives, Tregallion?'

'No. They're like sharks. If there's too much risk, they'll sheer off; if not, nothing will stop them. Seremai and Orde helped. We looked well armed and determined. Can you shoot?'

'A shotgun. My father taught me.'

'Good. We'll go a little further so's not to frighten the camp, and I'll teach you to shoot my rifle. If you like.'

We drove for a time in silence, then I said: 'Should we pack up and leave?'

He shrugged. 'They may well come back. Why are you so determined to stay?'

'There's more to find.'

'How do you know?'

'Intuition.'

He laughed softly. 'Very female.'

'Are you being patronising?'

'Not at all. It's just that you're so self-consciously scientific one minute, so totally subjective the next. It's enchanting. Shall we stop here? I think we've gone far enough.'

I switched off the Land Rover. 'Why were you laughing at me earlier? When Victor wanted us to leave the dig?'

He shrugged. 'I think it doesn't matter what one does: you can be a dustman or a king; it's the way you do it that matters. It's a moral process of facing dilemmas and choosing. We betray God and the universe when we choose untruly, when we don't choose from our knowledge of our deepest, most primitive self. I was interested to see

227

you caught in a situation where your sense of self was compromised by your need to think of other people's safety. I think you chose quite well. It's not a compromise, as you think. It's an intelligent choice: you can still dig away for fossils and feel validated, do what the gods sent you for; and you can enjoy being sensible and altruistic at the same time. You won. Victor lost. It's quite dangerous, though. You're playing with chance, the unknowable. What if you're wrong and the shifta come back and kill everyone, then where will you be? Compromised, and your sense of self violated. The void.'

I stared at him.

'And I wondered,' he went on, watching me carefully, 'if this skull you're looking for is something more than just a skull? Your holy grail? You calvarium full of Christ's blood, your sacred chalice?' I said nothing.

'Shall we shoot?' he said, and took down his gunslip and laid it on the bonnet of the Land Rover. He undid the brass buckle and reached in and drew out a double rifle with a beautifully figured walnut stock. The blued barrels gleamed satiny and I smelt the tang of Rangoon oil that I remembered from my father's gun safe: aromatic and sour. He pushed over the top lever and the barrels swung down to reveal twin breeches.

'It's just like my father's, his double barrel shotgun,' I said.

'Yes, except these barrels are rifled to stabilise this bullet.' He held up a long brass-gleaming cartridge, slid it into the right hand barrel, swung the barrels up. The action closed smoothly with a soft click.

'What is it?'

'A Westley Richards four-seventy hand-detachable boxlock. See?' He broke the rifle, carefully extracted the cartridge, opened a small plate under the rifle and removed a complex but beautifully made piece of lockwork. 'These cock and fire the thing.' He replaced the lock, closed the plate, inserted the cartridge, swung up the barrels and handed me the rifle: 'Careful; it's heavy.'

I took the rifle, surprised by the weight, shouldered it the way my father had taught me. Tregallion stood behind me, positioned my hands on the stock and said: 'Tuck the butt back into your shoulder.'

I could smell him: shaving soap and citrus and a faint scent of maleness; sweat, sunheat on skin, leather. I felt the firm touch of the flat of his hand against me as he pressed my shoulder forward into the butt and its red rubber recoil pad. And the momentary contact, unexpectedly intimate, of his chest against my back as he leant towards me from behind and said: 'Hold the pistol-grip quite firmly; and just squeeze the trigger; don't pull, squeeze . . .'

I squeezed. There was a boom and in the sudden shock of the recoil I was falling backwards towards him, the muzzles rising unstoppable in recoil, the lava sand erupting in a black explosion where the bullet struck the dune eighty yards away. I was filled with the knowledge of unthinkable power; and he simply caught me against his body, hard, unyielding, and held me momentarily. I turned, confused by the noise and recoil and an unknown sensation deep inside me that felt very like panic. He took the rifle from me and smiled down into my eyes and said: 'There. That wasn't so bad, was it? Now: let's see if you can hit anything.'

I stared at him. He reached out a finger and touched my cheekbone and said: 'You'll have a bit of a bruise there, come morning. The stock whacked you. But it'll look quite becoming; mar that perfect beauty just a bit. Make you mortal.'

We sent the telegrams from the small post office in Maleleji. Two sweating tellers worked without speaking behind a worn counter. The ceiling fan was motionless, its mechanism long fallen into disrepair: cobwebs bound it to the ceiling. There was a queue. Local businessmen in shiny black suits, frayed white shirts and thin ties; smiling Indian traders who owned the dukas, their wives shimmering brilliantly in saris, eyes kohl-lined; blonde Scandinavian girls with pale eyes and skin, homemade leather sandals, dirty kikois and thin bearded boyfriends with unwashed feet; and young

backpackers who'd convinced themselves that they'd penetrated the complex mysteries of Africa by smoking an excess of marijuana and chewing khat.[15] They wore mass-produced beaded wristlets entirely devoid of chthonic power they'd bought at local markets under the mistaken and optimistic impression that they'd thereby be protected from evil.

We bought fresh vegetables from the rowdy market, tinned jam and bottled pickles from the dukas. Tregallion insisted on buying a case of Tusker beer from the local bar, a white-painted hovel with a motor car speaker wired to one wall. Reggae and an overflowing dustbin, a pye-dog asleep in the thin shade and a one-legged drunk snoring in the dust, his wooden crutch tied to his wrist to prevent theft. A hand-painted red and blue sign nailed above the door said: 'That London Hotel'. It was dark inside and music shrieked loudly, all semblance of melody suppressed by the broken speaker and the volume. The local whore, a wide-hipped girl in a loose blue shift with massive breasts and back-combed hair dyed ginger at the ends, propositioned Tregallion and I saw him laugh and give her money. When we stood outside again in the sun and silence I said: 'Investment for later?'

Tregallion said: 'The malaya? She offered to do a private show for me and my "thin wife". How could I refuse?'

Albedo

The
World
of
Whiteness

Alchemy, like modern quantum physics, is no more or less than the projection onto inanimate matter of the contents of the unconscious in its efforts to achieve wholeness. In this process the union of the opposites — the female albedo or moon with the male rubedo or sun — in the mystery of conjunction was considered critically important.

Charles Young: Archetypes in the Primitive Psyche

The uroboric circularity that is so obvious in early descriptions of the alchemical process reveals that the searcher will be defeated in his attempts to peer into the mysterious workings of god's imagination, which will remain always unknown. The circular alchemical process: Albedo-Rubedo-Nigredo-Albedo — will repeat itself without end. Hence the image of the snake eating its tail.

Krystina Korcak-Dukowska: Quantum Reality: The Masks of the Gods

TWENTY-FIVE

... 'Tell them to chop carefully, Munyakai,' said Patterson sharply. 'The tusks are paper-thin where they sit between the eyes.'

Munyakai said 'Ndio' and spoke to the sweating bearers in Swahili. They rested on their long axes and listened attentively.

They were chopping out the tusks of the elephant that Janey had shot the day before and now, looking at the bulging grey mass of putrescent meat and dried blood, at the long-lashed eye covered with dust, Janey wondered at the sense of it all. And it wasn't just the elephant: Patterson was in a quiet controlled fury because Audley had proven without doubt, and in front of the black gunbearers, that he was a coward. He'd run from the elephant's charge; he'd fired wildly and nearly killed Patterson. It was unforgivable.

Patterson had woken her early and they'd mounted up in the cool air and ridden out ahead of Munyakai and the askaris. The pagazis with their spears and long axes had trailed along behind. Jamie was nowhere to be found. The gunbearers said he'd set off before dawn, hunting alone in the nyika. For a moment, staring at the dead elephant's eyeball, dusty, the pupil dilated until no iris showed, Janey felt a startling premonitory fear. As if she was not in control; as if she'd set in train by her infidelity with Patterson a series of events that were bound about by their own logic and which she could not ever control. She looked at the vultures clustered nearby in the acacia trees, their necks craned to see, their wings rustling like a taffeta evening gown.

'Nasty looking birds, aren't they,' said Patterson.

'Yes,' said Janey. 'Patterson — can't you talk to Jamie? Tell him it doesn't matter? He's in such an awful state.'

'No,' said Patterson shortly. 'My talking to him wouldn't help at all. And anyway, what I think is of no moment to Audley. It's what he thinks that matters.'

'That's not true, Patterson. You know that. You know how much Audley admires you and respects you.'

'Even now?' said Patterson drily. 'Even now?'

'Even now,' said Janey. 'You don't hear what he says in his sleep. I sleep with him. I do.'

'Yes,' said Patterson. 'You do,' and turned away.

Twenty miles away Jamie lay face down beneath a thorn tree, his body taut with anger and jealousy and a pain so intense it shook him like a fever. He cursed himself for his weakness, berated himself for his stupidity. Why had he run? The elephant dark and big, bulking before him . . . The tusk long and white, the little focused eye? Why? And now this: the way the boys looked at him, the pity and derision.

Jamie thought: I'll kill him. I'll shoot him in the back. I nearly did it when the elephant charged; if I hadn't been so scared, I'd have shot him there and then. I'll kill him quietly and bury him or feed him to the crocs or leave him for the lions and vultures and hyenas. He'll be gone inside a day and a night. Less.

There was a sudden rumble and thud of hooves. Jamie sat up, watched a herd of zebra gallop in a small khaki dustcloud into the distant treeline. Once there, they turned and looked back. What had alarmed them? He scanned the bush through his binoculars, saw a lioness amble lazy-shanked from behind a thornbush. He watched her in silence, thinking: No, I'll not kill him myself; I'll pay one of the bearers to kill him by magic. Away from camp, out in the nyika. In the middle of nowhere. I'll kill him by proxy.

★

When we reached camp in the late afternoon, John Morton was waiting for me in the dining tent, looking uncomfortable in a shining set of new khakis. Chinta was there too, pouring tea and looking inscrutable. A folded fax lay on the table beside him.

'Hello, Kathryn,' said Morton. 'I've come to give you a hand.'

I introduced Tregallion, who sat and poured tea, handed me a cup. He examined Morton carefully.

'When did you get in?'

'Oh, half an hour ago. I left as soon as I got your letter about your fossils. Which I must tell you I've not yet been permitted to see,' he added, glancing at Chinta who looked more inscrutable than ever. 'Ray here said we should wait for you since you'd made all the most important finds.' It hurt him to say it.

'There's time,' I said. 'How's your dig?'

He shrugged. 'We've had some problems, nothing major. Fever amongst the workers; that visiting chap from Illinois, I think you know him? Mike Oehler?'

'The climate man?'

'Yes. He came down with something or other and ended up in intensive care. We had one cave-in.' He smiled deprecatingly. 'Of course, the workers started talking about a curse: complete superstition! Azazelsgat: "The Devil's Cave"; what nonsense! There'll be some perfectly rational explanation, of course.'

'Of course,' echoed Tregallion.

'I hear you had a bit of trouble, too,' said Morton, lighting his pipe.

'A bit,' I said. 'Shifta. We've just been to Maleleji to send telegrams to the media announcing the finds.'

Morton frowned. 'Don't you think you've been a little hasty? Surely you should have waited for my OK? And what about the dating? How can you announce without solid dating?'

'Why should I wait for your permission, John?' I said quietly.

'Well; I'm your superior at the museum; you should confer with me before announcing. It's simply a matter of manners and protocol.' Chinta and Tregallion and I stared at him. He glanced at the three of us in turn, smiled hesitantly and said: 'I mean, I'm your boss; I'll have to co-author your papers, at the very least. Ideally, as your immediate superior, I should assume control and author the initial description, and make the media announcements.'

Chinta said softly: 'I don't think that's quite true.'

Morton turned to him. 'Why not? Why shouldn't I be involved? I'm her boss.'

'But you're not mine,' said Chinta. 'And you seem to forget that this dig has nothing to do with you, or your museum. It's funded and run by the Museum of Man, of which I'm an employee, and I have nothing but respect and admiration for Kathryn's professionalism and integrity. I cannot think she needs any assistance from you or anyone else in the preparation of her papers for publication. Further, I am in charge of the dig here, and I will decide who does what and when.'

Morton said: 'But —'

'And as for the dating,' Chinta went on, ignoring him, 'Seremai brought back faxes that were waiting for us at the poste restante in Marsabit. They're from Garth Tucher at Cambridge and Cathy Cohen at Cleveland.' He unfolded the faxes that lay on the table. 'They fix the date of our Bed Two, where we found both fossil skeletons, at around four point seven million years before present.' He smiled at me.

John Morton stared at him open-mouthed. 'What? What?'

'You've made,' said Chinta to me, 'the single most important fossil find this century. The oldest human ancestor ever discovered. Congratulations!'

'Rich and famous?' I said.

'Rich and famous!'

'Wait a minute —' said John Morton.

'What shall we call it?' said Chinta. 'Australopithecus widdensis?'

'Southern ape of Widd? Please!' I said.

'Well, what then?'

'Before we decide we should really consult with the international authorities on nomenclature,' said Morton.

'Yes, yes,' said Chinta. 'Of course we will.'

'How about Australopithecus malelejensis,' said Tregallion softly.

'Malelejensis? It's a mouthful,' I said.

'I like it,' said Chinta.

'Yes,' I said. 'I do too. Southern ape from the Place of Uncertain Winds. I like that.'

And that's what we called it.

<div align="center">★</div>

The world's media began to arrive the following week, escorted by a detachment of the Kenyan army commanded by a spruce young captain called Okumi who told us he'd been trained at Sandhurst. At first the press came in four-wheel drives, later in helicopters once the army had laid out a pierced steel plate chopper pad in the soft sand. They brought generators and tents, portable toilets and free-standing gazebos. They brought cameras and lights and tape

<div align="center">237</div>

recorders and notebooks. The army dug weapons pits and sandbagged foxholes and mounted machine guns and posted sentries and guarded us. Tregallion and Seremai quickly disappeared into the desert without saying goodbye.

I said nothing to anyone of my own thoughts about the fossils and their meaning. Chinta called a press conference and announced the fossils, explained the implications and emphasised our tentative conclusions, pointed out that excavations were continuing. Chinta very generously introduced me as the discoverer of the fossils and the journalists seemed intrigued and delighted that I was a woman and that I'd survived an attack by shifta. Early, the less scrupulous media seized on the shifta attack and the antiquity of the fossils; you may remember the appalling headline: 'Battling Beauty Finds Adam And Eve'.

The cowardliness and brutality of the attack were emphasised; we were presented as innocent, almost naive scientists engaged selflessly in the process of 'lifting the veil of human ignorance', victims of a lightning strike by crazed Muslim fundamentalists. Dark implications of near-rape and bloodletting were made. There were guarded references to my sinisterly scarred leg. Tregallion had been spotted by the journalist from *Homemaker Monthly* before he escaped and he was referred to as 'the dark explorer with the film-star good looks who fears nothing but the limelight'. Attempts were made to link us romantically. Yet even the most cynical of the journalists, and those cool professionals whose skills I respected, were eventually impressed. They asked acute questions, understood the implications, wrote good stories. They were a pleasure to talk to.

John Morton hung around the fringes of the media, trying to make friends and being rebuffed. I heard one exchange and took pity on him:

JOHN MORTON: Let me tell you, one must be extremely cautious in assigning significance to fossil finds whose taxonomy has not yet been firmly established —

TIRED JOURNALIST: Who are you?

JM: John Morton, research director of the —

TJ: Are you disputing the interpretation of the finds?

JM: Not exactly, I —

TJ: Do you dispute the dating?

JM: Not at all; I —

TJ: Did you find any of these fossils?

JM: Not exactly; but I —

TJ: Do you work here at the dig?

JM: No, not exactly, no; but I —

At a press briefing the next day I introduced him as my boss from
Johannesburg and he seized the microphone and began a haranguing
lecture on hominid taxonomy of such complexity the majority of the
journalists left the tent and the stringer from *Homemaker Monthly*
actually fell asleep in her chair.

The International Nature Trust, always happy to fund a project
once all the hard work had already been done and media exposure
was certain, offered a generous grant which we happily accepted and
featured a photograph of me holding the two now-famous crania on
the cover of their popular magazine. Two publishers from New
York sent faxes offering large advances for a book of memoirs (one
of which I accepted) and ATV in London sent a contract for a ten-
part series on human evolution starring me as narrator. The
tentative title was: 'Widd's Ancient World: The Ancestors of Man'.
Time and *Newsweek* both adopted us and Chinta and I appeared
together on their covers.

Then, as swiftly as they'd arrived, they were all gone and we tidied
up the mess, buried the rubbish and settled back to the grind of

239

excavating fossils. John Morton didn't leave with them. He'd unwisely pitched a small hiker's tent downwind of the latrines and insisted at first on following me to the fossil site each morning. At first: Quasimodo had transferred her hatred from Orde and Victor to John and ambushed him relentlessly, voiding a smelly stream of pip-like turds onto his boots at every opportunity. Eventually, you knew when John was near because of the awful smell. After a series of daredevil ambushes by Quasimodo he took to pottering about alone with his geologist's hammer at a safe distance, tapping disconsolately at pale tuffs and uncovering dozens of rock-rabbit fossils which he continually mistook for those of important marker-tuff pigs.

Tregallion returned but made no comment about his absence. He and Seremai pitched in and worked side by side with us doing the heavy work: digging, shovelling, sieving. At night, we picked away at our fossils in the gas-lit work tent. Oriana Talmadge and Grenville sent a note in the care of their servant Amman, who arrived dressed in a long white robe cinched in at the waist by a wide belt into which he'd stuck a curved dagger with a jewelled hilt and scabbard. An ancient silver-inlaid muzzle-loading jezail was propped beside the driver's seat. I saw him and Orde deep in conversation beside Oriana's old but immaculate dark green Land Rover while he waited for my reply to the note, which read:

Dear Kathryn,

We were both delighted to hear on the wireless of your discoveries (BBC Overseas Service and a very interesting programme too) and would love to see you again and hear of your adventures first hand.

Perhaps we could come down and visit the site? Of course, we don't wish to intrude or interfere with your work in any way, but we would love to see you.

Send a reply when it suits you.

Yours,

Oriana and Grenville.

There was a PS in Oriana's hand: 'Have you discovered anything new about Patterson?'

I wrote a note inviting them to visit us whenever they wanted to. When I handed this to him, Amman bowed, hid the letter deep inside his robe next to his skin, tightened his belt and said solemnly: 'Do not fear, my lady. Your message will not fall into the hands of the infidels. Farewell.'

Captain Okumi insisted that we all have firearms training. He set up a two hundred yard shooting range amongst the dunes, his men erected targets and we were summoned early one morning to the dining tent where a thin weapons expert called Sergeant Ugaya introduced us to the Army's issue weapon, the FN automatic rifle, and exposed us relentlessly to Soviet-bloc weapons until we could identify RPGs and Degtyarev machine guns with ease.

On the range, Orde, Seremai and Tregallion scored so consistently well with the unfamiliar FN rifles that Okumi hastily excused them from target practice on the grounds that their continued participation would be a waste of ammunition. Chinta regarded the weapons with distaste but in time learnt to shoot competently. Oddly, Marion was a good shot and looked every inch a modern Valkyrie lying on the firing line: her blonde hair pulled back in a pony tail, her spread legs brown and slender in her khaki shorts. Sister Mary refused to take part and stared at the weapons training from a distance, her fingers pressed against her ears, her eyes squinting against the sun, a small sinister black-clad figure incongruous amongst the red dunes where the sound of gunfire echoed about her.

I found the FN clumsy and unbalanced after my father's shotgun and Tregallion's beautiful hand-made .470 but I'm reasonably co-ordinated and Sergeant Ugaya said I shot 'quite well for a woman', whatever that meant. Victor was hopeless. Clumsy when he should have been adept, it seemed his hands were controlled by an

antagonistic alien intelligence. After two 'accidental discharges' right on the firing line — one of which nearly emasculated Sergeant Ugaya — Okumi surrendered and declared himself satisfied.

Tregallion dismissed the FN as 'vulgar' and insisted I borrow his second rifle, a beautiful little .275 Rigby, for protection. This slim rifle was identical, he said, to that used by a famous elephant hunter called Bell to kill over a thousand elephant at the turn of the century; so I had 'no need to fear for its effectiveness on mere people'. Thorough as ever, he took me out into the desert one Sunday and taught me to shoot it. The recoil was slight and I found I could hit multiple targets quickly, working the bolt without lowering the rifle from my shoulder. Shortly after this he disappeared yet again into the desert without a word and I found I missed him more than before, more than I'd expected.

One evening I uncased my cello and played some scales to loosen my fingers and tune the instrument. Then I settled back in my camp chair outside my tent and played one of my favourite Bach solo cello pieces: the slow Sarabande from suite number one. It only takes about four minutes and I played it three times, getting the intonation and rather difficult fingering right the last time. When I listened to the last note die into silence I heard soft clapping. I raised my bow and opened my eyes. Seremai Smith was sitting on the ground in front of me. He clapped slowly, softly. 'Beautiful,' he said. 'Beautiful.'

'How long've you been there?'

'I arrived just as you started this last time. I heard you from my tent. Beautifully played, congratulations.'

'You must be tone deaf. Shall we have a drink?'

'Whisky?'

'Yes, I've got some Lagavulin. Will that do?'

We sat outside in my comfortable camp chairs and sipped our drinks and watched the stars. Seremai was very easy to be with; he never spoke unnecessarily and understood the value of silence. Eventually I said: 'Where's Tregallion?'

'Off in the desert. Or somewhere. He'll be back.'

'What do the two of you do in the desert all the time?'

'We talk. We argue. We shoot a bit for the pot, birds; we take photographs. Tregallion writes.'

'And for money?'

'I've got a private income; and Tregallion made a lot of money as a professional hunter for a while.'

'Here? I thought all hunting was banned here.'

'It is. He used to hunt in Tanzania and Botswana. He had clients who came back every year. He's very good. Then he took out celebrities on photographic safaris for a while; then he did ecosafaris, but realised the people weren't really interested in trees or the lifecycle of a dung beetle; they just wanted to see lions and leopards and elephants. And of course, The Kill. They all wanted to see The Kill, so he chucked it and now we do nothing.'

'Does he ever take women away?'

'No.'

'Do you?'

'Sometimes,' he smiled. 'Why?'

'He's not gay, is he?'

'Tregallion? Never. At one time he was the most unrepentant poon hound I ever saw.'

'But not any more? That's a disgusting phrase.'

'Yes, it is. Not any more.'

'Celibate?'

'Celibate.'

'Why does he go off like this all alone?'

There was a long silence. Finally he said: 'Tregallion's not very at ease with himself.'

'Why not?'

I heard Seremai chuckle in the dark. 'This is very difficult to say —'

'Why?'

'He's my friend; I don't want to betray his secrets.'

'I'm not asking you to.'

'No. Perhaps — Look, Tregallion's a strange man. He has a kind of closeness to the bush that goes beyond pleasure. It's as though he intuits his unity with the whole cosmos through the intimacy he feels when he's in the bush. There's a place he found nearby —'

'Nearby here?'

'Yes. It's a crater lake and he goes off there sometimes to be alone. He's never taken me there, never taken anyone there.'

'Why not?'

Another long pause. Then: 'Because he says he saw God there.' It was impossible to miss the irony in Seremai's voice.

'You don't believe him?'

'Oh, I believe him. It's true enough, for him. But I'm a scientist: I need proof. I believe there's a discontinuity between the "real world" and the world of our mental images. Tregallion's vision of

God may've been the product of a deep internal longing; but he behaves as though it was a real phenomenon.'

'But surely —'

'Yes, I know it's fashionable to declare there's no differentiation between the phenomena of the mind and what's "out there". I'm saying that it was real for Tregallion, but not for me.'

'What happened?'

'To Tregallion? He simply encountered God, apparently. The way he describes it, it was as a kind of complex, very passionate aesthetic knowledge — like seeing a great painting or hearing a great piece of music. Things seen or heard so deeply that you are the music while the music lasts. Eliot.'

'Yes.'

'The trouble is, it's never happened ever again. You know, for a long time he had a quote from Gerard Manley Hopkins on his pinboard: something about the world being charged with the grandeur of God. But he doesn't feel the grandeur or the immanence of God all the time. Not at all. Sometimes, on his worst days, I think he imagines a sort of gung-ho God, all piss-and-vinegar like a B-movie Marine colonel eager to napalm Vietcong villagers and their pet pigs. Vulgar. So —'

'So he wanders in the desert.'

'So he wanders in the desert. He's a sceptic; he's disappointed: he hopes his vision wasn't just an excess of biophiliac joy brought on by visiting the place he loves so much.'

'Perhaps that's what God is,' I said, unthinking.

'I doubt it,' said Seremai. 'If there is a God.'

'Do you think there's not?'

'For me the existence of God would be proven if I could understand the mechanism that drives the cosmos. That means mathematics. But I gave that up at Cambridge because it seemed to me that the sequence of mathematical proof or inference that would terminate in understanding is finite; it's unable to be completed. I'd never know.'

'There's that question in Martin Heidegger —'

'Something about "Why is there anything at all rather than nothing"?'

'Yes —'

'You mustn't ask that question.'

'Don't be stupid. Why not?'

'What's the point of asking a question you can't answer? All metaphysical questions are meaningless because they're unanswerable. Don't ask them.'

<p style="text-align:center">★</p>

It was at this time that I suddenly became overpowered by the vacancy and silence and vastness of the desert. It was not mere agoraphobia; I felt the constant oppression of the dryness, the lack of fruition, the sterile abiotic silence and the absence of lushness deep inside my psyche and began to get snappy and irritable. There were no gods here.

I missed the places of my youth. I missed the Santa Cruz landscape that had always seemed alive with a running vein of fire, the trees rooted in abundance, drinking in sun and sky and air. I wanted to hear the calls of a dozen birds whose names I did not know; I wanted to feel a thick wet ocean wind against my face; I wanted to touch a tree trunk — never cold, even in the rains — and feel the sap vibrate against my touch like a lover's tongue. I wanted to see pod mahogany trees with their great spreading crowns ride the first high summer rainwind; I wanted to hear tamboti pods snap open in the

sun with a sound like the tentative crackling of fire on dry kindling. I wanted a little biophiliac delight; I did not want this deprivation of the senses; this black, sterile, windscoured, sandtorn, sunrent dead zone of the flesh and spirit. Above all, I wanted rain.

Tregallion noticed it first. We were working late in the tent and Chinta made some perfectly innocent remark and I snapped at him. He gazed at me in dismay. I put down my dental pick, walked over to him, put my arms round him and said: 'I'm sorry, Chinta. I'm sorry. I think it's the heat.'

'I think we need a break,' said Tregallion. 'Let's go away tomorrow for the day. For a week.'

'I think I need a drink,' I said.

'Good idea,' said Chinta. 'Both. Let's have a drink, and why not go away tomorrow for a week? I'll look after the dig.'

'I'm sorry I snapped at you, Chinta. You know I don't mean it.'

'Forget it. It's probably those shifta. They'd make anyone ratty.'

It was still dark when I woke. I packed Tregallion's little Rigby and a small backpack, bathed shivering in cold water and walked in the darkness to Tregallion's tent. I knocked on the tent pole but there was no reply. I pulled back the tent flap and called: 'Tregallion?' Silence. I hesitated, then entered his tent, thinking I might surprise him asleep. I switched on my torch. His camp bed was empty.

Inside, the tent was dark and cool. The groundsheet floor was covered with kelims the colour of garnets and dried blood. I switched off my torch. A Dietz lantern burned near his bedhead. I turned up the wick. His empty camp bed stood in the centre of the tent. A large pinboard was mounted on a blackboard stand close by. Feeling faintly guilty I walked closer and looked. There were clippings, scrawled notes, photographs. Three tarot cards — Death, The High Priestess and the Tower — were ranged beside a page torn from the Book of Job. A passage was ringed in red:

'...Then Satan answered the Lord, and said: Job refuses to deny thee for fear. And surely Job doth not fear God for nought?...But put forth thine hand now, and damage all he hath, and he will curse thee to thy face.

'And the Lord said unto Satan, Behold, all that he hath is in thy power; damage it as you wish; only upon himself put not forth thine hand. So Satan went forth from the presence of the Lord and sought out Job for to lay waste his life in the name of God...'

Another piece of torn paper, pinned beside the extract from Job, said simply: 'I am Outis.' Outis? Outis? Who or what was Outis? Beside this was pinned another fragment bearing the enigmatic question I'd discussed with Seremai: 'Why is there something rather than nothing?' He'd also torn the oracle's ancient injunction from a Latin textbook: 'Homo nosce te ipsum' : 'Man, know thyself'. Hard to do. A book lay on the low table by Tregallion's bed. I picked it up, found it was *Keraunos*, a collection subtitled *Thunderbolt for Pan* by Paul Morgan, the reclusive South African poet.[16] I'd read about him in *Bicamera*, where he'd been described, bathetically, as 'The Prophet of Loss'. A poem was marked. I read:

> You are my death and second coming, my birth
> And old age; you are galaxies time-dimmed spun on god's
> Still finger. No reach of sea streams with the power
> The subtle vortex your thighs enclose;
> And when I kiss your breasts
> I know at last the taste of opals veined with fire.

Poor Tregallion.

I examined his folding bookcase, found to my amazement a well-thumbed copy of Krystina Korcak-Dukowska's book, a complete set of Jung, including the rare *Seven Sermons to the Dead*; several books on ornithology, original works of philosophy — among them Herakleitos, my favourite; Hobbes, Schopenhauer, the *Critique of Pure Reason*, Heidegger, Henri Bergson and even Kierkegaard's

Letters to Felice — the collected poems of Hopkins, a treatise in Latin on Gnosticism and numerous popular books on palaeontology. I paged casually through Louis Leakey's book on Olduvai Gorge. A clipping fell from the pages and idly I unfolded it to be confronted by a photograph of myself at the head of an article I'd written about infant mortality amongst lions and australopithecines. I replaced it and returned the book to its place on the shelf.

Two open leather guncases lay on his bed. One held his rifle, the other a shotgun, their barrels gleaming black, their woodwork beautifully figured. I inhaled. The smell of musty leather and Young's .303 oil smelt exactly like my father's guncases. When he died, he left me his rifle and shotgun in his will but my mother gleefully sold them both for a fraction of their real worth, excusing herself on the wholly fabricated grounds of poverty. I touched a cold barrel, wondered if Patterson had grown out of the childish obsession with hunting that often deludes men into believing they're omnipotent; and remembered the way my father had hunted in Zululand. As Orde said: he hunted from his heart. When he went out to shoot for the pot he looked abstracted, as if passively awaiting the destiny of an antelope to intersect with his own. He did not hunt with aggressive male destructiveness; it was as if the animals surrendered themselves to him, as if death did not matter.

It was only then that I noticed Tregallion's etching. It hung in the darkness just outside the pool of light from my lantern.

I raised the lantern and stared. The etching was mounted inside non-reflective glass. An engraved plaque let into the wooden frame said: 'Study for "The Hanging Tree", 1620. Jacques Callot: 1592-1635. From the "Miseries of War" series, 1621.' There was a signature in the bottom left-hand corner beside the notation: 1/2. I stared. I'd never heard of Jacques Callot but I found the etching strangely moving: cool and composed but frightening in its calm observation of an act of terrible barbarism.

It was a beautiful midday in European summer: sunlit shadows fell directly beneath the tree. And the picture was well titled. In the

centre of the wide shallow etching stood a tree with two outstretched branches that reminded me of the great pod mahoganies you find in the sand forests of Zululand whose cantilevered branches swing out horizontally from the trunk and seem to defy the logic of mechanics and gravity. The branches of Callot's tree stretched out parallel to the ground and were bisected by the thick trunk.

In the distance was drawn up an army in good order: halberds, lances and pennants rose neatly skyward in disciplined ranks. There was a faint carnival air: tents had been pitched; particoloured flags waved gaily. Musketeers with shouldered wheel-locks stood watching from the left foreground; in the right foreground a bound man was comforted by a hooded priest. At the base of the tree stood several soldiers, at ease, their halberds held comfortably in relaxed hands. Their officers stood beside them, looking like D'Artagnan in their floppy musketeer hats, doublets and hose. Their rapiers were sheathed: they knew they had nothing to fear from this cowed band of raggle-taggle prisoners. They watched while a condemned man kneeling in deep shade pressed his bound hands together in prayer. A priest in monk's robes gave him absolution, blessing him with an upraised finger.

And there was no special hurry: the preparations were stately. At the base of the tree four soldiers rolled dice on a drumhead for the clothes of the executed which lay in an untidy discarded pile in the foreground. A tall ladder, braced against the trunk of the tree, bore a priest aloft. Above him the hangman fussily arranged a noose about the neck of a condemned man. The priest held up a crucifix towards him. It was difficult to see in the dark. I raised Tregallion's lantern and looked more closely. The man had clasped his hands before him in hopeless supplication, holding them out towards the priest and the proffered crucifix.

All this was both beautiful and horrifying. But it was the tree itself and its burden of dead that was so accusing. Callot was realistic in his observation, meticulous and controlled in his technique. There

was no intrusive point of view, no emotional excess, no passionate but tendentious moral outrage to compel agreement. Callot let the terrible image speak for itself. True, you could imagine Callot recording it all with pity and compassion; but recording coolly, nevertheless. His opinion was irrelevant; the image alone was damning enough.

From the wide-flung branches of the tree hung twenty men. Their heads were pitched forward in the broken-necked, chin-on-chest posture of the newly hanged. Noose-hauled backbones had humped the dead into concave-chested hunchbacks and some strange contraction of snapped neck, racked tendon and ligament had forced the men's straightened legs forward and outward. This strangling rictus had tautened their feet and they stretched out in sad parody of a male ballet dancer's pointed toes. It looked, I thought, as if the dead men were leaning archly forward in eternal contemplation of their toenails, Quasimodo marionettes watching their nailpolish dry.

Callot's realism was trenchant. You could feel the heat and smell the sweat, see the older corpses turning slowly in the wind while the newly dead still swung like rundown pendula, the result of their unbound legs searching wildly and hopelessly for a purchase on empty air while the noose slowly choked them. Dancing the jig of death, snaggle-toothed Elizabethan pirates called it, death's-head humour, chuckling unrepentant on the scaffold at Tyburn.

Death lasts forever but its onset can be uncertain. Dead hearts would settle slowly to immobility; faint ghostly firings of ganglia would shiver cardiac muscles with fibrillation to deceive the listening apothecary; the ladder-borne cleric, Bible and crucifix in hand, would harken earcocked for final rattling exhalations. Then muttered priestly benedictions, the tears and wailing of wives and lovers, sweethearts and mothers echoing unheard in dead ears; soldiers' laughter, drunken revelry beyond midnight, tin flutes and fifes, a little drumbeat in the dark and the slow-turning creak of the burdened ropes. At dawn the army would march on and the corpses

251

would be left to rot on the tree. No burial for the treasonous in those days. The summer flowers would bloom on, unimpressed.

And torments awaited them unimagined by swaggering lover and witty sage: sunblack and windswung, old men and youths, the ugly and the lovely would all be mummified flesh together, cotton hose disfigured by faeces and semen, contused tongues poked out blue and mauve between clenched teeth, all hung up like sundried beeves. Skullbone showing maggot white in the midday sunlight; rain-washed vertebrae pulled through the flesh of necks by raw hemp showing skinflecked like oxtail bones. Sharp-billed rooks and carrion kites from the Russian steppes would come rustle-winged to peck dead eyes from their sockets; the small relentless nibbling of ants by day, needle teeth of rats by night, beetles and maggots, torment without end. Men die, we women mourn. What a sight to unsettle the devout. I turned down the lamp, went outside and wondered about our capacity for vengeance and cruelty. I was still deep in thought when Tregallion walked from the shower tent a few minutes later.

'How are you, Miss Widd?'

'Don't call me Miss Widd, you know I hate it. How did you sleep?'

'Like the dead.' He collected his bag and the two guncases and said: 'Shall we go?'

We drove out of camp while it was still dark. The army sentries waved us goodbye in the low light before dawn proper and I watched ahead of us the dunes that seemed massless and dimensionless: paper cutouts placed one in front of another unchanging, unmodulated, bleak all the way to the horizon. Tregallion glanced at me and said: 'You're very quiet.'

'Am I? I'm sorry, I don't mean to be.' I couldn't very well tell him I'd been upset by his etching of 'The Hanging Tree' while snooping inside his tent. 'Where are we going?' I asked.

'Wait and see.'

'Where?'

'Somewhere nice. A garden. An enchanted garden.'

'Whose garden?'

'Whose garden?' He pondered this. Then: 'God's garden.'

★

Four rivers drained into the lake which lay placid and unruffled in a wide volcanic crater way out in the black vastness of the stone-cracked, sun-riven desert far from Maleleji, our Place of Uncertain Winds.

We stood beside our Land Rover on the windy heights above the lake and looked down three thousand feet to its calm surface. The climb by Land Rover from the desert had been slow and laborious. Earlier, we'd passed a group of singing Boran warriors raising water in giraffe-hide buckets from a permanent well on the eastern side of the mountain and bought a large hessian sack of hardwood charcoal from a toothless old woodburner who squatted unspeaking by the side of the track. Why he sat there I can't imagine; there was no busy thoroughfare. Tregallion said he'd dug and hammered the road out of the rock all by himself and it was really no road to speak of. A passing traveller, unknowing, would miss it. But when you stopped and looked for it, it was there, as inescapable as moonrise. You had to believe in its existence to see it. Yet the charcoal burner sat there patiently day after day, waiting for travellers who did not pass.

A small bird with a pinkish beak and a black headband flew around us. 'Masked lark,' said Tregallion. 'You only find them here in the lava desert.' The wind lifted my hair, dropped it again about my shoulders. Tregallion touched it lightly, let it fall.

'Like a dark halo,' he said, and smiled at me. I shivered. The wind was not cold; there was something else.

253

'I found this place by accident,' said Tregallion. 'I'd been wandering in the desert for months, looking. I knew it had to be there, somewhere. And one day I left the car below and just walked up the side of the mountain and there it was. The Boran won't come here.'

'Why not?'

'I've never found out. They're very evasive.'

'And this is it? The enchanted garden?'

'Yes.'

'Can we go down?'

'Of course. Getting to the top's hard. From here on it's easy.'

We slowly bumped and shuddered our way down to the lake and as we drew closer, so the vegetation changed from desiccated succulents struggling to suck moisture from black rock to soft grass and finally, when we reached level ground beside the lake, to scented acacias and palms. I climbed out of the Land Rover and looked up. The palms stood erect and still beside the water. The air was humid, rich and thick on your skin. Weaverbirds fastidiously rejected nesting sites, a small dark falcon swung on pointed wings between the trees and butterflies fussed everywhere.

Tregallion watched me. I walked into the forest. There was a sweet scent on the air. I walked on, found its source: the mahogany trees were thick with small off-white blossom. I walked deeper. Sunlight penetrated the leaf canopy in shafts. Wild flowers wound about the treetrunks. I looked at them, touched one. Their petals were soft and white, caught in sunlight, flaming bright against the eye. I put both hands against the dark trunk of a mahogany tree, felt the bark coarse against my palms and for an instant the whole weight of the earth pulled down on me from deep in its core. The tree was rooted; momentarily, so was I. I turned to Tregallion to hide my surprise.

'What flowers are those?'

'The white ones? Anticleia. You don't find them anywhere else. Named after Odysseus's mother. Do you remember? When he went down into Hades, the place of the dead, to see her, she said to him: "Make haste back to the light." That whiteness reminded me of the light of the — what? — the here and now? In the middle of all that darkness.'

'How do you know all this?'

'I discovered the flower. The least I could do was name it.'

A swallowtailed kite flew high and elegant against the sky.

'Can we swim?'

'I'd be disappointed if we didn't.'

It was strange: I felt no self-consciousness about my leg or my nakedness in front of Tregallion. I saw him out of the corner of my eye as he stripped off his shorts and shirt, saw without looking the brownness of his sunburnt skin, the black hair curled mysterious and dark at the top of his thighs. The secret places, the softness and mystery there. He ran down the narrow beach, hit the water in a flat hard dive and then I was with him, the water velvet, silken on my skin, cool but not cold, its touch on my body as familiar as sunlight; as if, in fact, it had been waiting to touch me forever.

TWENTY-SIX

When we'd unpacked the Land Rover I handed Tregallion Patterson's two books, the unopened packet of court transcripts and Oriana's manuscript. 'Please will you read these? I need an objective opinion.'

'Of course. What about?' He looked curiously at the books and at Oriana's manuscript and raised his eyebrows at me.

'Unsolved mysteries,' I said.

He smiled, nodded. 'And of course you're Mercurius, the Eternal Seeker. No mystery too complex for your penetrating mind, no clue too obscure.'

'Just read the books, Tregallion.'

'My grandfather knew Patterson,' he said. 'Slightly. And I read this one, *The Maneaters of Tsavo*, when I was a boy. Good adventure stuff.'

'The other is good murder stuff, too,' I said. 'Or suicide.'

'Is that so?' he said, paging through *Nyika* with interest.

Towards dusk I found thin lichen-encrusted twigs at the feet of the flowering acacias, broke thick dry branches from a dead monkey-thorn that had fallen nearby. I lit dry grass, fed twigs, knelt by the fire and blew on the small sparks until the thicker kindling took and flamed suddenly with a soft pop. I carefully placed bigger pieces of thornwood on the flames. The burning lichen smelt salty when it burnt, exactly as it had when I was young, camped with my father in the sand forest beyond the Ubombo on the seaward side of the vast

Makhatini flats where the elephant bulls came quietly at night from Mozambique to forage on the sweet grass around our tent on the banks of a nameless river.

'You seem very at home,' said Tregallion, tapping tent pegs into the firm soil. He'd laid the tent out flat after inserting the tent poles.

I hammered at my tent peg. How could I tell him that when I was in the bush I felt that until that moment I'd been a darkened house and that all my curtains had suddenly been opened so that my every room was flooded with sunlight? Except the basement, of course. There should be no sunlight in the basement. I did not say this. I simply said: 'I am. My father often took me camping in Zululand. Similar trees.'

'Tell me about him.'

'He was a vet in northern Zululand, and I grew up going round the bush with him. There was tryps — sleeping sickness?'

'Nagana.'

'— Nagana — in the cattle on the Mozambique border then and he was doing research there. I loved him. He died of cancer.'

Tregallion said nothing. For the first time in years I thought of my father lying in the ward where he'd died: sunlight and fresh cut flowers, the view of the flame tree with blossom that burnt incandescent red against the summer sky. The bedpans and catheters; the narrow bed, my father curled up small in sleep, deadened by morphia. He'd been a big man before, but the tumour was relentless and he was ground away by pain.

'I loved him,' I said.

Tregallion nodded. 'How old were you?'

'In my twenties.'

'Hard.'

I shrugged. He stood, looked skywards. Windblown clouds swelled together overhead. 'Ready?'

He pulled on the guyropes and the tent rose up. I hooked the ropes on my side over the tent pegs, pulled them taut, ran round and secured the ropes on his side. The tent stood erect and tall. Tregallion smiled at me. I tightened the guyropes that secured the two tent poles, looked with pleasure at the taut canvas.

'It's a good tent,' I said.

'Yes.' He pointed. 'That patch there: a friend of mine was taken by a lion through the side of the tent; I bought it and patched it. Do you mind?'

'Not at all.'

Tregallion had brought a three-legged pot and a deep frying pan with a long handle, thin camping mattresses, two mosquito nets, a kettle, a camp bath, a small gas freezer and a coolbox. We ate simply that night: mposho meal cooked in the three-legged pot and thinly sliced pieces of guineafowl simmered on the coals in the pan with tomato and onion. At ten Tregallion yawned, stretched. 'You take the tent,' he said. 'I'll sleep by the fire tonight. We'll pitch the other tent tomorrow.'

I looked up. The clouds had built into flat-topped umbrella thorn masses that shone white in the light of the risen moon. As I watched, lightning quivered incandescent right inside the clouds, showing purple and contused in the night. I could smell the coming rain; the air had cooled; the night was inexplicably still. Tregallion watched sardonically as I packed dry firewood under the overhang of the tentfly. When I looked again, the sky was filled with cloud.

'What about rain?' I said.

He glanced up at the sky, shrugged. 'It never rains this time of the year; it just looks threatening.'

'OK,' I said. 'I'll take the tent. Sleep well.'

★

The rain came at midnight.

I heard thunder like the voice of a god inside my head; woke into silence. I lay and listened. Then, without warning, the rain fell. The thin sheath of cotton canvas vibrated with the impact of falling water. The thunder came again, wrathlike, grinding the air. The rain fell harder. The violence was trenchant. I crawled from my sleeping bag, stomach taut with ancient fear, pulled back the tent flap, looked out. The rain swayed, squall-driven. Stacked clouds ran heaven-high before the wind. Lightning ignited again and there in the middle of the beach I saw Tregallion dancing in the rain, naked, arms upstretched to encompass the sky, embrace the thunderbolts; a muscled figure incandescent at nighttime in the flickering light, a fugue made flesh.

Lightning struck the earth again, a gentian flame in the darkness. I smelt burning ozone. The thunder seemed not a thing of air, incorporeal, but as if it rose up from deep within the earth, a subterranean rote of gneissic rock. Clouds swept like bats' wings across the moon. The rain fell on.

'Tregallion!' I called. 'Tregallion; come in here. You'll be killed!' But he heard nothing, danced on, stupid bastard. I pulled on my rainjacket and ran from the tent, terrified by the storm that erupted discordant all around. The whole earth was disrupted by primordial anger: air, wind, rain, the lake waves, the entire cosmos out of joint.

The lightning struck again; mauve electric traces lingered on the retina. From behind, caught in sudden light, Tregallion seemed almost a mythical creature, faunlike, part ancient satyr, part idealised Greek warrior, part ancestral ape. His buttocks were clenched with the effort of his dancing, long smooth muscles paralleling the indentation of his knobbled backbone, calves tensed with the energy that drove his elastic leaps and inept jetés. He was

no dancer; but his movements had a pure barbaric charm that matched the brutality of the storm. I ran up to him, took his arm. He turned to me, eyes laughing with delight. Perhaps he was drunk.

'What a storm! What a storm!'

'Don't be a bloody fool,' I shouted over the rushing wind. 'Come into the tent, you'll be killed out here.'

A ringing thunderstone of light struck the lake and convinced him. The rain fell harder. In the lightning I saw that he wore round his neck a thong from which hung two pieces of bone: a spearpoint-shaped fragment and another that looked like half a wishbone. I pulled his arm. 'Come!'

Inside my tent he suddenly shivered and I handed him my spare towel.

'Thank you, Miss Widd,' he said. His eyes were laughing.

I lit a paraffin lantern and turned up the flame. I was too wet and cold for modesty. I found my towel, turned my back on Tregallion, stripped off my rainjacket and, naked, began to dry myself. I felt him watching me. 'Stop staring and come to bed,' I said.

'Yes, Miss Widd.'

'Not like that,' I said and climbed into my sleeping bag. 'There's a blanket in my bag. You can use that.'

'Chimps celebrate thunderstorms,' he said, towelling vigorously. 'Why shouldn't I?'

'Because you're a risen ape not a fallen chimp,' I said.

'Have you got any whisky?'

'In my bag. Help yourself.'

He poured a tot of Lagavulin into a tin mug, bled cool water from the condensation bag, sipped, smiled. He was still naked. I decided not to look at him.

'Can I pour one for you?'

'Please.'

Outside, the storm tumbled air and rain together in a tumult. The tent heaved in the wind. 'I'd better check the guyropes,' I said and unzipped the sleeping bag. He handed me my whisky.

'Let's not bother with that,' he said. 'Let's leave it to the daemons. Chance?' He raised his glass to me, still naked. 'The thunderbolt steers all!'

'You'll get cold,' I said. 'Use the blanket.'

He bent to my bag, darkness in the shadows between his thighs, mystery. I looked away. His maleness was intrusive, demanding attention. I resented the casual power in his body, the indolent, arrogant assumption of physical competence, the palpable reserve of strength I could see in the curve of his thighs and chest. If he'd been younger it would have been vulgar; but his was no longer the enchanting untested arrogance of youth. There was humility in the way he moved. I could see scar tissue and the worn edge of lined skin and gnarled knees. Hard living had exacted a price.

I sipped my whisky and watched him. I had not slept with a man for a very long time and the memory of Marion was still painful. Tregallion wrapped himself in my spare blanket, lay down uncomplaining on the hard groundsheet, wriggled himself into a comfortable position near me. The tent was filled with saffron light from the oil lamp. The rain thrummed steadily on the canvas but the wind had dropped. There were no gusts now; a cool steady pressure from the lake inflated the tent wall like a sail and troubled the oil lamp. Shadows flickered against the cotton ceiling. Tregallion lay on his back and stared up at them and said: 'Do you know that passage in Plato, that bit in the *Republic* where he describes our knowledge

of the phenomenal world as shadows thrown on a cave wall by sunlight outside? Thrown by ideal objects we can't see?'

'Yes.'

Silence. Then I said: 'Who is "Outis"?'

Silence. He said: 'You were in my tent?'

'Yes. I'm sorry.'

He ignored this, said: 'In the *Odyssey*, when Odysseus escapes from the cave of Polyphemus, the one-eyed giant, he calls himself "Outis" — "Noman".'

'Why do you call yourself Outis?'

He sighed. 'What you saw in my tent, that's really only for my eyes, but since you ask: I fear we're all Noman in the eyes of our dear invisible God. The absentee landlord.'

'And that thing about why is there —'

'Why is there something rather than nothing?'

'Yes.'

'I think that's the opposite of being Outis; I think about those things all the time. Seremai says I shouldn't ask those questions because there's no answer. One hand...'

'How did you meet Seremai?'

'I've known him my whole life. Almost. He's a bit younger than me. He's the son of the son of my grandfather's assistant preacher.'

'Complicated.'

'Not really. My grandfather came out to Africa from England at the turn of the century with the London Missionary Society. But he fell in love with the country and out of love with God and decided to

farm instead. But God waxed exceeding wrath at his intentions being thwarted and had his revenge: rust got the wheat and anthrax got the cattle and to this day only God knows what got the sheep so my grandfather thought he ought to appease the good Lord. He took his Bible and his hymn book and went north to the Lado Enclave between Uganda and the Sudan when all the elephant hunters moved there. Lawless place. He started out preaching but no one was interested and anyway he liked elephant hunting much more than singing hymns and saving souls. He made his fortune like they all did then, shooting elephants for their tusks. Awful, really.'

'What's that got to do with Seremai?'

'My father had a lay preacher with him, Kariuki — Seremai's grandfather. He discovered that serving N'gai was a lot less rewarding than hunting elephants with my grandfather. He was a tracker, really: he was killed by an elephant up in the Lado. My grandfather promised Kariuki he'd look after his son and that his son — my father — would do the same. Seremai and I were educated on foul gains from ivory hunting. All the money was in trust. Just as well; my father was useless, never earned a penny in his life. He used to get drunk in the bar of the Muthaiga Club in Nairobi and in the Norfolk and pretend he was a Great White Hunter and try to sleep with gullible tourists. He took out a licence every year and shot the odd elephant, poached the odd buffalo, drank it all away. He's dead, now.'

'Cirrhosis.'

'No. He drowned one night in a puddle four inches deep outside his bedroom at the Blue Posts hotel in Nyeri during the long rains in nineteen seventy-five.'

'Drunk?'

'Drunk.'

'And your mother?'

263

'Elizabeth. She was apparently very beautiful but I don't remember her; she died from blackwater fever when I was three.'

'And the farm?'

'Still there. The house burnt down one year but Kenyatta didn't appropriate it. I never go there now. There're some peasant farmers on it now, banana shambas.'

'And how do you know Oriana?'

'Questions, questions, questions.'

'But how do you know them?'

'My grandfather knew their family in England. When they came out to Africa, they stayed friendly. They're my sort of African family. Mother and father.'

'Grenville's gay, isn't he?'

'Yes.'

'How did you find out?'

'We had an American student here for a while who was gay. He was doing a graduate thesis on the incidence of homosexuality amongst the local tribes which took a sudden leap when he arrived. A case of observation interfering with the experiment? How did you know?'

I thought about Orde and Grenville, their flaccid erections, the vacant evacuated scrota, the plaintive touching, but just said: 'I guessed. And you wander in the desert?'

'I wander in the desert.'

'Why?'

'I need to.'

'And why do you dance? That was very silly, you know, in the lightning. Why do you dance?'

'All these questions!'

'Why?'

'Seremai is an astrophysicist,' he said reluctantly. 'A theoretician. He's logical, addicted to elegant mathematics, trapped by his fear of imagining. He's in great pain, run through by his refusal to speculate. He's like a beautiful butterfly on a pin. He knows there's more, but he can't prove it, so he can't believe. I love him, he's the opposite of me, but I can't be like him. I have to dance as a sort of counterpoise to a world that's gone mad with the power of its rationality. Does this make sense? I've never tried to say it before.'

'Go on.'

He sighed again. 'I can't explain it. It's as if I'm lived by forces I don't understand. I dance them, I don't analyse them.' Impatiently he said: 'It's a form of prayer.'

'To the absentee landlord?'

He said nothing.

'Why do you have a photograph of me?'

'My, you have been thorough!'

'I'm sorry I pried. I didn't mean to.'

'I read that article of yours on death in lions — social predators — and australopithecus and I liked your mind. I thought you'd be the right person to work on an interesting ancestral skull if I ever found one. That's why I sent those fossil bits to Chinta.'

'But you couldn't know he'd contact me.'

'Not for sure, but Chinta's no idiot. I asked around. You have a reputation.'

'So I'm here because of you?'

'Yes. The arch-manipulator.'

'Why do you do it?'

'Manipulate?'

'No; walk around in the desert.'

'Nothing to tell.'

'There is, there must be. Look at you.'

He looked at me.

'Don't look at me like that,' I said. 'For God's sake: you wander around in the desert with a tracker who quotes Herakleitos and both of you listen to Bach at midnight and get drunk. What happened?'

'Nothing. I just got tired of the world.'

'And Seremai?'

'Him too.'

'Tired of what?'

He sighed and shook his head.

'Is that why you like that Jacques Callot etching of "The Hanging Tree"?'

'You saw that, too? Do you like it?'

'Very much. A bit too much, actually. It seems — I don't know — '

'Ah! I know — as if it's an etching of an actual event but at the same time — We all live at the base of the Hanging Tree waiting for death? I think you like it because it's our plight too, Kathryn. All of us. What's that line from Hopkins? "Goldengrove"? Yes: "It is the plight man was born for; it is Margaret you mourn for."'

266

'Yes. All that.'

'Do you really like it?'

'Yes.'

'I'll see if I can find you the other one. There're only two studies in the edition. Callot destroyed the plate afterwards. The final etching's in the Bibliothèque Nationale in Paris. I've seen it. It's just as moving.'

'Who was he? Is he famous?'

'Callot? No, not really. He lived through the Thirty Years War and did a series of etchings — a bit like Goya's later — called "The Miseries of War". Great compassion. Clear eye, don't you think? No sentimentality there. Totally unselfconscious; unlike "Guernica", which I completely hate. All that prefabricated passion.'

'Imagine a war thirty years long. What were they fighting about?'

'Didn't you do history?'

'No. Maths.'

'How awful for you. They were fighting about religion. Not about God, mind you; about religion. Protestant against Catholic. There were dead everywhere, right through Europe. Like Biafra. Or Rwanda. Or Chechnya. And don't forget the Hundred Years War.'

'A hundred years —'

'Exactly. Would you like a Callot? The other "Hanging Tree"? If I can find it?'

'Don't be absurd; I could never accept it. And anyway,' I said, to change the subject, 'what's that you wear round your neck?'

He touched the two pale pieces of bone and said shortly: 'Not a noose. It's thahu.'

'What's thahu?'

'Magic. Curses. Blessings. Thahu.'

'That's what baboons say: Thahu! Thahu! At least, that's what one said to me just the other day. But what bones are they?'

'Just bones.'

'Please tell me.'

'Not now.'

'When?'

'Perhaps never. Go to sleep.'

The wind gusted suddenly, fell quiet. We lay and listened. I sipped my whisky. The rain beat down on the canvas, the shadows of our little world danced on the walls and ceiling and I fell asleep softly, gently, unknowing, and woke with the silent dawn, Tregallion's arm tight about me, his head chaste beside mine on the pillow.

TWENTY-SEVEN

I wondered if he was gay. I moved slightly, looked at the wild dark curls, the cheekbones, his mouth. He'd made no attempt to sleep with me. He'd spoken with affection of Seremai. Were they lovers? The wind had died. Carefully I lifted Tregallion's heavy arm, unzipped the sleeping bag, dressed quietly, opened the tent flap and looked outside.

The sky was a dark hyacinth blue, sucked clean as a river pebble by the rain and the high night winds. A tentative bank of scumbled clouds slowly evaporated in the east. I lit a fire with the dry wood I'd stacked prudently beneath the tent flap, made coffee, filled a galvanised bucket with water from the lake and set it deep in the coals to heat for my morning bath. The lake was still. Hottentot teal paddled busily, burrowing amongst their tail feathers with wriggling bills. I listened to the birds: hadeda ibis, two combative redchested cuckoos, a coucal, a white-bellied loerie, a monotonous redfronted tinker barbet tapping metallically; and away in the trees, distant and faint, the tumbling minor-key arpeggio of a tambourine dove. I sat quietly in my camp chair and sipped my coffee.

The tent flap rustled and I turned to see Tregallion wrapped in a dark blue kikoi, his curls more tangled than ever, his chest broad and dark-matted. I looked at him, watched the way he whispered good morning, watched the way he bent to the coffee pot beside the fire. This is not fanciful: I could feel his whole being expand to encompass the sky, the lake, trees, the air and the birds. He walked up to me, his chipped enamel coffee mug in one hand, and put his arm around my shoulders and kissed the top of my head.

'Are you gay, Tregallion?' I said.

'Gay?'

'Yes.'

He sat in the other camp chair, his eyes alert, watchful and smiling, and said: 'Why do you ask?'

'Because — well; you know why. You didn't try.'

'And if I had? Would you have said no?'

'Yes.'

'Well then.'

'You couldn't know that.'

'Of course I could.'

'And Seremai?'

'Gay? Seremai?' He laughed. 'Seremai is the most unrepentant poon hound I've ever known. He's the only man I've ever known who's made love to a woman on a butcher's block.'

'Metaphorical?'

'Real. At our old safari camp at Kapembe in Zambia. Shall we swim?'

<p align="center">★</p>

We camped there for seven days and I felt all my tensions slip away and regained some of the peace I'd last known as a child. We pitched the second tent and Tregallion slept there, comfortingly close. He seemed not to notice my scarred leg at all. We read and swam and Tregallion taught me new birds that lived only in the rich tropical tree canopy of the paradise crater. He carried Patterson's books and Oriana's manuscript with him around camp and seemed especially fascinated by the transcripts of the Nairobi court of inquiry: large A-3 photostats from the Public Records Office in Kew. After breakfast he

read them in the sun; he read them in his tent during his afternoon siesta with the flaps tied back to catch the cooling breeze that rose off the lake, read them by oil lamp light in his tent after dark. But he said nothing. When I questioned him, he simply said: 'Not yet. I'm still thinking.'

He also carried around a thick book that bulged with loose papers and markers and clippings. It was bound with worn python skin and Tregallion was forever making notes, scribbling marginalia and furiously writing in it. I questioned him about it but he said, shortly, that it was merely his 'journal'. One day when he'd wandered into the surrounding forest to identify an unknown bird I shamelessly opened the snakeskin cover and paged slowly through. It seemed more diary than journal, more palimpsest than notebook. I found eccentric quotes, like this one from William James's 'Essays on Truth and Morality', written in 1910: 'Our ancestors have bred pugnacity into our bone and marrow and thousands of years of peace won't breed it out of us.' And this from Hopkins: 'The world is charged with the grandeur of God.'

There was a bromide of Goya's terrifying etching of a sleeping man surrounded by lions, babyfaced bats and winged harpies. It bore the inscription: 'The sleep of Reason brings forth Monsters'. I found a quote from Umberto Eco: 'A novel is a machine for generating interpretations.' Beneath, Tregallion had scrawled: 'What if the universe is the same?' There was a photograph of a young girl, perhaps five years old, pretty, with long unbrushed blonde hair and Tregallion's eyes, photographed standing in front of a large rock, smiling shyly at the camera. I closed the journal, wondered who she was. I knew I could never ask him.

We fell into an easy routine. He fetched water and chopped wood, I lit fires. We shared the cooking and the washing of dishes. Camped so close to the water the mornings were crisp, days hot, the nights pleasantly cool. The sun was warm but even at midday in the shade of the trees the air was chill. We slept early, woke before dawn, watched every morning the light creep up between the trees and

illuminate the quiet lake; and I think I shall recall till my deathbed the pure ringing of Tregallion's axe as he chopped thornwood for our fire while dawn cormorants slid ghostly across the lake with the night mist still rising all around them.

There were no more storms but once I found a fiscal shrike's larder. In Zululand we called this shrike the 'Butcher Bird' because of its habit of hanging its kills on twigs to form an avian gibbet. One day I found the desiccated carcass of a small unidentifiable songbird hung up like a minatory voodoo fetish beside the scaly corpse of a skink. The skink's blue throat was gashed through. I watched and waited and even heard the shrike call but he did not appear before dusk and I walked home thinking about parallel evolution and the bone midden we'd found at our dig.

I'm afraid I showed off a little. When our bread ran out on the third day I decided to impress Tregallion with a little family bushlore. I heated his three-legged pot on hot coals, emptied into it a small packet of self-raising flour, added salt and a bottle and a half of Tusker beer, stirred the contents into a thick dough. Tregallion watched all this in silence. I seated the lid firmly and placed coals on top. An hour and forty minutes later I removed the lid and exposed the crisp golden crust of a well-baked loaf. 'There,' I said. 'Beer bread.'

Tregallion was gratifyingly impressed. 'Where did you learn that?' he asked, buttering a hot slice.

'You'll get heartburn,' I said. 'From Meshak, my father's old Zulu cook. When my parents separated, my father moved to Ingwavuma, right at the top of the Ubombo mountains in northern Zululand. He had a house there. I used to stay with my father on alternate holidays. There was no electricity. I remember Meshak cooking on an ancient wood stove; a Dover, I think. It was a big black thing. The kitchen was always warm, even in winter, and always smelt of honey, because we burnt Lebombo ironwood in the stove.'

'Very impressive.' Tregallion buttered another thick slice. 'You loved your father, I remember you said; but you seem to've liked him as well. This is very good bread,' he added through a mouthful.

'Very much. He was my best friend. And I loved Meshak. I remember him padding about the house in a pair of plimsolls with no laces. He was a quiet, elegant elderly man. He ironed all my clothes with one of those heavy old irons you put coals in. All my clothes had little burn marks from the coals. They used to tease me mercilessly about it at school.'

He nodded and watched me, the smile lines at the corners of his eyes just visible.

I'm not a silly girl. I've learnt to distrust my own motives and my capacity for falling in love. Suspicious of my own vulnerability after the loss of Marion, I watched Tregallion very carefully for flaws during the week we camped at the lake. At first sceptical, later touched, I saw how fascinated he was even by tiny creatures: tree agamas with heads the brilliant blue of a vervet's scrotum; orange and white butterflies; little geckos who walked the walls of our tents with suctioned feet and feasted on light-bewitched moths; blood-red dragonflies; the troop of softly fluting banded mongoose who raided our camp one noon and smashed a dozen precious eggs by flicking them expertly backwards between their hind legs, thereafter avidly eating the yolks. There was no deception. Tregallion's delight was wholehearted and real.

This delight, I thought later, clumsily, was the result of his contentedness simply to be part of things; he did not need to feel superior. His passion was for union. Even his insistence on exact taxonomic classification, I decided, came from his need to better know those animals and plants of the biosphere of which he was a part. He did not accurately identify birds or trees in order to insulate himself from their power, nor to have power over them. He did it because he loved them. He also possessed to a degree I have encountered in no other human being a capacity for cat-like

273

stillness. For Tregallion, being still was not mere inactivity; it was a positive, regenerative act.

There was also in him a freedom of spirit and a wildness that was unlike any wildness I'd seen before. It was not the reckless testosterone frenzy of urban men; it was quieter, more elegant. I think it was in its essence an acknowledgement of his kinship with all creation; he lived happily in the dominion of the beast and the trees. He was biophiliac joy made manifest.

Sitting around the campfire one night watching sparks fly up from the gnarled wood I wondered about the sadness that I knew underlay everything he did or felt. On an impulse I said to him: 'Tregallion, what do you think about it all?'

He did not say, stupidly, all what? but sat in silence for a moment before replying. Finally he said: 'I think I resent the fact that I'll never know why I'm here or what it's about. I think it's a betrayal that God, if there is a god, created a universe so complex it lies beyond the grasp of a primate whose brain evolved solving the problems of survival on the savannah: hunting, foraging, clan-building; loving the wind and sunlight.'

One night, alone in my tent, I thought of Tregallion and despite my pessimism it came to me that I might not be unhappy and alone forever. Perhaps, I thought, the hard catechisms of love I have learnt have earned me this blessing. Needless to say, I was wrong; but at the time this thought allowed me a glimpse of happiness that I will remember always. But I should have been warned, because that night I had a dream.

I was in the old Elephant House at the Johannesburg Zoo. The bull elephant they kept there was sleeping peacefully until I stroked his side. He woke with a start and I saw terror in his small eye. Then he looked at me in recognition and a very strange thing happened: his sawn-off tusks began to grow and he lost the look of resignation he'd had. He stood straighter. His tusks grew until they were again the long, sap-stained parentheses of his years of freedom in the bush.

The keeper — a small, wrinkled man holding a broom — looked in at us and called: 'Oi! You! Get away from the elephant!' The elephant turned, drew taut the chain that manacled him to the deeply sunken post in his gaol and swung his hind leg in a powerful arc. The chain snapped. Links tinkled onto the parquet floor. The elephant trumpeted once, loud in the vaulted confines of the Elephant House. As I watched, he walked quickly out into the sunlight and air and disappeared.

No doubt I should have recognised this as a warning that Tregallion could be tamed but not domesticated. I did not. Perhaps I should have known it for an arcane hint that my own unbroken covenant with the wild was claiming me; but I didn't.

One dusk a bushbuck visited us, stepping daintily through the grass towards our tents, small black-button nose questing wetly for our scent. She stopped in a last xanthin pool of light and her coat was tawny and russet, soft spots showing pale on her flanks. We watched silently as she browsed on the white anticleia flowers. Then she left as softly as she'd come. It was a blessing, a gift from Pan or Dionysus, I thought, and felt without knowing why that Tregallion thought so too.

Early one morning we followed to its source one of the streams that fed the lake: a spring that bubbled up clear and cold from a narrow opening in the basalt. We filled our waterbottles from this pristine source and later, heading campwards, Tregallion stopped where the river swept slow and flat across white sand and said: 'Can you make it across?'

'Winner of a dozen galas? Freestyle under sixteen champion?' I said.

'Just asking.' He pointed across the river. 'There's something you should see.'

We stripped and he swam ahead of me. I wondered about crocs but decided to say nothing. Tregallion climbed out where we'd once seen baboons pull out waterlilies by the roots and squat down to eat

the bulbs with a crunch that echoed like a crisp red apple's. We climbed over a dead tree fallen athwart a black sprawl of igneous rock. The bush noise — birds, water — was suddenly muted. I looked up. We were under a great overhang of sandstone streaked black where rainwater had leached out minerals. The sand underfoot was soft and fine. I saw dassie spoor, the sinuous mark of a big resident snake and there, beyond a bone-white strangler fig, a vertical wall of pale rock covered in red ochre paintings. Impala, jackal and zebra, holy eland and hunters who flew godlike on unfettered feet, their spears poised. I sat down naked and wet on the soft sand and looked in silence. Tregallion said nothing. I thought of the long millennia we'd lived side by side with wild animals and wondered when it was that we'd lost our feeling of kinship with the beasts. We stared for a long time. Then Tregallion pulled me to my feet and we walked away towards the river.

I stopped and looked back once and saw our trail of footprints impressed on the sand beneath the overhanging rock: mine smaller than his, his more steeply arched. Tregallion held out his hand and we walked back to camp at dusk hand in hand, unspeaking, the blue-chalk smoke of our fire idling upwards amongst the trees.

After breakfast on the seventh day, surprising myself, I said to Tregallion: 'I've got a great favour to ask you. Will you forgive me?'

'Of course.'

'Can we visit Oriana?'

'What a good idea.'

'Can we go past the post office at Marsabit first?'

He stared at me curiously but said yes, and added: 'If we're going to pitch up unannounced, at least we can take dinner.'

'What?'

'Wild duck?'

It was still night when Tregallion woke me, and cold. In the dark tent he handed me a mug of coffee and left me to wake. When I'd washed the sleep from my eyes I found him at the fire cooking eggs and bacon in his shallow long-handled pan. He'd blown the coals into flame, propped gnarled wrist-thick sticks together to make a small blaze and boiled water for more coffee. I could smell bacon and firetoast. There was no need to speak; we ate in silence in the chill morning while the stars were still bright.

After coffee he packed a picnic lunch and his shotgun case into the Land Rover and we growled slowly away from camp as the sun turned the sky to mackerel-skin in the east. The moon showed through the cloud. A black-backed jackal trotted fox-footed across the track ahead and disappeared into the grass. Later I heard him call: thin and despairing in the night. An hour later Tregallion parked the Land Rover under a wide branching acacia and put his shotgun together. I watched him fill his pigskin ammunition bag with paper-cased shotgun cartridges the colour of red hibiscus, then followed him in silence through the sparse acacias to a tall stand of sedgy grass at the side of the lake. Small waves hissed and flopped onto the sand. We sat and waited. I glanced at my watch: just five o'clock.

Through thin layers of cloud over cloud in the east the sky turned to mercury and pale turmeric and we saw the first high vees of duck trudge from the light and disappear into darkness behind us. Then came the low fast pairs of honking Egyptian geese, necks outstretched, rowing powerfully on flexed pinions across the sky and gone quickly in the west. We waited in the cold. I watched the sky and clouds. Then, trembling on the air, came the big squadrons of teal and pochard, pygmy geese and plump green-winged yellowbills. Tregallion slid two red and brass cartridges into the breech of the shotgun and swung up the barrels with a soft click. He stood looking as the duck drove towards us, high and outlined black against the lightening sky. I have never seen so many waterbirds aloft at the same time.

Two small coveys of yellowbills swung down and around on rigid wings and planed lower, turning inland to approach the lakewater from behind us. I realised they would pass directly overhead. As they banked again to make their final approach, still fifty yards up, Tregallion turned to face them. They flew lower, swung on hard driving wings.

Tregallion raised the shotgun and seemed to fire the moment the butt touched his shoulder. Feathers burst from the leading duck. I saw its wings fold neatly back against its body; its head fell and I watched it tumble in a slow, dead arc into the shallows. The birds were already past us. Tregallion pivoted quickly after the first shot and fired at the last duck in the covey. Feathers dusted out against the sky and the bird tumbled headlong into the lake and lay still. The smell of shooting was sweet and sharp on the air. Tregallion pushed over the top-lever, lowered the barrels and the spent cartridges ejected with a hollow cardboard-and-brass ringing. Smoke curdled from the breech the way I remembered it from the times I'd shot with my father in Zululand: mornings as crisp as fresh lettuce, the dead guineafowl heavy, warm and speckle-feathered in my hands. Tregallion bent and retrieved the fired cartridges and put them into his cartridge bag.

'Two's enough, don't you think?' he said.

'Yes.'

'Are you all right?'

'Yes. I think so. I used to shoot with my father but I haven't shot anything since I was a child.'

'Was it awful?'

'A little. I like it that you're not greedy.'

'I don't shoot for fun; I shoot for food.'

'We'd better fetch the ducks. Are there crocs?'

'We'll soon find out, won't we?'

As we drove back to camp I sat with the two ducks resting on my lap. I spread wide their sinewy pinions, saw their closed dead eyes. They smelt faintly of wet dust and the sweet scent of wild thyme after rain. Their wing feathers were a brilliant iridescent green, aflame even in death. I was relieved that they were unmarked, the pellet holes hidden beneath their feathers. Distracted by the countryside I forgot about them, stroked their feathers absentmindedly; but as we turned into camp an hour later I saw that my hands were covered with their blood.

★

We struck camp and packed the Land Rover early next morning and as we ground up the steep walls of the crater I turned back to look down at the lake. I watched until the trees closed out the view then we crested the top and were heading down the far side of the caldera and the desert stretched hot and barren without end and the lake was gone forever. I felt myself begin to cry. Not loud nor long; more a melancholic weeping at the perfection and its loss. Tregallion said nothing but put a hand on my shoulder and let it rest there.

On the road to Marsabit we passed an open-air butcher's shop: a reed and thatch stall where flayed yellow-fatted carcasses were hung up in the heat. The fly-tormented meat was blackening in the sun. The horns of dead cattle were stacked neatly in one corner. The plump proprietor smiled as we passed, and I turned to wave and saw an old man with blue cataracted eyes raise a hand in greeting and farewell.

★

We went into Marsabit and I collected two post restante faxes from the affable postmaster. Deeply tempted, still I did not open them. We reached Oriana's camp at teatime, dusty and tired. Amman greeted us.

'We've come to stay for the night,' said Tregallion, handing him the drawn but still feathered ducks. 'Cook these carefully, you syphilitic pederast.'

'One word from me and my faithful tribes will embark on a fitina that will leave your loathsome body picked clean by carrion kites and jackals and your unbelieving countrymen weeping for mercy as we ravage your womenfolk,' hissed Amman. They shook hands. Amman examined the plump ducks with interest. 'A l'orange?'

'Plain roasted?'

'Very well. I'll tell her ladyship you're here,' said Amman. 'And I'll have your bags put in the two big guest tents. You know where they are.'

'I didn't know Oriana had a title,' I said to Tregallion.

'She doesn't. Amman does that to irritate her.'

He led me through the quiet maze of tents and thatched walkways until we came to two big Manyara tents pitched on a slight eminence above a cliff and commanding a view of the desert that stretched uninterrupted to the Indian ocean. I stared. It was one of those views that transcends pure landscape and seems to vibrate with meaning: as arcane as the simple statement of the first voice of a Bach fugue.

'Home,' said Tregallion.

'Yes,' I said.

'Shall we unpack?'

'Yes,' I said, but I could not move.

Tregallion left me standing there, staring. I could feel it: I was at a juncture in my life, a joint. The desert lay hot and enigmatic and impenetrable. I thought about my two unopened faxes, decided to keep them unopened till the next day. I looked up at the sky. It was a translucent after-dusk gentian all the way through to attendant

night. No help there. I was still staring when Amman arrived with a tray bearing a whisky decanter, a glass, a chilled soda siphon and a short note from Oriana. A large calico bag hung over his arm.

My Dear,

What a wonderful surprise! Dinner's at eight. Since this is so important an occasion, we thought perhaps we'd dress? I've sent a gown for you. I hope it fits. Please will you humour me and wear it? Till later.

Why important? And what about shoes? Perhaps she'd send shoes.

'I'll put the gown in your tent,' said Amman. 'There are also shoes.'

'Thank you.'

When he'd left I went in and undid the tapes of the bag and took out a strapless ballgown in the softest midnight-blue silk satin. The fabric was dark, almost black, but where the light caught its folds the satin shone iridescent purple and mauve. I felt the thickness of the fabric, the softness and fineness of the weave. There was a label: 'WORTH. GROSVENOR STREET'. Ethel Jane's couturier. I felt suddenly as if I were a character in someone else's dream. I remembered Tregallion's comment: 'I'm lived by forces I do not understand.' Feeling uncomfortably like Cinderella, I tried on the shoes which were made by Dawson's, and of black grosgrain satin with a small heel. They fitted well enough.

Amman had placed a week-old copy of the *Daily Telegraph* (Airmail Edition) and quite new copies of *Vogue* and *NewsBrief* beside my bed. I glanced through *NewsBrief* and saw pictures of Rwandan slaughters: bodies tumbled between rough pews in a church. A fallen wooden madonna lay beside them. Shot through with bullet holes, a dead village elder looked like a nail-racked Christ by Matthias Grunewald. There were pictures of trampled bodies at a Zairean border post, all children; dead cholera victims lay beside a dirt road wrapped in beautifully woven grass mats. I stared for a long time at

these images. Later, still thoughtful, I lit the paraffin lamps at sundown, went through to the rear of my tent where there was a flush lavatory and a real bath. Amman had put a bottle of Floris Lime Bath Essence and a wrapped tablet of Imperial Leather soap beside a fluffy towel.

Flying ant wings lay in the bath, delicate, dry, filigreed. I brushed them out, ran hot water, added bath essence. As the sun disappeared I poured a small whisky, dashed in soda, climbed into my scalding bath. I lay back in the hot fragrant water with my eyes closed, sipped my drink. The luxury! After living for five months under canvas the sheer indulgence was wonderful.

Tregallion came for me after dark. I'd pinned up my long hair and struggled alone with the hooks and eyes of the ballgown, determined to be dressed and made up before he arrived.

He stared at me. 'You are very beautiful,' he said.

'Shut up, Tregallion,' I said. 'I'm not very confident in this gown. Why does she want us to dress up anyway?'

'No idea.'

'You're sure I don't look a complete fool?'

He shook his head. 'Beautiful.'

I looked at him. He was more groomed than I'd ever seen him: Grenville's spare dinner jacket fitted him quite well but there was nothing to be done about the undisciplined curls. His starched pleated shirtfront was crisp but his black bowtie was carelessly tied.

'Here,' I said. 'Let me do that.' He stood obedient while I retied his tie, pulled it tight.

'Where did you learn to do that?'

'My father.'

He took my arm. We walked through to the sitting room tent where Oriana and Grenville were waiting for us. Oriana kissed my cheeks, her eyes shining with obvious pleasure that went beyond good manners. Grenville shook Tregallion's hand and hugged me. 'Welcome, welcome,' he said. 'What a wonderful surprise. I've opened some champagne. We still have some, can you believe it? One case. Do you like champagne? Come and sit down.'

Simba, startled from sleep, leapt to his feet and barked once hoarsely before catching our scent. He ambled to Tregallion, sniffed his trousers with deep interest, wagged his stumpy tail at me in condescending greeting and flopped down exhaustedly beside Oriana's chair.

'You're very kind to lend me this gown,' I said to Oriana.

'Nonsense. You look beautiful in it, it suits you.' She sipped her champagne, smiled at me. 'And why have you come?'

I glanced at Tregallion. He was deep in conversation with Grenville.

'I wanted to ask you some things about Tregallion.'

'What about Tregallion?'

'Why is he here?'

'Where?'

'In the desert.'

'We are all in the desert.'

'I know that. But he's — I don't know —'

'He hasn't told you anything?'

'No. I hardly know him. Seremai told me a little. Has he ever been married?'

'No. Are you thinking of being the first?' she said with a tiny smile.

'Heavens, no! But he speaks as if he's been very disappointed in love.'

'He was,' she said, very carefully, stared at me.

'Well?'

'He had a lover,' she said slowly, 'who was not terribly stable. They had a child together. She burnt their house down. The child died in the fire.' I stared at her.

'Their house? Which house?'

'On his farm in the Aberdares. He won't go there any more.'

'I see.'

'Do you?'

'I don't know. I think so.'

Simba sat up, made a few tentative passes at his ear with the claws of a hind foot, more in warning than in retribution, and sat staring fixedly at me with his yellow lion's eyes. Grenville poured champagne. I felt Tregallion looking at me. I turned and he watched me gravely. I smiled at him.

At dinner, Oriana said: 'Kathryn, now you're so famous, Grenville and I hope you'll still visit us.'

'She's become very bossy,' said Tregallion.

'Tell us about your finds,' said Grenville. 'And the shifta.'

I did. Tregallion interjected with sardonic comments; the roast duck were succulent, the champagne a perfect dry complement. The evening passed very quickly. Over coffee, I said: 'You must come down to see us at Maleleji.'

'We'd love to.'

'Why not bring your violin when you come?' I said, without knowing why. 'Perhaps we'll have a duet. I haven't played for months.'

Oriana watched me for a moment, then said: 'Grenville will bring his violin, too, and his viola. He still plays well, despite his awful arthritis, don't you, Toad?' Toad smiled and said nothing.

'What shall we play?'

'What music have you got?'

'We've got any amount of Beethoven. Or Bach?'

'Offenbach? Don't much like Offenbach,' said Grenville.

Oriana rolled her eyes: 'Turn up your hearing aid, for God's sake!'

'Bach?' asked Tregallion. 'What Bach? Have you got the Art of the Fugue? I'm sure I saw —'

'Yes. The Art of the Fugue, I think we've got it. It's in the piano stool. With that prayer for the dying?'

'Yes,' said Tregallion. 'That one. Why not bring that?'

I looked at Tregallion in the candlelight. He was not good looking in the conventional sense but I thought him suddenly very beautiful. The dark hair, the piratical face, the white teeth and his eyes that watched and absorbed all but did not judge; his compassion. And his hands holding his wine glass: they looked gentle and strong. Objects fell to his hands as if they belonged there. It was as if his soul rested in the shape of his hands. I looked more closely. That was it; it was his hands. It was all in his hands.

★

As we walked through the darkness to our tents, our way guided by the storm lanterns' tiny flames, I said: 'Tregallion, have you read all that Patterson stuff yet?'

'Yes.'

'And?'

'About what and?'

'About Janey. Why did she do it? Fall in love with Patterson?'

'I'm not certain she did.'

We stopped outside my tent. 'Would you like a nightcap?'

'Yes. Thanks.'

We went inside and I poured him a whisky. 'How do you mean?'

'I think —' he hesitated '— I think she was tired of living at one remove from her innards.'

'I don't see.'

'People who live in cities are accustomed to the objects that surround them making sense and having meaning because they generously confer it. We're happiest when objects are benevolent.'

'I don't understand what you mean.'

'Well, your letterbox is hardly terrifying; and in Oxford or Tunbridge Wells or in your Johannesburg museum, there's not much to remind you of the impenetrability of-of-of things-that-are-not-us.'

'Yeees,' I said doubtfully. 'So?'

'Wait! In old cities there's something comfortable about the streets and buildings; they become as cosy as an old pair of slippers, domesticated and tame. They become landmarks or tourist attractions or Places of Historical Interest. Take a cathedral: imposing and magnificent. Yet it's still there to serve us, built to be a consecrated place that helps intercede on our behalf with God, the ultimate Other. It's comprehensible and approachable. Friendly,

almost. We like that best. And that's my point about Ethel Jane. She was imprisoned inside a concept of herself that her age and society and men had created. She was a landmark, a place of historical interest. People didn't see her any more, they saw her role. She wasn't free, any more than a zoo animal is free. Or a cathedral.'

'Tregallion —'

'No, listen.' He enumerated on his fingers: 'We cage, prune, fence off, set into bondage, tie up, train, domesticate, interbreed, reduce, bonsai, photograph, cast neatly in bronze, worship, deify, anthropomorphically paint, damn, idolise, reify, analyse, vivisect, explicate, murder, hunt, lock up in game reserves, kill or pretend not to notice those things which refuse to acknowledge us. We even call them ugly, excommunication of the direst sort.'

'Tregallion!'

'But in Africa there aren't a lot of cities; and in the bush there're wild animals and lakes and rivers and mountains that are as mysterious as Stonehenge and even more impenetrable because they're not man made. Think about our crater lake.'

'So what? What's that got to do with Janey?'

'Everything. Cities cosset our illusions of centrality, our desire to seem more significant than we are, but Africa is soberingly indifferent to our existence. So the inscrutability of the trees and savannah is almost humiliatingly real. Spend one night alone in the bush like Janey did with Patterson and you'll look on the elephant and lion and even the antelope with humble eyes, just like she did. You may even look at your letterbox differently. That's what happened to her. Until she went to Africa she was a good little wife and she had a good little husband and they probably had a nice little social sort of sex life, all ritualised and cosy, like a couple of coddled eggs in a pan.'

'You can't say that for sure.'

'Well, no. But then she realised there was no divine sanction for her being the way she'd been taught to be. She was like a letterbox: created by men for men. She'd always been inauthentic; she'd always felt things second hand, through her social mask. There was absolutely nothing primal in her life at all. And then suddenly here she was in a land that ignored Audley and all his silly patriarchal ideas and assumptions and he looked idiotic. The trees didn't care, the lions and elephant didn't care. He looked accidental, not necessary. So did her whole social self. So she surrendered to the idea that she could be real. And Patterson was the only one who understood that for the first time, ever, in her life, she was acting from a central core of truth.'

'My, what a speech.'

'Yes. And now I'd like that drink, please.'

'It's in your hand.'

'So it is.'

<p align="center">★</p>

... So this at last was the still point of the turning world; this was the divine insanity she'd read about but never known. The thornbark was rough where her palms pressed hard against it, her weight supported on her arms. This was real: the elephant bull browsing on a camelthorn fifty yards away, unaware of their ecstasy, was real; the violet sky, overarched weightless with ever-changing clouds, was real. He was real, behind her, his breath on her neck and in her ears, his kisses wet in the curls at the nape of her neck. The sun was hot on her skin. She shivered with fear. For the first time, it seemed, she was awake, not living in someone else's dream. His arms went round her from behind to pull down the taut satin and she felt him press against her. He held her breasts in his hands with desperate tenderness. 'God,' he whispered in her ears. 'God...'

Through the palms of her hands she could feel the sap vibrate in the veins of the tree; the whole weight of the earth pulled down on her

suddenly through the roots of the tree; she felt herself sway. She was rooted; the tree had never known her yet she was part of it; part of the whole savannah now and even the wind. Against her will the long muscles of her thighs began to tremble uncontrollably and she was crying now, keening between clenched teeth. She could hear him calling to her from far away. Small thorns pierced her hands but she did not notice. She opened her eyes and saw, inches from her face, the powdery yellow sulphur bark of the fever tree, runnels of golden sap and a dozen ants foraging, greeting, exploring, hurriedly scurrying amongst the runnels, entirely indifferent to the shaking cosmos inside her. God's joke, she thought; this is God's joke. His sweat fell onto her back. She laughed, head thrown back, at God's joke and his hands went to her hips. She sensed the first long shivers reach up through her body from her toes, uncontrolled shudders that shook her like a malarial fever. Her eyes went dark and she heard him call to her from deep in the night. She wanted to answer but was incoherent.

Then the tree pulled down at her again, suddenly; she felt the whole weight of the turning world draw her down into its heart. She began to fall, tumbling forever as if in a dream. Then she was kneeling, thorns and grass hard against her knees and palms. Through her tears, she thought: this is god; this is god; this is god, I am a god and felt herself contract in quick hard ripples. Then the great white bird rose on beating wings in the night silence and she was gone forever.

★

I lay naked beside him on the tarpaulined tent floor and looked at the moonlight coming into the tent through the opened flap. Tregallion was asleep, arms outflung as if inviting crucifixion; as abandoned in sleep as he'd been when we'd made love.

The first time. How strange that such an ordinary act can change entirely the relationship between two people. When he'd come to me uninvited, my tent inside was cathedral-like, candle flames in the dark. He'd led me silently to a camp chair, knelt in front of me as if to pray. Then he'd slid the full sculpted folds of the ballgown skirt

upwards to the top of my thighs and bent forward and kissed me and — And then, later, when I leant weight-forward on both hands against the tent pole and looked at him over my shoulder I felt the sap rise up in him as it did still in the dead wood of the tent pole, sleeping only until then, waiting, and in me; and I knew that I would love him forever: that when I died the last fading image on my sightless retina as I fell headlong into the pit would be Tregallion's face watching me from the shadow.

It had been unlike anything I'd ever done with my other lovers. There'd been a third presence, a daemon, a god or a devil in the tent with us, urging us to acts of barbaric intimacy. His tongue probing my darkest places, my lips enclosing him, the salt and mystery, as if I'd taken the moon into my mouth and tasted its light. I opened my legs wide and he kissed the shadowed hollow of my thighs where the tendons drew out darkness and I lay back, neck arched when I felt the hot sudden wetness of him drying on my face and lips, libations pooling in the hollows of my throat and neck. Tregallion. And the wind: was it a wind? There was a wind that blew through us and made us its own. We were unbounded, then. The wind carried us away and I knew I knew nothing but wind. I was the wind and there was only the wind, there was nothing but wind.

How to say this? With Tregallion for the first time I understood that making love is a form of prayer, of homage to all creation. Yes, yes, I know all orgasms are wonderful: the frictive delights, the mounting tidal waves of pleasure. But I can say this now: with Tregallion, everything was different. Not what we did, no; the physical repertoire of sex is tediously limited. All I can remember is that I felt when we made love as if I had a place in the universe; I belonged, I was transcendent at last. I understood for the first time what Tregallion meant when he'd said: At the core, life is steel on stone. There is no way out.

A hyena howled far away, another joined in, whooping, voice pitched high and then another and then the desert was silent. I listened. Then I curled my body small and turned my back to him

and wriggled into the incurve of his waist and felt the swell of his shoulder and laid my head on his outflung arm and slept.

★

When I woke he was gone. Sunlight filled the tent. I stretched, feeling the tenderness, the presence of him inside me still. I found my two faxes, opened the envelopes, read. Slowly, to make certain, I read them again. Then I pushed open the tent flap and went outside. The day was bright, the sun high. Tregallion was standing naked, his back to me, staring out over the desert. I looked for a moment at the deep incurve of his spine, the knotted punctuations of his backbone, the ridges of muscle where my hands had rested, the swell of his buttocks where my nails had pulled him into me. Would he remember the wind?

I walked up to him and put my arm round his waist. He pulled me close, kissed my forehead and said: 'We were gods, weren't we?'

'Yes,' I said. 'We were gods.'

I handed him the faxes. He read them. 'Who are these from? All these figures.'

'That one's from Mike Dunke at Harvard; he does research into what fossil hominids ate, based on the different kinds of carbon found in fossil bones. The other's from Anton Prinsloo at the University of Cape Town. He establishes the ratio of strontium and calcium in fossil bone.'[17]

He looked questioningly at me. 'You don't understand?'

'No. Is it important?'

'Very.'

'Tell me.'

'The first shows the level of carbon isotopes, C12 and C13, in our robust and gracile fossils. There's the same level of C13 in both, see? there? and much more C13 than C12.'

'So?'

'C13 occurs more in savannah grasses, C12 in trees and bushes because of the different ways grass and trees photosynthesise.'

'Grass? But we can't digest grass.'

'Exactly. They weren't eating grass; they were eating the meat of the animals that ate the grass. We were eating savannah grazers.'

He stared at me. 'We were carnivores? Even then?'

'No. We were omnivores. But it shows that both our fossils were eating the same things: meat and other things: roots, tubers, fruit. So they can't be two competitive species; they must be one. They occupied the same ecological niche. Not one gracile and one robust; but one species, Tregallion. One species.'

'But they're so different,' he said sceptically.

'I know. That's where the second test comes in.'

'Calcium and what?'

'Strontium. There's always a lower level of calcium in female bones; different metabolism, breast feeding, general osteoporotic problems.' I pointed at Anton Prinsloo's figures. 'See? Our gracile hominid has high strontium, low calcium levels.'

'So it's female?'

'Yes. Yes, yes, yes. I think we've got one species with huge sexual dimorphism. The little one's a woman, the big one's a man. One species.'[18]

He laughed at my excitement. 'Are you going to announce?'

'Not yet. But we must go back now. I had these tests done without telling Chinta. I must share this with him, now. And Victor.'

He nodded and touched my face. 'You do understand about last night, don't you?'

'What about last night?'

'That we were gods. Do you understand?'

'Yes,' I said. 'I understand. I was afraid you wouldn't.' I touched the two bones that hung from the thong round his neck. 'And these? You said you'd tell me.'

'My God, you can nag. The bones, the bones. They're both from animals I knew well. I was a sort of honorary game warden up in the NFD once and I got to know the animals.' He touched the spearpointed bone. 'This is from the tusk of a big elephant bull I knew. One year I missed him; I found him dead that dry season near Seralippe lugga. He'd died of old age, he wasn't poached. His tusks were still in their sockets. I stayed there beside him for a day and a half and while I was there three other bulls came, separately, to the skeleton and played with his bones.'

'Odd.'

'Not odd at all. Mourners.'

'And the other?'

'It's a floating collarbone from a lion. They have two. Not many people know about them any more; they're supposed to be big medicine. I knew this lion from a cub, up near Barsaloi. I knew his mother; we used to call her Cyclops because she'd lost an eye.'

'Porcupine?'

'Perhaps. He was the smallest of the cubs but he grew into a lovely lion. I shot him because he'd had his jaw broken by a Grevy's zebra and when I found him he'd been without food or water for more

than a week. He was so weak he could hardly lift his head. The hyenas were already there, waiting for him. They'd've eaten him alive. So I shot him.'

'Was it awful?'

'Yes.'

'I'm sorry.'

'Don't be.' He looked out across the desert. 'What made it hard was that for a long time I thought I actually was those two animals. The shrinks call it "participation mystique" in the mistaken belief that if you name something you can remove its power.'

'So.'

'So.'

'So the bones?'

'So the bones.'

We breakfasted with Oriana and Grenville who were touchingly upset that we weren't staying longer. When we were saying goodbye at the Land Rover I noticed the protective calico bag of the ballgown zipped inside a clear plastic cover, lying on top of our bags and camping gear.

'Oriana —'

She put her hand on my arm. 'I want you to have it. It seems almost to have been made for you.'

'I can't possibly.'

'Of course you can! Don't be so silly. I don't need it. And anyway, I think you may need it again.' She smiled at me.

'Come to us,' I said. 'I'll wear it then.'

As we drove off, I heard Grenville call: 'We'll come to you at Maleleji! Soon! Go carefully.'

I looked back. They were standing together hand in hand, watching us. I waved and they waved back. I watched them until the distance hid them from view.

<p style="text-align:center">★</p>

We reached camp just after dinner. The dining tent was already deserted. Hamid happily unpacked the fresh eggs, fruit and vegetables we'd bought in Maleleji and cooked us omelettes. I could hear distant frantic bleating and shortly afterwards Quasimodo appeared, tugging her grinning young handler behind her. She greeted me with quick muffled bleats, glanced speculatively at Tregallion's boots as if contemplating a retributive deposit of turds but decided to butt me affectionately instead.

'Shall I come to you later?' said Tregallion as we walked together to our tents.

'Yes. Come soon. I want you. Come soon.'

TWENTY-EIGHT

Next morning I woke alone. Chinta brought coffee early to my tent.

We sat in my camp chairs and I showed Chinta the faxes of the results of the carbon and strontium tests. He was pleased, but irritated with himself. 'I should've thought of that,' he said and stared at me in wonderment. 'One species?'

'One species.'

He nodded slowly. 'It makes sense. Sexual dimorphism in gorillas and chimps is quite marked; and in afarensis.'

'Exactly.'

'One species?'

'One species.'

'This is going to cause trouble, you know that,' he said.

I nodded happily.

He laughed and said: 'Oh: this'll please you. I got the biometric analysis of the teeth from Frances Kline. The molars are smaller than afarensis, the canines and incisors are bigger; so they're more primitive. Very pongid. Trend line analysis puts them much younger, around four and a bit million. And there's another thing.' Almost shyly he reached into his toolbag and handed me an endocast,[19] perfect in its detail. The folds of the hominid brain, the fissures and arteries and veins showed clearly.

'That's beautiful,' I said. 'Did you do the cast?'

'Yes.'

'It's beautiful.'

'More important than that, if you look at the veinous drainage pattern here and here — ' he pointed ' — you'll see it's very different from Homo habilis and Lucy. It's final proof that we've found a very different species. Different from chimps and gorillas too.'

'Yes.' I turned the endocranial cast to the light and looked at the left supraorbital region. The damage to the brain tissue was clear. 'And this?'

'Yes,' said Chinta unhappily. 'I know.'

I handed him the cast. 'I need photographs of the endocast,' I said.

'I've already shot them. And I've sent a cast to Nussbaum at the British Museum for comment.'

Chinta told me that he'd also found more pigs to support our dating with sound biostratigraphic evidence. I watched him while he talked and realised I was deeply fond of him and that he was far from happy.

'Chinta,' I said. 'What's wrong?'

He sighed. 'I wasn't going to say anything.'

'Tell me.'

He hesitated. 'It's Mary.'

'What about her?'

'She spent a lot of time with me, talking, while you were away.'

'What about?'

'Death.' He watched me.

'Death?'

'Yes. Death.'

'What? Death in general?'

'No. My death.'

I watched him.

'I know, I know. It sounds crazy. I told her to fuck off eventually and she just smiled and went for Victor instead. He's drinking more and more and talking to himself and he's started crying too. She follows him around like a vulture, sort of waiting for him to die. It's terrible to watch. Really.'

'I see. And Marion?'

'You know Marion. She just sits and smokes those Turkish cigarettes of hers and stares at them both and smiles.'

'She's not well, either.'

'I know. That whack on the head. And then there's your pal John Morton —'

'Surely he's not still here?'

'Oh, yes. He's spending a lot of time with Mary as well. I see them everywhere, heads close together like boyfriend and girlfriend, talk, talk, talk. Always whispering. And he's changed.'

'How?'

'I can't say, really. It's as if — I don't know: he looks triumphant.'

'Triumphant?' I stared at Chinta. Perhaps he needed a break from the dig.

'Don't look at me like that,' he said. 'I know it sounds crazy, but it's true. And they've had some odd guy visiting; I don't like the look of him at all. He's bad news.'

Later that day after lunch I understood what Chinta meant. Marion didn't come to lunch; Hamid sent a tray to her tent. Seremai had gone off to Marsabit on unnamed business, Chinta had taken a picnic basket to the fossil site and Sister Mary and John Morton were out walking, madly in the midday sun. Tregallion, Victor and I were alone in the dining tent. Orde had taught Hamid some new recipes and he proudly served us a very good chicken salad with wholegrain mustard dressing.

Victor was already drunk. He sat at the head of the table, mumbling to himself, eyes unfocused, entirely unaware of our presence. His food was untouched. He held a tea-dark beer glass of scotch and water in his hand and sipped it constantly with slack lips. Whisky dribbled down his chin. The front of his bush shirt was wet with the spilled drink. Tears ran down his face. Eventually he passed out and began to snore. Hamid shook his head and served coffee.

'How long has he been drinking like this?' I asked Hamid.

'Four, five day now, maybe one week. Very bad. Very bad. He die soon.'

'Why do you say that?'

In reply he pointed and I looked out to the desert and saw John Morton and Sister Mary walking together, hands behind their backs, heads bowed. They stopped and stared up the murram road. I saw a small dark figure bicycling towards us down the road from Maleleji.

'Who's that?'

'That laibon. Nandi man, from Maleleji, Mister Kimeu. Big dawa.'

'What's dawa?' I asked.

Tregallion said: 'Medicine. Or poison.'

'Do you mean Victor's being poisoned?' I said to Hamid, who shook his head.

'No, m'sabu, no poison. That man Mister Kimeu, he put poison in the head, make madness. Thahu. He's father, he also laibon, and he's grandfather before. Very bad.'

'Has he been here before?'

'Yes, maybe one week before. They talktalktalk. Very bad.'

'Who?'

'M'sabu Mary and Mister Morton.'

'Does he cycle all the way from Maleleji?'

'Mister Kimeu, he ride the night, he not cycle. He only ride bicycle for white people to see.'

Mister Kimeu had cycled closer now. There was nothing overtly wicked in his appearance. He looked prosaic rather than evil. He'd tied a yellow water gourd to the handlebars, a giraffe-hide bucket swung behind his saddle and a large brown fibreboard suitcase, bound about with red rubber strips cut from a motor car inner tube, was clipped onto the rear carrier. He was dressed in a shiny black suit and wore a white shirt and a neatly knotted black tie and an old pith helmet. The suit was unfashionably cut and he looked like a preacher from a rural mission until you saw his eyes, which even at that distance I could see were dark yellow, not black. They stared out hooded from under low lids. They were entirely blank and eerily unseeing, as if he was listening attentively to howling voices inside his own head. He dismounted and watched us where we sat in the dining tent, then he, John Morton and Mary walked away towards John's tent near the latrines.

'I know about him,' said Tregallion. 'I know about him and his father and his father's father. This isn't good.'

'Why?'

'They send for him,' said Hamid. 'I hear from servants; she and Mister Morton talk, then they ask Ibrahim the tentboy where can

they find laibon. He say where in Maleleji and they send him to fetch Mister Kimeu.'

'How did Ibrahim get there?'

'With the supply truck.'

'When was this?'

'The day you go away.'

'Why?'

'They after Mister Victor, m'sabu. The thahu.' Tregallion stared at him unspeaking. 'I not like it, m'sabu,' said Hamid, polishing a tumbler vigorously. 'I not like it at all.'

But nothing happened. Mary and John Morton appeared at drinks time and chatted, apparently amiable. I watched Morton's eyes for any sign of illicit triumph but saw none. Mary smiled her crocodile smile and was ingratiatingly pleasant. I saw Mister Kimeu cycle away into the dusk and excused myself and impulsively followed in the Land Rover. He'd left just ten minutes before and I expected to pass him along the road but although I drove for nearly half an hour towards Maleleji I did not see him nor was I able to find the tracks of his bicycle in the soft red sand of the desert.

<p style="text-align:center">★</p>

The next three months passed in a slog of hard work and I forgot Mister Kimeu and all thought of witchcraft. It was time to consolidate. The report on the microwear on our hominid teeth arrived from John Michaelhouse at Harvard and confirmed our ideas on omnivorous diet. Todd Wister the locomotion man visited us and wrote a paper on the erectness of our hominids' posture, which was confirmed by the scans showing the size and proportion of the hominids' semi-circular ear canals. The geologists' report and the specialists' papers on our five forms of dating arrived in the post as did confirmation of the Gilbert Normal polarity of the rocks

found in our tuff. I was particularly pleased that the newest relative dating technique — electron spin resonance — used by Sandra Kinnear at CalTech had placed both hominids in the same timeband. Our date of four point five million years was 'rock solid' said Chinta with a silly grin.

Victor drank more, Marion smoked and watched Tregallion and me with a detached smile, distant and beautiful. John Morton went out of his way to be pleasant and even Sister Mary appeared to relax her rigid unindulgent mask and enjoyed the odd glass of wine at dinner.

I should probably have realised that she was simply masking her real nature but I was busy writing the formal descriptions of our fossils for publication and was stupidly content to accept her behaviour at face value. Seremai sent word from Marsabit that he was laid up with malaria and would stay in the cool uplands for a time. Chinta had begun to catalogue every fragment of fossil bone we'd found and supervised the final stages of our dig. None of us expected to find more fossils. We had no right to expect more.

Then, unexpectedly, Mary confronted me. One hot noon when the sun teemed down Mary sought me out in the shower tent where I'd gone to wash away the dust of our morning dig. I was drying myself when she appeared, gaunt-eyed and dressed as always in her black shift. Her eyes flickered in one comprehensive unashamed glance all over my body, registering breasts, pubis, waist, buttocks and nipples all at once. When she looked up into my eyes I had the uncomfortable notion she knew the size and intensity of my orgasms. I put on my clean khaki shirt, buttoned it.

'I wanted to apologise to you,' she said.

'Whatever for?' I pulled on my panties and my shorts.

'For Marion.'

I watched her, unspeaking. I buttoned my shorts.

302

'I know you were lovers,' she went on. 'And I feel bad about usurping her affections. But I want you to know that I am not to blame.'

'Do you?' I said. 'I don't believe that for a moment.' I dried my hair.

'I know you've got a lot of anger,' she said. 'I know that. I just want you to know that even though I think your preoccupations are trivial, I still don't dislike you.'

'Trivial?' I picked up my washbag and towel and walked towards the dining tent.

'May I walk with you?'

I said nothing. She fell into step beside me, talked headbent to her feet: 'Trivial, yes.'

'Why?'

'Can I tell you a little about myself?'

I put my washbag and towel on the dining table, took a cold Tusker lager from the gas fridge, prised off the top with my Swiss army knife. She sat and watched in silence, patient, unrelenting. I pulled out a chair, sat down and drank from the bottle. The beer was cold, the bubbles sharp and bitter on my tongue. 'Go on.'

'You, I think, have always led a relatively sheltered life. Protected. I think you are removed from the awful realities that ordinary people face day in, day out, in Africa.'

I said nothing. Mistakenly encouraged, she said: 'I wanted from my early youth to be a nun. I convinced the monseigneur at the local seminary in the town where I lived that I had a vocation.'

'Where was that?'

'Belgium,' she said. She waved a hand, faintly irritated. 'My devotion was compelling; I was devout, chaste, in love with God. I

303

completed my novitiate but found I did not share my fellow sisters' preoccupation with the hereafter, and I want you to understand why.'

I drank more beer, nodded.

'In the town where I was born there was little crime, very little violence. A good bourgeois place. No passion, no real suffering. I did not know what suffering was. I expect,' she said, watching me, 'that you think you understand suffering because of your leg.' When I stayed silent she smiled slightly and said: 'Part of my novitiate was passed in Zaire: I worked in a mission deep in the country of the Azande, between the Bomakandi and Uelle rivers. The nearest town was Isiro and even that was five days away by truck. We were in the darkest place in Africa that I know. It is very primitive there and the people suffer terrible disease and bear their suffering with commendable fortitude. I did not understand why until later. In fact, they seemed almost amused by my concern for their wellbeing, as though such efforts were a waste of time, a sin against some unspoken but accepted metaphysic.

'I grew to know the local people well; and I liked them. One day a woman I knew brought her little daughter to the mission. She was seven years old. She'd been raped by countless men from a nearby tribe then tied to a stump. They'd lit a fire under her. She was terribly burnt before her mother found her.'

'That's awful.'

She nodded quickly as if dismissing my sentimentality. 'I use that only as an example. There were many other much worse cases of suffering: river blindness, filariasis, wasting diseases, casual slaughters, ritual amputations, jealousy murders, leprosy, unnamed fevers, blackwater, muti killings, red diarrhoea that kills a patient in four days, hideous disfigurements: our inhumanity to each other and God's abandonment of us. Like many innately religious people I could not understand that an omnipotent God could allow such terrible things to happen. I could not understand why terrible things

should happen to good people who had committed no sin in this world to deserve such punishment. Nothing I had been taught prepared me for this. My compassion was for suffering humanity — now, here — not for suffering Jesus. Do you follow? I could not accept the solace of a postponed reward in paradise.'

I nodded, fetched another Tusker from the fridge. She watched me all the time, waited until I sat before continuing. 'I think that your interest in our ancestral dead is caused by similar preoccupations,' she said and smiled wryly. 'However, your quest is dignified by its very disinterestedness; it is distanced from real human concerns and suffering; it is Parnassian, academic, aloof, elitist. It has nothing to do with the privilege of ordinary suffering nor with anything so mundane and unelevated as the everyday. And that is why I consider it trivial. Through it, you are able to dabble safely with your petty concepts of our evil — or God's evil — without ever facing the real bloodletting and suffering that takes place in the here and now. You are essentially selfish. You do not get your hands dirty; you do not get blood on your hands.'

'You don't know that.'

'Yes, I do. You have no real compassion. In suffering, you are a dilettante. You are driven to give your own life meaning, you are not driven to save others from seeing how pointless their own lives are. You resent the commonality of your lot. Deep inside you, you are in revolt against your terrible ordinariness. You wish to be special, elect. You attempt to dignify your being with illusions of grandeur: you are not a poor forked creature, dismayed and bewildered, no, not you. You are special. A cosmic detective, a Seeker-After-Truth, a dedicated scientist determined to shed light on our dark side. Yes?'

She smiled at me. I said nothing.

'You believe that somehow there must be more than this drab, undifferentiated ordinariness. Disappointingly, evil is not special, nor is death. It is ordinary. That is one of its most awful aspects: it is banal. It neither dignifies nor elevates; it simply happens. It is

inescapably prosaic. And that is why Marion chose me instead of you. When she nearly died, she needed someone who understood death and its terrible ordinariness. Not as theory; but as fact. Not death as a metaphysical betrayal, but as a drab occurrence. When someone you love dies, nothing happens. The birds still fly, rivers flow, the sun comes up and goes down. No fissure opens deep in the earth, no thunderstorms rattle and thud. We are not interconnected with the rest of the universe. We are isolated, alone, mortal and afraid. Marion realised that love has no effect on death: it still happens, despite love. Do you follow?'

I watched her and said nothing. She turned away and stared out across the desert. I followed her gaze and saw a small dung beetle, head down, busily rolling a large sphere of goat turds endlessly backwards across the sands.

Watching the dung beetle, she went on: 'It was then that I found that the god the local tribes worshipped was not our god of love nor even our pettily vindictive Old Testament god; but a figure at once beneficent and actively malefic. I investigated their rituals, took part in their masses, if I may call them that. There was a strong sadistic and sexual component which I found reflected my views of our creator very aptly. There was a considerable amount of ritual cannibalism involved, and I indulged in this as well. With relish, in fact; I have never been able to lose my taste for eating human flesh.' She watched me with an ironical smile but I managed to keep my face expressionless.

She went on: 'When the Church found out about this they castigated me brutally; and I'm afraid to say that when I asked the Mother Superior to explain the difference between cannibalism and communion — when we eat the flesh of Christ and drink his blood — she was unable to offer any satisfactory explanation for condoning one and condemning the other.'

'Transubstantiation?' I said mildly.

She shook her head. 'Of course they mumbled a lot of metaphysical nonsense about spirituality and metaphors and symbols but I had made my point: faith demands that we believe in the truth of communion; that we believe the wine truly becomes Christ's blood and the host his flesh. Naturally —' she glanced slyly at me '— the Mother Superior found my idea that the Church practised ritualised cannibalism shocking and unacceptable and I was asked to leave.' She chuckled slightly at this. 'I handed in my rosary, as it were, but I continued to try to help people in pain whenever I could.'

'Where?'

'Oh. Mogadishu. Terrible deaths in Mogadishu. And I should like to go to Bosnia. Rwanda . . .'

'What happened to the young girl?' I said.

'Her?' Mary turned back and looked at me. 'She died.'

Hamid appeared and said: 'Lunch, m'sabu?'

'No,' I said. 'Not now.'

'Yes,' said Mary. 'What is it?'

'Cheese salad, m'sabu.'

'Yes,' said Mary. 'I'll have that. And bring lots of tomato sauce.'

The salad came. Mary poured tomato sauce liberally on top and began to eat. I turned away and saw the dung beetle still rolling his ball of goat turds towards the horizon.

I wondered: Should I respond? Should I demean myself? I heard myself say: 'You don't know me at all, Mary. I'm going to tell you one story and then I'm going to leave and I must ask you never to speak to me again. I don't like you, I don't trust you and I think you care nothing for Marion. She fell into your hands and I fear for her.' I leant over and gripped her hand as she was lifting a forkful of salad to her mouth. 'Look at me and remember that I say this: if you harm

her I will find you wherever you are and I will kill you.' She watched me unspeaking, her eyes black, all pupil.

I released her hand and the salad fell with a soft plop onto her plate. 'There is a cave at Shanidar in Iraq,' I said. 'In it there is a deep grave that contains the body of a young neanderthal male. About twenty-three, we think. He died from cerebral haemorrhage: his skull is crushed on one side. He was buried with ceremony: he lies on his side, head pillowed; and when they buried him his friends piled his body high with spring flowers: bachelor's button, grape hyacinth, sweet hollyhocks and flowering groundsel —'

'— You can't —'

'Yes, I can. Fossil pollen analysis. My point, that you seem to ignore because it doesn't fit in with your own especially vile idea of gods, is this: someone loved this young man so deeply they went off into the hills, picked the flowers and made him a bed of spring blossom when he died. They thought about him in death, not about themselves. They understood that to be deprived of the transient glory of the here and now, of sunlight and rain, is terrible. They had no faith to sustain them, no omnipotent god to turn to in need; but they loved each other and they weren't even human yet. Love is ancient. I want to know about that, I want to understand that. That's why I dig up bones; I'm not interested in myself any more; unlike you, I don't believe I deserve special salvation. I'm one of a species, I don't count. I'll tolerate you because Marion brought you here and I love her. But in future keep the grisly details about your wasted life to yourself. I don't care if you live or die but quite frankly, I think I'd be happier if you were dead. And when you die no one will pile your grave with spring flowers. Think about that.'

★

Sometimes when I woke in the night I would see a light burning in Marion's tent and I wondered — was she enjoying lustrous and masochistic Sapphic intimacies with the brutally adept Mary? Was she dying inside? Perhaps not. Perhaps she was sitting wrapped in her

long blue silk gown, legs crossed, gazing at herself in the mirror of her improvised dressing table, the smoke from her cigarette pooling around her head as she examined her flawless face for inevitable signs of ageing, or watched her eyes for signs of the madness she suspected but dared not credit. I worried about Marion.

In contrast, Tregallion enhanced my life. For the first time I knew a love that was at once profound and uncomplicated. Even the delights I'd known with my lover the writer seemed to me now mere juvenilia. Our pathologies had entwined as neatly as our hands: the eager engagement of mutually compatible diseases. Confusing intensity with true passion we had fought primordial battles, casting each other as villains and soulmates in an ancient masked theatre of the psyche that was compelling and seemed entirely real simply because it rose up unstoppable from the deepest recesses of the unconscious. This was not love, it was addiction. It was not devotion, it was obsession. We were each possessed by our own inner devils; we were lived by forces we did not understand.

But with Tregallion, everything was entirely different. He set me free. Even Marion and her happy acceptance of homoerotic passion had not released me as Tregallion did. His love seemed entirely unconditional. He accepted me as I was, leg and all, and loved me heart-whole. I remember him saying once, quaintly: 'I'm good at love. Some people are good at games or cooking; I'm good at love. I love long and hard and solid. I can out-love anyone.'

He was the only man I've ever met who had freed himself from his past. His love was not driven by fashionable psychoses: early nipple deprivation, an unfair share of nourishing breasts or frustrated Oedipal longings. I was no mother figure burdened by his chaotic infantile needs. I carried for him no rag-tag baggage of psychological projections. He loved me: unreservedly and deeply. And I loved him back.

It was strange to feel again the intense palpitant longing for another human being last felt when I was a teenager and love with all its painful raptures was new and unexplored. There in the vacant spaces,

seemingly suspended in time, no before and after, I knew again the searing truth that only love and direct ecstatic contact with the godhead can bring: the only important thing is to love true and hard. All the rest follows. There in the vast desert bleaks the call of the nightbirds came clear through the silence and we heard it where we lay smelted together, tasting each other's sweat, breathing each other's breath. The salt of my own interstices was on his tongue and lips, the slipperiness of him lingered in my mouth. The desperation, the intimacy and the fire: limpid kisses in the long hot afternoons, the whispering and suppressed cries, and at night while we made love in the flinty cold we'd hear outside the crunch of the sentry's boots as he marched the dead hours of the night away in lonely patrol.

Tregallion. The sad heart quickens in memory now that he's gone; the blood still beats deeper. I remember: if I thought of him while out working the dusty pits of our dig, I'd feel inside a soft sweet flowering, feel a multifoliate rose open deep inside me: beyond memory and tears, beyond blood or my love of sunlight. Age-old and precious, born in me before words. Tregallion: my love, my love. Gone forever now, as evanescent as grass-shadows running with the wind.

One night when we lay together — the night before we made our final discovery — he said to me: 'I like Marion. Were you lovers?'

'Yes.'

He was silent.

'Does that titillate you or shock you?' I said.

'Neither. I like her.'

'She was better before,' I said, not thinking.

'Before what?'

'Before Victor smacked her on the head with one of our fossils.'

Tregallion sat up and looked at me. 'Jealous of you?'

'Yes.' I told him the story.

'So that's why he's so odd. And her,' he said, and lay down on his back. He rested his hand on my thigh.

'I worry about her,' I said.

'Why?'

'I think she knows she's a bit deranged but she keeps up her façade of ironical coping because it's a habit and because she's too proud. I mean, she'd never come to me and confide if she was worried, never.'

'Then there's nothing you can do. She's chosen.'

I sat up and looked at him. 'Is it all so simple for you? She's chosen, so what will be will be? I shouldn't interfere?'

'How can you? To me, that'd be an awful invasion of privacy. Maybe not for her. Do you know?'

'No ...'

'Well, then. You can't just interfere because you're worried. Learn to live with your worry instead. Harder but more honourable.'

'And then there's Sister Mary. I worry about Marion and Sister Mary.'

'Why?'

I thought about the time Mary had come to me in the shower and told me about her novitiate and excommunication, her affection for cannibalism and her worship of dark gods. 'I think she's bad for Marion,' I said.

'Why?'

I told him what she'd told me and he lay in silence for a time and then said: 'Her god's a bit like Shiva, the Hindu goddess of

destruction. You know they have three gods? Vishnu, Shiva and Brahma? The creator, the destroyer, the preserver? All in one?'

'I still worry about Marion.'

'Why?' he said smiling. 'Mary's already eating Marion alive but I don't see Marion complaining.'

'Don't be trite. And it's not jealousy on my part as your stupid smile implies. And then there's what Mary said about me —'

'What?'

'She said I was a dilettante.'

'She did? Why?'

'She said I didn't really care about human suffering in the here and now; that I was a dabbler, dignifying my ordinariness by elevating myself above the blood and snot and tears of everyday life.'

'I've never thought everyday life had much to recommend it. Nasty —'

'— brutish and short. I know, but that's not the point —'

'I know that. We're not obliged to care about human suffering. I think you need to make a distinction between — Look, I've always thought you could divide people up into two kinds: draw a cross with equal length arms; the horizontal axis denotes people who think only of the here and now: social workers, humanists, politicians, economists, accountants. Jolly materialists. The vertical axis belongs to people like you: to mystics and metaphysicians and religious teachers; to anyone who wants to know the why of our being here in our twilight of dreams. The first group call the second dreamers; the second find the first trivial. You belong in the second by nature. You can't change that. Mary belongs in the second but doesn't have the courage to dream.'

'So you don't think I'm trivial?'

'No, you're not trivial. I think you're brave and I think what you're doing matters very much.'

I put my head on his shoulder and he ran his hand down my back, caressing each vertebra one by one with his fingers.

'Tregallion,' I said. 'Why don't you dance any more?'

'I don't need to. I love you instead.'

'Tell me about your lover. The special one.'

There was a pause, then he said: 'There's nothing to tell, really. She's gone. They've both gone.'

'They're dead?'

'Just Kate. How do you know about them?'

'Oriana.'

'Oriana talks too much.'

'And Seremai.'

'Seremai talks too much, too.'

'What was her name?'

'My daughter?'

'Both.'

'My lover was called Julie. Kate was my daughter.'

'How old was she?'

'Five.'

He was silent. I listened to the empty desert. No wind, no nightbirds: silence.

'If you want to know: all I remember,' he said slowly, 'was driving up through the avenue of flame trees towards the house. I could

smell it, charred wood and something sour mixed in: acidic, rancid. Burnt plastic... I think I knew, then. And when I came round the last bend, there it was: all burnt down. Smoke and charred wood. It'd just collapsed in on itself. The rain had put the fire out. Nothing left to find, at all. It was gutted. I knew she'd done it, timed it to coincide with me coming home. She was gone.'

'I'm sorry,' I said.

'The only thing that didn't burn was the thigh bones. They're too thick, you see.'

'Tregallion —'

'I saw one. It was so small.'

'I'm sorry.'

'Don't be. There's nothing left to say, now. They're gone.'

There was silence. Then I said: 'Tregallion, I can't have children.'

He was silent. Then, quietly: 'Why not?'

'I had an abortion once, a long time ago. It went wrong, there was infection, and the doctor said I'd never have children.'

'I'm sorry. But it makes no difference to me.'

'I just thought —'

'I know what you thought.' He held me tighter. 'But it makes no difference. Go to sleep now.'

And I did, lying with my back towards him, his arms around me, tight and loving, my head on his shoulder. When I woke once in the night I knew he was still awake and I thought I should say something to comfort him but I couldn't think of anything so I listened to the wind instead and saw the dandelion moon through the open tent flaps hanging low over the desert and went to sleep again, safe in his arms, with its light on my face.

314

TWENTY-NINE

...When he slowly folded the dense layers of satin and shot silk back from her thighs and bent to kiss her or gently pulled down the whaleboned bodice of her corset to reveal her nipples, she realised that it was more than an act of sexual passion. She had become an icon; she was Janey, but something else as well: she embodied all womanliness for him. She could sense in Patterson's touch the delight that the layered textures of silk and skin brought him. And when he caressed her tenderly in the secret places between her thighs she felt herself each time begin to shudder in response. She had no control. Now, she said, Now, Patterson now!

And afterwards when she crept quietly into the tent where Jamie slept his fever sleep, she would fall asleep wrapped tight around her dreams of Patterson. Once the rain slid in a smooth wet sheen down the lions' bronze flanks. Hansom cabs clopped horsedrawn across the cobbles; their wet hoods glistened patent-leather black in the rain and the horses' breath puffed out white in the cold. Janey watched from her own brougham, hearing the rattle of a wind-driven gust above. She held her breath, watching. Amber in the winter light three lions walked quietly across Trafalgar Square. Pigeons took to startled flight. She saw the notched ear of the big male lion and recognised him from her visits to London Zoo. There, he'd paced in controlled fury back and forth across the width of his cage, turning always at the wall with the same hypnotised dip of his shoulder. How had they escaped? His eyes were saffron when he stared at her. He sniffed at the air with a little lift of his head. He seemed to be waiting.

Then Janey saw Patterson standing beside the nearest couchant Landseer lion, his hand resting gently on the wet metal that showed

verdigris in the rain. The three lions mounted the steps and lay down beside their metal brothers. The male, his mane tangled by rain, glanced at Patterson, then hung back his head and yawned.

Patterson beckoned her. She turned to speak to Audley but he was asleep in his seat, mouth open, snoring softly. Quietly Janey rose, descended the creaking narrow steps of the brougham and ran in the rain towards Patterson. The lions ignored her.

Patterson held out his hands to her and swung her up and onto the rump of the nearest lion. She said nothing but her seated heart knocked at her ribs as Patterson unbuttoned her frock and pulled it down over her shoulders. Her breasts fell into his hands and he bent to kiss them. She felt her legs open unwilling against the insistent pressure of his knee. Half-ashamed, she felt herself soften and open for him. The wetness as never before, the swelling. Patterson gathered the fullness of her skirts, raised them about her thighs. She felt the sudden pressure and distension deep inside and lay back onto the cold wet metal and pulled Patterson down on top of her.

Surrounding them, the London traffic had stopped to watch. Men politely applauded. Patterson ignored them. The lions stared interestedly and the male rose, walked towards her and bent to lick her face with a tongue that rasped against her skin. She closed her eyes and hung back her head as the ecstasy began to shake her and felt the rain fall on her face and into her open mouth and held Patterson tight and knew that now they would never be parted ever again. Then the shudders began and it was as if the lion had begun to roar inside her: the crescendo held her for a moment and then came the soft rolling diminuendo into silence. She bit Patterson's neck.

Beside her in the tent, Jamie sat up in his camp bed, his heart running away with his breath. He swallowed. What had woken him? A sound? A dream? The night was silent. Then a lion roared distantly, a sound that was more thud than roar. Deeper than hearing, it ran into the very soul. Jamie lay back and pressed his

pillow to his ears but the roaring intruded still, as if the lion were right there beside him in the tent.

★

The next day I found the footprints. It happened by chance. I was walking towards the fossil site thinking about Tregallion and his daughter, head bent, when I came to a weathered buckle in the volcanic surface that exposed a tuff the same colour as our Bed Two. Naturally, I stopped to look and there, as if cast in concrete, was a small clear footprint. My heart beat suddenly fast and hard. The big toe was long and very slightly everted but the arch was obvious and the other toes were parallel. I stared. Fossil footprints have only ever been found once before, by Mary Leakey at Laetoli. But hers are dated at between three and four million years; these would be a full million years older, giving us a glimpse of life deep in the impenetrable gloom of the Pliocene.

I sat down suddenly. My legs simply gave way. My knees were shaking. I stretched out my hand and cleared away sand and weed, touched the print. It was small, about the size of a modern twelve year old girl's. I knew immediately that it would match the size of our female hominid fossil. I looked up towards the fossil site where Chinta was hard at work, sieving overburden in a thick cloud of volcanic dust. He was perhaps thirty yards away.

Between the footprint and the fossil site there was another uplifted dark tuff. I quickly walked over and brushed away desert sand and found a distinct heel mark, unmistakable sign of a strong heel strike and therefore of a powerful striding gait. At a glance it looked like a zebra print; but when you looked more carefully you could see the beginning of the arch. This was larger than the other. I was looking at a male print. I closed my eyes. I knew. If we removed the pale tuff above, we'd find a trail of prints, male and female, leading to the site where we'd found both fossil hominids. I stood up. I'd walked that route to the fossil site a hundred times and never noticed the prints, yet they were so obvious! How had I ever missed them?

317

Trying to keep my voice calm and level, I called: 'Chinta?'

He looked up. 'Yes?'

'Would you come here a minute, please?' I said. 'I've got something to show you.'

<center>★</center>

We celebrated that night in the dining tent. Everyone was there except Seremai who was still in Marsabit. Victor, relatively sober, produced more vinegary Asti Spumante, and we toasted our success in warm bubbly. Orde sipped a whisky and smiled tolerantly. John Morton attempted bravely to congratulate me but failed and spent the rest of the evening talking emphatically and softly to Sister Mary, who watched me all the time with unsmiling eyes. Marion sat beside me and took my hand and held it gently throughout the evening. Her delight was evident. Tregallion stood close by me. Awed by the enormity of the occasion, Hamid's nerve broke and he reverted to earlier bad habits and served roast goat, boiled goat, braised goat, fried goat and goatburgers, all inedible.

'We couldn't have wished for more,' said Chinta. He counted on his fingers: 'The oldest fossils; the most complete fossils; male and female fossils; the best dated fossils; and now footprints as well; two sets: one male, one female. I can't believe it!'

Nor could I. I pondered the events necessary to preserve the footprints: a volcanic eruption that produced a fine natro-carbonatite dust; a brief rainstorm to dampen the dust just enough so that it would accept the prints without distortion; conveniently passing hominids; a further eruption to cover the prints; more rain to form a protective laval layer. Chance and necessity had combined to bring us, intact after nearly five million years, a glimpse of preserved proto-hominid behaviour that I'd had no right to expect. It was a gift. Tregallion caught my eye and smiled. I smiled back. He whispered in my ear: 'Will you wear your ballgown for me tonight?'

'Yes,' I said.

★

It took us six weeks to excavate the trail of footprints. They were fragile — the tuff was as crumbly as meringue — and it took time to preserve each one painstakingly with Bedacryl. I was not certain why, but I decided immediately not to uncover the final six feet of the trail.

We invited Todd Wister back and he wrote a long interpretation that confirmed what he called our hominids' 'nearly erect bipedal plantigrade gait'. There were dozens of other tracks as well: elephant, guineafowl, a large cat — perhaps ancestral to the false sabretooth dinofelis — springhares, baboons, giraffe, three tortoises and, of course, hyena. It was a vivid re-enactment of one day in the life of an entire biotic community nearly five million years deep in the past.

Every evening when we'd finished work and the site was deserted I'd stand there in the clustering dusk and stare. Perhaps I'm very primitive but it took little imagination to visualise the scene: the distant volcano thundering dust into the blue sky; the clotting rainclouds; the elephant walking wearily dustcovered down to the stream to drink; the guineafowl scuttling on quick feet, ferreting in the dust; the dark muscled sabretooth cat frightening the baboons with his coughing grunt; and the two half-people, walking together alone in the wilderness, under the volcano, their eyes wide with fear.

We cabled the media from Maleleji and soon the helicopters and four-wheel-drives began to arrive and the circus began again. Tregallion immediately disappeared into the desert; Victor held drunken court, discoursing learnedly on suid evolution, and Chinta and I conducted the journalists on a tour through our fossil tent and our library where the specialists' reports on dating and locomotion were kept. Finally we took them to the fossil footprint site and they all stood silent and stared. Hardened cynics that they were, this glimpse of a living past was still stunning. The hominid expert from *International Nature* summed it up when she said: 'This is going to

make a lot of people very very cross indeed.' She was right. Eventually they left, Tregallion returned from the desert and we burnt their rubbish and returned to work excavating the last six feet of hominid trail closest to the fossil site.

Our last find was the greatest and most enigmatic. When we finally uncovered the remaining six feet of the trail that led almost up to the site where we'd found the fossil skeletons I stared for the first time at the incoherent dents and smears in the tuff and knew I was seeing the vestigial evidence of a terrible, all too human drama.

'Chinta,' I said, 'get the army's best tracker over here now.'

When the tracker arrived — a small wrinkled man with long drooping earlobes — our assembled workers made a soft murmuring.

'What do they say?' I asked.

'WaN'drobo Maasai,' said Chinta. 'He's a WaN'drobo Maasai; they're the best trackers.'

We took him to the beginning of the footprint trail and Chinta told him to tell us what he saw. Incurious, unquestioning, he followed the trail, speaking in a soft voice and pointing with a thorn twig. Our entire workforce followed in a silent, watchful group.

Chinta translated: 'They walked together, man and woman, the man in front; they stopped there, because the man saw the elephant that stood over there and waited; then they walked on and the elephant crossed behind them: you can see the elephant prints overlay the man's there and there; then they walked on and stopped to look just here; see? There's a half turn to the left. Then they walked on, faster now, and the man turned round there and he stamped his foot: there, that print; and the woman stepped back, in fright. He dropped something, there. Then the man turned away and they walked on, faster again, but the woman ran to the man and he turned round and —' The tracker had stopped. We'd reached the final point where we'd found the fossil skeletons.

320

The tracker stared at the blurred footprints and smeared fossil mud, hesitated, cast about, then spoke rapidly to Chinta in Gabbra. A low murmur came from our workers. A few men nodded. Chinta turned to me, his eyes chaotic.

'What does he say?'

'He says —' said Chinta and stopped. He cleared his throat, stared at the tracks. The tracker watched him in silence. 'He says that the woman ran up to the man, and the man grabbed her and swung her round and hit her on the head and she fell there.' He pointed at a wide smear in the tuff.

I stared at him. The tracker watched us in silence. The workers waited, watching. I felt myself swallow. Chinta started to speak but changed his mind. I let out my breath. I needed to think.

'How certain is he?' I said.

Chinta spoke to the tracker and he replied emphatically.

'Very,' said Chinta.

'Let's have a holiday,' I said. 'Tell the workers to peg the site and then take a day off. We need to talk about this.'

★

After talking to Tregallion I walked two more army trackers through the sequence and got the same interpretation; not satisfied, I found a tracker in Maleleji and another from the nearby Gabbra village. They agreed with the first three trackers. Seremai arrived back from Marsabit looking drawn and tired but we showed no mercy and immediately took him to the site. He walked it and commented a little more slowly than the first army tracker and interpreted the tracks in the same way. He, Tregallion and I stood together staring at the tracks that dusk and I knew I would have to write a paper on them myself.

321

Tregallion turned to me. 'You've got the earliest evidence of infraspecific violence here,' he said.

'I know.'

'It's going to upset a lot of people.'

'I know.'

'Even Chinta,' added Seremai. 'Especially Chinta.'

'Yes, I know.'

Early next morning I arranged for a cast to be made of the fossil dents at the spot where the male hominid had 'dropped something'. Chinta walked with me to the site and we stood and stared at the footprints. 'Are you going to write a paper?' he said.

'Yes.'

'Violence?'

'Yes.'

'You can't prove it.'

'No. But I can get close.'

'How?'

'I've got the scanning electron microscope pics of both skulls; I've got matching scans of the kudu femur; I've got the Maleleji Mission's X-rays of Marion's skull and Doc Ludovic's report; I've got the photographs of the endocranial cast; and I'm getting a Scotland Yard forensic surgeon's report on all of it. I'll be close.'

There was a pause.

He cleared his throat. 'I don't agree with you that violence is in us, somehow, in our genes. Inescapable and unavoidable. It'll encourage

a kind of "nothing can be done about it" attitude. I see nothing but trouble. You know that.'

'Yes.'

He stared at the footprints, shook his head. 'I don't care how many trackers you produce who tell you the same story. Do you understand? I can't agree.'

'I know.'

'Why do you have to insist on the bad side, on the killing? Is it some kind of awful fear you have of your own capacity for violence? Maybe you know you're bad inside, so you have to prove we all are? Less guilt?'

'Chinta, we learnt to be aggressive on the savannah because we had to, but that's not all we learnt. We're gentle, too, and we help each other when we're sick and we bury our dead with ceremony and we love children and each other and even love animals. It's all natural. We just need to be careful about pretending we're all good when we're clearly bad too.'

'I don't agree with you. At all,' said Chinta firmly. He turned and walked away.

His lesson was not long in coming. But then, it was a lesson for us all.

★

Did I dream him, or did he appear because I sought him? Perhaps you don't believe in ghosts. Let me simply tell you what happened that night and leave you to decide.

I was deep in sleep when I heard Quasimodo squeal. I woke instantly because she never uttered a sound at night. As I turned to feel for my torch on the tarpaulin floor I saw a pale figure standing mute and appealing at the foot of my camp bed. I did not immediately recognise the face. I felt my hair stand on end and my

flesh crawl. The tent seemed inexplicably cold. I stared in fear, my heart thudding hard. The figure was uniformly pale, faintly luminous and dressed in a bushjacket, jodhpurs and puttees. As I watched, the figure raised one hand palm upwards towards me as if begging. The face was filled with what I can best describe as helpless appeal. As the figure stepped hesitantly towards me I recognised John Patterson. I opened my mouth to call out. Beside me in the dark, Quasimodo squealed again and at the sound the figure turned its face slowly away and faded sadly into nothingness like a dream.

I found my torch, switched it on and swept it around the dark tent. There was nothing. I reached out my hand and touched Quasimodo. She was shivering. I patted her, dressed, went outside into the cool night and blew my small fire into flame. I added more wood, sat in my camp chair and thought about what I'd seen. Quasimodo curled up doglike by my feet, her tremors lessening until she slept. Ten minutes later I heard Tregallion's soft voice call: 'Hodi! Hodi?'

I replied: 'Karibu,' and he stepped into the circle of firelight.

'You're up early,' he murmured and sat in my other camp chair.

'Yes. I couldn't sleep.'

'Nor could I.'

'Tregallion? Do you believe in ghosts?'

'Why, have you seen one?' he said, teasingly.

'No, I just wondered. I've been thinking about Patterson. Wondering what happened.'

'Have you read the transcripts of the court of inquiry?'

'No.'

'I'll get them.' He returned with Oriana's large buff envelope, sat.

'I was thinking that they seemed so bound; as if they were caught in a process they didn't understand and couldn't control.'

'Yes,' he said thoughtfully. 'I thought that too. But what strikes me most about the Uganda Railway, by way of example, is how much Patterson's story resembles ancient myth.'

'It does?'

'Listen: here's western technology, all steel and steam and arrogance, trying to master the intractability of Africa. Don't forget: the Victorians really did call Africa "The Dark Continent". Africa and women were always mysterious and full of evil and temptation. They were irrational and primitive. And what happened? In response to the steel and noise and hammering and blasting the primitive opposed malaria and dysentery and fever; even monsters: maneating lions that were almost more magical than real. And Patterson — dull, methodical old Patterson — kills the lions and the steel road rolls on. Mechanism wins; the mystery goes.'

'Then what did Janey see in him if he was so dull?'

'Nothing. I don't believe she really saw him as he was; she saw what she wanted to see. Yes, he was an initiate into the mysteries of Africa, granted; he was brave and strong and he was a kind of wizard because he could read all the invisible signs of the bush. But he was really just a kind of Rorschach inkblot in which she could see whatever she needed to. And she needed power and mystery so he became a kind of warlock for her.

'I mean, look at this —' he opened the envelope, shuffled through the court transcripts. 'Look here: she lost control completely. When her husband fell ill, she moved into Patterson's tent! Look: see? Here: this is Saiba's testimony. He was Blyth's gunbearer, a Maasai. See here, it's been marked by the Colonial Secretary, Lord Crewe... "Mrs Blyth slept in Colonel Patterson's tent." And here: "After Captain Blyth's death, only one tent was pitched for the Europeans." And here: this is Asmari bin Kombo, headman of the

askaris: "After his death only one tent was pitched for the Europeans instead of two... It was a small tent, two loads..." And this: this is pretty damning: Ibrahim, Janey Blyth's personal servant, says: "When he was given medicine at 6.00 pm he vomited immediately. When I saw him lying on his back I knew he was asleep. I went back and told Colonel Patterson that Mr Blyth was asleep — then both Colonel Patterson and Mrs Blyth laughed. It was a laugh, not a smile — they just laughed gently and did not make much noise." And this was just after Blyth had collapsed with sunstroke after hunting a giraffe.'

'Not exactly damning.'

'Not exactly compassionate either! Wait. See here? "Mrs Blyth slept in Colonel Patterson's bed — her bed was not brought from Mr Blyth's tent. There was only one bed in the tent and they both slept there..." And this: "After Mr Blyth died we pitch only one tent and Colonel Patterson and Mrs Blyth used to sleep in it. They used to go to bed together and took their tea together in the morning. They undressed every night."'

He smiled at me. 'You see? And Patterson and Blyth had just fought over an elephant they'd shot. It says here —' he paged through the documents '— here: "I was sleeping and a Maasai boy — Colonel Patterson's boy — woke me and said: 'Listen, the gentlemen are quarelling.'" And here, this is Saiba, Blyth's gunbearer, again: "Mr Blyth shot an elephant on the road, it went off, we followed. Colonel Patterson shot it twice then it charged his horse. That night there was a quarrel between Mr Blyth and Colonel, then they shook hands..." But the saddest thing is this bit here, after Blyth's death. His gunbearer said: "She was crying and Colonel Patterson was crying, so we hid the guns lest they should shoot themselves and leave us all alone in the nyika..."'

★

...Blood, thought Patterson, there's blood everywhere.

Dripping from the dense acacia thorn onto Aladdin's white flank, hanging in thick coagulating gobbets from the thorns, wound in blackening streamers from the low branches. Bright red arterial blood, yellowish bile-coloured blood, blood thick and dark and venous; kidney blood, liverish blood, stomach blood mixed with leaves. Blood everywhere. The elephant was doomed but apparently hadn't noticed.

Poor Patterson. He had no way of knowing that he was caught in the toils of magic, no way of knowing that the darkness, sent by a witchdoctor, was hidden in the wind to blind him to danger, no way of knowing that his life was to be washed in blood. Like all mythical heroes, Patterson and his voyagers were bound by the inner logic of their history to meet and conquer a monster. They met theirs in the heat of the day on the banks of a dry river where the washed sand burnt white in the sun.

They were crossing the dry bed of the Lungaya river when Patterson saw him: a lone elephant bull watching from the shade of tall riverine trees that stood on the far riverbank. He reined in Aladdin who was skittish with fear, scenting danger, and said, 'I think we'd better dismount.'

'Why?' from Audley.

'Because I think he's going to charge,' said Patterson calmly.

'My God, do you?' said Janey. She dismounted, took her .450 double from her gunbearer and said to Patterson: 'Solids?'

'Absolutely.'

He watched her open the big double rifle, check the long brass cartridges were solid points, watched her close it. The elephant was now at the edge of the far bank, head raised slightly, watching their movements and tasting the air with his upraised trunk for their scent.

'Shouldn't we go back?' said Audley in a thin voice. Patterson looked at him. Sweat had started on his forehead and nose. His eyes were wide.

'Why, Jamie?'

'You know. He might catch us, kill us. Or someone.'

'We're three, he's one; we're armed, he's not.'

'It still seems wrong. Why provoke a charge?'

'We'll not provoke him,' said Patterson. 'We'll just stay here quietly. He doesn't know what we are yet. He can see us, but he can't scent us. I think if we're quiet, he'll go.'

'Will he charge?'

'He'll come if he wants to,' said Patterson. He watched the elephant.

The wind ran round in quick eddies, blowing the river sand. The elephant lowered its trunk, folded back its ears and came for them.

'Janey,' said Patterson. 'Wait till I say, then fire!'

'Oh, God,' said Audley.

'You too,' said Patterson. 'Back her up if I tell you to.'

The elephant came at a fast shamble, eyes fixed, trunk tucked in.

'Now!' said Patterson. 'Janey, shoot now!'

Janey raised her rifle, sighted on the bull's chest and pulled the trigger. There was a boom and the rifle was rising up in recoil... She heard the thunk of the bullet strike and heard Patterson call, 'Now, Jamie!' and heard the boom of Audley's .450. Patterson said, 'Damn, you missed!' And then she saw the elephant still coming, saw Patterson run forward to meet its charge.

The elephant came in a silent rush. Dust burst from his footfalls. His ears are folded back so neatly, thought Patterson, and his feet trip along as prettily as a dressage pony's. But the pale curve of the long single tusk and the strangely long-lashed eyes — so focused and angry — were real and Patterson knew there was only one salvation.

Patterson waited him out, rifle half raised. He felt the ground shake, heard the beat of his own heart thick in his throat. He shouldered the .450, saw the tall bead settle between the vee of the rearsight, aimed at the centre of the bull's chest and squeezed the trigger. The boom of the shot, the smack of the bullet's impact and the elephant's squeal of pain were almost simultaneous. The elephant fell back onto its haunches. Patterson ran to the side, opening the angle for a heart shot and heard the whack-boom of a double rifle. The bullet kicked up sand yards from the bull, making the strange whistle-whip of a near miss that Patterson remembered so well from the South African war.

'Don't shoot! For God's sake, you'll kill me!' he shouted, and turned to look over his shoulder. He saw Jamie with his .450 raised.

'No, Jamie —!' he shouted and threw himself flat as Jamie pulled the trigger. The bullet rattled harmlessly away through the trees.

'Stop him, Janey!' called Patterson.

The elephant was struggling to its feet now, blood pumping from a chest wound. Patterson raised his rifle as the big bull turned away and made for the cover of the trees. He felt only compassion now; the elephant was in pain and Patterson wanted to stop that. It was a risky shot: aiming for the short ribs from behind, Patterson hoped the bullet would rake forward through the chest cavity and reach the heart or lungs. As the elephant slowed to climb the far bank Patterson squeezed the second trigger, saw the bullet's impact burst dried dust from the elephant's midriff as the rifle rose in recoil. The elephant faltered but did not fall and shambled across the dry riverbed, up the bank and into the trees. The tall acacia bush closed

around his wrinkled grey stern with its absurd little tail and he was gone.

Patterson pushed over the lever on his rifle as he ran and the breech opened. Shiny brass cartridges ejected with a metallic ping and flew over his right shoulder in a blur of golden brass. He reloaded with the two long solids held between the fingers of his left hand, swung up the barrels and closed the breech with a click. He pushed up the safety under his thumb and climbed the far bank and entered the dense acacia thicket. With his left hand he carefully slid two more cartridges from the bullet loops sewn onto the left breast of his bushjacket, held them taut between his fingers and stopped to listen.

Nothing, no sound. Birds, a monkey in the distance. Now baboons giving their startled alarm call. Heat and sweat. He heard a footfall behind him, turned and saw Jamie and his wife. Their faces were white. Janey's eyes were wide with shock and excitement.

'Did you get him?' she asked.

Patterson shook his head. 'Hit him twice but he didn't fall.'

Behind her Patterson saw the frightened faces of Abuddi and Abdi Hassan, the gunbearers. Asa Ram, his syce, ran up.

'Patterson, I'm most dreadfully sorry —' said Jamie. He looked distaught. 'I was shooting all over the place, but I thought the elephant had you for certain.'

'We'll talk about it later,' whispered Patterson.

'But —'

'Leave it, Jamie,' said Patterson shortly. 'No more talking. He's wounded in here —' he gestured at the thick wall of acacia before them '— and we've got to find him.'

'Can't we just leave him?' whispered Jamie.

Patterson looked at him coldly. 'No, we can't.'

'But why not? He'll die soon enough.'

Patterson stared at him. 'He's hurt and he's frightened,' he said. 'I want to put him out of his suffering quickly; and if we don't, he may kill someone perfectly innocent. Now Janey —' he turned to her, took her firmly by the shoulders '— I want you to stay here with Abuddi and Jamie. Climb up on that high rock there if you need to, but whatever happens, DON'T MOVE. I'm going after the tusker on Aladdin; I'll have a better chance.'

'I'm coming too,' said Jamie.

'No, Jamie.'

'Dammit, Patterson, I'm coming. You can't handle this alone. It's my shauri too, you know.'

Patterson looked at him. I'd rather have Janey with me, he thought; she's a steadier shot and a steadier head. But after that business down at the river, perhaps I'd do better to have you where I can see you... 'Very well,' he said. 'But stay where I can see you, otherwise I can't shoot safely.'

'Patterson —' said Janey.

'Yes?'

'Please be careful... I've a terrible feeling about all of this.'

'Of course, old girl.'

'You too, Jamie,' she said. Jamie bent and kissed her nose. Patterson looked away. As Asa Ram ran up with the horses loud cries came from the tail end of the safari where it meandered through the bush.

'Damn!' said Patterson. Then, quickly: 'It sounds like he's doubled back and found the baggage mules.' There were loud screams. A single shattering trumpet followed. There was a shot: a hollow boom.

'That's one of the askaris; that's a Martini Henry carbine,' said Patterson. There was a long human scream. Patterson slid the .450 into its scabbard and swung up into the saddle. 'We should go, Jamie,' he said and urged Aladdin forward through the thornbush.

★

They followed the wounded bull's blood spoor for an hour through the thick scrub acacia. Blood hung from the trees, washed the tshani grass red, squelched in pools beneath the horses' hooves. Patterson reined in Aladdin and stopped to listen. Aladdin was skittish, frightened by the blood scent. The bushes moved slightly to the left.

'Watch out, Patterson, there's something coming,' said Jamie at Patterson's side. The bush parted and Munyakai bin Dewani ran forward.

'Bwana, the elephant is killing the mules!' shouted Munyakai.

'Where?' Patterson dismounted and took his .450 from its scabbard.

'There —' Munyakai pointed. 'Back by the river!'

'Let's go forward on foot,' said Patterson. 'Come on, Jamie.' To Munyakai: 'Keep the horses here with Asa Ram; Abdi, come with us.'

Patterson walked slowly forward through the interwoven thorn-bush, following the blood spoor. Jamie pushed through the bush alongside instead of following behind. Abdi Hassan obediently spread out beside Blyth.

'Jamie,' said Patterson, 'that's a bit dangerous. I'd follow behind, if I were you —' The trees parted up ahead and with a shrill shrieking trumpet the elephant charged without hesitation straight towards Jamie.

'Shoot!' called Patterson but Jamie stood rigid with fear, his rifle gripped tight in his hands. Branches flew as the bull shouldered its way through the thicket.

'Shoot him, for God's sake!' shouted Patterson but Jamie was shaking now, incapacitated by terror. Patterson could see his eyes wide and fixed. He threw up his rifle as the elephant shambled past, ears flapping, so close Patterson could have reached out and touched his bloodstained flank. His sights rested for an instant just ahead of the bull's earhole and he fired. The elephant flinched, blood sprayed, the elephant swerved and charged on, trumpeting with rage.

'Shoot him, Jamie!' screamed Patterson but Jamie dropped his rifle and ran.

Changing direction slightly, the bull headed for Abdi who also turned to run but tripped and fell headlong. The elephant swung his trunk like a polo mallet and knocked the gunbearer's turban from his head. Squealing like a pig, the elephant tusked the turban and paggri into the earth. Patterson sighted and fired a slanting shot and the elephant parted the trees ahead and was gone. Jamie was nowhere to be seen. Silence.

Holy Mary, what a mess! thought Patterson. He ran to the gunbearer who had sat up, shaking his head and rubbing his shoulder. 'Are you all right?' asked Patterson. Abdi said nothing, staring at his ripped turban that the elephant had tusked into the ground. He looked at Patterson in horror, eyes unfocused. Shock. No point in trying to get any sense out of him, thought Patterson.

'Stay here!' he said and reloaded as he ran forward, following the blood spoor.

★

For another hour Patterson spoored the wounded elephant through the hot thorn thicket. Each step he took was slow and deliberate. The whole bush had fallen silent. Sweat beaded on Patterson's body, ran in rivulets down his back and into the cleft of his buttocks. The blood spoor had dried to black. Where the elephant had passed, the bush had simply closed up again. Patterson found that his hands

were shaking. Bad sign, too tense. He sat down to rest and listen, eyes closed. Nothing.

No, wait: there, a rustle. He raised his rifle, aimed and saw the cautious face of one of the safari askaris, armed with an old Martini Henry rifle, appear through the thornbush.

'Ali!' called Patterson and the askari turned with a start and stared at him as if he were a ghost.

'Ali!' called Patterson again. 'What are you doing?'

'Bwana?' Ali walked slowly towards Patterson, eyes wide. 'You are not dead?'

'Of course I'm not dead. Do I look dead?'

'But all the blood, bwana!'

Patterson looked down. He was covered with the elephant's blood. His khakis were soaked in it, face splashed, arms thick with blood. From the bush emerged five more askaris, all armed, all looking terrified and amazed at the same time. They stared at Patterson in disbelief. Ali reached out a hand and touched Patterson lightly on the face. Patterson pulled back.

'What the hell is going on here, Ali? Where's Munyakai? Where's Asa Ram? Who told you I was dead?'

'Abdi Hassan, bwana. The gunbearer, he say the elephant kill you! He say the elephant push you into the ground.'

'The bloody fool! Where's Asa Ram?'

'He is dead, bwana. The elephant kill him, kill your horse and — And kill —'

'Asa Ram dead? My God; and Aladdin? And who else?'

'He kill the m'sabu,' whispered Ali and started to cry. 'Do not strike me, bwana, I beg you!' he said and fell at Patterson's feet, wrapped

his arms round Patterson's legs. 'I am so sorry, bwana, to tell you this sad thing. Oh, bwana, so sorry!'

'Who killed the m'sabu? Was she shot? Was it Bwana Blyth? Who?'

'The elephant!'

Patterson felt his scrotum crawl tight with fear. 'Where?' he said very calmly and pulled Ali to his feet. The small askari would not look at him. There were tears on his face. Patterson shook him. 'How do you know? Where is the m'sabu?'

Ali pointed towards the river. Patterson ran off, his heart grown small and cold in his chest.

★

The elephant did not kill Janey. Tregallion showed me a telling photograph in Patterson's book. Janey is perched high up on the dead elephant's shabby wrinkled rump, her legs coyly crossed, rifle propped against the elephant's right leg, her head turned slightly like a pinup's into her upraised right shoulder to offer the long smooth plane of her neck to the camera. Her right hand rests caressively on the elephant's flank. The hand is small, her bushjacket seemingly too large for her, the tininess of her body emphasised by the massive swell of the elephant's belly and leg.

We are unbounded. It is easy to move back in time: to imagine Patterson holding her under the arms, her breasts level with his eyes as he boosts her upwards onto the four tons of bloating meat, the faeces and blood and seminal fluid of the elephant's last humiliating moments coagulating in the dirt. Behind her, lala palms sway in the breeze. It is easy to forget the elephant drowning in its own blood, the pain and burning and the rising darkness that finally eclipsed all thought of revenge as the animal fell headlong and rolled with a last trumpet onto its side, the top rear leg stretching and stretching helplessly for a final purchase on nothingness.

And Patterson with his treasured Kodak in hand, saying: Cross your legs, my dear (looking at the curve of her thigh in the jodhpurs, the gleam of leather boots) and: Turn your face a little to the light and straighten your back a little (her breasts full and soft under the silk) and finally: Hold still, now... Then the click of the shutter, the illusion of permanence. Did he help her down? Kiss her? Did she smell the dried blood on his bushjacket and know that she would find his lips in the darkness that night, kiss him, tease with her tongue and when she felt him respond, bite his lip softly and say, How do you want me, Patterson? Kneeling in front of you? Will you hold my neck from behind and push my head down hard? Please?

The things they did that she had never done before, not even with Jamie — (terracotta tempera on the walls of Pompeii, illicitly visiting the men-only murals in the ancient Roman whorehouse, shock at the swollen phalluses and the women's expectant mouths, open) — yet now she felt at night in the stifling tent with Patterson's pale body beneath her hands, as if welded into her consciousness, the instant knowledge that God and the devil were one: co-eternal, co-regent, holding her life in sway. There was law in the universe, that she knew; but as she licked catlike at Patterson's sinewy body she knew also and without doubt that even divine law could be perverted and destroyed.

Nigredo

The
World
of
Darkness

In the fire of an inner harmony some surrender their senses in darkness; and in the fire of the senses some surrender their outer light.

Bhagavad Gita 4:26

The Devil. Major Arcana: an inverted pentacle shews that he is not of this world; the sign made by the right hand indicates that he will hinder the spirit at all times; he holds the fire of destruction in his other hand. The wings indicate that he is a creature of darkness. He is inexplicable.

Tarot And Witchcraft. From: Index Ludorum Proibitorum (1497) Fr Francisco Mendoza, SJ & Fr Gottlob Sprenger, SJ Edited by Dr Gottlob Paiss. Beolgorod University Press, 1937

THIRTY

That night, sitting outside my tent with me and Tregallion, Seremai explained his long absence. He'd been down with a touch of malaria, true; but he'd also been up to Mogadishu and found out about Sister Mary. I watched him quietly as he spoke. He'd always distrusted Mary.

'Mogadishu's a mess,' he said. 'The UN forces are pretty powerless and the bandit warlords do whatever they want. They fight each other and they all fight the UN troops. There's a lot of killing. Sister Mary was a nursing sister at one of the mission hospitals. She treated the wounded of all sides, of course, but the UN troops I spoke to remembered her very well. Tregallion, pour me a whisky, would you?'

Tregallion poured us each an Ardbeg, added cool water. Seremai sipped, nodded and went on: 'They called her "The Angel of Death".'

'Who did?'

'All of them: Americans, French, Somali, all of them.'

'Why?'

'Ah. Because she used to sit with the badly wounded ones and whisper to them while they died. But that's not all. The other ones — the men who were wounded but not terminal — she'd sit with them too, and talk to them; and the soldiers, all of them I spoke to, swear she talked the wounded to death.'

'Talked them to death?'

'Yes. And they're right. I checked the records. The mission hospital she worked in had a higher proportion of dead to wounded than any other in Mogadishu. What do you make of that?'

★

I don't remember whose idea it was to have a farewell feast. Orde perhaps, desperate for interesting tastes to delight his fastidious palate; but once conceived, the idea took hold and we suddenly found ourselves faced with the logistics of feeding and watering the entire workforce and our Kenyan army guards. Confronted by this organisational challenge, Victor stopped drinking and took control. The clipboard and pince-nez reappeared, as did a stopwatch, whose purpose I never entirely grasped. The road-worn supply truck made additional provisioning trips to Maleleji and the army's commissariat pitched in and our days were enlivened by the sight of large helicopters on illicit supply missions hovering, landing, offloading and disappearing tail-tilted back towards Marsabit. Orde was put in charge of catering and spent hours poring over putative menus with Hamid and the fat army chef. The kitchen coolroom was suddenly hung about with flayed carcasses. When I asked him what we'd be eating, Hamid smiled broadly and said: 'Eclectic, m'sabu. Mister Orde says definitely eclectic.'

Invitations were delivered and Oriana and Toad arrived the day before our feast, driven by Amman in their impeccably kept but now dusty green Land Rover. We put them up in a spare tent.

'We've brought the violins and a viola,' said Grenville. 'Is that all right? We thought you might like to have that concert?'

'Good idea,' said Tregallion. 'Bach. Did you bring the Bach? The Art of the Fugue. But we don't have a viola player.'

'Yes, we do,' I said.

I took Grenville's viola and sought out Marion in her tent at sundown. She was half undressed, sitting at her improvised dressing table, smoking and watching herself by the light of a storm lantern

in a large looking glass she'd propped precariously against the tent wall. She wore a strawberry lace bra and a matching tanga and I looked at the way the light fell in a golden paraffin swathe across her breasts in their lacy half cups, remembered not without a pang the way she'd once kissed me.

'Kathryn,' she said, watching me in the mirror. 'It's nice to see you.'

'I've got a favour to ask you,' I said.

'Of course. Anything.'

'Well; don't be too hasty. I want you to play the viola in our quartet at the feast.' I put the viola case down in front of her.

She stubbed out her cigarette and opened the case and stared at the viola. 'It's beautiful; but I haven't played since school. I'll be awful. Is it an Amari?'

'Yes. It doesn't matter if you're rusty. I'm rusty. Oriana plays well, but Grenville's arthritic. It'll probably sound hideous, but Tregallion's quite determined.'

She smiled. 'Tregallion, Tregallion, what a rapscallion! Is he a good lover?'

'Really, Marion.'

'Well, is he?' Her eyes sparkled.

'Yes,' I said, laughing. 'He is, if you must know.'

'As good as me?'

'Different, very different.'

'All that sordid penetration... Does he think he's God's gift? That horrible phallocentric arrogance.' She shuddered slightly. 'All that messy squirting.'

'No,' I said. 'No. He's not like that at all.'

She lifted the viola from its case, took up the bow, played a tentative C, a quick but clumsy scale, a surprisingly deft arpeggio. She nodded at me. 'Why not? I'll have to cut my nails, but that's not such a bad thing; Mary's been on at me for weeks to do that.' She smiled mischievously up at me. 'She says they hurt. We didn't think so, did we?'

I said nothing, looked away. She smiled at my embarrassment. 'Are you ashamed of being my lover?'

'Of course not.'

'Do you miss me a little?'

'Yes.'

'Did I hurt you terribly?'

'Yes.'

She stared at me. 'I'm sorry. I think I was a little mad for a while.'

'No matter. It doesn't matter now.'

'Why not? Is it Tregallion?'

'Partly. Partly just healing.'

'Have you told Tregallion?'

'About us? Yes.'

'Does he mind?'

'No.'

'Does he fancy a threesome?'

'Marion.'

'I like him.'

'So do I.'

'Shall we practise tomorrow? What are we playing?'

'Bach. The Art of the Fugue. We've chosen a slow one. The last one that's based on some chorale. A Prayer for the Dying? Do you know it? Everyone else does except me.'

'I think so. I think I remember some of that from school. I had quite the most pretentious viola teacher. She loved Bach and looked exactly like John Lennon in drag. Why did you choose that?'

'Tregallion insisted.'

'Really? That's interesting...'

'Why?'

She shrugged. 'The unfinished fugue... We'll never know the ending Bach had in mind, will we?'

'No.'

'Will you send me the music?'

'Of course.' On an impulse I said: 'Marion, have you ever seen Patterson?'

She studied me very carefully in her mirror before replying: 'How could I? He's dead.'

'You know exactly what I mean. Have you?'

After a long pause she said: 'Yes.'

'When?'

'About a year ago.'

'In the night?'

'Just before dawn.'

'Why didn't you tell me?'

'Would you have believed me?'

'No.'

'Well then. Have you seen him?'

'Yes.'

She nodded without speaking.

'Why haven't you nagged me about Patterson?'

She shrugged. 'Circumstances... And Patterson doesn't really matter, does he? Really? Why should Patterson matter?'

'You were obsessed when I first met you.'

'Yes, I know.'

'You could hardly talk about anything else.'

'Yes, I know.'

'So?'

'So I've changed.'

'Why?'

She drew on her cigarette. 'Oh, my whole life's changed. But I did think, once, that I'd clear his name, reveal all: the witchcraft, the conspiracies, all that. But now — I don't think it matters at all.'

'I thought there might be something else, some other reason —'

'No.'

'I must go.' I bent to kiss her cheek but she caught my hair and pulled my head down and kissed me on the mouth. Her tongue flickered against my lips. I could taste her lipstick. I stood back. She smiled up at me.

'Just to remind you of what you're missing,' she said. 'Till tomorrow?'

'Till tomorrow.'

'Remember Patterson!'

Walking back to my tent I wondered if I should tell Tregallion about Patterson's ghost but decided I'd feel too silly. Perhaps later. I never told him and now it's too late. I sometimes wonder if it would have changed anything at all.

We met Oriana and Grenville early the next morning and they and Marion greeted each other with real pleasure. I had the curious feeling that they knew each other much better than I'd suspected but dismissed it as fancy. Tregallion's constant nagging had persuaded us to rehearse the last of the fugues — the unfinished number eighteen quadruple, as Marion had said, that concludes with the beautiful Prayer for the Dying. Strangely, its ecstatic serenity suited each of our musical temperaments and the tempo was a stately adagio that even our unpractised fingers could master.

We tuned up and while the army strung fairy lights and erected trestle tables we began tentatively, shyly, to play together. I won't say we were good; but at least we weren't awful. It became apparent that we'd all been well taught and we had two things in common: our feeling for Bach's phrasing of the complex fugue was almost identical and our intonation was still amazingly precise, so at least we played more or less together and in tune. From time to time the camp servants and the soldiers would come and stare and whisper and smile uncertainly at the unfamiliar sounds that floated across the desert.

By mid-afternoon we'd managed to run through the fugue twice. The Guarneri Quartet weren't about to offer us jobs but I was quite pleased and rather surprised by our competence. The feast was scheduled to start at seven and at four I heard drumming from the workers' tents and a few deep male voices began singing a strange

pagan lament that hung suspended on the quiet desert air. I listened for a time then went into my tent to bathe and dress.

There I found two gifts, both wrapped in black paper; and a great etched brass vase filled with a mass of white St Joseph's lilies, the funeral flowers, and a handful of the pure white anticleia blossoms from the woods at our crater lake. Their scent filled my tent: thick and spicy but with a hint of putrescence. I breathed in. The perfume was strong. I sat and stared at the flowers. There was a card which I read. 'My love,' it said. 'Think of me. We were gods.' It was unsigned. How had he managed to smuggle that exuberant mass of flowers undetected into camp, into my tent? I breathed in again: the scent was as dark as our lovemaking. He'd chosen well. I tore the black wrapping paper from my first present and found inside a flat blue leather jewel box from Garrard's in London. For a wild instant I thought Tregallion had given me an engagement ring but I should have known better. I raised the sprung lid and saw a lion's floating collarbone, identical to the one Tregallion wore round his neck, hung from a twenty-four carat gold chain.

The other gift was no less wonderful. When I tore the paper away I found a framed etching; looked disbelieving at the brass plaque let into the walnut frame, and read: 'Study for "The Hanging Tree", 1620. Jacques Callot, 1592-1635. From the "Miseries of War" series, 1621.' I looked at the bottom left hand corner, found Callot's signature and the notation: 2/2. Where had Tregallion found it? How had he found it? How much, dear God, had it cost? I stared at the etching. The corpses hung taut-legged still, the condemned waited patiently for death. The priest, secure on his ladder, held up a crucifix to a victim as the hangman fitted the noose carefully about his neck. The dead swung in the wind. I remembered Tregallion's comment: 'That's our plight too, Kathryn...'

★

I was seated at the head of the long table with Grenville on my right and Marion on my left. Tregallion was at the far end. Oriana was seated on his right, captain Okumi on his left. The rest of the guests

— workers, the army troops — sat at the three tables that surrounded an open dancing area lit by faggots dipped in diesel that burnt with a dark red flame. Shadows flickered and spat.

Hamid had pressganged troops into service as waiters and the first courses began to arrive: a galantine of vegetables, a duck terrine stuffed with wild cèpes and a cold cucumber soup. Orde had excelled. Grenville chose the terrine and smiled at me while he chewed. 'Delicious,' he said. 'Orde certainly knows his stuff.'

'Yes.'

'How're your Patterson researches going?'

'Badly. I've been too busy with the dig. But Tregallion's been reading everything. He's quite engrossed. Why?'

He chewed thoughtfully for a minute, then said: 'I did think I might have one piece of information that might help you.'

'What?'

He glanced at Marion who was sipping her wine and talking animatedly to Okumi.

He turned up the volume of his hearing aid. 'It's about Oriana,' he said softly. 'D'you remember I told you that Sebastian found Patterson and Oriana's mother making love in the Red Bedroom?'

'Yes.'

'Nine months later, to the day, Oriana was born. And Patterson always took an inordinate interest in her wellbeing.'

I stared at him. He smiled at my reaction.

'Not proof,' I said.

'No. But my — what? Dare I say instinct? — tells me I'm right.'

'I'll have to think about this.'

He raised his glass. 'To you, Mercurius; the eternal detective. All hail!'

Beside me, Marion raised her glass. Her eyes met mine over the rim. She smiled at me and I felt a sudden malevolence and turned to see Sister Mary watching me, eyes dark, from further down the table. I shivered but Marion just laughed.

★

After dinner Captain Okumi announced that his men and the field workers had composed a praise song which they wished to perform. We settled back in our chairs and the scratch choir assembled on the rectangular dance floor and began to sing. It was not a joyful song: there were falling motifs and little contrapuntal laments when their voices rose high in mourning. The drumbeats thudded and pattered, the voices rose and fell in cadence and when they finally fell silent I felt my throat tight with my need to cry. I turned to Okumi and said: 'Why so sad?'

'Ah, Miss Widd. That's because of the loss. We have come to love you all, but now we must part.'

Then it was the turn of our quartet. I think we played well, because the audience was silent and rapt. We must have made a strange sight, sitting there in evening dress amongst the flames, under the overarching desert sky, playing Bach amongst the fossils near the caldera of the burnt-out volcano. A little wind rose and shuffled the pages of our music on the music stands and there was even a throb of lightning and thunder way beyond the invisible horizon. Perhaps the rain was coming at last to break the drought. We played on, matching the lightning with contrapuntal fire. As the last serene note was overtaken by silence, the audience began to clap. I felt foolishly proud as we stood and bowed. I saw Oriana smiling at me, her violin bow reflecting the diesel flames. Marion laughed and lit a cigarette. Grenville stretched his fingers. Marion exhaled her Turkish smoke and said: 'I rather enjoyed that. I think we did very well.'

We sat again at the table. The waiters opened wine and we drank. I saw Okumi hurry up to Grenville and hand him a piece of paper. Grenville read the message then rapped with his fork sharply on his glass for silence.

'Since I am known to all involved, and because I am by far the oldest here,' said Grenville, 'I have been asked, ladies and gentlemen, by Captain Okumi to read you a message just received by radio from Marsabit.' He adjusted his glasses and said: 'It's from the Raymond Dart Foundation in Pretoria. It says: "The Raymond Dart Prize of half a million dollars has been unanimously awarded to Ray Chinta of the Museum of Man, Kenya, and Kathryn Widd, of the Johannesburg Museum. Congratulations to you both."' He looked up and beamed at me, all wrinkles and silver hair. There was a burst of applause.

Chinta came to me, took my hands and said: 'I knew we'd do it. It was all you.'

'No, Chinta.'

'You know how I love you, don't you?'

'Yes. I love you too. No one will ever understand.'

He put his arms round me and hugged me.

'Rich and famous?' I said.

'Rich and famous!'

I kissed his cheek and saw his eyes were wet. Dear Chinta. How I miss you. Then the crowd surrounded us and I remember Orde kissing my cheek, Marion holding my hand and laughing, Victor smiling and wiping his eyes. Even the Kenyan troops seemed pleased. I saw Tregallion watching, his eyes smiling. Only John Morton and Mary were missing. But I remember thinking that the others all looked so happy; so very, very happy.

Captain Okumi had wired a public address system to his Discman and to my surprise a recording of the Congolese 'Missa Luba' came through the loudspeakers. The innocent faith of the pagan voices was very touching. The complex African rhythms and the choir's acidic quartertones overlaid the consecrated Latin text with a knowledge and acceptance of evil that I'd never heard before in any western mass. Something in this moved Okumi and he walked to the dance floor and began to shuffle and jump. One or two of the workers and soldiers joined him and then, elated by the music, a mass of dancers was suddenly on the floor, twisting, leaping and spinning, a fugue made flesh, their arms upstretched to encompass the stars. The diesel flames flickered heavenward, their bodies reached up, crouched down close to the earth, then sprang starwards.

Tregallion appeared beside me, said: 'Come' and led me to the dance floor.

'No, Tregallion,' I said. 'I can't; I can't dance.'

'Don't be an idiot,' he said. 'Of course you can dance.'

He took my hands and I thought, What the hell, why not? and clumsily began to mimic his steps. We danced the whole Mass through, and at the end stood together hand in hand, smiling and breathless.

Tregallion walked me back to the dinner table. 'I told you you could dance,' he said. He held me, kissed my mouth softly. I saw Marion watching us. In the torchlight Tregallion's face was that of a depraved angel.

'You dance like a devil,' I said.

'You play like an angel.'

Marion rolled her eyes. 'God save us, this is nauseating. A marriage made in heaven,' she said. 'Obviously.'

I invited Oriana and Grenville and Tregallion back to my tent for a late night celebratory drink and a snack of smoked Nile perch sandwiches. It was past two in the morning as we sat outside my tent in the chill night and talked. Oriana said: 'I suppose in the excitement you've abandoned Patterson entirely.'

'She has,' replied Tregallion. 'I haven't.'

Oriana turned to him. 'You?' she said. 'You?'

'Yes.'

'Why?'

'Unsolved mystery,' he said. 'Unsolvable.'

'Yes,' said Oriana and nodded. 'Yes. And what do you think?'

'As I see it there are only four possibilities,' said Tregallion. 'One, Audley James did it himself; suicide. Two: Patterson shot him with the revolver while he was with him in the tent or from outside through the tent wall with a .450 hunting rifle; murder. Three: Janey shot him; murder. Four: She or Patterson paid one of the safari staff to do it. Conspiracy and murder. All of it nasty.'

'None of it nice,' murmured Grenville.

... The desert was cold and quiet before dawn. Janey pulled back the flap of Patterson's tent and walked softly in the darkness towards her husband's tent pitched thirty yards away under a straggling whistling thorn that gave a little shade in the heat of the day. The desert hills around Laisamis were dark and bulked around the basin of the wells. She stopped outside Jamie's tent. Her heart was beating wildly. Her hands shook. She closed her eyes and took one deep shuddering breath and then pulled back the tent flap and slid into the tent. A paraffin lantern burned low near the bedhead. She could just see her husband through the pale folds of the mosquito net. Jamie lay on his back, head thrown back, mouth agape, snoring softly. She stared at him in silence, appalled by her

thoughts. Then she remembered. She walked quietly on the tarpaulined floor towards him, lifted the mosquito net and felt carefully beneath his pillow for the butt of the Webley service revolver she knew would be there. She could smell him: fever sweat and the scent of the Penhaligon's toilet water he dabbed on his temples in the heat. She held the revolver in her hand for a moment, thought of Patterson's tongue probing her, licking her. She took a deep breath and drew back the stiff hammer of the Webley using both thumbs and placed the muzzle of the revolver in Jamie's mouth and pulled the trigger.

No; perhaps Patterson sat beside Jamie in the oil lamp lit tent and waited for his friend's eyes to close in sleep. The desert was cold and quiet still but Patterson knew that dawn was not long off: his watch told him it was almost four. Jamie made a soft whispery inhalation and Patterson thought how frail he looked, how eaten away and diminished by fever. So frail... Patterson took the thought and strangled it: there was no time for compassion. He knew what to do, how to do it. Could he do it? Wonderingly, Patterson reached forward and slid his hand beneath the sleeping man's pillow and felt for the cold butt of the revolver hidden there; grasped it; withdrew the revolver and held it, black and heavy, in his hand. There was a slight noise from outside. Patterson called out: 'Who's there?'

'It is Idi, bwana. I have come to watch Bwana Blyth.'

'Good. First go down to Munyakai bin Dewani and tell him to get ready four pagazis to carry Bwana Blyth in the hammock.'

'Ndio, bwana.'

Patterson looked down at the sleeping man. The last time: the last breath. He leaned forward, kissed Jamie softly on his clammy forehead then stepped back, placed the dark barrel of the Webley revolver in the sleeping man's mouth and pulled the trigger.

There was a roar and blood and bone spattered the tent wall. Appalled by the mess and the gaping wound in Jamie's skull,

Patterson fumbled the dying man's thumb inside the trigger guard of the Webley and turned away, retching, from the body that shuddered beneath the sheets. Quickly he crawled out beneath the flaps at the rear of the tent and ran in the darkness towards the camel porters...

No: not Patterson; Patterson hadn't done it. It simply did not feel true. But what if Embu reached in the pocket of his ragged khaki shorts and felt the smooth crisp paper of the English pounds the m'sabu wa safari had given him and edged in the darkness towards the tent that stood beneath the ragged whistling thorn where the ants had eaten galls into the thin acacia wood and the dawn wind whistled a doleful note as he moved closer. He crawled snakelike under the pegged folds of the rear of the tent, saw the oil lamp burning dull yellow not a pace from him now. Slowly he knelt, felt beneath the pillow while the bwana Blyth snored on and felt the revolver's cold metal. He drew it softly from beneath the pillow, cocked it as he'd been told to and placed the barrel in the bwana's mouth. Just then Janey opened the tent flaps and called 'Jamie?' Embu squeezed the trigger in fright and the revolver went off with a roar and the bwana's legs thrashed and he heard the m'sabu scream and watched her run from the tent...

'I think,' said Tregallion, 'that Janey did it and Patterson suspected and did everything to protect her from harm. He was a man obsessed with his own idea of himself as a gentleman; he'd sinned against his code; the least he could do was keep her from harm.'

'I don't know,' I said.

'No,' said Oriana. 'And we'll never know for sure, will we?'

As I walked with Oriana and Grenville to their tent, I said softly: 'Can Grenville hear me if I speak like this?'

'No. Why?'

'Have you ever seen Patterson?'

She walked in silence for ten steps before saying 'Yes. Once.'

<p style="text-align:center">★</p>

Later, when the singing had stopped and the fires had burnt down and the last drunken voices of the soldiers had ceased, I lay with Tregallion and listened to his heartbeat, felt his blood thud deep inside me. The tent was filled with the light of a tumescent moon.

The lion's collarbone hung down from its chain around my neck and when he entered me, Tregallion took the tip of the bone in his mouth and pulled tight and drew my mouth down onto his and I swear I could taste in the kiss the blood of the dead lion on his lips. Then there was the sudden ecstatic serenity that never ends and I heard my voice call out and Tregallion was beyond control, riding the night. And then we both went away and there was just the darkness and the scent of the lilies, the white funeral flowers, and the anticleia blossom and the taste of the lion's blood in the pitch dark tent and I did not know where my body ended and the stars began.

I woke just after dawn. I was alone. I lay and thought about our lovemaking, felt the tenderness of recurrent plunder between my thighs. Five minutes later Tregallion brought fresh coffee, kissed my face and said: 'Were we gods again?'

'Yes.'

'Do you think that's wrong?'

'No.' I pulled him down beside me. 'Tregallion, I haven't thanked you properly for the lion's bone. And for the Callot etching.'

'Did you taste the blood?'

'Yes.'

We thought about this in silence, then I said: 'Tregallion, that etching; you really are extravagant.'

<p style="text-align:center">354</p>

'Do you like it? Really?'

'You know.'

'Yes,' he said. 'I thought you would. It took a bit of doing but finally Christie's found it in a private collection in Brussels.'

'How can I thank you?'

'You don't have to; it already belonged to you. I simply found it and returned it to you.'

'Nonsense.'

He laughed and poured more coffee.

'How's the camp look?' I said eventually.

'Wrecked. It was a helluva party, wasn't it?'

'Yes. And you taught me to dance and we won the Raymond Dart Prize.'

'And you won the Raymond Dart Prize. And we were gods.'

'What a night! Am I spoilt, or what?'

'You deserve it.'

'So does Chinta. My God, but he works hard. I'm almost more pleased for him than I am for myself.'

'Are you going to write a book?'

I sipped my coffee. 'I suppose I'll have to. I've already had an advance.'

'Lots of pictures, gallant heroes, skulls, ancient murder?'

'Even Victor. And Quasimodo.'

'Even Quasimodo. Where is she?'

'With her goatherd. And you. In detail.'

'Never.'

'Pictures of you, too.'

'Not a chance. My family would disinherit me. But you should do a book.'

'Funny, though, I've been thinking about you and your fugues. I think I might do two books: the one the publisher wants and the real book, my book. But I don't think I'd find a form for my book that'd be enough like a fugue to cope with all the ideas I'd like to use. I'd like to write a book in counterpoint; a fugue using cancrizans and inverted themes and augmented themes and diminished themes and mirror-fugues; all the contrapuntalist's techniques in one book.'

'My, my. Literary polyphony.'

A pause. Then he said: 'No one's asked you what happened to the man and the girl, four and a half million years ago?'

'No.'

'Do you know?'

'Yes.'

'Well?'

'He hit her on the head with the kudu femur and killed her. Then he committed suicide.'

He stared at me.

'He struck himself three times on the head with the femur. Cerebral haemorrhage. And before he died he threw the femur as far away as he could.'

He frowned. 'Is that possible?'

'Yes. I wrote and checked with Doc Ludovic at the Mission. Subdural haemorrhage can be quite slow. He'd've had time to throw

the femur away before he collapsed. He'd lose consciousness and die while he lay there.'

'You can't know that.'

'No. It's what Doc Ludovic said, what the fossils say, but no one will believe me.'

'No.'

I sipped more of my coffee, watched him looking out at the day. Finally he turned to me and said: 'I've been thinking —'

'About what?'

'I don't know if I'd be any good at this but I thought — Well, I wondered — Actually, I think you'd really like my farm in the Aberdares. So I was wondering if you'd like to go there with me and see. I've been thinking that it's time I rebuilt the farmhouse there. I thought perhaps you'd like to rebuild it with me.' He glanced at me, sipped his coffee, looked away, looked back at me.

'What about ghosts?'

'You'll banish the ghosts.'

'And the banana farmers?'

'It's a huge farm. I'm sure we could come to some arrangement. I know the chief.'

'Are you proposing to me, Tregallion?'

'Well, no; well, in a way, yes. I thought we could try living there together and see —'

'And Seremai?'

'What about Seremai?'

'Won't he mind?'

He grinned. 'If I don't ask you Seremai soon will. And anyway, Seremai can have his own camp somewhere on the farm. I told you, it's huge. You can drive for a day and a half and not reach the northern boundary.' He drained his coffee. 'Well?'

I kissed him long and softly and he smiled at me and said: 'Well, then.'

★

The army cleaned up the wreckage of the party and after lunch Oriana and Grenville said goodbye. Amman was suffering from a ferocious hangover and sat morosely behind the wheel of the Land Rover. Oriana took my hands. 'Don't forget Patterson,' she said. 'There's still a mystery there to be solved.' She kissed my cheeks.

'I know.'

'Goodbye,' said Grenville. 'Remember what I told you.'

'Yes.'

Tregallion and I waved them goodbye and watched them drive down the road to Maleleji. I was about to turn away when I noticed a small dark figure emerge from the coalescing dust of their passage. The red mist began to settle and I saw the outline of a bicycle, the dome of an old pith helmet. Mister Kimeu. What was he doing here? He raised a hand mockingly in greeting or farewell. Tregallion had walked away. I followed for a moment then turned to look back. The red dust, backlit by the low sun, swirled and clotted. Mister Kimeu was gone.

THIRTY-ONE

That night Tregallion slept with me night-through for the first and only time. I did not sleep. I lay awake breathing lightly so as not to wake him, my whole flesh singing still. I looked at the way his hair curled, the way his body lay totally relaxed and abandoned in sleep. Arms splayed, legs spread across the bed in surrender to oblivion.

When we'd made love the night before the feeling was so intense I'd heard from afar my own strange pagan cries and did not know eventually whether I was air or sunlight, starlight or water. Lust that intense is anarchic: it is lightning and storm wind, not parterred garden and orchard. In the sweet dementia of my senses I was all things wild; our necromantic intimacies conjured up strange mutations in the psyche. And when I lay in Tregallion's arms in the dark, quiet at last, hearing our contrapuntal heartbeats in my ears I realised that in the silence I could hear the whole earth breathing with us and I began to understand what had happened to Janey.

Early, well before the false dawn began to drain darkness from between the stars, Tregallion stirred, reached sleepily for me, hid his face between my breasts and lay silent for a time. The bed was warm and safe.

He said: 'It was never like that before, ever, was it?'

'No. Not even for us.'

'Not for anyone, ever. We were more than gods.'

'Yes.'

I could feel his breath on my nipples. Then he sat up and listened and said: 'Something's wrong.' He cocked his head on one side like an old dog and listened.

'Wrong? What's wrong?'

'I don't know. I must go,' he said and threw back the covers. 'I can feel it.'

Not understanding, I said, 'My love. It's cold outside. Stay a little while.'

He climbed out of bed and said: 'No; I'll just go and take a look. Don't worry, I'll take Seremai with me. I won't be long, I promise.'

Betraying myself, I held onto him and said: 'But how can you leave like this? After what happened?'

'I can feel something's wrong. I won't be long.'

'Please don't go; please. I'm frightened!'

But he went, wrapping his kikoi around his waist and leaving the tent as quietly as a jackal. I lay on my back and cried. I listened, heard the Land Rover start, heard their soft voices, heard the crunch of tyres on gravel, the hesitant whining of its worn gearbox as it climbed the hills. I listened until there was no sound but the desert silence. Perhaps he'd been mistaken.

Then I went to sleep, the smell of his body all around me, the wetness of him still on my thighs, the seed of him deep inside me. He could never escape me now. We had been gods; no: we had been more than gods.

★

They came down on us at dawn like a pack of wild dogs.

There was no warning. The first I knew of the attack was the drumming of horses' hooves that rose up from beneath the ground. I

360

woke with a start and sat up in bed, my heart pounding. Quasimodo growled beside me. I reached out a hand and touched her, found she was shivering. I could hear faint ululations, warcries and screams, the roar of engines. I heard, faintly, the distant metallic ankh-ankh-ankh of mortar bombs exiting their mortar tubes. Then the first bombs hit with crumping thuds and the small-arms fire started.

I ran out of my tent in a panic, still half asleep and looked to the east. There I saw a strange sight, half biblical, half the echo of an ancient dream of violence and pillage, all as if in slow motion.

Pouring down on us from all sides out of the stony desert hills came a horde of Somali shifta. Some were mounted on camels, bridles chased with silver. Others rode wide-eyed Arab stallions, wet with sweat, their bits thick with foam. Others drove Land Cruisers, recoilless rifles mounted in the rear, heavy sandbagged Russian machine guns biting the air with a slow measured thudding.

They seemed resurrected from all the ages of man. A nightmare dredged from the deepest levels of the spirit. There were footsoldiers wielding curved Ottoman swords with jewelled hilts that caught the low sun. Flowing robes and shining armour; rag-tag bits and pieces of khaki and tattered flak-jackets, half-naked warriors with matted hair and warpaint. A horseman wearing a suit of chain-mail shone godlike in the low sun. Everywhere there were weapons: silver-inlaid jezails that coughed black-powder smoke, old Lee-Enfield three-oh-threes, AK-47s, scimitars, stone clubs, spears bound about with tufted fur, turbans, bronze helmets, braided locks of hair, wild eyes and pounding feet. And in the halo of the morning sunlight I could almost hear a hymn: this was more ancient than love, more trenchant than sex. There was a lascivious delight, almost palpable, in the air. A lust for decreation and decay, all counterpointed by the clattering rattle of automatic rifle fire and the thump of exploding grenades.

Our Kenyan army guards began returning fire from the sandbagged weapon pits. I saw off-duty troops running from their tents, pulling on equipment. There came the wham-boom of an RPG. The smoky

trail of its solid fuel motor arced across the dawn and the warhead detonated inside our water bowser with a white roar of flame. The next barrage of mortar bombs exploded amongst the tents: clouds of smoke and dust erupted about a core of brick-red flame. Tracer, a pale new-leaf green in the predawn light, lassoed sweetly across the sky.

Screams and rifle fire and chaos. Primeval fear and terror. Quasimodo ran terrified from the tent. I called to her but she ignored me and ran into the desert. She'd be safer there. I grabbed Tregallion's Rigby and my ammunition pouch from beside my bed, ran to the nearest sandbagged pit and threw myself down. Oh God: could I remember what to do? Safety off, mate peepsight and foresight: a dark figure with upraised sword distant on a camel, squeeze. The rifle bucked and I saw the camel fall, its rider crucified against the sky. Sheer luck. I worked the bolt, swung on another rider, fired, missed, fired again and saw him stiffen in the saddle and roll backwards from his horse. I found I was crying and wet with sweat. Filled with exultation, I screamed abuse. I fumbled cartridges down into the magazine well of the Rigby, small soft points that shone golden in the morning.

I saw a Land Cruiser drive right through a tent and emerge with a screaming body impaled brokenly on its bullbar. From the flatbed at the rear a mounted machine gun spat tracer at our troops. I aimed wildly at the cab, pulled the trigger and saw my gunfire punch black holes in the driver's door, watched his arms fly up and his turban fall. The Land Cruiser careered into a dune and stopped dead. Gripped by a kind of madness, I fired until the rifle was empty. Tracer from one of our machine guns hammered into the truck's bodywork. Flame spurted. An explosion engulfed the cab as the fuel tank exploded. Wrapped in flame the machine-gunner ran from the flatbed and fell screaming. I felt in my magazine pouch for ammunition, reloaded the rifle.

A mortar bomb exploded directly in the latrine pit and a cloud of faeces, stale urine and mud erupted in a stinking cloud. John

Morton ran screaming from his hiker's tent, waving his passport. Two horsemen, one dressed in flowing black, the other in white, twitched their reins and converged on him. Morton saw them and fell to his knees, hands clasped together like a supplicant. The rider in black leant out lazily from his saddle, raised his scimitar overhead and swung it down with the casual skill of a polo player, neatly shearing John Morton's head from his shoulders.

I closed my eyes. Where was Chinta? Where Marion? Why wasn't Tregallion here, the bastard, why had he left me? Where were they, why was I alone? Amid the screams and gunfire, explosions and dust, the roar of engines and the weeping of dying men, I saw Sister Mary, dressed in black, walking calmly about, watching the carnage as if she were strolling the tables at a charity booksale. I shouted but she did not hear me. Dark angel, she walked untouched by bullet or sword or club. All about was blood and death and ancient fear. Riderless horses, collapsed tents, blood and torn flesh. I found I was praying out loud: laudate dominum, laudate dominum. Kyries of rage and fury. Praise the Lord: kill and live.

A horseman in a billowing white burnous, bent double like a pigsticking cavalryman, slashed at the guyropes of Marion's tent. I raised my rifle and fired. Missed. The tent fell. Marion ran naked from the collapsing folds, blonde hair flying. The horseman tugged his reins and raised his scimitar and swung it down in a shining arc as he rode past her and I saw her fall with the boneless finality of the already dead. I fired at the horseman's departing back, saw him fling up his arms, fall from his horse, an explosion of blood across his white burnous. I scrambled from the sandbagged pit and ran to Marion but I knew I was too late. I lay beside her, cradling her close to me. I was too frightened to cry.

'It's no use,' said a whispering voice. I looked up. Sister Mary knelt beside me. 'She's gone. She's at peace now.'

I stared at her in horror but she smiled sweetly at me, stood and walked away through the smoke and dust.

There came the distant ankh-ankh-ankh of mortars again and a chain of explosions marched across the excavations where we'd found the footprints. I ducked. Shrapnel hissed and whined past me. Our Kenyan army guards had regrouped and I heard the rapid patter of their light machine guns. I looked up and saw horsemen falling in twos and threes. Camels roared. Then the battered jeeps and surviving riders were mounting the far dunes, the horses' forefeet digging into the soft sand, haunches muscled, the vehicles' rear wheels kicking up catherine wheels of dust. They crested the rise and were gone into the morning sun. It was all over as unexpectedly as it had begun. Silence.

No, not quite; simply no more gunfire. The tick of burning metal. The moaning of the wounded. My ears sang from the shooting. I could smell burning rubber, burnt paint and the metallic scent of fresh blood tainted with perfume. I held Marion close and began to cry.

★

Okumi radioed Marsabit and the army flew in reinforcements later that day and a young major took command. They erected medical tents, tended the wounded and dying, questioned us one by one. They persuaded me to leave Marion's body, carried her away from me. I walked the smoking battlefield and called for Quasimodo but she did not come.

Chinta had been shot. His body lay sprawled beside his rifle. A wide stain of blood had soaked into the sand. I knelt beside him and held him and rocked his body back and forth but he did not come to life. I do not know how long I held him. Near dusk two gently smiling medics prised my fingers loose and carried him away. I stood and looked around. Victor was nowhere to be found. A single foot, severed at the ankle, was all that remained of him. I looked briefly at John Morton's body. His ambition had killed him; once released by Kimeu's dark skill, the curses did not distinguish between good and bad, friend and enemy. His passport was still clutched in his hand. His head, wide-eyed with surprise, stood erect three feet away on the

sand as if he'd jokingly buried himself up to the neck on a sunlit beach. I could not look at him. Orde was slightly wounded by shrapnel in the chest and arm. His sandbagged pit was surrounded by the bodies of fallen shifta that he'd killed with hunter's precision. Orde and I searched together and questioned the helicopter pilots, but Tregallion and Seremai were nowhere to be found. Quasimodo was still missing.

We'd lost half our workers, thirty-seven Kenyan soldiers had been killed and there were fifty-six bodies of dead shifta lying in amongst the dead camels and horses and burnt out jeeps.

I sat down on the sand and wept. Sister Mary sat beside me and put her arms around me and said softly, 'You must not be sad. They are at peace now. Life is hard, but death is easy. So easy . . .'

I said nothing. A Kenyan army officer hurried up to us and said: 'Can you help, please? We need help with the wounded.'

'Why did they do this?' I said.

He shook his head. He did not have much English. 'There is a warlord,' he said and stared at me. 'He is a warlord,' he added again, more gently, and pointed somewhere between the sand dunes and the sky.

'Who?'

He shrugged. 'Allah?' he said, and frowned. 'Maybe Allah?'

'Allah who?' I asked, thoughts of retribution in my mind; but he simply smiled in embarrassment and said: 'He is just Allah. Please; help.'

The army choppered in more reinforcements, posted more sentries. Before midmorning on the first day helicopters casevaced the worst cases out. The troops zipped Marion's and Chinta's bodies — and Victor's foot — into body bags and flew them out to Marsabit. I watched the helicopters whuck away into the darkening sky. I

questioned many soldiers and all the chopper pilots but no one had seen Tregallion, Seremai or Quasimodo. Somehow, I did not feel hopeless. It seemed impossible that they could be dead. I knew the universe could not be that cruel.

We worked through that day and the following night trying to save lives. Sister Mary sat with the worst cases, the maimed and dying whom triage had determined should simply be given morphine until death claimed them. I saw her whispering to the dying, mouth bent down close to bloodstained faces or bandaged heads, easing them on their way to silence.

Next morning, while it was still dark, I walked the battlefield again calling for Quasimodo but it seemed she'd very wisely decided to stay in the desert like Tregallion. The army marshalled a small armed convoy. I was to drive to Maleleji with Orde. I sat on the sand and smoked a cigarette given me by an army chaplain. The desert was cold and quiet before dawn. The hills were dark and silent.

Orde started his Land Rover and I smelt the diesel exhaust sharp on the air. I looked around. Smoke still rose from the burnt out Land Cruiser I had shot at and I could see the holes punched in the body panels by my rifle fire. The tyres still burned with sudden little spurts of eager red flame. Overlooked by the diligent burial corps, the charcoaled body of the driver — the man I had shot, I had shot — sat gaunt and black in the cab, mouth agape. Where the bodies of the dead had lain, the sand was discoloured black with dried blood. The carcasses of the horses and camels had already bloated in the heat and I could smell their corrupted flesh. From nowhere, vultures had appeared, riding the dawn thermals. They were perched now on the dead animals, legs braced, pulling at dark sun-dried strands of flesh.

From where I stood I could just see the mortar bomb craters in the pegged area where we'd found the fossil footprints. Some of the poles had collapsed, others stood awry. Many tents were burnt out, the tent poles stark. Our fossil tent lay in shreds. A mortar bomb

had landed foursquare in its centre. The fossils had all been destroyed.

'We'd better be going,' called Orde from his Land Rover.

'Yes,' I said. 'I suppose so.' I put my cello case, Tregallion's Rigby, my framed etching of 'The Hanging Tree' and my bag in the back of the Land Rover and climbed up in front beside Orde and put on my sunglasses.

'All set?' he said quietly.

'Yes, I suppose so. Where's Sister Mary?'

'I think she left with the last chopper.'

He put the Land Rover into gear and drove carefully past a dead camel and onto the gravel track. Two vultures ran with outstretched wings and flapped heavily into the air. We drove in silence for a time and then I turned and looked back. I could still see the column of thick black smoke from the burning Land Cruiser but the tents were hidden by a low dune covered with thornscrub. As the dust of our passage settled I thought for an instant that I saw a small prosaic figure standing beside a bicycle, watching us as we drove away but the tumbling dust plays tricks with vision and when I looked again there was no one there.

We found her just two kilometres along the road. She was lying quietly on her side, in a dry pool of blood, her eyes open still in surprise. She had been speared. The long shaft had passed through her body just behind the shoulders and pinned her to the desert sand. She had not died quietly. The sand beneath her small hooves was rucked up where she'd tried to get a purchase on nothingness as death came. I told Orde to stop the car and we stared down at her in silence.

'I'm sorry,' said Orde. 'I'm really sorry.' He walked away.

I buried her a little deeper in amongst the dunes where we often walked together at dusk, fruitlessly pondering the mystery of my fossil finds, wondering about human nature and the cosmos. I built a small cairn of stones above her grave and stood there for a little while in the rising heat, wondering what to think. Nothing occurred to me so I walked back to the Land Rover and got in. Orde drove off. As we rode into the morning of the new day I felt my heart contract and I began to cry. Orde looked startled and put a hand on my shoulder and said: 'I'm sorry, Kathryn. I'm so sorry.'

'It's nothing,' I said, crying. 'It's nothing. It'll pass. It's just the goat. I can't see why the bloody goat had to die.' I turned and looked back but I couldn't see the cairn of stones over her grave at all. It was too small in all that wasteland of desert and dry scrub.

I turned and faced the road ahead, the wind fresh in my face and felt Tregallion's child kick once hard in my stomach, dancing his cosmic dance, eyes closed, a fugue made flesh, asleep amongst his stars.

EPILOGUE

All actions take place in time by the interweaving of the forces of Nature; but the man lost in selfish delusion thinks that he himself is the actor.

Bhagavad Gita: 3:27

Life is a lion, but we are just people. What chance does a mere person stand against a lion?

Al'N'galla proverb

Grief is endless. My life now is a threnody and will be until I die. I am diminished in spirit, in my heart is a cinder. In a way, I am like my cello. When I returned to Johannesburg and first uncased it to play, I discovered that a tiny piece of shrapnel had penetrated the case and shorn a hole, narrow but damning, through the body just below the sound post. I had it repaired but the sound was never the same again and now I never play. I cannot play. My touch is gone. The small gift I had was interpretative: I could sense the right phrasing quickly and some magical unthought knowledge in my fingers gave my playing an authority and passion which has now left me forever. I am like my cello: riven through. I do not sound purely now.

I went to a shrink for a time who told me I was 'dysfunctional', whatever that means. I know that I will never confront what happened in the desert. I have locked it away in my dark basement and thrown away the key. To open that door would be to invite complete derangement; I am not strong enough. I still wake at night crying soundlessly, and I shall continue to do so until death takes me. There is no healing. Who could heal me now? I do not know.

I do know that I have not slept with any man since Tregallion, will never again. He was my life and my life has left me.

I never saw Tregallion again. The army never found his body, nor Seremai's. They found his Land Rover, its aluminium bodywork punched through with bullet holes, burnt out and smoking, twenty miles away in the desert. When we reached Marsabit I threatened and cajoled the army into sending out further search parties for Tregallion and Seremai but they found nothing. A helicopter patrol was equally

unsuccessful. A windstorm had obliterated all tracks. Tregallion, Seremai and the shifta had simply disappeared into the desert.

My fury would not let me be. Before I left Kenya I drove up to the Aberdares, questioned the locals and eventually found the ruin of Tregallion's house, rotting away amongst the banana shambas. I interrogated the farmers but no one had seen or heard a thing about him. I wrote pleading letters to the Somali government, but received no reply. There is nothing else I can do. For all I know, Tregallion is wandering still, dancing at midnight to the great plaited harmonies of the Art of the Fugue, waiting still for his death and trans-]figuration. I suppose I'll never know his fate. It's one of the things I've learnt to accept: that there is a limit to the knowledge I have been given here and now. But I would be lying if I said I did not miss him bitterly; and I sometimes wonder what I will tell the boy when he asks me about his father.

Tregallion's son is a dark child with strange eyes, tawny-green like his father's, that fix your own and watch. I have called him Daniel, after his father. He smiles very rarely and when he does I seem to feel the whole universe light up. No doubt that is merely a doting mother's idiocy but truly, given my doctors' earlier prognoses after my abortion, I cannot but think his conception was something of a miracle.

We often sit in our overgrown garden where the bougainvillaea flowers brilliant magenta and the yesterday-today-and-tomorrow fills all the air at dusk with inviolable scent. Emulating my father, I take the child to the bush whenever I can: we own a hundred-acre farm in the lowveld, bought with the money from the Raymond Dart Foundation. I built our simple camp beside a river: whitewashed walls to waist height, reeds to the roof, kasense grass thatch, the whole constructed around iron-hard mopane logs. The child seems to regard these visits to the bush as very solemn occasions and always asks to wear 'The Lion Bone', Tregallion's last gift, that hangs always around my neck. When I pass the thin chain over his head, he holds the bone gravely and watches me for any sign

of loss. He is thoughtful, like his father. But his melancholy passes when we roll up the bamboo blinds of our bush-house and startle the water leguaan who dozes on our roof in scaly reptilian torpor.

Each time we arrive at our bush camp we perform a small unconscious ritual of exorcism. I pour a hefty gin and tonic; Daniel fills a water bottle with sweet rain water from our barrel; and we always walk slowly down through our stand of bush-willows to the river, our feet crunching on the trees' fallen winged seeds. Across a brief rapid where the river flows fast and white over dappled rocks, there is a shallow cave where Bushmen long ago drew on a flat rockface ochre and black renditions of holy eland and pursuing hunters who fly on god-driven feet.

One hot day we canoed across the flat dark-running river further upstream and walked together to the cave. I watched the surprise and delight in the boy's eyes when he saw the paintings, unseen for centuries, watched him reach out a hand and touch the flying hunters.

Even in the city I observe the boy carefully. And when I see him engrossed in the flight of a passing bird or fascinated by MacPuss's play, I wish my parents were not dead, wish that Tregallion could see him. Often, watching him, I think how much joy he would have brought them all. I remember the desperate melancholy of my parents' time together, their essentially pointless lives and meaningless deaths. I know, in my worst moments, that they died understanding nothing, bewildered by the desperate injustice, the unanswered questions, the endless silence.

★

History is a lion; it sometimes eats us alive. Now, here and now, sitting in my office at the museum in Johannesburg, it is evening and my desk calendar tells me that it's the summer solstice and full moon. But when I look out at the sky I do not see the jolly Man-in-the-Moon face from my calendar page rise up through the mucky clouds that squat toadlike on the horizon. I see instead a soft

373

powderpuff moon; clouds shires long, as tall as glaciers; and inside the clouds, lightning that trembles white, pink and peppermint green. Icecream clouds. Yet another summer storm: unrepentant and irresistible, arrogant as only a god can be. Pigeons warble fat-throated on the windowsill. In the streets below, the winds ransack dustbins and chase paper and wrinkled plastic bags down the empty pavements. And the abattoir scent is there yet again: sweet and hot, reminder of all our deserts.

On my desk stands my framed medal from the Raymond Dart Foundation, one of the pair awarded to Chinta and me for our discoveries in the desert. To me, the medal is a reminder that I pointlessly sacrificed people I loved during my vain quest for truth. I cannot believe that a tentful of fossils can justify the death of so many. I remember my last view of the campsite: the shreds of the fossil tent waving in the breeze, the pieces of fossil bone scattered all over the sand by the exploding mortar bomb. The trustees invited Chinta's widow Iris to the awards ceremony in Johannesburg but she did not come. I accepted the medal on his behalf and sent it to her along with his cheque and a note explaining my view of what had happened in the desert and how much I loved him; but I've received no reply. Perhaps I did not expect one.

And Tregallion. Even now I find it hard to accept that if Tregallion died, he died because of my stubbornness. It is terrible to think that I still know nothing about his fate, that Daniel will probably never know his father; strange to think that Tregallion may still be dancing his mercurial cosmic jig at moonrise somewhere in Africa, unaware that he has already found immortality of a sort. If only I could tell him.

Watching the coming storm, I think of the time Tregallion and I spent together at the crater lake, remember the thunder and lightning, the feeling I had when we made love that he'd created stars in my heart. When we were together we talked of nothing base or mean; there was no pettiness of spirit between us. And to comfort myself when my grief and loss are at their worst, I sometimes lie to

myself. I tell myself: what happened has spared us the indignities attendant upon marriage. If we had been together, how would we have borne the small unrelenting humiliations of ordinary life? The dirty nappies and midnight feeds, the tedium and little frustrations that make it impossible for a free spirit to live heroically in the face of coming age and growing acrimony. Would we, I wonder, like all other married couples, have pretended to ourselves and others that our boredom was a deeper kind of love and our indifference merely a calmer intimacy?

I know we were spared all this but it is a barren comfort because I know too that the loss of love in the time of your maturity is more damning than any loss suffered in youth. This loss is final: it closes eyes, draws curtains, locks doors forever. There is no going back. This loss is your shroud. This loss tells you: at the core, life is steel on stone.

When I look out at the city skyline and the early pink neon of the massage parlour that opened recently across the street, I remember again the safari we made into the desert where we lost everything: each other, our lives and our innocence. I ponder the evil summoned up by Mister Kimeu and Sister Mary and wonder where she is now. I think of Patterson caught in the grip of the nyika, his mind despoiled by whirling magic, curses that would never be lifted, blood oaths that would never die. He must have looked at the stars and wondered about death and ancient gods, and thought: There is no end to suffering; life is surely steel on stone.

There is no end to irony, either. I received in the post the other day a letter from Oriana's solicitors. It said briefly that she and her husband Grenville had committed suicide; a mutual pact. There was no apparent reason. Both had still been in good health. A note had been found asking the solicitors to forward an envelope, unopened, to me. This they enclosed with their compliments etc etc.

I looked curiously at the envelope, addressed to me in Oriana's sprawling hand, opened it. Inside was a short note.

'My dear,' it said. 'It seems reality has a way of mutating. I found the enclosed amongst some papers left me by my mother; one of those trunks one never opens. But Grenville and I decided to tidy things up a little, and so... I thought you should see it. I wonder what it means. So elusive, truth. But you are Mercurius, the eternal seeker, are you not? Perhaps you'll be rewarded where we weren't.

'One thing troubles me. I do not like to lie, but I'm afraid that I did lie to you, unfairly, as did Marion. You no doubt wondered sometimes why she and I were so curious about Patterson. I understand that Grenville told you a little about my mother and Patterson, so perhaps my interest is understandable. Perhaps when I tell you that Marion was my granddaughter you will understand her obsession too. I think we were unfair to you; when I think about it now, Marion's passion for secrecy seems inexplicable.

'I apologise to you for the deception and hope you can find it in your heart to forgive me. Sadly, I'm afraid there's little likelihood of our meeting again, so I must tell you now how much we both applauded your love for Marion, and how much I enjoyed your friendship. Yours, as ever, Oriana.'

There was a PS: 'Grenville sends his love, too.'

A voice from the dead. Or was it? Marion and Patterson and Oriana. Who would have thought it? Who could have guessed?

I looked at the enclosed piece of paper. It was a certified copy of a Nairobi police report dated 31st October, 1908. All Souls Night. Halloween. It read:

> As instructed I proceeded to Lersamis (sic) in the company of Doctor P.J. Hackitt. The body of Blythe (sic) was exhumed from a grave piled high with stones but very shallow, viz. not more than two feet deep. The autopsy was performed on the morning of (undecipherable date) by Dr Hackitt. His report is appended.

His finding is that the wound in Blythe's head is likely to have been made by a large calibre hunting bullet of solid, not expanding, construction, approximately of .450 calibre fired from a range of between ten and twenty feet from a rifle. This is at variance with the testominy (sic) of Col. Patterson, who states that Blythe committed suicide with a/ his service revolver.

There was a signature that I could not read.

I remember staring at the report and wondering about the truth. They were all dead now. No one would ever speak to me, tell me the truth. If only the dead could speak to me, the failed seeker. Now no one will ever know.[20]

Sitting quietly by the river of our bushveld farm, I think often about Oriana and Grenville, living their lives together on the edge of that mighty desert, together still in death. I think also about our small hunched ancestors crouched in trees at nightfall, the dusk wind turning their fur: waiting for night to come down with all its terrors. Leopard and hyena; mystery and the unknown; silence and darkness. I also think about the gifts they have bequeathed us over the millennia: the hard desire to endure, the laughter and dancing, the curiosity about the stars and the terrible capacity we possess to turn our own kind into enemies. Our love of blood and of children. But as Tregallion himself once said: To the gods, bloodletting and childbirth are hymned equally with hallelujahs.

I wondered if that was true, still missing the point. How Tregallion would have laughed.

★

There is an odd footnote to this story.

I have often wondered if I could have learnt from what happened to me in the desert. Surely, I thought, all that loss and death, all that heartache should teach me something important about the future

377

conduct of my life. I often return to my ageing copy of Korcak-Dukowska's book, stained with rain from the crater lake, pierced through with a bullet hole, and read the line I once read long ago in this same office: 'Hidden behind his masks, the creator is invisible, unknowable. Accidental, pointless, our cries echo across the vacant spaces between the stars, unheard in a universe that makes no sense...'

I ponder this line yet no matter how hard I try, I cannot divine a pattern in what has come to pass. Then, as years passed, I remembered that every visit to Africa is a visit also to the museum of your own past; and I began to think that reliving my experiences in memory would reveal their significance to me, that I could somehow redeem meaning from oblivion through a disciplined excavation of lost time. In this I was wrong; but I was given a tantalising glimpse of another truth. Whether it was a divine gift or merely a rude spawning of my troubled unconscious, I will leave you to decide.

Deep asleep one night, I heard a baby crying. I woke instantly, thinking it was my son. Yet even as I stood naked beside my bed, still half asleep, I caught the ghostly hem of a dream as it fled from me into the dark passage of time: as I was descending the museum's long stone staircase, listening to the triple echo of my passage — footfall, stick, footfall — I saw a narrow door open in the shadow to the left at the bottom of the stairway. There was a slight movement in the darkness behind and I strained to see, but the door swung shut and closed with a firm double click. Thinking I might have surprised a thief, I tried the door when I reached the ground floor but it was locked tight from the inside. And then a strange thing happened, the sort of thing that can happen only in dreams.

As I turned to go the door swung silently open to reveal a dark room lit by a Dietz paraffin lantern. I turned back and walked slowly into the room. It was windowless and empty; except for a painting that hung on one wall. I walked closer and saw, in the storm lantern's yellow light, that I was looking at a copy of Jacques Callot's etching of 'The Hanging Tree'. It was identical to the one that hung in my

study, given to me by Tregallion a lifetime ago. I looked again at the swinging corpses, at the condemned men waiting at the foot of the crucifix-shaped tree, and remembered Tregallion.

There is one comfort. MacPuss now has a friend, a wild tabby cat who lives on the bald mountain behind our house and favours us with occasional visits and even allows us the rare privilege of stroking him carefully behind the ears. His purr is loud and rough and his eyes when he looks at you unblinking are the pale green of ripe hanepoot grapes. We call him Poor Tom, after the role of the ragged madman adopted by prince Edgar in *King Lear* when he and the broken king and the king's Fool wandered all night through on the stormrent heath.

Once, tempted beyond good manners, I picked him up and his pliant body became instantly taut and hard and he turned his head and looked straight into my eyes as if to say: All right, just this once, I trust you; but don't do it again. I am a king... I think, in fact, he allowed me to hold him simply because I'm a woman.

He's twice condescended to be loaded into MacPuss's cat basket and taken to the vet. The first time my son and I found him lying in the sun, panting and half-conscious, his right front paw swollen and taut with pus. In his eyes I could see bitter resentment that this sac of corrupted tissue had been fixed to him, a king, like a trail of tin cans. The second time, my son found him lying close to MacPuss on our outdoor sofa, his hindquarters wasted and shrunken and matted with faeces, his head grotesquely swollen with a sinus abscess. His suffering must have been terrible but he endured the vet's examinations and his temporary incarceration in the vet's cage with stoical calm and returned to his mountain more of a prince and ragged madman than ever.

The strange thing is this. When I wake in the night and think of Tregallion and Marion and the others who died, it comforts me to think of Poor Tom stalking his stony mountain in the long unlovely reaches of the night, hunting fieldmice and frightening rivals; and

staring up, like me, at the great incandescent galaxies of stars with green uncomprehending eyes.

ENDNOTES

1 This interestingly named site, recently discovered, displays early signs of fire use amongst hominids. Azazel: a little-used name for the Devil. Gat: (Afrikaans) a hole or excavation or access to a geologic downpipe. Also: slang for the anus. Azazelsgat was so named by early missionaries who saw it as a place of evil and avoided it.

2 The late Raymond Dart, the Grand Old Man of African palaeontology, discoverer of the 'Taung Baby', an Australopithecine man-ape thought to be one of our earliest ancestors. His seminal work *The Predatory Transition From Ape To Man* was influential in its time, but his central thesis has fallen into disrepute. See *The Hunters or the Hunted* by Dr C K Brain.

3 Chinta refers to the crest of bone on the top of the skull for the attachment of the powerful masseter muscles characteristic of the vegetarian robustus.

4 Ceremonies such as these endured at least into the twenties, when George Rushby, an elephant hunter, recorded the blessing of his rifles in a similar pagan ritual.

5 'Oh, Great Spirit that flies in the night
Oh, Great Spirit of the night
Fly in the darkness and infect the heart
Of The Bad One;
Oh, Spirit that flies in the night
Oh, Great Spirit
Hear my cries and kill.'

Trans: Dr Jakob Neukraft: *Fragments of Witchcraft in Pre-Colonial Africa*. University of Leyden, 1922.

6 Pigs.

7 Potassium found in rocks contains a proportion of the unstable isotope potassium-40 which decays over time into the inert gas argon-40. This gas accumulates over millions of years, is trapped inside the rock, but can be released by heating, and measured. The more argon-40 relative to potassium-40, the older the rock.

 The Argon/Argon technique involves bombardment of rock with neutrons. This converts the isotope potassium-39 into argon-39. The potassium-40 present can be inferred, and the argon-40 measured using a mass spectrometer. Volcanic rocks are perfect for these techniques, since all argon-40 stored by the rock is released by the high temperatures at eruption; the geological clock is 'reset' to zero at the moment the lava is deposited.

8 The Norfolk Hotel has since played host to numerous modern celebrities from Robert Ruark and Ernest Hemingway, to Karen Blixen, Denys Finch Hatton and Berkeley Cole.

9 I later discovered that this is unlikely. Nairobi had been out of bounds to the Maasai since the 1906 'rebellion'. Perhaps they were Lord Delamere's personal askaris.

10 In 1908 Elinor Glyn made her stage début reclining on a tiger skin. Lord Curzon, besotted, sent her the skin of a tiger he'd shot. So did Lord Milner, whom she later inexplicably thought the reincarnation of Socrates.

11 Global Positioning System (GPS). A small handheld navigation aid that locks onto signals from three orbiting satellites to give an accurate map reference.

12 Solid geological work is critical both for radiogenic dating of hominid fossils (Potassium/Argon and Argon/Argon); and for correlating fossils of other species found at the same site in association with hominid remains. Without accurate aerial photographs and a full geological survey it is impossible to establish the precise positions of fossil finds relative both to each other and the geology of an area.

13 Tiny zircon crystals are found in volcanic tuffs. Researchers polish these crystals to remove surface scratches. Any remaining marks are the result of radioactive uranium-238 atoms exploding inside the crystal. U-238 decays steadily into lead at a known rate; by counting the number of 'fission tracks' in the crystals researchers arrive at a reliable date for the volcanic tuff and hence for fossils found there.

14 Hipparion, an ancestral horse, has a small bump on the surface of its teeth, called an ectostylid. Equus teeth do not have this bump. Hipparion became extinct around three million years before present. Any fossil found in a bed below it must be older.

15 Khat: 'Bushman's Tea' (Catha edulis). Prized in tropical Africa for the natural stimulant contained in its leaves.

16 Paul Morgan: *Keraunos: Thunderbolt for Pan*. Slim Volumes Press. London, 1991.

17 These techniques were developed by Nick van der Merwe of Harvard and Andy Sillen of the University of Cape Town respectively. Any errors in the application of these techniques in the novel are those of the author.

18 Sexual dimorphism: the difference in body structure based on gender. Males are usually bigger than females, but not always. When sexual dimorphism is great, sexual behaviour is likely to involve dominant males commanding harems of females.

19 Endocranial cast: very occasionally crania are filled with mud or volcanic ash which hardens within the cranium taking on all the

features of the brain imprinted during life on the receptive inner walls of the skull. An endocast is therefore an accurate reproduction of the brain of an extinct creature, allowing researchers to compare cerebral structure.

20 When I got back to Johannesburg from my ordeal in the desert and had gained a little perspective I was sufficiently curious about Patterson's fate to do a little research. In the musty recesses of the War Museum and in the reading room of the Johannesburg Reference Library I found clues and tantalising fragments. His life was ruined by Blyth's death and the ensuing scandal and although he went on to command 'Patterson's Column' under Allenby in Palestine and marched beside that gallant general into a liberated Jerusalem, his life was over. Freddy Jackson had pounced on Blyth's death like a leopard and worried Patterson's bearers and camp servants ceaselessly until he obtained by resolute cross examination testimonies that seemed to implicate Patterson. He forwarded an unending stream of reports and despatches to the Colonial Office and, malevolent to the end, spread damning rumours through his powerful contacts at the Foreign Office.

He won, Patterson lost. On 8th May, 1908, there were questions in the House of Commons about Patterson and his conduct while he was on safari with the Blyths in Kenya. The Colonial Secretary, Lord Crewe, explained to the House that Patterson's health had 'broken down' and that he'd been forced to leave the Colony. But I thought I knew better; I knew they'd asked him to leave. Rather than accept the court of inquiry's findings and the testimony of despised black menials that implied a less than innocent role for Janey, I suspect the Foreign Office made a deal: they sacrificed Patterson to save Janey's honour.

Poor Patterson. His obituary in the *New York Times* said he'd died in Los Angeles in 1947; but he'd really died in the desert; the rest was just waiting. His beloved Janey sailed back to England with him from Kenya on the *Herzog* but their love was

over. She never remarried but devoted herself to good works and in 1918 was awarded the MBE for unnamed contributions to the war effort. Perhaps she became a spy; a Mata Hari in the cause of Britain and the Empire, constant concubinage for King and Country.

Patterson commanded the Zionist Mule Corps at Gallipoli, fought with Allenby in Syria, commanding 'Patterson's Column', and became well known for his attempts to raise a Jewish army to fight Hitler. The Zionist Mule Corps numbered among its members David Ben-Gurion, future prime minister of Israel, and the famous sculptor Jacob Epstein.